THE BOOK OF MEV

THE BOOK OF MEV

MARK CHMIEL

To order additional copies of this book, contact:
Xlibris Corporation
1-888-795-4274
www.Xlibris.com
Orders@Xlibris.com
24804

Contents

PART TWO

PART THREE

RESOURCES

For
Joanie French,
Sheri Hostetler
& Steve Kelly

Hold it all.

Sheri Hostetler

Acknowledgements

I am grateful to the following people who, over the last several years shared friendship, hospitality, stories, e-mails, feedback, funds, comic relief, encouragement, inspiration, insight, diversion, remembrances, poems, prayers and love in action. This work would have been impossible without this community of angels, bodhisattvas, sages, teachers, critics, gadflies, students and friends: Jean Abbott, Madeleine Cousineau Adriance, Lubna Alam, Safa Alamir, Cris Airahgi, Nora Archer, Lilia Azevedo, Courtney Barrett, Michael Bartz, Jeannette Batz, Terry Becker, Dana Bell, Dan Berrigan, Jenny Bird, Julie Birkenmaier, Maria Bowen, Dennis Bricking, Joe Brunworth, Betty Campbell, Francine Cardman, Mary Charlotte Chandler, Teka Childress, David Chmiel, Jim Chmiel, MO Chmiel, Nan Cobbey, John A. Coleman, Jane Corbett, Marian Cowan, Trish Curtis, Nina Diamond, Yael DiPlacido, Virginia Druhe, Polly Duncan-Collum, Danny Duncan-Collum, Mary Dutcher, Eliana Elias, Ann Ellis, Marc Ellis, Robert Ellsberg, Hedy Epstein, Kate Erickson, Mary Beth Erickson, Melinda Erickson, Deanna K. Erutti, Colleen Etling, Tracy Fantini, Anne Farina, Christy Finsel, Annie Fitzgerald, Mary Flick, Jim Flynn, Joanie French, Judy Gallagher, Mary Beth Gallagher, Nina Garrow, Ivone Gebara, Pat Geier, Julia Goeke, Jason Gonzalez, Bob Goss, Gustavo Gutiérrez, Cathy Hartrich, Becky Hassler, Cathy Heidemann, Colette Hellenkamp, Jamie Hendrix, Rob Henke, Laura Herbig, Meg Herbig, Tony Hilkin, Peter Hinds, Dan Hoffman, Suzanne Holland, Dan Horkheimer, David Horvath, Sheri Hostetler, Julie Jakimczyk, Jack Jezreel, John Kavanaugh, Judith Kelly, Kathy Kelly, Steve Kelly, Cathy Kennedy, Jennifer Kennedy, Zeina Kiblawi, Penny Kimes, Jerry King, Marty King, Annerose Kocis, Gary Kocis, Sue Koehler, Ken Krueger, Laura Krueger, Ruth Krueger, Pierre LaBoussiere, Nancy Laleau, Belden Lane, Bob Lassalle-Klein, Lynn Lassalle-Klein, Layla Lavasani, Louise Lears, Dianne Lee, Kathryn Leeker, Carol Leslie, Siony Levrault, Kate Linden, Megan Lippert, Nicholas Taggert Long, Marilyn Lorenz, Kara Lubischer, Lauren Lux, Mary Kate MacIsaac, Elizabeth Madden, Anjali Marwaha, Cristobhal Mayorga, Betty McAfee, Kate McCarthy, Patrick McCarthy, Mary Ann McGivern, Eileen McGrath, Donna McKenzie, Avis Meyer, Katie Meyer, Sara A. Meyer, Alex Mikulich, Kara Mikulich, Bill Miller, Mary Mitchell,

Tina Modde, Karen Mohan, Margaret Mary Moore, Carolyn Moritz, Pete Mosher, Maggie Rose Murphy, Erin Nealon, Joey Neilsen, Esther Neuwirth, Cathy Nolan, Barbara O'Connell, Angie O'Gorman, Bill O'Neill, Rich Ober, Beth Obertino, Danny Orlet, Sharon Orlet, Anita Oza, Vishal Oza, Jennifer Parker, Anna Paszyna, Lois Patton, Tim Pekarek, Peter Pfersick, Kara Piccirilli, Olivia Pike, Jeni Poell, Kathryn Poethig, Janey Prejean, Barb Prosser, Evie Puleo, Melissa Puleo, Peter Puleo, Jr., Peter Puleo, Sr., Bill Ramsey, Gerri Rauck, Jim Reale, Jane Redmont, Ellen Rehg, Myrrah Rehg, Gail Robinson, Clare Ronzani, Ginger Rose, Julie Hanlon Rubio, Victoria Rue, Mary Clare Ryan, Lenore Salvaneschi, Annjie Schifelbein, Kevin Schneider, Marla Schrader, Brett Schrewe, Eric Sears, Greg Shufeldt, Simone, Paul Spitzmueller, Tricia Stackle, Don Steele, Barry Stenger, Mary Timm-Harrison, Anne Tresedor, Jenny Truax, Erin Vonderehe, Anne Walter, Samantha Watts, Cece Weinkauff, Laura Weis, Claire Weiss, Emily Weiss, Elisha Wellman, Michael Whiting, Magan Wiles, Andrew Wimmer, Margaret Winkler, Ginny Winter, Rich Wood, Scott Wright, Jerry Wuller, Mary Wuller, João Xerri and KC Young.

Prologue: Writing/I

I knew it was coming, but I just kept putting it off.

When I was an undergraduate in the early 1980s, I suffered from the debilitating condition of not being able to get far on an assigned composition unless I really liked my opening sentence and first paragraph. In the era before PCs and laptops were commonplace in homes and at universities, I ripped up innumerable sheets of looseleaf paper until I could get the right beginning.

A few years later, when working as a lay minister in two Catholic parishes in Louisville, Kentucky, I was given a copy of Natalie Goldberg's book, *Writing Down the Bones*. Natalie's advice for would-be and stalled writers was to do "writing practices" and keep the hand moving across the page for a certain length of time. I took great interest in her serene advice, "Sit down with the least expectation of yourself; say, 'I am free to write the worst junk in the world.'"[1] And hoping for the kind of liberation she promised, I proceeded to fill notebook after notebook with uncensored scurve and silliness. That college paralysis had become a thing of the past. I trained myself to be able to write about any topic and not care what anybody thought, especially my own smug, nefarious internal critic.

But that January 1996 there was a short writing task that I had been avoiding. After all, there were seemingly more important things to do than sit down at my desk, now often stacked high with winter coats, as the St. Louis temperatures had taken a chilling dive. There was my new role of apartment maitre d' and host: welcoming the family, friends, acquaintances, voyeurs, do-gooders and merely curious who had been arriving and moving through the modest five rooms of our home.

There was reviewing the phone log that a neighbor often kept for us, freeing me from returning each and every phone call, a draining chore that would have necessitated far more coffee than I was already consuming.

Then there was the major labor of translating: not from one language to another, but from wordless raised eyebrows, moans, giggles, stares and screams to English for the many people who were congregating in the first floor flat in this Forest Park Southeast neighborhood.

Realizing what was upon us, my mother-in-law gently encouraged me: "You've got to do it. You're the *one* to do it." She was right. And I took heart in her own difficult determination: She had gone to Kriegshauser's to make the necessary casket selection with a Visitation nun, a friend of the family. How could my mother-in-law pull that off? I realized she had an indomitable will, even as her heart was breaking all over again each day she walked into our apartment.

One of our recent out-of-town visitors had been a Catholic nun, KC, who was a wise companion when we had lived in Oakland. Coming on a pilgrimage of sorts, she stayed with my in-laws at their comfortable home in the suburbs. KC later told me how, one night, she came upon my mother-in-law weeping as she was knitting a frayed blouse. Mrs. Puleo looked up at KC and said, "A mother shouldn't have to knit her daughter's shroud."

No. She shouldn't.

And a husband shouldn't have to write his wife's obituary three and a half years into their marriage, either. But that second week of January, as we kept vigil through the night, we were expecting Mev to die any minute. And, reckoning that I would have far more urgent matters to attend to within a few days, and with the *New York Times* obituary page as my guide, I finally made space at my desk and took a stab:

Mev Puleo, a photojournalist whose work focused on the lives, struggles, and dignity of poor people around the world, died _____ at her home in Forest Park Southeast in Saint Louis. She was 32.

Ms. Puleo, who received the 1995 *U.S. Catholic* Award for furthering the cause of women in the Catholic Church, began her work as a social documentary photographer in 1982 in Tijuana at the California-Mexico border where she taught during summer vacations while a student at St. Louis University. She also traveled to Haiti several times during the mid-1980s with the local Haiti Project; there she volunteered at Mother Teresa's Home for the Dying. Photographs from these travels appeared in the book she co-authored with Jesuit Father John Kavanaugh, *Faces of Poverty, Faces of Christ*, in 1990.

She traveled to Brazil on photojournalism projects in 1987, 1989 and 1990. After conducting interviews in Portuguese with lay Church members, theologians, and bishops, Puleo published a book on the Catholic Church in Brazil, *The Struggle is One: Voices and Visions of Liberation*, in 1994. She recently adapted the book to a video of the same title. In her more recent work, she participated in fact-finding delegations

to Haiti during the period of the military coup government in 1992 and to Chiapas, Mexico, after the Zapatista revolt in early 1994.

Ms. Puleo was one of three emcees at the 1993 World Youth Day in Denver that hosted Pope John Paul II. She also served as board member of the activist organizations, Brazil Network and Christians for Peace in El Salvador.

Ms. Puleo was born in St. Louis and attended Our Lady of the Pillar Grade School and Visitation Academy. She recently received the first annual Visitation Academy Award of Excellence. She graduated from St. Louis University in 1985 with a B.A. in Spanish, Latin American studies, and Political Journalism. She received her Master's Degree in Theological Studies from the Weston Jesuit School of Theology in Cambridge, Massachusetts, in 1990. She was enrolled in the doctoral program in Worship, Proclamation, and the Arts at the Graduate Theological Union in Berkeley, California, when she was diagnosed with a malignant brain tumor in April 1994. In honor of her work and service, the Jesuit School of Theology at Berkeley presented her with the Pedro Arrupe Award.

She is survived by her husband, Mark Chmiel of St. Louis; her parents, Peter and Evie Puleo, of St. Louis; two sisters, Laura Krueger, of St. Louis, and Rose Kocis, of Houston, Texas; a brother, Peter A. Puleo II, of St. Louis; and three nieces and two nephews.

I would write these paragraphs, it turned out, the day before Mev died.

What are we supposed to do, those of us whose beloved, soul-mate, dynamo of delight, and poetic muse, has trekked on, passed away, died? We are here, but they are where? Absent, yes, definitely absent, then preternaturally present at the most eccentric times, times, yes, we're off-center, because they—these treasures of pulse and synapse—centered our lives, in grace, with gratitude. What to do?

I wrote, I wondered, I redacted.

And so, this work is an eccentric response to awe and ache, a daydream after a nightmare came true, a mishmash of memories, and an affectionate writing-down-my-bones beyond that obituary.

PART ONE

Be in love with yr life

Jack Kerouac

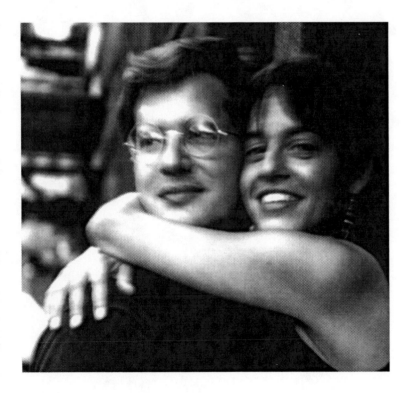

Mark Chmiel & Mev Puleo; North End, Boston, Massachusetts; 1990
Suzanne Holland

Face to Face/1

It was love at first laugh.

Ah, what a quickening I felt upon hearing it—a laugh so full of unabashed enthusiasm and delight that, if it could only be bottled, and marketed in the global economy, it would surely put Prozac and all its rivals out of business. A soul-laugh, so refreshingly different from the superficial chitter-chatter titters, hoots and sniggers I heard on an all-too-regular basis. I wanted to fuse with that laugh.

On this sunny afternoon in early July 1988 I had settled into my spare monastic room. Suddenly, I stopped organizing my books to glance out the window. There below me, I saw the young woman who was the source of the joy that had wafted up on the warm summer air and that had immediately cheered me up.

Coming to new environs always unnerves me for the first week or so—it had been true in England in 1982, Nicaragua in 1984, and Guatemala in 1986—and arranging my books is one of my neurotic rituals to restore some semblance of order and equanimity. Packing more books, journals and notebooks than clothes in my battered, college-era suitcases, I had brought Thich Nhat Hanh's *Being Peace* with the resolve that, during the five weeks I'd be in the graduate program, I would immerse myself yet again in the practical wisdom of this Vietnamese Zen Buddhist teacher.[2] How I needed to learn to savor the present moment, instead of getting fixated on one of my colossal mistakes in the past or being allured by some fantasy in the future.

I also lugged *The Chomsky Reader*, which I presumed would come in handy at this month-long conference on "The Future of Liberation Theology" at the Maryknoll School of Theology in Ossining, New York.[3] A political activist and linguist, Noam Chomsky had produced an extensive series of critical writings on U.S. foreign policy that I read with as much assiduity as any devoted scholar of sacred Scripture— Judaic, Christian or Muslim. In addition, I hauled along many other books of theology, history, philosophy and literature, which I pondered how to arrange on the desk: alphabetically, or thematically, and, besides, I'd have to make even more room for the scores of books I'd assuredly soon be checking out of the Maryknoll library. The sheer bulk of these volumes manifested my hope that I'd actually find the time to read them

all, a hope so often dashed in the past. At such moments, I'd remember a line told me by one of my friends: "Insanity is doing the exact same thing over and over again, and expecting a different outcome." No, this time would be different, really, I would get through every last one of these books.

I observed that the energetic woman was gliding along with a rather short, middle-aged man who appeared to be a Latino, maybe even a priest, given his untucked but dressy white shirt and navy trousers. (No matter what self-conscious efforts at disguise and bonhomie, some priests' apparel is a dead give-away, just as their tendency to make flirtatious remarks to attractive young women reminds their parishioners that "Father" is not so otherworldly as to pass up an opportunity to notice their daughters' glad graces). The two were moving at a vibrant clip and speaking excitedly to each other. The woman, whom I guessed to be in her mid-20s, was olive-skinned with short dark hair and wearing a jean skirt and sleeveless white blouse. I presumed—no, hoped—that she was a participant in the same Summer Program. Then I turned away to resume finding the best place and order for my books in what was to be my residence for the summer.

Suzanne, a friend of mine from Louisville, had also made the trek to Maryknoll, the headquarters of the Catholic Missionaries of the United States, where each summer the Institute of Justice and Peace offered graduate courses in theology. Three years older than me, Suz was aspiring intellectual, an avid cyclist, and articulate bon vivant. Having left an impressive and promising career as a fund-raiser in which she hobnobbed with the likes of financial wiz and motivation-meister W. Clement Stone, Suz became part of the Woman Church feminist collective and a co-member of the Sisters of Loretto.

Given the crowd that had gathered at Maryknoll for this program, I hoped to take vicarious comfort and refuge in Suz's charming extroversion, for I had been seized with a clinical bout of shyness such that I could have made Emily Dickinson look like Robin Williams doing stand-up. Each day, I felt anxiety about the prospects of taking my meals in the Maryknoll dining room, where I never knew who would just plop down and immediately strike up a cheery, unwanted conversation. As insurance against this unsettling possibility, I would make it a point to shmooze with Suz through the buffet line and sit with her.

One morning during that first week of the conference, I found myself following her and, voilà, setting down my tray across from the laugher, whom Suz had already met. She wasted no time: "Mark, this is Mev. She's been studying at MIT."

"Oh, *MIT*?"

Suz knew immediately how to pursue my raised voice of interest by asking, "Mev, have you ever gone to hear Chomsky at MIT? Mark's really into Chomsky."

"No, I haven't heard him yet, I just took one course with a Jesuit there. On the History of Technology. I'm a student at Weston in Cambridge. Are you into linguistics?" she asked me. So, she wasn't a Latina, with her Midwestern, all-American non-accent.

"No, I've only read Chomsky's political stuff." For the previous five years, I had done pastoral work in the inner city and in the plush suburbs, attempting to raise awareness and organize responses to a variety of social issues, primarily the U.S. government's support for the Nicaraguan contras and the military governments of Guatemala and El Salvador. Suz and I had gone to Nicaragua on a 1984 Witness for Peace delegation, which attempted to provide a nonviolent shield of relatively privileged U.S. people for Nicaraguan civilians against contra attacks. As Mev was vigorously munching her cereal, I decided to mention some of my modest credentials: "Chomsky's work on Central America was helpful to a lot of us in the Louisville Solidarity movement."

"Really? In St. Louis I was involved with the Pledge of Resistance, and we have a Sanctuary house there." The Pledge was a nation-wide effort to organize legal protest and nonviolent civil disobedience to the Reagan Administration's intervention in Central America. Sanctuary was a movement that began in the Southwest among Churches to offer aid and succor to refugees fleeing persecution in Guatemala and El Salvador.

"Same with us in Louisville." So, she and I had a common experience of church-based activism, which wasn't too surprising given that we were both at Maryknoll, some of whose missionaries had become intimately and famously involved in the struggles for survival and liberation with poor folks across Latin America, Africa and Asia.[4]

As Mev turned to engage another breakfaster, I smiled to myself as I took in her dark eyes, matter-of-fact attitude and cup-overflowing confidence.

Those were the first of 10,000 impressions.

Seeing The World/I

The second week of that Summer Program at Maryknoll, Mev made an announce-
ment after one of the morning sessions that she was going to present some of her
photographs in a slideshow/meditation on a night when there was no scheduled
speaker. Curious about what made this self-promoting impresario tick, I wanted to
attend. Her slideshow, with taped instrumental music to establish a contemplative
mood, was a welcome relief from the intense, sometimes strangely cerebral presen-
tations during the day about global liberation theology, the suffering of the poor and
the consequent responsibility of U.S. citizens. She presented a series of her photos
from her travels in Brazil, Mexico, Haiti and Russia, and, as I confronted the faces of
Mev's subjects, I was reminded of one of my favorite poems, Thich Nhat Hahn's
"Please Call Me by My True Names," especially the concluding lines:

> Please call me by my true names,
> so I can wake up
> and the door of my heart
> could be left open,
> the door of compassion.[5]

Her meditation lasted about 15 minutes, leading the group of 20 into an awareness
that our discussions during the day ultimately were about flesh and blood people,
with names, faces, histories, heartaches, resilience and desires. Afterwards, feeling
hesitant to speak directly to Mev, I went up to my room and began to write out Nhat
Hanh's poem, since I had learned it by heart years before and often used it for a
morning meditation. I also wrote a note of thanks to her for the presentation, and I
pinned the note and poem for her on the community bulletin board. This was safe,
spiritual flirting.

The next day Mev thanked me for the poem. She was delighted that I liked her
work and said she had not heard of Thich Nhat Hanh, which rather surprised me.
Surely, if she were familiar with the prolific Trappist monk Thomas Merton and

renowned Jesuit priest Daniel Berrigan, she would have come across their citing Nhat Hanh as a vital influence in their own lives. I recalled that Berrigan once referred to Nhat Hanh as "foam-rubber dynamite," as he was the monk who helped lead the Buddhist peace movement during the cataclysm in Vietnam in the mid-1960s. Back in 1983 I'd been given a mimeographed copy of Nhat Hanh's manual, *The Miracle of Being Awake*, by Brother Anthony, a wiry, garrulous monk at the Abbey of Gethsemani, outside of Bardstown, Kentucky, where my community and I used to escape city bustle for quiet days of reflection.[6] But I learned that Mev had other spiritual teachers. She said she'd studied at St. Louis University with John Kavanaugh. "The John Kavanaugh of *Following Christ in a Consumer Society?*" I asked.[7] I had read Kavanaugh's stimulating book right after I graduated from college. "Yep, one and the same." Feeling ever so emboldened by this inconsequential exchange, I told Mev I'd like to get together sometime to hear more about the work she'd recently done in Brazil, and she beamed, "Sure." She appeared eager for any audience, even an audience of one. But as is so often the case with fresh acquaintances, we didn't make specific plans and, before long, the day's events at Maryknoll had us going in different directions.

I had first studied at Maryknoll in the summer of 1985, when I met Marc Ellis, a young, provocative professor and the director of the Institute of Justice and Peace. Ellis's reflections on the Jewish struggle to be faithful after the Holocaust prompted me to do a little genealogical work when I returned to Louisville. I recalled my father's vague references to his granny's incomprehensible Yiddish as I was growing up, and had realized that my father had been born of a Jewish mother. During the latter 1980s, my father, who converted to Catholicism in the early 1950s so as to be able to marry my mother, would say, almost as a boast, "I'm 99% Jewish." I only corrected him a couple of times, when I reminded him that he was also "50%" Polish," as his father had left Warsaw in the first decade of the century. I would occasionally visit my great-aunt Leah, who lived close to the University of Louisville, and she would tell me stories about our family, which came over from Russia in the early 1900s. My mother, being of German descent, seemed a little put off by my growing interest in all things Jewish: "You never ask about *my* side of the family." I didn't feel a need to; after all, I'd grown up around them all my life.

People gathered at the 1988 Maryknoll Summer Institute to celebrate the life and work of the Peruvian theologian Gustavo Gutiérrez, whose 1971 book *A Theology of Liberation*, had become a classic in theological circles.[8] Over 100 participants from

around the world had come to Ossining to pay tribute to Gustavo and to ponder the future of this dramatic, dangerous kind of grassroots Christianity.[9] Oddly enough, Maryknoll, in opulent Westchester County, was the headquarters of some radical and committed priests, nuns, brothers and lay people, and it was a natural place to reflect, pray and explore the road ahead.

The Roman Catholic Church had long been in cahoots with the Latin American military and oligarchy—basically, the super-rich. And with the rise of Christian Base Communities, prophetic bishops, Bible study and literacy campaigns, some sectors of the church began to walk away from the good life with the generals and landowners and into the slums. Thus, in Latin America, to be a certain kind of Christian invited persecution, disappearance and torture, compliments of the powerful, who did not like their status quo messed with. While vocations to the priesthood and religious orders plummeted in the U.S. church after Vatican II, Latin American vocations were on the rise, in a situation where people were getting killed for practicing their faith (a.k.a. being "subversives"). Part of the Latin American church was vitally, dynamically engaged in the struggle for justice and, so, under siege. As the outspoken Brazilian archbishop Helder Camara remarked, "When I give food to the poor, they call me a saint. When I ask why the poor are hungry, they call me a Communist."

Marc Ellis was a chief organizer of the conference and so was frequently meeting with presenters and students. One Saturday morning, I finally had a chance to chat with him. I ran into him as he waited with his luggage in the main hall at Maryknoll during a break from one of the sessions. He was soon on his way to Kennedy Airport to fly to Oxford for a Holocaust conference on "Remembering for the Future." Ever congenial with me, Ellis took time to ask me how I was enjoying the program.

"I like it, many great theologians are here. But you know, Marc, sometimes even liberation theology can sound a little too triumphal." I didn't need to spell out what I meant to the Jewish professor, for he knew as well as I did that there were occasional strains of liberation theology that reformulated traditional Catholic assertions of being the Way, the Truth and the Life. Since my own probes into my family background, Jewish history and the Holocaust, I had gotten much more sensitive to such features of the Catholic faith. I then put my cards on the table: "You know, what I'd really like is to come to Maryknoll full-time. I have plenty of parish

experience and I'd love to study."There were times when I felt like an outsider to what I judgmentally deemed as cocky Catholicism, even in its upbeat American manifestation, and I felt often at ease with Ellis, probably the only Jew ever employed at the Catholic Foreign Mission Society of America. It was also because he was only eight years older than me and so laid-back, in his faded jeans, worn-out Nikes and rumpled plaid shirts. Perhaps this informality of his had been reinforced by his own experience of living at the New York Catholic Worker House in the 1970s when its co-founder, Dorothy Day, was still alive.[10]

Intrigued, Ellis informed me, "The great thing about Maryknoll is the intersection it provides: First World and Third World, intellectuals and activists, Christian liberation theology and, with me here, recent Jewish thought." He smiled, took out a piece of paper, scribbled a note, and asked me to give it to Maryknoll's Director of Admissions the following Monday. I found out that next week that Ellis had recommended that I be given a complete tuition scholarship for the Master's Program in Justice and Peace Studies, with room and board thrown in. This was one of those uncanny examples of the fulfillment of "Knock, and the door shall be opened to you."

Present among us at Maryknoll were such religious thinkers and activists as Enrique Dussel, a philosopher forced by military threats to leave his native Argentina in the mid-1970s; Rosemary Radford Ruther, an American Catholic feminist theologian; and Gregory Baum, a Jew born in Austria in the 1920s who later converted to Catholicism. Each of these intellectuals was committed to a Catholic Christianity open to the world, explicitly critical of social injustice, and supportive of an inclusive community. Other theologians had also come from Trinidad, Australia, Brazil, Malaysia, Pakistan, Sri Lanka, West Germany, Chile, the Israeli-occupied West Bank and Indonesia. There were scores of other lay workers, ministers, activists, priests, nuns, academics and grad students, some of whom had worked in Christian Base Communities abroad or their equivalents in the United States. Spanish (and, I would later realize, Portuguese) was becoming the theological language to know, supplanting German and French after Vatican II. These Latin American languages, reflecting the original European conquest, were now also the tongues of the refugees, the children, the manual laborers, the farmers, the elderly—*el pueblo, o pôvo*—whose faces Mev had captured so poignantly in her photos, those faces that invited us to wake up.

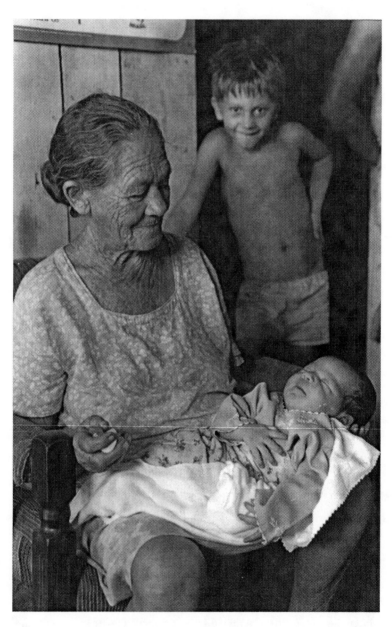

Ziza's Child; Marabá, Brazil; 1987
Mev Puleo

Poverty and Riches /1

Mev . . . now what kind of name was that? I'd heard the name Maeve, which is an Irish name, but Mev was Sicilian on her father's side and German on her mother's. Plus, she spelled and pronounced hers differently. Where did "Mev" come from? She informed me early on that it was a nickname a grade school friend had given her, short for Mary Evelyn—Mary for her aunt and Evelyn for her mother. It had stuck ever since seventh grade. Even after being around her only a few times, it was clear she acted more like a "Mev" than a "Mary" or even "Mary Evelyn," as "Mev" was original, short, and brisk. She later informed me that the scientific abbreviation *mev* stood for a million electron volts.

One morning, I observed Mev and Gustavo Gutiérrez walking together through the outdoor dining area at Maryknoll. She had first studied with him in 1985 at a summer course at Boston College. Suzanne mentioned to me that Mev had secured an interview with Gustavo. It wasn't such an unusual experience for Gustavo to be interviewed that summer, since there was so much hoopla surrounding him, including a press conference and write-up in the *New York Times*. But for Mev, it was a major opportunity to ask her most pressing questions to someone whose theology had been nurtured amid poverty and suffering, as opposed to academic conferences, air-conditioned seminar rooms, fax machines and ever-expanding libraries.

The 1988 Maryknoll Summer Program was intended to celebrate several anniversaries. First, we honored Gustavo's work on the occasion of his 60th birthday. Second, we took note of the 20th anniversary of the Latin American Bishops Conference at Medellín, at which they gave voice to the need for a preferential option for the poor. And third, we marked the 15th anniversary of the English publication of *A Theology of Liberation*, Gustavo's most famous book and one updated for publication that summer.

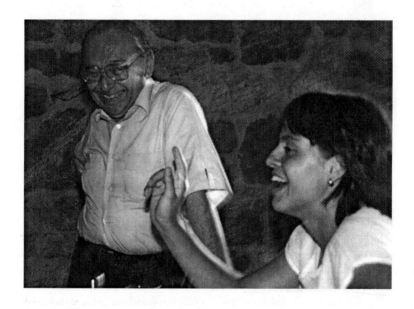

Mev Puleo and Gustavo Gutiérrez; Maryknoll, NewYork; 1988
Suzanne Holland

Gustavo lived in Lima, worked at the Bartolomé de Las Casas Institute and served as a pastor to the poor in the slum of Rimac. Although he had become one of the world's most well-known theologians, he was quite humble, taking all the festivities and testimonies in stride, appreciating people's affections but also remembering that his work made no sense apart from his struggling people back in Peru. To those folks, he was simply Padre Gustavo. He didn't appear prey to the kind of self-important individualism of our usual American celebrities.

Later that summer and into the fall as I got to know Mev better, I learned that she—peripatetic photographer, devotee of the poor, interviewer of liberation theologians—had been born into an affluent family, the fourth child of a middle-class mother and a father who had lived the rags-to-riches ascent of some Sicilian immigrants. She had grown up in a fashionable suburb of St. Louis, gone to preppy Catholic schools and traveled to China, Africa, Europe and Latin America on vacations. Yet after university studies, she moved into a poor neighborhood in North Saint Louis

and tried to bridge these distant worlds of the rich and the poor. For someone with all of her advantages and privileges, Mev had been more committed to experimenting with downward mobility and voluntary simplicity than being ensconced in an upper-middle-class enclave. In her interview, Mev's questions to Gustavo were those of a passionate young woman concerned, anxious even, to find her place in this world of gut-wrenching poverty and soul-numbing wealth.

ॐ

Interview[11]

Mev: In recent years people are talking more about the spirituality of liberation theology. How would you describe this spirituality?

Gustavo: First, we have to say that spirituality is a "way" to be Christian. Spirituality is more important than reflection. Or, to be more exact, all reflection on faith (theology) is inside of something more important: the way to be Christian (spirituality).

What I just said is true for *all* theology. It seems to me that behind liberation theology there is a spiritual experience of a liberating God, the experience of innocent suffering, the experience of the hope of the poor.

Mev: Why do you describe the suffering of the poor as "innocent" suffering?

Gustavo: I believe that here "innocent" doesn't mean "not a sinner." Every person in some way is a sinner; that is, at some time he or she rejects the love of God and neighbor. Innocent in this case means someone who suffers a situation that she doesn't deserve. I think of children in my neighborhood, for example, who are malnourished and spend their days in the street. They don't deserve this kind of life. They don't deserve to live in such small houses and sleep with the whole family of six or seven people in only one room. This is what we call the suffering of the innocents.

And it's not only the children: This is true for adults as well. There are people who can never eat what is necessary to live humanly or have a house with enough room to live with dignity. These are great sufferings— sufferings of *innocent* people because they don't deserve this suffering.

Mev: You speak from time to time about humor. What is the role of a sense of humor in theology and in ministry with the poor?

Gustavo: I talk about not taking ourselves too seriously. I believe that humor is something that allows us to take a certain distance from things so we don't feel too much in the center of everything. I often fear that living in the midst of such severe problems we understandably tend to think that ours are the greatest problems of humanity. We even tend to take theology and people *doing* theology too seriously. I also consider humor important in life because it helps us not to be closed to other things and persons. I believe that one of the greatest victories of those who oppress the poor is if they can make the poor bitter. Bitterness makes us closed to other people. One thing I see and admire in poor persons is that they know how to keep up a certain capacity of happiness, and humor is an expression of happiness. The joy of the poor is not superficial.

 The poor have a sense of humor, though not intellectual or refined humor. The children in my neighborhood have a great sense of humor. The intellectuals, on the other hand, tend to think they are the center of the world. Also, people who are worried, tense and busy tend to think that the whole world revolves around them. For people like this, humor is great therapy.

 Humor lets us laugh at ourselves and the events in our lives. I don't mean we should laugh at other people. Humor doesn't mean making fun of others. I'm impressed by the Bible with its many expressions of humor. Taking ourselves too seriously is an obstacle to the Gospel.

Mev: Are there different kinds of "poverty"?

Gustavo: For me, the poor is the insignificant person, the non-relevant person. No one pays attention to the poor person in society or even in the church. A great majority of these "insignificant" people are poor, in the economic sense. To be discriminated against as a woman, for example, is to be poor, insignificant. But, you know, the great majority of insignificant women are poor, economically speaking as well.

 Now there are human problems besides poverty—old age, loneliness and alienation. Not all suffering is from poverty. But real poverty is characterized by death. Real poverty is people with no means to live with human dignity.

Mev: We are sometimes criticized for our consumeristic lifestyles and the influence of our culture abroad. Do you notice this in our context as well?

Gustavo: I believe that this is the nature of a rich country. Consumerism is to consume for mere pleasure more than is necessary. This is exactly the contrary when you come from a poor country. The things I notice the most seem like a joke. That is, here in the United States the most sought-after foods are low-calories. The most valued food in poor countries is food *with* calories. It's understandable, but it's an incredible contradiction. Here, the people want to eat food with as few calories as possible to not gain more weight and people in poor countries try to eat food with many calories to gain at least a little bit of weight. We come from very different contexts. Consumerism is certainly a very great human deformation. Furthermore, it brings a permanent search for money and buying, encouraging us to forget the needs of other persons. Consumerism truly blinds people. This is very strong in this country, as in all rich countries. It's also strong in Europe, Canada and Japan.

Modest Shopper; Boston, Massachusetts; 1989
Mev Puleo

The United States does have a very big influence. I believe that through the means of communication, such as the TV, the North American way of life is very present among other peoples. Some of the positive values are present here, but also many limits, such as when people from our cultures want only to imitate the North American way of life.

Mev: What are your own hopes, then, for people who are born rich?

Gustavo: I love to answer this remembering a sentence of Dom Helder Camara. He was in Switzerland many years ago criticizing the Swiss banking laws. You know, there is more Latin American money in Switzerland than in Latin America. Dom Helder was very critical of this. He finished his speech affirming in a very simple way, "It is more important to be Christian than to be Swiss." The next day a daily Swiss newspaper asked for the expulsion of Dom Helder Camara for insulting the country.

Very frankly, I think that for Christians in this country it is more important to be Christian than to be North American, just as it's more important for me to be Christian than to be Peruvian. Thus, I'd desire that the rich people of a country such as yours have a big consciousness of their responsibility as human beings and as Christians before the poverty of this world. Also, it seems to me that there are things that will not change in Latin America if things don't change in other parts of the world—in Europe, the United States or Asia. I believe that our problems today are more universal and planetary. I come here to teach because it's good for persons in your world to know more directly the voice and reflection of the poor of Latin America. Also, we need the solidarity of people in this country. Solidarity from other Christians is really important for the poor of Latin America.

$$\sim$$

Eventually, Mev shared her musings with me. "The poor of the Third World are often said to be voiceless. But that's not true. They've got a voice, but *we've* just got to hear it. I'm going back to Latin America next summer." I asked, "To Brazil?"

"Yeah, I've got friends in Brazil, and I'm going to interview them and their friends and see what they have to say about faith and hope and love. Who knows," she chirped, "maybe I'll go to Peru and see Gustavo."

Face to Face/2

I didn't have much contact with Mev for a few days, though I would spot her in the Maryknoll dining hall and after lectures when she was chatting animatedly with one or another of the movers and shakers of the conference. I observed that she and Suz had hit it off, and, I found out later, Suz would ask Mev with her customary brashness, "So, what do you think of Mark?" as she played the role of mediator if not yet that of matchmaker. Suz and Mev recognized one another as a "soul-mate," and Mev welcomed her interest in joining her the following summer on a trip to Brazil for the project she was in the process of discerning. As I saw them together a lot, I wasn't up to threesome-ing. Let them share their souls, I thought, a little jealously.

Besides, in an earlier conversation with the two of them, I heard Mev list the criteria any man would have to meet if he were to have a shot at her. I was taken aback by her bluntness, even as I realized that most of us have just such a list of relational sine qua nons but not always the temerity to announce it publicly, at least when sober. Mev's essentials for her Ideal Man included: (1) be able to live simply; (2) be fluent in Spanish; (3) be willing to live in Latin America for extended periods of time; (4) be committed to spending time with poor people. I was batting, at most, one for four, and chuckled to myself how stupidly clear she was about her future love interest—stupidly because I understood how far I was from being such a possible prospect. (In Antigua, Guatemala, I lasted all of two agonizing days in a Spanish language immersion course before I bagged it to do a sight-seeing jaunt with my best friend Pat Geier and her Guatemalan beloved Cristobhal, whose Ladino physiognomy was a delightful combination of the Buddha and Elvis Presley.)

Several days later on a Sunday afternoon after Mass, Mev asked me to take a walk with her, and I sensed that something was on her mind.

"I was hoping that you would come to talk to me about my work in Brazil. I didn't want to force it on you. I was waiting for you to let me know when you had the time."

"Well, I've got the time now," I responded, thinking "*Carpe diem*." By this time, I felt no pressure to impress Mev, because it was so obvious that we were moving in

very different orbits. It was more likely for me to visit the West Bank than Caracas or Santiago.

But that afternoon as we walked around the well-groomed Maryknoll grounds, Mev wasn't interested in talking about Brazil, the Third World debt or the revolutionary implications of the Christian Gospel. Instead, she told me how hard her first semester as a master's student had been. Evidently, some Jesuits, lay students and other ministers throughout the Boston academic theological community had become quite interested in her, though she did not initially recognize that they were so smitten. That is, until some of them put the moves on her and surprised her with their non-celibate zeal. "I wonder if I give off mixed messages. This happened five times in my first semester at school." She offered this without *braggadocio*, only bafflement.

Mev was confiding in me, surely not as a possible love interest, but as someone who could listen and not pass judgment. Unlike my diffidence after her photo-meditation, I didn't feel embarrassed in being forthright with her. I told her that she was a shining, smart and perceptive woman, and it was natural that young Jesuits and other students were going to be charmed by her. She simply needed to be clear about what she wanted.

"But see, that's it. They think I'm interested in them *that* way, and it's the furthest thing from my mind. Something happened last semester, and I just don't know what to think about it."

I told her she could tell me if she wanted to.

She informed me that she had met a much older scholar, but he wasn't simply brilliant and accomplished, he also cared about the world of suffering people. She learned a lot from him and held him in esteem. Once, he left a message on her answering machine, and when Mev returned his call, he extended an invitation to go out with him to dinner and see a movie. She was so flattered—how could she not be, here he was, an expert academic, taking such an interest in her. So they went out and had a lovely time as they talked about faith, politics, school, art and food. At this point, she paused and sighed. "And by the end of the evening, guess what?"

I winced. I was anticipating an incident involving force or intimidation. "What?"

"He proposed to me. Marriage! These were his words: 'I am near the end of my career, and you're at the beginning of yours. I can help you, we can even move to Brazil.' [Well, I mused, this man was nailing Mev's acceptable male criteria with a vengeance]. I didn't know what to say. I mean, I respected him, thought he was a wonderful man, but it never entered my mind to think of him as my husband! But he had thought of me *that* way."

I was relieved that this was all it was, that there was no nastiness involved. "So you let him down easy?"

"I didn't want to hurt his feelings. I think he thought it had to do with his age, which wasn't the main point. The point was it wasn't mutual. I had no idea that he had had *that* kind of interest in me. And he wants to get married, like that, bang? What is *this*?"

This was simply the disorienting delight of falling in love, which happens to 50-something-year-old men, not just their sons. I felt a little sorry for the sagacious scholar who so unnerved Mev with his matrimonial proposal, even as I could sympathize with his attachment to her: those wide-open-at-life eyes. She was effervescent and penetrating, strong yet vulnerable. It was easy to see why he was over-the-top love-struck.

"Well, it happened again."

"What are you talking about? Someone here at Maryknoll?"

"Yep. Two days ago I took José to the airport, he needed to go to another conference." As Mev mentioned his name, I recalled that it was the two of them I had seen walking when I first heard her joyous laugh. "We had a great talk on the ride into LaGuardia, and he even invited me to Latin America to visit him and see how he and his team do pastoral work in the slums. When he got his bags out of the trunk, he came up to me, hugged me, and then gave me a French kiss."

She peered at me, waiting for me to express shock, for she seemed strangely guilt-stricken. All those parish training sessions in interpersonal listening skills came back to me: "So, José kissed you, and you were feeling . . . ?"

"I wonder why he did that. I was taken aback!" Now that it was out in the open, Mev's guilt was giving way to irritation. "Then he smiled, turned around and left for the terminal. It kind of pisses me off now that I think about it."

"But you're also wondering if you had led him to think that such an expression was fine and dandy?"

"Well, yes, maybe. I mean, why am I being French kissed by a priest, much less José, who has done so much good working with the poor and promoting liberation theology?" Mev had just lost what the intellectuals call "primary naiveté."

"I hate to say this, Mev, but I suspect that this won't be the last time men, and religious types especially, are going to be attracted to you." Not having any sisters, I suddenly had a novel experience—feeling like an older, protective brother. Poor José, the only strike he had against him before this oscular *faux pas* at LaGuardia was being a priest, and, hence, in a position of untouchability and respect as far as Mev

was concerned. Up to that point, he was an exemplar of simple living. He was fluent in Spanish and Portuguese, as well as German, French, and English. He lived and worked in Latin America among the insurgent poor, when he wasn't going to international theology conferences and French kissing adoring young women who flocked to hear his message of liberation. There I was, experiencing a little *schadenfreude* that Saint José had gone down a notch or two in Mev's estimation.

The next Friday at dinner a group of students decided to go to a neighboring town to see the new movie *The Unbearable Lightness of Being*. When Mev encouraged me to come along, I readily said yes. But despite the salacious scenes throughout the movie, there was no bearable or unbearable contact between Mev and me that evening. Which was fine, since I simply enjoyed sitting next to her. I imagined we were an older Jane Gallagher and Holden Caulfield. She'd be great simply to hold hands with.

Being Present/I

On Monday August 1, I realized that the Summer Program would soon be over, and in 10 days I would be looking for work in Louisville.

But that evening, I decided that I didn't have to decide how I was going to make money. I was glad to spend a quiet evening reading Nhat Hanh's *Being Peace*, breathing and reciting gathas throughout the evening. A gatha is a verse that Zen practitioners developed to stay rooted in the present moment, aware of whatever they are doing. Nhat Hanh would later publish a collection of gathas for contemporary life, but at that time I was familiar with this all-purpose gatha:

> Breathing in, I calm my body.
> Breathing out, I smile.
> Dwelling in the present moment,
> I know this is a wonderful moment![12]

Gathas were deceptively simple; the trick was to remember to use them to stay calm, cool and collected before the storms of emotion hit me.

As I was becoming quiet, mindful, equanimous, even joyful, I heard a knock on my half-open door. It was Mev coming by for a visit. Perhaps it was my sincere Buddhist-inspired mindfulness, but I felt pleasantly detached from this marvel of a woman whom I welcomed to sit before me. We chatted about Dan Berrigan, the Jesuit priest who had been giving inspiring presentations that day. Mev then noticed that I had a Jean-Paul Sartre biography on my desk. She'd not read Sartre, and I briefly told her about the "liberated" relationship he had had with Simone de Beauvoir. In a short time, we had managed to move from the political implications of Berrigan's reading of the sacred Scriptures to the variations of relationships. Having already shared some of her problems with men with me, Mev evidently felt she could put more of herself out before me.

"You know, Mark, I'm terrified of you."

"Mev, how can you be terrified of me? I'm just sitting over here. There's nothing menacing about me, is there?"

"No, but you're an available man. I'm terrified of available men."

"What makes you think I'm 'available'?"

"You're single, and . . ."

"I'm not in my fifties, and I'm not an aspiring Jesuit, and I'm not married, and . . ."

"You're available."

"You make me laugh." And she did. For here was the woman who, having taught herself Portuguese, was so bold as to spend three months roughing it in Brazil, traveling all over the Amazon by herself. She'd traveled to Haiti and Mexico, too, with aplomb. Yet, here she was, in a Maryknoll dorm room, scared of being with me, a so-called available man.

Just then, a neighbor knocked on the door, and, straining to be polite, I invited him in. We started a three-way theological discussion during which I noticed I was growing mildly anxious. I had been enjoying this promising private time with Mev. When still another student came by, we all agreed to go out for ice cream. But Mev and I had definitely entered a new stage. For her to own up to such terror was to make room for something else, but what? Two hours before, I was ready for an evening of serene detachment, with such visions of a conscientious and curvaceous woman definitely not on my agenda. By 9 p.m., I had some wisp of hope. I was not terrified of an available woman.

Several of us went into Ossining for ice cream—one of Mev's regularly indulged-in pleasures—and then we returned to the Maryknoll campus where we all took a walk. She mischievously put a couple of fingers full of ice cream down my back. Was this a sign from God? We joked with each other amid the new energy that had been exchanged between us. At 10:30 p.m., though, we all went our separate ways— "Good night, see you tomorrow"—and I returned to my room. There, however, a familiar urge grew louder in my mind: "Oh, go to her room, and just see what happens."

As I knocked, Mev was dressing, after having gotten out of the shower (for I'd retaliated and put ice cream inside the back of her shirt, too). She invited me in, and, after some small talk, I offered to give her a massage, to which she responded with eagerness.

I left at 1:30 a.m., not having recited my gatha in six hours. But I had been very engaged in the present moment.

Gratitudes/1

Kissing changes everything.

The next morning we were a couple. Or, on the way to being a couple. One night later that week, I saw Mev take out from under her pillow a rosary as I was getting ready to tuck her in before she went to bed. I was not sure what she was going to do with the rosary. I had not used one in many years, such Marian devotions and conservative accoutrements of the traditional faith having been passed up for Dan Berrigan poems, iconic photos of Oscar Romero, as well as the conviction that women should be priests, too.

"What's the rosary for? Do you say 'Hail Mary's?'"

"No, I used to when I was in my charismatic phase. I told you about that, back in high school, our hearts were on fire for Jesus and all that. No, I don't say prayers to Mary. But I do pray in my own way."

"Really, what do you do with them? The beads, I mean."

"Well, when I get ready to go to sleep, usually I've already done my journaling and done my examination of conscience, and I will put my finger on a bead and begin my gratitudes."

"Gratitudes? What are gratitudes?"

"I'll give thanks for one thing, or person, or event, or challenge of the day. Say, like today, the fact that I am working on the interview with Gustavo. So I'd say something like, 'God, thank you for allowing me to meet Gustavo and for the sharing we had about faith and the poor.' Then I'll finger another bead and see what pops up for me next. Simple. Until I fall asleep." *rosary*

"I never thought of using a rosary like that," I said, genuinely impressed by the simplicity of it. "How long have you been doing these gratitudes?"

Mev curled up in the spare bed and beckoned me to come sit next to her. "Oh, since about sophomore year in college. You know, Mark, it's not always so easy for me to do this, to be grateful. I've got such pride and willfulness."

"Did your old charismatic school pals do gratitudes?"

"I don't think so. Anyway, I'd just rather go to sleep grateful instead of anxious."

That night I knew what she meant.

Exchanges/1

"But what do you think?"

"I think it's great!"

"You don't have any doubts about me doing it?"

"Of course not. Look, I'm doing the same thing. It's important to continue your education. And it sounds like Maryknoll's going to pay you to study there. Can't beat that."

"But what about all the terrible stuff going on in the world? I feel sorta guilty, studying, while there's all that violence in Central America."

"Believe me, I know what you mean. But it's really okay to do this. In fact, it's not just okay, cause from everything you've told me recently, it sounds like you have got, how did Marc Ellis put it, 'an intellectual vocation.' Some of the most influential people in my life have been teachers, scholars and writers. Intellectuals."

"You don't think it's selling out?"

"Nope."

"Really?"

"Truly."

Meanwhile, Elsewhere in The World . . . /I (Dissidents/I)

A Testimony from Jean-Bertrand Aristide, Haiti, 1988

Haiti is a prison. In that prison, there are rules you must abide by, or suffer the pain of death. One rule is never ask for more than what the prison warden considers your share. Never ask for more than a cupful of rice and a drink of dirty water each day, or each week. Another rule is: Remain in your cell. Though it is crowded and stinking and full of human refuse, remain there, and do not complain. That is your lot. Another rule is: Do not organize. Do not speak to your fellow prisoners about your plight. Every time you get two cups of rice, another prisoner will go hungry. Every time another prisoner gets two drinks of dirty water, you will go thirsty. Hate your fellow man.

Another rule is: Accept your punishment silently. Do not cry out. You are guilty. The warden has decreed it. Live in silence until you die. Never try to escape, for escape means a certain return to this prison, and worse cruelty, worse torture. If you dare to escape in your little boat, the corrections officers from the cold country to the north will capture you and send you back to eke out your days within the confines of your eternal prison, which is Haiti . . .

I say: Disobey the rules. Ask for more. Leave your wretchedness behind. Organize with your brothers and sisters. Never accept the hand of fate. Keep hope alive. Refuse the squalor of the parishes of the poor. Escape the charnel house, and move toward life. Fill the parishes of the poor with hope and meaning and life. March out of the prison, down the hard and pitiless road toward life, and you will find the parishes of the poor gleaming and sparkling with joy in the sunrise at the road's end. Children with strong bodies will run with platefuls of rice and beans to greet their starving saviors. That is your reward. Along that hard and pitiless road toward life, death comes as an honor. But life in the charnel house is a disgrace, an affront to human kind.[13]

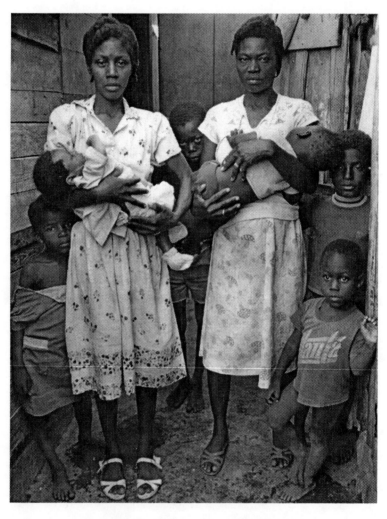

Boston slum; Port-au-Prince, Haiti; 1986
Mev Puleo

Love Letter/I

It *is* so easy to fall in love. I agree with Linda Ronstadt. Staying in love, deepening that love, transforming that love—well, as Spinoza concluded in his *Ethics*, "But all excellent things are as difficult as they are rare."[14] Staying in love is rare.

It was so typical of me to "fall in love" at the very end of the Summer Program, when the pressure was on, it's do or die, go for broke or never know what "might have been." Ah, contingency—what if I had not been in my room that night of August 1 when an incipiently mischievous Mev stopped by to, um, you know, talk. She was terrified at 8 p.m., and we were kissing and giggling at midnight.

The summer session was coming to a rapid end, and I had a lively farewell with Mev at LaGuardia Airport. I returned to Louisville and got a job as a waiter at a well-known bistro and proceeded to wrack my brain distinguishing different kinds of wines, pastas and appetizers. I made the most of my working-class hero status by carefully observing and imitating a busboy, Alex, whom I recognized as a Zen Master. He received huge tips from us servers because he was indisputably the world's greatest busser: arriving in the nick of time with that needed ketchup bottle, cleaning our tables with dispatch and perfection to keep us ready and in business for more customers, filling water glasses and coffee cups: He was everywhere, but unobtrusively. He was quiet, almost mute, and I liked that about him. On a weekend night, he easily pocketed a couple of hundred bucks, and he made the simple and inglorious chore of cleaning tables a cause for marveling.

I grew to love working at the bar and grill because I knew in four months it would be over. I started at the bottom of the seniority list, worked my lunches, made a pathetic $100 a week that first month, and then slowly moved up the manager's chart as servers came and went, and I picked up extra shifts—some weekend evenings. I found a real sense of camaraderie among the workers, as exploitation ($2.10/hr) can really aid in forming a community. And I was enchanted by more than one waitress (how luminously fey and fetching they were in mere blue oxford cloth shirts and khaki pants), even as I wondered about Mev being enchanted by the more theologically minded brainiacs in Cambridge. That fall, she confided in me that one

Jesuit seminarian—again from Latin America—responded to her enthused description of our meeting each other with the curt comment, "Just a summer fling." Although that thought surely passed Mev's mind, she resented this Jesuit's dismissal, which may have been motivated by a twinge of jealousy, as he had once, oh so innocently, felt Mev up while the two of them were swimming at Walden Pond.

Mev and I phoned each other at least once a week, and I wrote letters to her that, I thought, indicated my interest in for her. She informed me on the phone, though, that my letters of garrulous schmaltz occasionally annoyed her. At that time, she was a little suspicious about men falling in love with her—it was so easy, after all—but not understanding her—it was so hard. Having traded shifts with some new friends at the restaurant, I paid her a visit in October over a long weekend. Naturally, she and I had to move from the infatuation of early August to the difficult sorting out of "who are you anyway?" And so my idiosyncrasies, self-will and pettiness (and Mev's, too) began to assert themselves, and we found ourselves realizing that our theme song, Bobby McFerran's "Don't Worry, Be Happy," which dominated the airwaves at the time of our meeting, had given way, abruptly, achingly, to the Beatles' 1965 standard, "We Can Work It Out" (with stubborn emphasis on the line which goes, "Try to see it *my* way . . .").

It was true: Mev and I both were curious about each other, but we had not made a firm commitment as of yet. The long distance was a curse—how could we go forward being so far apart?—and a blessing—as it gave us space to ask, "Well, what do I want?" I wasn't *married* to Mev, after all, and so I allowed myself some mild flirting. (In one absurd case, this consisted of offering a winsome and beautiful blonde waitress a listen of one of my Chomsky cassette tapes on U.S. foreign policy in Central America. She gladly accepted, listened to them with interest, but, despite some mutually bright then somber eye exchanges that indicated "it would be nice, but the timing is all messed up," I neither initiated nor received any physical affections from her.) And Mev, I later learned, was going through similar temptations from men in the bright and handsome Weston student body as well.

When I arrived in New York in February to begin my studies at Maryknoll with Marc Ellis, I received a message that the academic dean needed to see me that first evening about an important matter. "Are they going to renege on my scholarship?" was my first, it-must-be-a-catastrophe thought. When I went to the lobby of the main building, I found no dean, only Mev, who had orchestrated this ruse as a surprise welcome. After five months of me in Louisville and Mev in Cambridge, Ossining, New York seemed like a short hike to Boston. At that point in early

February, I then had no idea of how well I would get to know Interstate 90. Or how much money the two of us would spend on stamps.

<div align="right">November 9, 1988</div>

Hello Marquinos!

That's your name in Portuguese—like Marquito in Spanish. Well, kiddo, how are you? I've been thinking about you lots lately. Pardon me for not writing more in these recent days. Our letters on both sides surely have let up a bit. Ebb and flow. Ma Bell (or is it AT&T?) knows we're still communicating. Thanks for the Charlie Brown card—I love Snoopy, as you know.

Life is good. I had a great conversation with my mom about coming home for Christmas. I'm going home before Christmas, staying for New Year's, then I want to come to Kentucky for a week and a half or so, January 2 'til the 12th. What do you think? I may start at Suz's. Anyway, I'll be glad to visit you both, and I really think it will be nice (there are lots of other great adjectives I could say, but I don't want to spend all night typing out adjectives) to spend a chunk of time in the same city with you given the long-distance nature of our relationship! So, anyway, what do you think? Well, my mom and I had a swell chat. I think I'll have a party at their house New Year's weekend so I can invite lots of my St. Louis friends so I can see people without spending forever and ever traveling around St. Louis. I miss my old parties—it should be fun; I'll spread the word at Thanksgiving. Maybe we'll throw in a Mass. Maybe John Kavanaugh will be around. Wanna come?

Well, externals of life are swell—so GREAT! At the same time, my insides are basically OK, but a little quiet, silenced, remorseful, aware lately. Mark, I really need the sacrament of reconciliation. I haven't been since June, after many months that climaxed in my relationship with J. It's not like I have a time limit on how often I need to go, but I really feel it in my gut—no mistaking this one. I just am really aware lately of my self-righteousness, snobbishness, arrogance, judgmentalness, pride, competitiveness, etc. I walk with much remorse these days. But sometimes the pride feels like a full-fledged compulsion in that even

when I'm aware of it, it doesn't go away—even if I want it, desperately try to want it to go—it doesn't. Then I feel proud that I'm aware of my sinfulness, then I feel more remorse for my pride. Ugly cycle. I try to remember old tips from Marian Cowan [Mev's spiritual director]—gratitude and a sense of humor. I try both. But, I also feel God forging in me a new sense of reverence. I pray: "Jesus, Son of the Living God, have mercy on me, a sinner." And I feel peace. More than "guilt," I feel dependence, love, longing, loved, forgiven, welcomed, at-home. So, my life has recently been a flow of awareness, remorse, prayer, reverence. Ebb and flow. I now sing to a piano melody I made up, haunting and pretty: "God of compassion, God of mercy—heal me, forgive me, teach me your way of life."

And you. How are you? Who are you? I am grateful you are in my life. I love you, Mark. I don't always feel like saying that. I don't always "feel" that. But it is true for me to write it right now. You are a beautiful human being. You, too, give me cause for reverence, awe, gratitude, silence. I look forward with patience to being with you more—being with in different and many ways. Many forms of "presence," you know. Odd, Mark, I don't feel swept away. Is it because I am so into the challenges and joys around me in Boston? Is it because of the distance, that I put a distance around my heart? Whatever it is, I wonder how much you sense it and does it ever worry or hurt you. While it is a curious thing for me, it is also inexplicably healthy. My commitment to you isn't mostly emotional, but nor is it intellectual consent. I just plain like you. I sense much, much potential in you and in our friendship. There is much room for growth in both of our lives and in the intersections of our lives. I am grateful. I am patient. Sometimes I feel "cramped"; sometimes I miss you lots; sometimes I want to live in the same city; sometimes I need more space even though we're apart; sometimes I think we'll be friends a long, long, long time; sometimes I can't get a sense beyond the very present moment. Ebb and flow. But today, right now, I say "I love you." No music playing, just me with feelings, thoughts and things that can never be put into words. Reverence. Awe. Gratitude. Shades of gray. Learning to love the process, the unknowing, the mystery. Enter. Welcome.

Your letters made me uneasy for a while. We already talked about this. Part of it has to do with so much being directed at me. I want to hear about you. I get scared of having influence and effect on people. Not you in particular, but overall—in lots of relationships. While I crave to be loved, acknowledged, affirmed, accepted, liked—I also have this fear of people falling or being in love with me. I court danger, too. My, we humans are complex, dappled ("glory be to God for dappled things"). So, how are you? In these recent words, I've been telling you how I am. Among other things, to be specific, a relationship from my past has reopened this week. A Jesuit. Dear person. I like him alot, but am not in any special way "attracted" to him—as he is to me. It is a delicate dance and risky to be in a relationship with this type of lack of mutuality. But, after years of distance we are gradually, cautiously making a new stab at friendship. Fear on both sides for different, obviously related, reasons but affection and care on both sides too. I hate messiness, but I am willing to re-enter this one.

So, here are a few windows into my life lately. Here are a few windows into where I am in our relationship lately. Yes, tonight I miss you. I would like to talk to you, to visit, to be together. At the same time, I am grateful for this time and desire to write you tonight. God is good. God has greater things in store than we imagine. God is. Oh God, what are we to do during four years of George Bush? I think I'll start now campaigning for Noam Chomsky—92. Noam, ninety-two—they sound good together. I also think I'll see *Rattle and Hum*—to check the pulse of America and to check out another part of your life. Well, time to close. Take care and know I think of you. I think many thoughts and non-thoughts. I feel many feelings and non-feelings.

Peace blossoms and ear muffs and Toto too!,
Mev

Reading/I

During that Spring 1989 term, Mev immersed herself in Latin American liberation theology and analyses of issues like the prevalence of torture and the crushing international debt, since she was preparing to go to Brazil in the summer to pursue her project of interviews. I spent much of my own time reading Holocaust literature, testimony, novels and theology. I focused particularly on the works of Elie Wiesel, the advocate of the remembrance of the Nazi regime's relentless genocide of the Jewish people. I also read Emil Fackenheim, Irving Greenberg and Richard Rubenstein, all religious thinkers from the Jewish tradition who attempted to come to grips with the Nazi program of extermination. It was Greenberg who formulated a famous epigram designed to check intellectual pride and presumption: "No statement, theological or otherwise, should be made that would not be credible in the presence of the burning children."[15]

I'd first encountered Wiesel as an undergraduate at Louisville's Bellarmine College, where I read his memoir, *Night*, in a course in Theology and Modern Literature in 1982. That reading left me profoundly disturbed as to the health of Christianity, which had so long underwritten Jew-hatred. Later, when I was a lay minister involved in parish education, we sponsored a Good Friday Way of the Cross throughout key "stations" in downtown Louisville. This contemporary Via Crucis was an attempt to make connections between this archetypal instance of passion, suffering and death and those of our own time. So we stopped in front of the Immigration and Naturalization Service office (since many of us were involved in the Sanctuary movement, harboring "illegal aliens" from El Salvador and Guatemala). For the 12th Station (Jesus dies on the Cross), we stopped at the Catholic Cathedral on Fifth Street. Patricia Ramser, one of the leaders in the local Sanctuary movement, reminded us of our tradition's own complicity in the deaths of Jews as she read aloud the following passage from Wiesel's book, *A Jew Today*:

> How is one to explain that neither Hitler nor Himmler was ever excommunicated by the church? That Pius XII never thought it

necessary, not to say indispensable, to condemn Auschwitz and Treblinka? That among the S.S. a large proportion were believers who remained faithful to their Christian ties to the end? That there were killers who went to confession between massacres? And that they all came from Christian families and had received a Christian education?

In Poland, a stronghold of Christianity, it often happened that Jews who had escaped from the ghettos returned inside their walls, so hostile did they find the outside world; they feared the Poles as much as the Germans. This was also true in Lithuania, in the Ukraine, in White Russia and in Hungary. How is one to explain the passivity of the population as it watched the persecution of its Jews? How explain the cruelty of the killers? How explain that the Christian in them did not make their arms tremble as they shot at children or their conscience bridle as they shoved their naked, beaten victims into the factories of death? Of course, here and there, brave Christians came to the aid of Jews, but they were few: several dozen bishops and priests, a few hundred men and women in all of Europe.

It is a painful statement to make, but we cannot ignore it: as surely as the victims as a problem for the Jews, the killers are a problem for the Christians.[16]

Thus, at that 12th Station in 1986, we wanted to remember our Church's own failure toward the Jews, even as we tried to respond to the contemporary persecution of people throughout Central America.

At Maryknoll, as I became more critical of Christian supersessionism—that we Christians were the New Covenant, leaving the Jews behind in the dust—I also became attracted to, even enthused by, parts of the Jewish tradition. Wiesel himself did not write primarily about Auschwitz: He retold stories from the Bible, Talmud and Hasidic masters. Mev noticed both these critical and laudatory tendencies of mine. When I spoke enthusiastically about the genius of the Hasidic masters, she would remind me, just a little annoyed, of the genius of Saint Francis and his followers. When I expatiated glowingly about the Jewish intellectual tradition, Mev asked me if I ever read Thomas Aquinas. She began to fear that I was going to convert to Judaism, which, she assumed, would cause all kinds of conflicts between us. This possibility of becoming more immersed in the Jewish tradition had crossed my mind,

and had occasionally lingered there. Marc Ellis once told me a story of how he had led a summer seminar at Maryknoll with some liberation theologians from around the world. They were there for several weeks and then were to return to their communities in various Third World countries. One of them said to Marc as the seminar was ending, "It was nice, Marc, but now we are going back to where the real action is. Sorry you have to stay here." Ellis's comment to me: "In our tradition, study is one of the greatest of undertakings." And so it was, and I was definitely interested in it, staying up late in the Maryknoll library poring over the D804 and BM535 sections. But, as Mev occasionally reminded me, the Jewish religion also esteemed prophecy, speaking truth to corrupt power, as a great undertaking as well. But outside of Ellis at Maryknoll, I then had no Jewish contacts in New York or Cambridge; I still lived in a very Catholic world. And truth be told, I was most interested in the thought, not the practice (at least, not Orthodox). In Louisville, my Jewish contacts—outside my great-aunt Leah Salzman Miller—had been with secular, left-wing Jewish activists who had probably never heard of the Baal Shem Tov.

Seeing The World/2

After one of the previous summer's sessions at Maryknoll, at which Salvadoran theologian Jon Sobrino and Catholic feminist Rosemary Radford Ruether spoke, Mev criticized the inadequacies of so much academic theology, which, she believed, was hardly sensitive to the same questions as the liberation theologians. So few North American professors and programs seemed to have any awareness of the plight of world's majority of poor people. I had not been at this particular session, but I heard that Mev had tears in her eyes as she asked Sobrino and Ruether the question, "How can academic study be made more relevant to the real world?" For at one time, Mev had been considering the idea of going into Biblical studies, which made sense given her knack for languages and her avid practice of reading the Bible each day. She later approached Jon Sobrino and shared her questions with him: Should she go on for a PhD in theology and Scripture? Should she continue to use photojournalism to raise awareness in the United States about social injustice? Should she relocate to Latin America? Sobrino told Mev that the world didn't just need liberation theologians but also needed liberation accountants, architects, writers, And photographers. Mev was heartened by this reframing of the issue. She had come to the conference interested in theology, but she was becoming more aware of the need for liberation, on many fronts, in many forms, via many different paths.

At this time, I was working on a research project about the engaged Vietnamese Buddhists who struggled to promote peace in their country during the American war. In the mid-1960s, Thich Nhat Hanh had started a new Buddhist order, which tried to apply traditional teachings to their contemporary context. This "Order of Interbeing" lived according to 14 precepts, the fourth of which I once shared with Mev because it so reminded me of what she wanted to be about:

> Do not avoid contact with suffering or close your eyes before suffering. Do not lose awareness of the existence of suffering in the life of the world. Find ways to be with those who are suffering by all means, including personal contacts and visits, images, sound.

> By such means, awaken yourself and others to the reality of suffering
> in the world. [18]

That spring of 1989, before the demonstrations at Tiananmen Square, as my
mind went back and forth between Auschwitz and Vietnam, Mev was trying to
think through Sobrino's challenge on how to be a liberation photographer. She
grappled with this question in her journals but decided to make a more deter-
mined attempt, which she shared with me before submitting it for publica-
tion.[19] Therein, she grappled with the dangers of her craft as well as retrieved
the work of some of her precursors in socially committed photography. Not
surprisingly, Mev had initially been provoked by an article in the *Catholic Worker*
monthly newspaper.

ॐ

> "[I]n the current upsurge of photojournalism of the homeless, the
> camera has become merely an instrument for the invasion of privacy
> for the sake of an image-hungry public. These pictures that are
> taken of the homeless do not make one feel a personal connection to
> those photographed . . . rather . . . as the human spirit is deformed
> by the partial and superficial medium of the photograph, we are
> further distanced from the individual homeless person."—David
> Beseda, "The Peering Lens," *The Catholic Worker*, December 1985

Defensive and distraught: As a photographer who focuses primarily on the poor,
that's how I feel reading Beseda's article. Defensive because I desperately want my
photographs to revere the human spirit and bridge the distance between persons.
Distraught before the possibility that my photography contributes to human misery
and exploits the very people I hope to serve.

Beseda, who volunteers in a New York shelter for the homeless, is not alone in
his harsh words for photography. "Images transfix. Images anesthetize," warns critic
Susan Sontag. Her litany goes on: photography is invasive, violent, easily manipulated,
distorts reality, hides behind claims of objectivity, and so on. While there is truth in
each assertion, Sontag does not reveal the whole truth. Images can anesthetize, but
they can also agitate and motivate. Photographs can manipulate reality or help name
it. Pictures can distance us from one another or help us connect with each other. Art

can be used as propaganda to indoctrinate, but it can also be a tool of advocacy for the dominated.

All art is, in some ways, advocacy, at times regardless of—even contrary to—the intent of the artist. As a photographer, I wrestle with the ethical ambiguities of my medium, the moral dimension of photographing people—in particular the poor and dispossessed. How often I risk offending, humiliating, and violating them, especially those unaware of—and thus not consenting to—my presence. Like it or not, I participate in the violence named in the language of photography—"loading" film, "aiming" a camera, "shooting" pictures.

At the same time, I truly believe that my camera is an instrument of communication that can help build community. The lens is the eye of my soul, through which I touch the world and the world touches me. It captures something of terror and tenderness, anguish and innocence, carrying them to eyes that otherwise may never see. When photographing children in Missouri, Haiti or Brazil, I ask, "Dare I invade their lives, steal this moment?" Yet how can I *not* share these children with the world, bringing them back with me to hearts who might receive them, voices who might speak for them?

A hundred and fifty years ago, photography pushed beyond the bounds of traditional art forms and communications media with its mystique of veracity. Photographs were supposedly more "true to life" than drawings, a more "objective" recorder than the written word. Beyond the mystique, however, photography is as susceptible to manipulation and misinterpretation as other media. A human enterprise, it is laden with human bias: artists, editors and viewers alike are driven by unique, conflicting motives and worldviews. Photos have been used to promote and degrade people, to sell and protest wars. Angle, lighting, cropping, subject choice, text—all shape photographs to fit someone's ends.

When we are aware that we do not take neutral photographs *of* the world, we can consciously choose to take photographs *for* the world we desire. For example, I recently read about a small group of peasants in rural Peru who use photography as a testimony against structural violence. Rather than hiding behind claims of "neutrality," they reveal the false neutrality of other media and unveil the hidden purposes of the structures surrounding them. In their own words:

> The Social Photography Workshop is a recently born movement that
> wants to break the silence imposed on people for centuries. Through

the image, we denounce the violence we are living. Our goal is to act to change the consciousness in our groups and in all of Peru . . . We want to spread an image of our reality that denounces the never-ending injustices, of the violence and daily death we encounter in our search for solidarity. Photography is for us a means of active nonviolence, a means of supporting grassroots organizations.

The peasants' candid creed breaks through both manipulation and the myth of neutrality: Photography can be used either to lubricate the unjust system or to critique the system, motivating people to struggle against it.

The key is this: the more *intentional* artists are in how we use our media, the less likely our work will be manipulated to serve other people's intentions. Likewise, as viewers, the greater our critical awareness, the less likely we will be manipulated by the plethora of images vying for our attention.

I am intrigued that Sontag's critique of photography seems to revolve around its ambiguity and elusiveness. Though a critic of Western culture, she indirectly buys into our culture's obsession with the unattainable: clarity and control. My vision runs to the contrary: embracing ambiguity and open-endedness, we open the door to the mystical dimension of photography. Entering the gray area of this medium, we discover a profound means for relating to the "other."

The definition of "mystical" aptly describes my experience of photography: spiritually significant or symbolic, based on intuition, contemplation or meditation; mysterious, enigmatic. Often in picture-taking, intuition mysteriously overpowers my other senses. I am awestruck when my developed pictures include significant details of which I was not consciously aware while shooting. To my surprise, a photo of a blind woman begging includes a young boy gaping at her; to my amazement, orphans innocently playing also wield a gun. Similarly, people look at my photographs and see things I never noticed, feel things I never anticipated. Photography also involves and invites contemplation. Images—a child held in a mother's hand, shadows on a door—become icons evoking meditation. Taking *and* viewing pictures are opportunities to engage, step back and reflect on facets of our world. The photographic image is evocative, dynamic, fluid—always unfinished.

Blind woman; Madrid, Spain; 1983
Mev Puleo

Art is thus a response to the world, but also a question to the world—both critical and creative. Art breathes exclamation marks, question marks and ellipses into a world too easily constrained by periods. Another treasure nestles in the mystical and contemplative folds of photography: the potential not just for communication, but for communion with the other. Taking pictures is clearly one way I relate to the world—a relationship that can take on different tones. For example, it can be acquisitive, a means to capture a world that seems unattainable; or dominating, an attempt to manage a world I find overwhelming. But photography can also serve as a means of identification with others, a channel for compassion that tries to bridge different worlds. Jacob Riis, a social reformer of the late nineteenth century, illustrates this when describing the inner impulse that led him to take photographs:

> We used to go in the small hours of the morning into the worst
> tenements to count noses and see if the law against overcrowding

was violated, and the sights I saw there gripped my heart until I felt
that I must tell of them, or bust, or turn anarchist, or something.

Moved in his deepest being, Riis groped for a way to relate to human suffering, and to
relate suffering to others. Himself an immigrant who once lived on the streets, he identified
with those he photographed. Using pictures as his chief tool for advocacy, Riis helped
secure numerous housing projects and parks for the exploited people of New York.

Eugene Smith, a more recent photo-essayist, identified even more profoundly
with the people he photographed—not because of socio-cultural similarities, but
because of a shared humanity. Through photography, he experienced a mystical sense
of communion with persons across the globe. The passion of his photos echoes in his
words about Saipan during World War II:

> [T]iny babies on the backs of their mothers, older children, fathers,
> grandfathers—all human lumps of fright and terrible weariness—
> young and old so helpless.
>
> With sickness and realization that was sour in my throat, the
> scene pounded home to me that but for the luck of U.S. birth—my
> people could be these people, my children could be those children.
>
> I saw my daughter, and my wife, and my mother, and my son,
> reflected in the tortured faces of another race. Accident of birth,
> accident of home—damn the rot of man that leads to wars. The
> bloody dying child I helped momentarily in my arms while the life
> fluid seeped away and through my shirt and burned my heart into
> flaming hate—that child was my child.
>
> And each time I pressed the [camera] release it was a shouted
> condemnation hurled with the hopes that it might survive through
> the minds of the men who will sit down hence to plan the next
> period of liquidation.

[handwritten margin note: my life is mere luck, accident]

With passion and commitment, Smith took pictures against a world of torturous war,
for a world where all live as sisters and brothers. Like Riis, he identified with the people
he photographed and pleaded their case with image and word; like the Peruvian peas-
ants, his photography mediated his outrage and plea for peace. Smith and countless
photographers in his wake still compel us to identify with the persons pictured.

Like Sontag and Beseda, many of us are tempted to be intolerant of the ambiguity

and intimidated by the risks of photography and other art forms. Ultimately, I believe we are most daunted by the mystery, the question, the possibility: "It could be us." Through my own photography I strive to bridge the distant worlds of our small globe. I contemplate the mystery: It *is* us.

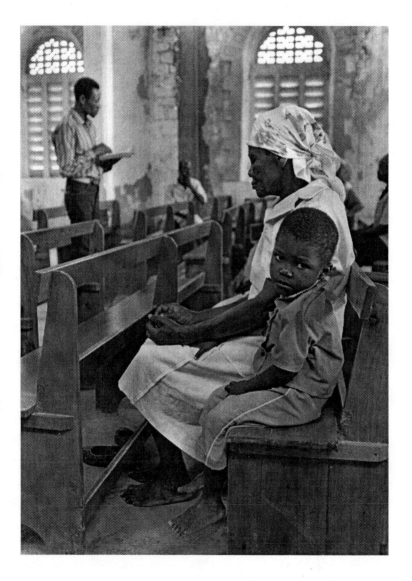

Praying; Cap-Haitien, Haiti; 1992
Mev Puleo

God/1

One of the first spats Mev and I had was over God. Or more specifically, atheism.

A strong and vibrant Catholic, Mev was, at that time, an avid proponent of liberation theology, as evidenced by her desire to return to Brazil and interview ordinary men and women of faith.

But she also confided in me that, while an undergraduate, the violent history of Christianity rocked her faith—Crusades, Inquisition, Holocaust—such that she might have left the church altogether had she not found a counter-example: her friends in the local Catholic Worker Movement, like Teka Childress and Ann Manganaro. I could relate, since, for me, it had been a diocesan priest, Jim Flynn, who invited me to live and work with him after I decided to blow off law school when I was in my last semester in college. In 1982, Flynn had just been assigned to an inner-city parish in Louisville, had thrown himself in the ever-growing peace movement (provoked by the blithe Ronald Reagan's lethal arms build-up), and formed an intentional community with a couple of Xaverian religious brothers and laymen. Like Mev, I knew—from books—some of the horrific history of official Christianity. Yet I, too, was attracted by the living, dynamic witness of Jim Flynn, who soon dedicated his life to the Central American victims of the U.S. government's assault throughout the 1980s, going so far as to live in Nicaragua and Guatemala for extended periods of time.

In one of our early discussions, though, I once put in a good word for atheism, which took Mev aback. To her, atheism seemed tantamount to a defect, a defiance against the God of liberation. Here she was, attracted to me, and so in response to my remarks about atheism, she felt compelled to ask, "Well, you do believe in God, don't you?"

And the simplest answer to that burning question of hers was "Yes and no."

She looked bothered.

"Mev," I said, "even the Latin American liberation theologians you so esteem do not quite put the issue the way you do. For many of them, the issue is not whether you believe in God or not, but *which* God you believe in."

"But still!"

"There are a lot of gods in Latin America, and here in the United States, as well: National Security, Property, Capital. 'Gods' which people in power were ready to defend, particularly by rooting out 'atheistic Marxist subversives' and getting the church to support them in their crusade."

"Those people don't really believe in God!" she protested.

I went on: "It's not so simple. Believing in God is evidently easy—you've heard of the Chilean military officers—good Catholics all—who were daily communicants and then went to do their chores of torture for the fatherland? What kind of God were they praying to?"

"Not the same one I am."

"Right, but the Latin American theologians would say we have to be atheists when it comes to the gods of capitalism or militarism. We have to deny them."[20]

When I put it in these terms, Mev was just a little more open to what I was saying, even though she initially feared that I was leaning towards Sartrean atheism, a position that she believed was smug, proud and arrogant.

"Mev, when I was 16, I read a little book by the psychoanalyst Erich Fromm, *You Shall be As Gods*. I've never forgotten it. He has a couple of lines where he says that what we need in the 20th century is not more theology—talk about God about which there is such debate—but about idols—those social forces that do violence to human beings in pursuit of objectionable ends. And these idols are all over the place. Plus, you can say you believe in God, and in the U.S., it doesn't mean that much. But in Latin America if you deny or criticize or even subvert the idols, you'll face recriminations. This is why, ethically, Fromm believed that 'idology,' a word he coined, was more important than theology."[21]

She seemed less suspicious as I put these views in terms she could understand. She and I would have many more occasions to come back to these issues about God and atheism, idols and belief, since we were both theology students. Even while beginning study at Maryknoll, after having had many years of Catholic education, having gone to thousands of Masses since my youth, and having read a fair amount of theology, I felt like I needed a sabbatical from God-talk. "God" had been invoked for so many base intentions and justified so much carnage. Enough already.

Nevertheless, it was more of a challenge when, after such conversations, I remembered a saying, "It is more important to act in God than to talk about God." And it was there that Mev taught me plenty, not by profession or debate, but by her practice.

Accompaniment/I

As Mev and I became closer geographically, we discovered, with appreciation and anxiety, how different we were from each other. I liked rock and roll (Bruce Springsteen, the Clash and U2); she preferred Broadway musical soundtracks and the Franciscan troubadour John Michael Talbot. I was open to non-Catholic spiritual wisdom (the *Bhagavad Gita*, the *Heart Sutra*, Wiesel's commentaries on the Hasidic masters), while she was steadfastly committed to the mystical and prophetic traditions of Catholicism. I was exploring questions about Christianity's historical anti-Semitism, while Mev was critical of the contemporary American church's indifference to the poor. I grew up in a working-class family where the symbol of culture was the *Reader's Digest*; Mev was raised in a home of the *nouveau riche* where she learned piano, enjoyed an indoor swimming pool and traveled around the world for vacations. ("Vacations?" I responded to her question about where my family went during the summer, "My father was working all the time, I don't remember vacations.") Physically, I was 6'2" and Mev was 5'2". Often, when we were feeling affectionate, one of us would invite the other, "It's time for Koala!" and Mev would scamper back a few yards, turn around, then sprint toward me and leap up into my arms as she'd wrap her legs around my hips, the prelude to a lengthy embrace.

There was another difference. In those days, I had a penchant for resorting to various self-help manuals, time management schemes, and spiritual programs with their promises of how eight disciplines, six skills, and three lessons could lead to personal transformation.

With raised eyebrow, Mev said, "I don't see why you need those books, Mark." She seemed truly perplexed. She pursued her goals so easily and naturally, while I had to work, sweat, strain and seek insight from many sources. She had a difficult time appreciating that others weren't so sure of their goals or about how to achieve them. I responded to her skepticism, "You know me, Mev, I'd rather read everything I can about self-transformation before attempting it." Then, I would tease her about being a peacock, ever ready to flaunt her charms and accomplishments before an admiring crowd.

Still, I was inspired at her own stamina for multiple commitments: She was a dedicated student, gregarious friend and committed photographer. She found time to swim several times a week at a Harvard pool, host parties and frequent the ubiquitous frozen yogurt shops around Harvard Square. She kept up with her Spanish and Portuguese. She also "tithed time." This was a practice she had learned from her mentor John Kavanaugh, who thought of it as a complement to the Biblical practice of giving so much of one's material resources. Some people find it relatively easy to give money, but it may be more demanding to give one's precious time and offer presence to those we would just as soon not face—the poor, aged, abused, depressed and terminally ill.

When Mev had been a high-school teacher at her alma mater, the Catholic girls' prep school Visitation Academy, she would regularly bring her usually (like her) highly privileged students to the Catholic Worker house of hospitality, Karen House, to the chagrin of more than one pair of suburban parents. (However, when confronting Mev's articulate and confidence-inspiring sermon about the importance of such journeys, some of the parental disquiet would diminish). She would also take her students to Haiti during the Christmas break to work in the clinics run by the Missionaries of Charity and thereby miss some of the craze and commercialism of the American Christmas as they joined up with the nuns to hold and feed children, pull teeth and administer shots. She also believed that it would be good for me to have a similar practice and have some real contact, since I so often was focused on books and conversation. "But I always have something else to do, there's so much to read," I told her.

Amid her busy life in Cambridge, Mev continued to tithe time in modest ways by visiting an elderly woman, Maybelle, who lived not too far from her apartment, as well as by making occasional trips outside of Boston to visit a Venezuelan prisoner, Carlos.

Mev's journal, Spring 1989

WOOSH!!

What a day . . .

I am "so far" from the poor from whence solidarity?

Disappointed I wasn't on the list for prison liturgy

 hurt, stung, angry at how the guard spoke to me . . .

How *dare* he?

How smug am I!

Where's the Buddhist detachment . . .

strategies and spiritualities fail . . .

I who want to identify with the lawyer

not the poor woman whose lover is in the slammer

so far from solidarity

so far from non-violence

so far from detachment, forgiving love,

yet in all this

am I somehow closer to the poor?

As I taste the sting of insult,

the frustration of closed doors,

the powerlessness before the gatekeeper?

In the waiting area/visiting area

tongues to calm me

Aaagh families & lovers

intimate embraces violated by 60 eyes

spectators

yet we all *try* to respect each other because

we know how it feels

How does it feel

to be in love and see your beloved

in a cold, crowded room full of people?

Not just brothers & sisters in the family of the imprisoned,

but guards

and cameras

and mirrors

and gates

and guns

and . . .

Aaagh . . .

I think of Mark

yes I think of Mark

Please call me by my true name

young lovers

old beloveds

a gray-haired couple

embracing for dear life

dear life

dear

life

so many stares eyes faces families

Carlos

comforts me, calms me, cheers me . . .

Counsels me, inspires me, touches my heart

He calls me good

I am more sure of his goodness than my own

but I trust

Solidarity

a lesson in the jail

You teach me your ways

You reveal yourself to me

in unexpected

ways

God,

you make me more whole

Expand me

expansive

is a virtue

Carlos is not a "preso" [prisoner]

he's a friend

Maybelle

sometimes I feel like I'm behind a 1-way mirror

& she can't tell I'm there

then a flicker of teeth

a grin a sparkle

before she lapses back into the crazed stare

asking for people who are long dead

she does want to escape

who is more in prison, she or Carlos?
I am baptized by them
evangelized by them
they teach me my true name
as does Mark
whether the name is

Maybelle; Cambridge, Massachusetts; 1989
Mev Puleo

beloved or fearful one
naked one or aroused one
vulnerable one or empowered one

in love one or muddled one

beautiful one or bewildered one

friend or competitor

lover or chum

passionate one or tearful one

hurt one or dancing one

angry one or playful one

naming

we are named.

Amen.

Meanwhile, Elsewhere in The World . . . /2

A Testimony by Father Javier Giraldo, S.J., Colombia, 1989

One day in 1989, in the city of Bucaramanga (capital of the department of Santander), a group of union members set up a meeting for me with a young *campesino* they had helped escape from the neighboring department of Cesar.

At first glance, the man seemed normal in appearance. He had a good sense of humor, and, if you spoke to him for only a short while, his tragedy remained hidden from you.

When you spent more time with Lucho, however, you learned of the continual nightmares which afflicted him and the screams that awoke the others who slept in the same room; of his dislocated knee and multitude of other health problems and his constant, agonizing headaches.

Lucho lived in a small town in Cesar, and, although not himself a union member, he had always worked as a farm day laborer. He was friends with several members and frequently spent time with them in their union hall after work. That presence alone was enough for the army to label him a "guerrilla auxiliary."

Lucho planned to go home early that November afternoon in 1988. He left the union hall with a friend, but as they were passing a corner store, a group of laborers they knew called and invited them to have beer. The men drank quickly, both were in a hurry. But the group insisted they stay and have another. Suddenly and without warning, the men saw they were surrounded by soldiers. There was nothing coincidental about the men's presence there or the invitation; they had planned the encounter. There was no escape.

The men were forced into a house which stood opposite the corner store and belonged to a well-known politician and member of Congress. To their horror, they saw that the house also served as a training center for *sicarios*, a torture center and an army camp. First, their identification was taken from them; then, they were beaten

and tortured until they lost consciousness. A soldier watching the torture told the men they would not be permitted to leave the house alive now that they had seen what really went on there.

Just before midnight, the two friends were told they would die crucified on crosses. Outside, men began to load huge trunks of wood and iron stakes onto a pickup truck that belonged to the politician. The men were then tied together and forced up into the truck. In whispered undertones they quickly agreed to try and escape at the first opportunity; being shot and killed was better than crucifixion.

It was after one in the morning when the truck began driving out of the town. Suddenly, a struggle began in the back, the driver turned to glance back at what was going on and the truck swerved sideways and hit the railing of a bridge. Both men jumped from the truck. One of the *sicarios* fired, killing Antonino immediately. But Lucho, vomiting blood, managed to get free from him, off the bridge and into the darkness. When lights began going on and people began looking out of nearby windows, the killers drove the truck back over Antonino's body and fled.

For Lucho, the ghost of his dead friend became a constant nightmare that never leaves him. More recently, another ghost, that of one of the *sicarios* who was subsequently murdered, has also begun to haunt him. The crowds of the big cities do nothing to dispel these ghosts; sometimes in the entrances to large stores he sees the dead, in the bodies of the living, pursuing him, as reality and fantasy mingle, confusing and hurting him. But it is not only the dead that pursue him; members of that group of soldiers and paramilitaries are also after him. His crime? Having been a candidate for the cross and having seen firsthand what was hidden behind the door of the congressman's house.[22]

Poem/l
(God/2)

William Blake, *The Divine Image*

To Mercy, Pity, Peace, and Love
All pray in their distress;
And to these virtues of delight
Return their thankfulness.

For Mercy, Pity, Peace, and Love
Is God, our father dear,
And Mercy, Pity, Peace, and Love
Is Man, his child and care.

For Mercy has a human heart,
Pity a human face,
And Love, the human form divine,
And Peace, the human dress.

Then every man, of every clime,
That prays in his distress,
Prays to the human form divine,
Love, Mercy, Pity, Peace.

And all must love the human form,
In heathen, turk, or jew;
Where Mercy, Love, & Pity dwell
There God is dwelling too.[23]

Crisis/1

Mev was pleased that I was only a few hours away in Westchester County, where I was pursuing my studies on a free ride, indulging a passion for reading, even if the subject matter was so disorienting. I frequently made trips to Cambridge and, during the day while Mev was in class, I would read Wiesel's books in her apartment on Harvard Street. Later, I'd meet up with her for a snack at Au Bon Pain at Harvard Square or *rendezvous* with her and her friends at Avenue Seafood and Deli or Friendly Eating Place, both restaurants on Massachusetts Avenue.

That spring Mev was preparing to be true to her word: She was going to make another trip to Brazil, her second as an adult. She hoped to visit some of the people she had met two years before, including a very committed church activist, Maria Goreth, who lived in a slum, Liberdade, in Marabá in the state of Pará. She also wanted to visit Gustavo Gutiérrez in Lima while she was in the South American neighborhood. She planned to be gone for at least two months of the summer, and so we would have to connect by letters and postcards, since, where Goreth lived, like in much of rural Brazil, the phone system was mostly unreliable. I was planning on returning to Louisville to earn some money working at the restaurant and begin thinking about my master's thesis.

Mev and I had a last visit in New York with her best friend, Teka, who had flown up to accompany Mev on the road trip back to St. Louis before her departure for Brazil. When I got to Louisville in late May, most of the familiars were still at the restaurant. I was expecting to spend a low-key summer reading Hannah Arendt and Walter Benjamin until it was time to return to New York in mid-August.

I was surprised, however, when I received a long-distance phone call from Mev in June: "Marko, I'm coming home early."

Now, this was news. Mev, the accomplished and indomitable force, the sparkling activist, bagging it? "You're coming to St. Louis?"

"Yeah, would you come see me? I'm pretty raw."

"I'll be there." And we agreed that I would visit her in St. Louis over the Fourth of July holiday.

Looking back on my own trips to Central America in 1984 and 1986—the wearying grind, the foul outhouses, the precarious buses, the intestinal ache—I was less surprised at Mev's eagerness to come home early. A couple of weeks later, I saw her at the Greyhound Station in downtown St. Louis, where she picked me up. I had never seen her look as beautiful—so darkly tanned, lithe, her hair grown out. She seemed wispier than when I first met her at Maryknoll. When I gushed about her appearance, she said quickly, "Oh, I lost 10 pounds, it was awful, but I'm so happy to see you."

We immediately began processing how the summer went. Later, when we were sitting in her parent's kitchen, she received a phone call from Teka. "I'm embarrassed, Teka. I had to come home. I was just so worn-out. People will think I'm a coward."

Mev's self-recriminations caught me off-guard. Perhaps her own limitations were thrown into greater relief because she was talking to Teka, an exemplar of a committed life as a Catholic Worker. After all, Teka lived with poor women in North St. Louis, some of whom faced drug problems, alcoholism, domestic abuse and mental illness. She had lived at the Worker for 10 years—*everyday*, for 10 years—and I suspected that Mev thought she fell short of Teka's exacting standard of Christian discipleship (a standard Teka held for herself and which she never projected onto Mev).

Later, eager to help, or uncomfortable with her fragility, or both, I decided to boost her flagging spirits.

"You're not a coward, Mev. It takes a lot to know when you've had enough. No, it would have been silly to stay and really do damage to yourself."

She glared at me, and said slowly: "No, you don't understand."

And I didn't. So much of Mev's identity was invested in her work, her abilities, her success—the one thing to avoid, the number one calamity to stave off at all cost was failure. She didn't take too kindly to my efforts to shore up her self-assurance and I learned very quickly that she hated it when she perceived that I really wasn't listening. That's all she wanted—just to have me *hear* her anguish, confusion and self-doubt; but, true to the social construction of my pragmatic American gender, I wanted to fix her problem. There was no fixing this. Mev came home from Brazil broken, emptied, weary.

So much seemed to be up for grabs, and Mev disclosed that she craved to settle down. She eventually came to describe this time of her life as a "faith-crisis," by which she meant that she could no longer believe in the same God or have the same spirited, easy, even chatty relationship with Jesus that she had heretofore enjoyed. Her previously

strong faith was dispirited in Brazil, even as she realized that she was not so well put together as she had thought. As Mev and I continued to share our lives together, we both became aware of how much we had been influenced by our respective family histories. For both of us that summer, we began to see with new eyes—alternatingly critical and compassionate—the struggles of our families, which was our pain, too. For example, she was disturbed that she couldn't always control her reactions with members of her family. When we dined with them at spiffy Italian restaurants in St. Louis, Mev could easily be provoked to self-righteous and irritable outbursts. It may have been a novel sight at these gourmet places: the young woman pounding the white-linened table with her fist in loud exasperation at her brother who "just didn't understand" the struggles of the poor in St. Louis or Brazil.

After such trying encounters, Mev felt like a mess—she couldn't even respond with respect and calmness to her family. She was, like me, sometimes quite hesitant about sharing her most vulnerable anguish. But when she did, she had the most amazing experience: Instead of the feared judgment or expected rejection, she was startled and relieved to hear me tell her, "You're even more beautiful, and lovable, and dear." And she was.

Love Letter/2

Hello dear!

Today I know I want to come home to the U.S. and the only plane I can get before the 15th at $300 is next Tuesday at $100. Here I come.

I took a walk along the *favelas*, slums, shantytown of Zona Leste. These shacks are everywhere around here. Everywhere. Children flying handmade kites, maneuvering them between telephone wires. I called Ismar tonight. He is the communications prof that invited me a year and a half ago to talk to a group of seminarians from all over the country on how I use photography and communications for liberation in the US. This is a great sadness for me, heavy and dull, that I will miss the opportunity to exchange experiences with this group! This is the drawback to leaving early. But this one commitment doesn't carry enough weight to induce me to stay three more weeks and pay 200 extra dollars.

Walking. I sat on a small hill of dirt. Good to rest. My lungs and head hurt from coughing so much. My period is due tomorrow. I am tired—more than just physically.

The city. Scaped in smoke, sunset. Like pictures of hills in China, each row of mountains more vague as they recede into the mist. So are the horizons of high-rises, factories, smoke towers. The city sprawls out into infinity. Eternal. Speckled by simple kites, colors punctuating the grayness of urban everything.

I am tired. I am really tired. It is time. Somehow this distance makes my work clearer. I want to do one thing well. A whole photo-essay on the flood. An interview with photos of Ilza. A presentation just on persons I interviewed in Brazil who are trying to shape the world for the good. I still haven't developed all my good pictures from my last trip to Brazil. Do one job and do it well. Enough.

I want to go home. I want to do a retreat. I want, really want, to start taking pictures in the USA—in Cambridge, East Cambridge, North St. Louis, Bardstown Road in Louisville—pictures of "ordinary" things and everything. I want to visit my friends in St. Louis that I rarely have time to visit. I want to reconnect with my old students. I want to spend time with you in Kentucky. I want to really work in the

darkroom and try some new things. I want to be home. It is time. I am changing. I am actually desiring to focus and settle down more. That was unthinkable long ago, and undesirable until recently. I am changing. It is not the time in my life to stay here.

I am tired, Mark. I will read my novel and go to bed. Maybe I'll have a hot chocolate first, a real treat.

Mev

27 June 1989

Dear Mark,

Howdy, here I am at the computer listening again to Tracy Chapman. I leave tonight. I just wrote four thank you notes to the Maryknoll folks that have been so kind and accepting towards me. I wrote to Anne. That I felt somewhat embarrassed at how weak and "fallen apart" I've felt physically and emotionally, but her acceptance and love has helped me accept and love myself.

Last night again I felt depressed. Mark, it's hard to tell what's physical or emotional any more, they're so mixed. The night before last, I woke once coughing so fiercely, I thought I'd never be able to stop. Then I woke later with severe cramping and more diarrhea. Yesterday I ate only 1/2 cheese sandwich, then forced down a banana for dinner—no appetite whatsoever. That is really a weird feeling for this food-loving Sicilian! I slept 11 hours last night and my cold feels better today, though my stomach is still a bit shakey. I think I'll get tested for worms when I get back to St. Louis—better safe.

So, yesterday evening I lay in bed soaking my pillow with tears, wanting to call you. How very, very weak I've felt lately. You've experienced more of weakness than anyone I think, Mark. Thanks for loving me in it all. You commented on how my love/anniversary card was so "balanced"—I hope that you didn't feel insulted, because it is so liberating for me, Mark, that you know me in a balanced way and still love me. I hope you feel loved by me, Mark. I love getting to know you. The more I get to know you, the better it gets. Knowing involves loving, forgiving and, in turn, loving and forgiving ourselves. This time away has challenged me to love myself, and you've been a big help to me in that. I feel sorry for the letters that expressed my bad dreams and doubts, but I don't feel sorry that I wrote them, they express me in my weakness, sickness and depression. This is me, too. Now I look back at those feelings with understanding and compassion, but I feel differently. I trust in your love for me, that

you want me to come home and welcome me home if I need to be home. Thank you so much dear for your letters, phone-calls, sharing, affirmation, shared vulnerability.

I count the hours til I get home—none too soon. I look forward to the moment we can touch each other with our eyes, with flesh, playing toes together, reminiscent of the day at Maryknoll . . .

Mev

Life without Mozart

Mev's Journal, Summer 1989

here in bairro liberdade
the armpit of brazil
a swamp of discomfort and desolation
i think of the poster on randy's door:
"life without mozart"
(the drawing of a wasteland)

this is the wasteland:
desolate poverty
life without beauty, life without bread

the poor live without mozart
no ability, energy, books to read
thirst chokes the song in their throats

i've tasted the absence of bread
and the absence of mozart
not knowing which is more deadly

today life without bread
deafens my ear for mozart
deadens my capacity to care
kills my hunger for bread

theology, philosophy, eschatology are ghosts
because today there is
no reflecting, no understanding, no hope

my friend maria goreth

has a passion for theology

her eyes sparkle as she talks about

a week-long course on christology

but during that week course

she had to beg for food

she came home diagnosed with a weak heart age thirty-two

eight kinds of worms

raising three children she didn't bear

an aunt grandmother three brothers

no time money health opportunity for christology

yet

her eyes still sparkle for this mozart

the wastelands of our world can't afford mozart

or bread

nor can they afford the noise flies heat

rancid smells sleepless nights

nor can they stomach anymore overcrowding infighting massacres

broken families dehydrated babies or premature, uninvited death

the poor do not grow

accustomed to this stuff

they just don't have a student I.D. or a passport out

Bairro Liberdade; Marabá, Brazil; 1990
Mev Puleo
⤳ 80 ⤳

afterthoughts:

rudolf hoess listened to mozart as the chimneys outside his window

coughed up future mozarts

cd's play mozart in cambridge air-tight, temp-controlled houses

like dentist's music easing the anesthesia

sealing us from the want and wonders of our world's wastelands

"wonders of the wasteland":

there were other days in bairro liberdade

when mozart soared

in the cackle of slapping spoons

the outburst of dance in church

the strum of homemade guitars

the colorful art form of

community organizing

to demand bread

to celebrate mozart

The Gospel according to Ilza
(The Human Form Divine/I)

Even though Mev had not completed her original mission in Brazil, she interviewed enough people and took enough photographs to be able to put together some slideshows and presentations. In July and August, she worked in her father's darkroom in the family basement, developing her photos, while upstairs, she transcribed and translated the interviews.

She had experienced an excruciating though small glimpse of the exhaustion daily experienced by her Brazilian friends, but she also felt privileged to have witnessed their commitment to continue in the face of so much grief, turmoil and adversity. One of the important pilgrimages Mev made that summer was to Xapurí, the hometown of the assassinated ecologist and union leader, Chico Mendes. It was there that she had a long conversation with Ilza Mendes, Chico's widow. Ilza helped Mev understand more deeply the connections between defending the rainforest and defending the indigenous peoples who lived in the rainforest. Himself a rubber-tapper since 11 years of age, Chico had been the president of the Rubbertapper's Union of Xapurí in the forest-covered state of Acre, Brazil. Because of his organizing work with the indigenous and rubber-tappers, he was assassinated on December 22, 1988. His death had outraged many people around the world who had regarded him as "the Gandhi of the Amazon." Misery still appreciated company: Mev began to reorient herself by translating the interview with Ilza, who had faced tremendous loss at a young age yet managed to keep going forward.

Interview[24]

Mev: How did you meet Chico?

Ilza: When we first met, he was a young rubbertapper and I was only nine or ten years old. My parents and grandparents already knew him. Even as a child I

really wanted to meet him because I heard everyone say great things about him, that he was intelligent, friendly, caring and loved to play with children. It was around this time that he came to our house because he was out of work and had no home, all he knew was how to cut rubber. He offered to work with my father, giving him half of the rubber he gathered and my father agreed. He was a dear person like everyone said, we all loved him! We treated him like a brother.

Like all the rubber-tappers, we didn't have an opportunity to study. All I know today is what Chico taught me. Chico was probably the only literate one in the area. He found a book and began to teach us to read and write, myself and my three older brothers. Before he would go out to cut rubber at five in the morning, he would give us lessons and expect us to have them ready when he returned in the afternoon. There were no books around, so Chico found old newspapers and we'd learn what was going on in the world. We began to wake up to the world.

At this time, the massive deforestation began. It wasn't the rubber bosses anymore, it was the *fazendeiros* [big landowners, often cattle ranchers]. They began felling trees around Brasiléia and expelling the forest-dwellers. They wanted to turn the rainforest into pasture for grazing cattle.

Chico and the other union leaders responded by inventing the *empate*. This is when everyone in the community goes to the site of forest destruction. They gather peacefully, without arms—women, children and men—and ask the landowners to stop the deforestation. People often ended up confronting the police and even the army who usually support the rich *fazendeiros*—they've never been on the side of the little people. The police and soldiers come to beat up and expel the rubbertappers from the land.

Chico faced this alot, alongside women and children he was thrown in prison, beat up, left without food. But, as soon as people got out of prison, they would organize another *empate*. They managed to prevent destruction of a lot of rubber orchards and cashew trees.

After this, Chico started working with the Rubbertappers Union in Xapurí and became a city councilman. I didn't see him for about five years. I know he was a leader in the Worker's Party and worked with Lula [a presidential candidate of the Worker's Party]. I met Chico again when I was sixteen. When he returned to Xapurí recently acquitted of some supposed

crime, he was greeted by rubber tappers from all over Acre with posters and signs.

I was so happy to see him again—that's when we began to fall in love, around 1980. We were engaged in '82 and married in '83. We lived in the city, but didn't have enough money to survive since he didn't have a fixed salary. We married because we loved each other, even though we had nothing. At first, we stayed with friends for a year, but this was difficult. We didn't even have enough money for clothes or food. So we agreed that I'd go back to live with my parents and he'd keep his union work in the city. I was pregnant with Elinira then. We only saw each other once every two or three months because he traveled a lot.

After a year I couldn't take it anymore. I had Elinira and was pregnant with Sandino—I wanted to be with him. I told him he had to get a house for us in Xapurí, I just couldn't take the separation anymore. I didn't want to raise my children alone. Luckily, some group gave him a year's grant for his work. We finally got a house, the one we were living in when they killed him.

Mev: Did you understand the work he was involved in at this time?

Ilza: I began to understand it more and more, especially after I left the *seringal* [areas of the rubber trees] and lived in the city. I began to understand that my father really was exploited by the rubber boss. I realized then that Chico worked for the survival of my father and others like him. Any day, my father could have been expelled from the *seringal* and we might have starved in the city with our eight children.

The more I understood his work, the more I wanted to be beside him. He'd go to big cities to tell what was happening in the Amazon. I supported him because no one else had the courage to speak out like he did. People in this kind of work get death threats and often don't return from their trips.

Mev: When did they begin to give Chico death threats and who was threatening him?

Ilza: Chico was threatened for a long time—ever since he left our house the first time to demand workers' rights and the end to exploitation. In 1980 they killed Winston Pinheiro, a great leader in the Amazon. They intended to kill Chico in Xapurí at the same time. It was a miracle that Chico wasn't in Xapurí that day.

The *fazendeiros* of the Rural Democratic Union (UDR) were the ones threatening him and still are today. The UDR is not democratic. It's a group

that finances the death of people who threaten the power of the rich landowners. They go after union leaders and people that defend the environment from deforestation. They want to trade the rainforest for cattle pasture and are willing to kill for this right. They're a criminal organization.

Things really heated up in these past two years—he was more persecuted than ever. Every hour of every day they harassed him.

Mev: How was Chico threatened?

Ilza: A few years ago, when I moved to the city to be with Chico, the very *fazendeiro* who was behind Chico's death bought some land in Cachoeira and he wanted to fell the *seringal* to make a ranch. The rubber tappers of Cachoeira, more than 200 people, got together for an *empate* and wouldn't let the *fazendeiro* enter. From then on, Chico was threatened constantly. They began to try to bribe Chico when they saw him on the street, they'd gather people outside our house every night, they'd pursue Chico at the union, in the street, even in other cities. We finally asked people to accompany him on trips for safety.

Mev: Did you suffer any threats?

Ilza: Yes, they would harass me on the streets or encircle our house. Sometimes I'd come home and find 30 men standing outside my house, all with revolvers in their belts. They'd lift up their shirts to show the revolvers, trying to provoke us. This police station near our house was their hideout. We could see the gunmen go straight from our house to visit their friends at the police. They followed every move Chico made and studied when would be the best time to grab him. The police who were supposed to be protecting Chico shared their information with the gunmen; even the civil police helped.

During this time I was dying of fear. Sometimes I'd go to Chico and say, "Chico, they're going to kill you! Why don't you take care of yourself and go away? You have support in Rio and São Paulo, why don't you go there for a while?" He said he couldn't—if he did this, he'd be false, he'd be a coward. He was never going to run away from the people's struggle. Either he would do away with their wrongdoings or they would do away with him.

Mev: Was this hard for you to understand or accept?

Ilza: I understood because this was Chico's option. He wasn't afraid of death. He even told me that he would never stop defending the Amazon forest—never, never, never. They could threaten or do what they wanted, but he wouldn't abandon the struggle. Chico hoped that if they killed him, others would take up the struggle of protecting the forest and its peoples.

Mev: Were the bodyguards involved in his murder? Weren't they supposed to be his bodyguards?

Ilza: I have doubts. Not just doubts, I think it's true that the assassins managed to kill Chico a lot easier once he was under police protection. After two rubbertappers were murdered in the *seringal*, two of Chico's rubbertapper friends began to accompany him for protection, with their own arms. It was hard for his enemies to get close to him at this time. They didn't harass us as much. But Chico didn't have the means to pay these men to support their families, so they had to go back to the *seringal*.

Then the police guarded Chico. I could tell that the gunmen were getting a lot closer to us when the police took over. They would actually get within a few yards of Chico, with the police right beside him. We knew that the gunmen were friends of the police. They were actually supported by the federal and military police.

The gunmen took advantage of this. When Chico was playing cards with his friends one night, all Chico had to do was to ask the police to check out the backyard since it was so dark, someone could be waiting there. They were obligated to do at least that—there could easily be someone waiting for him out there. No, they stayed inside, silent, and kept eating dinner. Chico went outside all by himself. That was the moment they shot him.

Mev: Then what did the police do?

Ilza: I think the police knew all along that the men were outside to kill Chico. After the men shot Chico, they ran away. But when I came out to the kitchen to see who fired the shot, they hadn't even pulled their guns out to go after the assassins! They looked out the windows but didn't even venture out of the door! Then they ran to the nearby barracks to get help. After ten minutes, after *everyone* knew what happened. People were trying to get Chico to a hospital, and all of Chico's friends had shown up to help. Finally the police came back faking everything, saying they went to get arms and machine-guns. My God, the barracks is only a few yards away, they could have returned in two minutes. They gave the assassins plenty of time to escape. They didn't catch the guys because they didn't want to.

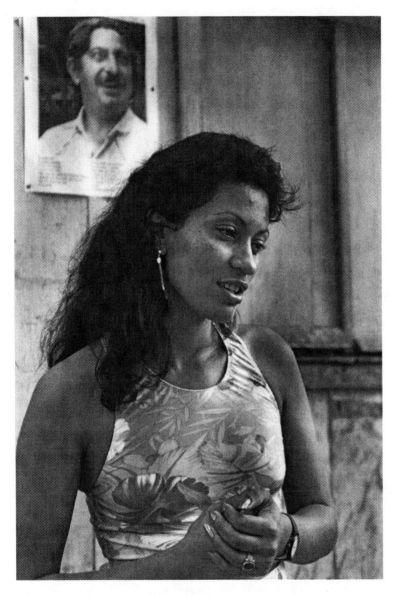

Ilza Mendes; Xapuri, Brazil; 1989
Mev Puleo

I'm certain they knew it was going to happen. They knew Chico was threatened every moment. If they were really protecting Chico, they would have gone outside with him that night.

Mev: Are there other women in a similar situation to yours?

Ilza: There are a lot of other women who are widows. Their husbands were also killed in the struggle, murdered by the same group, UDR. These woman are also lacking the means to survive. Many have bigger families than I do, six or seven children. One woman whose husband was killed nine years ago continues to go to work on the *fazenda* owned by her husband's assassins, but she has nowhere else to go!

With this, I began to wake up: We, too, are victims of these murderers. We don't have to keep silent and submissive before them. So, the Chico Mendes Foundation gives grants to these widows, survival resources, so that we can work *against* the assassins. Some day we will see these murderers punished.

I try to encourage the other widows to keep up hope and to struggle for change. It's easy to become discouraged.

Mev: At this point, what are your own hopes for your future and that of your people?

Ilza: As for me, my big hope is that the struggle Chico left behind will go forward, that we won't see any more forest falling to the ground, that it will be preserved. This struggle has to go on so we can have a better future and live in peace. Today, after five or six in the evening, we can't go out or leave our windows open because of the gunmen. We want peace.

I'm ready to give myself over to this struggle. After I saw Chico dead, my only hope for the future was to continue his struggle—along with his friends and my two children. I want them to grow up looking towards the goal of their father. When they're older, they can also participate in this struggle that their father began.

Mev: People say that Chico was very motivated by his Christian faith. Has your faith helped you at all in these recent difficulties?

Ilza: Chico had a lot of faith. Early in his work, the church supported him. They hid him in the church when people were after him. I'm also a Catholic and go to Mass. I talk to the priests and nuns because they are supportive. The priest here is committed to the struggle of the workers.

More than anything, I believe God helps people. When Chico died, I was filled with despair. I didn't want to live anymore.

I felt my life was at an end, I thought my children might die. I thank God so much that now I'm engaged in the struggle. God comforted me and inspired me to work alongside others and carry forward Chico's work. I'm so grateful to God for this help.

Now I see that they killed Chico, but they didn't kill the struggle of Chico's ideals. The important thing for us today is to continue Chico's struggle. As we do that, Chico's present at every moment!

Exchanges/2

"Oh! Look at you!"

"Yeah?"

"How lovely! Look at this shoulder, sans pareil!"

"You're teasing me."

"No, really, when's the last time your delts were acknowledged for the 8th wonder of the world that they are?"

"Honestly, you're the first."

"Don't forget that."

"I bet you won't let me."

"Here, let my fingers express their gratitude."

Day in The Life/I
(Love Letter/3,
Remembering The Dead/I)

After her rugged 1989 spring and summer in Brazil, Mev was glad to return to Cambridge and her dear friends in the Harvard Street apartment building, especially her roommate Margaret, a zestful cellist who brought her talents to the Weston liturgies, and Marcia, an M. Div. student across the hall with whom Mev hit it off. She had also taken to seeing a nun, Marie, for spiritual direction to help her sort out the chaos from the summer. In addition, two students with experience in Brazil joined with Mev to swap tales, jokes and recipes in Portuguese. She was also taking a course at Harvard in contemporary Muslim communities and doing research on the arch-conservative Catholic lay movement, Opus Dei.

She was thrilled that her old friend, Gene, a young Jesuit, was beginning his theological studies at Weston in Cambridge. He'd worked in Africa and was one of the few people with whom Mev could communicate about faith struggles. One September evening, a group of Weston students walked past a disfigured man in a wheel-chair begging outside the school. No one said hello or even acknowledged him, which prompted Gene later to ask aloud of his friends, "What are we about here? What are we studying?" A case of the discomforting applicability of that familiar tale of the Good Samaritan? As a result of Gene's apt questions, Mev made it a point to greet the man the next time she saw him; she was struck by his delightful smile. In posh and trendy Cambridge, Mev often witnessed homeless people struggling to find food and succor. As she later wrote me, their plight compelled her to want "to photograph. Interact. Bridge. Communicate. Advocate. Enter. Feel. Immerse. Scream. Be with. Cry. Create. Awaken!!!"

Even though Gene was a Jesuit for whom Mev felt a special bond, my jealousy wasn't triggered by him being in Cambridge. But I did wonder about the depth of Mev's feelings when she would speak with profound admiration about another

Jesuit she'd known in St. Louis, Steve Kelly. Steve was a Jesuit from the California province who, like Gene, had spent time in Africa as part of his spiritual formation. Evidently, he was a *bona fide* "radical," as Mev spoke in laudatory terms about some of his legendary exploits—he refused to pay any kind of phone federal tax, since that money could be channeled to U.S. military budget; he fasted with regularity; he attended all the demonstrations in St. Louis against the McDonnell-Douglas arms manufacturers; he raised provocative questions to the Jesuit community, which enjoyed a pretty comfy life, wine cellars and all; and, in the philosophy courses he and Mev took, he never once turned in a paper on time. There were more important things to do, Steve evidently believed, like opposing the American war machine. In my insecure moments, when comparing myself to Steve, I felt like a complete schlimiel.

At the end of October, Mev sent me a letter full of her typical preoccupations—our relationship, a forthcoming book project with John Kavanaugh (his meditations, her photos), the death of journalist Penny Lernoux who had been living across the street from me with the Maryknoll Sisters, and what she'd been reading. Although Mev didn't think of herself primarily as a writer (though she was a committed diarist), she was one of those people upon whom very little was lost.

October 30, 1989

Hello Mark!

Thank you dear one, you who call me by a true name—"precious"—that is delightfully disquieting to hear because it names me in beauty and value when I dwell in the name-realm of production and impression. Thank you dear, you whom I name—dear—dear to me, dear—"much loved, beloved, highly thought of, esteemed, earnest, with deep affection," dear to me, be loved, letting yourself be loved as never before, by your friend-lover-me, by mentor Marc, by your brother Dave, by Joan, by all-in-God, by Christ-in-street-dwelling-brothers, by all. You are dear. Dear to me. Dear apart from me. Dear to God. Dear.

Thanks for a wonderful, fun, relaxing, sufficiently productive, delectably fun, adventurously passionate, so very NATURAL time . . . yes, dear, so very, very NATURAL to hang out with you, study with you, live with you, eat with you, read magazines next to you, and critique papers with you, etc. Natural.

Monday: I've read articles on Rushdie, page of notes, page and a half of questions, will attend to pictures for John's book, Gene will come to "react" to them tonight, off in 2 hours for yum, ah, mmm, aha, woosh spiritual direction with wiz wonder woman Marie. I received your luscious (!) letter today and read it as I munched toasted cinnamon raisin bagel with real butter, wishing you were here to eat the edges I tend to leave behind but I "disciplined" myself (Hail, Hail Monsignor Escriva!) and ate crust and crumbs—and, what a loverly letter. "I believe in love" and you write about the so-called poor and I stand back in simple appreciation. This weekend you call me complete woman who is incomplete and I call you beautiful man whose imperfections forge your unique textured beauty.

Some things I've wanted to share with you. First, my response to Penny Lernoux:

I am so profoundly moved to my core. Reading *NCR*'s obituary and articles. I met her, she wrote me a letter encouraging me to be a photographer for and from Latin America. She was a living hero to me— not Gandhi from another country and another generation I never met. She was flesh and blood, a middle-class American like myself with a passion for communication. My camera is my pen. She understood. She was a model. An inspiration. I didn't always agree with her but *Cry of the People* changed my life.[25] It was my first encounter with liberation theology, my earliest understanding of oppression and torture and faith-inspired movements and celebrations of hope. And, in her dying, I am converted anew. My eyes cry with tears that understand more than my brain can fathom—these, her words:

> I feel like I'm walking down a new path. It's not physical fear or fear of death, because the courageous poor in Latin America have taught me a theology of life that, through solidarity and our common struggle, transcends death. Rather, it is a sense of helplessness—that I who always wanted to be the champion of the poor am just as helpless— that I, too, must hold out my begging bowl; that I must learn—am learning—the ultimate powerlessness of Christ. It is a cleansing experience. So many things seem less important, or not at all, especially the ambitions.

I weep. (Thank God I can weep! My tear ducts were clogged for years!!) Weep. I, too, am ambitious; I, too, want to be a champion of the poor; and I, too, am helpless and begging. I learned that when I had cysts that could have been cancer, when I lost most of both ovaries, when I was hungry-tired-depressed in Brazil this summer, when I touched death in Haiti, the dark tunnel last spring. Now, as I try to hold my life that is so uprooted these past months, it is true—my ambitions are less pressing. Two book offers and I am not off kilter and full of myself; I must weigh if I can emotionally withstand a trip to Brazil so soon. Life looks and feels different. I, who am so strong and so together, have buried "togetherness" because I am human. My photograph of the blind beggar—I see myself reflected in the bowl. I see my true self reflected in Penny's words. They reach deeper than I can at this moment. I cry. And life looks and feels a little bit different from now on.

Some thoughts from Salman Rushdie: One of Rushdie's characters loses his faith and is left with "a hole inside, a vacancy in a vital inner chamber." Rushdie writes, "I, too, possess the same *God-shaped hole*. Unable to accept the inarguable absolutes of religion I have tried to fill up the hole with literature . . . Literature is where I go to explore the highest and lowest places in human society and in the human spirit, where I hope to find not absolute truth but the truth of the tale, of the imagination, and of the heart." (What do we will our God-shaped hole with? Positive addictions and negative ones? Writing and ambitions? Mozart and fall leaves?)

"This is how religions shore up dictators: by encircling them with words of power, words which the people are reluctant to see discredited, disenfranchised, mocked."

Later:

Well, sweetie, p'doodle, panache, (I've seen that word used recently!), take care. I'll have seen you soon and I'll see you soon. Thanks for your friendship, love, affirmation, support, encouragement. Mark, you really are a cheerleader for me and I hope I am for you. Marie was asking me about you—and Mark, it helped me see what I'm already experiencing—there's something really beautiful flowing between us. So, natural, simple, earthy—yet all the more awesome because of its earthiness.

It was good to talk to Marie about returning to Brazil, etc. Spent the rest of the day working on the pix for John—it was really great, really contemplative, and I found phrases, words flowing in response to *every* picture. Gene comes over soon to share his impressions. So much to do, but the healthy me will say, what I've done today was significant—don't demean it by laying it against all I "want" to do. I most want to be present to the moment. The most important time is *now*.

So, peace and blessings and I'll talk to you sooner than this arrives! Long live virtue!

Mev

Prayer/1
(Being Present/2)

Throughout that fall and winter, I enjoyed my time at Maryknoll, taking long bike rides through the wooded Westchester County back roads to clear my mind after reading extensively at the intersections of the Jewish and Christian traditions, as well as ecclesiology, theological method and the history of Zionism. I was taking this latter independent study with Marc Ellis, who invited me to attend a conference held by Palestinian Christians on liberation theology in the context of the *intifada*. The conference was to be held the upcoming March, and Mev encouraged me to send out a fund-raising letter to my friends.

From high school until her recent adventure in Brazil, Mev had been an avid Bible reader. She had even considered going into Bible scholarship. But when she realized she'd have to learn Greek, Hebrew, Latin, German and others—"I'd be in school for years!"—she decided she'd rather spend her time doing photo projects. Nevertheless, that summer in Brazil in 1989 changed her deeply. She surveyed the vast misery of her friends in Liberdade and noticed how much worse life had gotten in the two years since her last visit in 1987. She told me how, at one point during the summer, she "slammed the Bible shut," as she couldn't reconcile all the suffering around her—hungry children, neighbors with miscarriages, people scrounging in the trash to make ends barely meet, repression—with Jesus' serene promises invoking the lilies of the field. She confessed her own physical and emotional limitations: It had been so draining to live the way the Brazilians lived in the slums, even if for only a few weeks. I recalled how Mev had once emphasized the heroism of these nobodies struggling to build the Kingdom of God against great odds. But she herself wasn't feeling very heroic. Her own experience overwhelmed the truths of sacred Scripture.

Still, I had no fear that, because of her faith crisis, Mev was going to say "to hell with everything!" and so insulate herself from the pain she had witnessed by instead mindlessly pursuing the American Dream. If this were a crisis to really worry about,

she'd be looking out for #1, stepping on people on her way to the top, since the bottom sure isn't an attractive option. She felt like something was dying in her, and it was: a faith that had to be resurrected, an innocence that God would somehow "save" the Goreths of the world from their affliction. From my reading of Wiesel at Maryknoll, I remembered one of the Hasidic master's dicta about "there being no heart so whole as a broken heart." Mev's heart had not turned to stone, but the old certainties weren't so readily credible. After what she had gone through in Brazil (which, she would be the first to admit, was an infinitesimal fraction of the harshness of what her friends there experienced on a daily basis), she needed some distance from the traditional, triumphal promises of Catholicism, even while continuing to take her theology classes at Weston. That fall and the following spring, Mev would slowly, painstakingly, with a lot of tears, try to piece back together her Catholic faith. She studied Christology with the Jesuit theologian Brian McDermott. She recounted to him that, after a Good Friday experience of death, abandonment, limits and anguish in Brazil, she felt herself to be stuck in Holy Saturday, that arduous time after crucifixion but long before any resurrection.

And so it was one weekend autumn morning in Cambridge that Mev confided to me her distress that she was unable to pray like she had been able only a few months before. She had feared that she was losing her faith, which had been the center of her life. As I had not had the daily practice of such companionship with the Bible, I proposed to her that she join me in one of Nhat Hanh's meditations. It's not that I wanted to proselytize or "fix" her, but I thought his simple yet profound pragmatism might resonate with her.

"O.K., Mev, here's a gatha we can use to keep our cool. Breathing in, we recite to ourselves 'in.' Breathing out, we recite 'out.'" We did it several minutes together, and she looked a little comforted. Then, we added other short verses for the in-breath and out-breath:

Deep/Slow,

Calm/Ease,

Smile/Release,

Present Moment/Wonderful moment.[26]

She later mentioned to me, "There are times, Marko, when it doesn't *feel* like such a wonderful moment."

Sitting/2

A Teaching by Thich Nhat Hanh

In the West, we are very goal oriented. We know where we want to go, and we are very directed in getting there. This may be useful, but often we forget to enjoy ourselves along the route.

There is a word in Buddhism that means "wishlessness" or "aimlessness." The idea is that you do not put something in front of you and run after it, because everything is already here, in yourself. While we practice walking meditation, we do not try to arrive anywhere. We only make peaceful, happy steps. If we keep thinking of the future, of what we want to realize, we will lose our steps. The same is true with sitting meditation. We sit just to enjoy our sitting; we do not sit in order to attain any goal. This is quite important. Each moment of sitting meditation brings us back to life, and we should sit in a way that we enjoy our sitting for the entire time we do it. Whether we are eating a tangerine, drinking a cup of tea, or walking in meditation, we should do it in a way that is "aimless."

Often we tell ourselves, "Don't just sit there, do something!" But when we practice awareness, we discover something unusual. We discover that the opposite may be more helpful: "Don't just do something, sit there!" We must learn to stop from time to time in order to see clearly. At first, "stopping" may look like a kind of resistance to modern life, but it is not. It is not just a reaction; it is a way of life. Humankind's survival depends on our ability to stop rushing. We have more than 50,000 nuclear bombs, and we cannot stop making more. "Stopping" is not only to stop the negative, but to allow positive healing to take place. That is the purpose of our practice—not to avoid life, but to experience and demonstrate that happiness in life is possible now and also in the future.[27]

Prayer/2

Mev's Journal, Autumn 1989

God, I used to think you dwelled in a secret chamber inside me. I used to think we were so close that there wasn't room for anyone else inside. I used to think I could only be really close to a person who was "as intimate" to you as I was—and how could that be since you and I had such a special relationship? That was part of how I defined celibacy. I didn't know if anyone could get in there. Not a husband, especially!

Now, there isn't a secret chamber. There is the God-shaped hole that will never be filled but only accompanied. At the core is a tomb with our silence, waiting, accompaniment. But all over is epiphany and Emmanuel, God-with-us. And I see your face in Marcia, Paul, Mark. Maybelle. I hear your voice in Mozart, rustling leaves, the trumpets of fall colors. Mark reveals the You in me to myself and I see You in him, too. God is love and there is something to what is between us that is greater than the sum—that "greater" is you.

And it doesn't steal me away from the poor, it doesn't compromise my alternative lifestyle, it doesn't dilute my intimacy with you. Rather, it energizes my commitment to the poor, it challenges me to be more true to and discerning of the lifestyle I feel called to, enhances my intimacy with you—opening chambers of my heart I never knew existed!

So, while I'm in the tomb and I don't know who Jesus is and if the "Christ" is Jesus and what the hell is going on with my faith—I am also in the womb and something new is being forged and revealed. It is as awesome and dumbfounding as new birth.

The Gospel according to
The State Department

One of the advantages of Mev's program in Theological Studies was that it allowed her to take courses at a number of universities in the Boston area. Before her Brazil trip in 1989, she had studied with a Harvard Biblical professor who talked about opening the canon of Scripture such that subsequent letters, documents and testimonies might also be considered inspired and speak to the deepest questions and hopes of the community of the faithful.

Of course, each of us may have our own storehouse of operative scripture— poems, song lyrics, autobiographical insights, mystical confessions and prophetic texts.

Mev's professor made sense to me: Not to put down the "original and secondary testaments" (literary critic Harold Bloom), but a lot has happened since then, hasn't it? Despite the optimistic Christian teaching about how the world has been totally changed since Jesus' life, death and resurrection, the world has not exactly been so totally transformed in the ways of peace and justice. Yet there have been ongoing revelations and inspired testimonies, like Dr. King's letter from the Birmingham jail.

But, as I learned with Marc Ellis, there can also be "anti-Scriptures" that are equally revelational and deserving of our attention and constant rereading. Ellis was drawing on some of his Jewish elders like Rabbi Irving Greenberg, who offered the following reflection on one example of Holocaust testimony:

> The Scriptures of the new era are hidden. They do not present themselves as Scripture but as history, fact, and sometimes, as anti-Scripture They are the accounts that tell and retell the event, draw its conclusions and orient the living. In the Warsaw Ghetto, Chaim Kaplan wrote in his journal: "I will write a scroll of agony in order to remember the past in the future."[28]

Because of Ellis's own growing commitment to the Palestinian people, remembrance of the European Holocaust was not and could not be enough. He expanded Greenberg's view by stating that "If it is true that the new scriptures, the scrolls of agony written with bitterness and hope, come from the ghettos of eastern Europe, are not similar scrolls being written today by Lebanese and South African women and men and their 'burning children'?"[29]

So, scrolls of agony and Dr. King's letter: Both are foundational texts of our time. More and more during my Maryknoll studies, I felt that it was not enough to read Jeremiah's lamentations and Luke's annunciations.

As I was reviewing Noam Chomsky's work, I came across a document that was a marvel of clarity and honesty. The document was a Policy Planning Study from 1948 in which the State Department's George Kennan lays out the essentials to his colleagues whose burden it was to run the world. It seemed to me that this revelation as to workings of the real world ought to be heard and understood by those who appeared in church each and every Sunday. Kennan stated:

> . . . we have about 50% of the world's wealth, but only 6.3% of its population . . . In this situation, we cannot fail to be the object of envy and resentment. Our real task in the coming period is to devise a pattern of relationships which will permit us to maintain this position of disparity without positive detriment to our national security. To do so, we will have to dispense with all sentimentality and day-dreaming; and our attention will have to be concentrated everywhere on our immediate national objectives. We need not deceive ourselves that we can afford today the luxury of altruism and world-benefaction . . . We should cease to talk about vague and—for the Far East—unreal objectives such as human rights, the raising of the living standards, and democratization. The day is not far off when we are going to have to deal in straight power concepts. The less we are then hampered by idealistic slogans, the better.[30]

Maintaining the disparity might come as good news to some of those 6.3% of the U.S. population, but not for many others in the world, whose children starve on the street or whose husbands moan in prisons or whose sisters disappear, never to return.

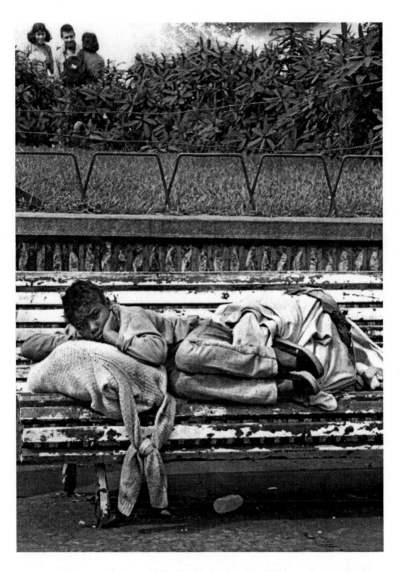

Street Child; São Paulo, Brazil; 1990

Mev Puleo

A School/I
(Dissidents/2,
Remembering The Dead/2)

Mev and I very tentatively began to broach the issues about life together after finishing our master's degrees. I spent much more time in Cambridge, as it was easier to be with Mev there than have her come to Maryknoll for a long weekend. Plus, I enjoyed the Cambridge scene: We often went to films at the Brattle Theater, took coffee or dessert at Algier's nearby, and Mev humored my bibliophilic mania by accompanying me to McIntyre and Moore Booksellers, Wordsworth, and Harvard Book Store, often in one night. We had it made.

But this was strange—what Mev and I were studying, with our respective focuses, was about those who did not have it made, in fact, far from it. One afternoon in mid-November at Maryknoll in a course on ecclesiology, we were informed that several Jesuits had just been murdered in El Salvador. It was an awful replay of December 1980, when four U.S. Churchwomen had been raped and murdered, and March of that same year when Archbishop Oscar Romero had been assassinated while celebrating the liturgy. How surreal, to be in such a comfortable position in New York learning about the different ways of being church in post-Vatican II Catholicism, and then hearing how the Jesuits had their brains shot out because *their* way of being the church was declared subversive by the Salvadoran government, which had long been supported by the U.S. government.

When I talked to Mev on the telephone, she was both saddened and indignant. Many people had assumed, wrongly, that because of her experience of travel in Latin America that she had spent time in El Salvador. Even though she hadn't, she felt a kinship with Jon Sobrino, the Salvadoran Jesuit intellectual who had advised her about photography back at Maryknoll in 1988. Sobrino had been giving lectures in Thailand at the same time his brothers—Ignacio

Ellacuría, Segundo Montes, Amando Lopez, Joaquin Lopez y Lopez, Ignacio Martín-Baro, Juan Ramon Moreno—had been taken out and murdered. Had Sobrino been at the University on that night, he, too, would today be regarded as a martyr.

In my studies of Elie Wiesel, I already had encountered his criticism of the failure of the Christian churches in Europe to confront the Holocaust, during which time there was no preferential option for the Jewish poor, who suffered expropriation, torture and mass murder. Such a preferential option for the masses of impoverished people had recently emerged, however, in the Latin American church, and was formalized in such gatherings as the Latin American bishops' conferences at Medellín in 1968 and Puebla in 1979. Ellacuría had been one of the foremost advocates of this Christian commitment to justice for the poor. In an essay, "Persecution for the Sake of the Reign of God," Ellacuría considered Oscar Romero to be a compelling example of the church's preferential option for the poor. In seeing Romero as an outstanding pastor and Christian, Ellacuría noted that Romero was only following in the footsteps of Jesus. Guided by Romero, the Salvadoran church committed itself more fully to the lives of the poor, helped them transform their misery and served as messengers and witnesses to the Reign of God. For these religious communities, intellectuals and pastoral agents, this was a Reign in which human dignity was respected and defended, a Reign that could not tolerate the human rights abuses perpetuated by the entrenched oligarchy and military. Ellacuría suggested that because of this prophetic option for Salvador's poor, it was inevitable that Romero and the church would be persecuted. He stated candidly that the Salvadoran church "has not been persecuted for defending dogmas, which for the moment do not bother those who wield power in this world; but it has been persecuted for heroically incarnating Christian virtues, and especially for standing with the poor and persecuted."[31]

Romero had been appointed archbishop because he was thought to be a conservative who wouldn't rock the ecclesial boat amid the growing civil strife in the late 1970s. However, when his priests began to suffer for *their* pastoral commitments to the poor, Romero began to embrace fully their preferential option, the eventual results of which Ellacuría enumerated:

> one bishop dead, ten priests murdered; three sisters and a lay missioner
> raped, tortured, and murdered; dozens of preachers of the word
> disappeared, tortured, and then slaughtered; dozens of priests and

religious in exile; churches, schools, and residences assaulted, searched,
shot up; church publications and media dynamited . . . In the annals of
ecclesial life today, it is hard to find a church as martyred and persecuted
simply for being faithful to its commitment to the poor, and for
striving to be the true people of God.[32]

Romero had been a pastor engaged in the defense of his people who were subject to torture, death squads, as well as the daily death of poverty. He also had implored President Jimmy Carter not to continue to send U.S. military aid to the Salvadoran killers. However, the American president, for whom human rights supposedly was so central, refused. Romero was assassinated a month later.

Ellacuría contended that this preferential option (with all of its dangerous consequences) had to assume a central role in the mission of the university.[33] As the rector of the University of Central America in San Salvador (which was founded in 1965), Ellacuría believed that the University had to confront the Salvadoran national reality, characterized by the dehumanizing poverty of the majority of the population. The University could not be a sequestered, detached haven from society; rather the University's center of attention ought to be this unjust national reality of misery for millions of Salvadorans. Thus, the University had to make denunciations of injustice as well as to announce alternatives that would allow the dispossessed majority a place of participation in determining their own affairs. Speaking from his academic setting, Ellacuría emphasized this link between the university and human rights:

We can say that the existence of the poor and oppressed majority in
itself represents the most powerful existential and material negation
of truth and reason. Overcoming this massive, unjust, and irrational
fact of the existence of the poor majorities is one of the greatest
challenges facing the intelligence and will of the university; namely,
that of helping these majorities find an adequate theoretical response
and an effective practical solution. A dialectical view of the problem
impels the university to seek to fulfill its proper university mission
and its mission as a social institution from this perspective of the
human rights of the poor oppressed majority.[34]

Indeed, as an academic institution, the UCA found several ways to make the

preferential option efficacious in its research, teaching and social outreach. The integral theme of liberation was promoted in theology and philosophy departments, while a number of publications by the faculty and dissertations by the students analyzed the structural injustice of the society. An Institute of Public Opinion was established in order to discover from the people themselves what they desired for the future of their country. Ellacuría also took a prominent stand on behalf of negotiations between the government and the insurgent FMLN in the civil war. In making such commitments, Ellacuría and the UCA embodied the critical intellectual conscience of the country. The Jesuit intellectual pointed out that in a five-year period, the university had been bombed 10 times, and both students and faculty suffered exile and harassment. Like Romero's pastoral mission, Ellacuría reasoned, "If the university had not suffered, we would not have performed our duty. In a world where injustice reigns, a university that fights for justice must necessarily be persecuted."[35]

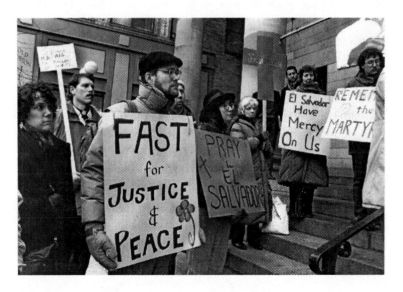

Remembering; Boston, Massachusetts; 1989
Mev Puleo

Ellacuría and his brother Jesuits performed this duty. Their dedication to

negotiations, land reform and popular participation were a scandal and a threat to the Salvadoran military and economic elite, who had long included the Jesuits on their death lists. In the chilling context of El Salvador, these intellectuals fulfilled the responsibility of telling the truth and exposing the lies perpetuated by the government and Army. Such conscientious activity entailed a predictable consequence: persecution of those who sided with the victims of power.

Mev threw herself into organizing and participating in vigils and demonstrations of protest in the Boston area. She expressed chagrin that more of the established Jesuit professors weren't taking an active part in the protests. Many of the Jesuit seminarians joined in legal protest in the Boston area, but we had heard that the young Jesuits from Berkeley were going so far as to commit nonviolent civil disobedience at the San Francisco Federal Building. Mev asked, "What does it take to get our professors concerned? Their own brothers have been assassinated! How come more of *them* aren't out on the streets?" I attended one of the Boston demonstrations, at which there were readings from the already designated Salvadoran martyrs. Mev moved through the solemn crowd taking photographs and joined in the litanies and singing. For standing up and speaking out in downtown Boston, there was no danger, only a little inconvenience, if that. It was good to be at a demonstration. I was so moved because here was living proof of one of the Gospel's truths—you shall be persecuted for the sake of justice—but ours was another universe from that of El Salvador, where tens of thousands of poor non-intellectuals, non-Jesuits had been tortured, disappeared and massacred.

The Jesuits' work was based on the promotion of human rights for the poor majorities as the most effective way of realizing the common good. Their lives dramatically incarnated a foundational Christian truth: Fidelity can lead straight to the Cross. Ellacuría once offered a spiritual exercise for the present age of atrocity that called people of good will to struggle so that others can experience a more abundant life:

> I want you to set your eyes and your hearts on these people who are suffering so much—some from poverty and hunger, others from oppression and repression. Then (since I am a Jesuit), standing before this people thus crucified you must repeat St. Ignatius' examination from the first week of the [Spiritual] Exercises. Ask yourselves: What have I done to crucify them? What do I do to uncrucify them? What must I do for this people to rise again?[36]

Shoetique; Tijuana, Mexico; 1986
Mev Puleo

Mutual Aid/I

During Christmas vacation in 1989-1990, I visited Mev in St. Louis. Early one evening, we drove to Karen House and, with the community members, proceeded to Scott Air Force Base in Illinois to protest George Bush's invasion of Panama. Teka was a catalyst of the proceedings, and I was impressed at how calmly and strongly she spoke in a media interview. It was all the more sobering at Christmas time to be vigiling as the U.S. military made havoc in Panama.

Later that week, I talked with Mev about my master's thesis. I told her I wanted to investigate the work of Chomsky and its relevance to the nascent Jewish theology of liberation.

"Well, you should go ahead and just write him."

"Whaddaya mean, 'write him'? Write Noam Chomsky?"

"Sure, I bet anything he'd be glad to help you out with your project. Go ahead."

I froze. It was easy for Mev to befriend Gustavo Gutiérrez, the world-renowned theologian. But I couldn't conceive of writing to Chomsky, whom I'd long read. Why would he write me back? I was a nobody. Besides he had far more important things to do with his study of linguistics, not to mention with a calendar booked two years in advance to give political lectures all over the U.S. and the world.

"I don't think so, Mev, he'd never write back. Anyway, why add one more thing to his desk, which must be out of control with correspondence?"

"Mark, you have to get over this reticence of yours. What's the worst that could happen: He'd never respond, for the reasons you mentioned. OK, fine, but at least give it a shot."

"Give it a shot"—Mev's *modus operandi*. Egged on by her utter confidence in me (and in Chomsky), I wrote informing him that I was doing a thesis on his work on the Middle East, and I asked if he would be willing to meet with me for an interview.

But there were other letters to write, too. Fund-raising letters, since I was accompanying Marc Ellis to Israel and Palestine in March of 1990 for the conference on Palestinian liberation theology. I wrote to many old friends, requesting even a few dollars to help me pay for my plane ticket, in exchange for which I'd be happy to

speak about my experiences to them or their group upon my return. I got this idea about fund-raising from Mev who had used it a few times to help pay for her trips to Brazil and Haiti. She and I then spent New Year's Eve at her sister Laura's home. It was a poignant night, as her husband, Ron, came out to join us, even as he was in the last stages of Lou Gehrig's disease.

Mev and I stole a little time alone to reflect on the year past and ponder the year of a new decade before us. We would both graduate in May from our master's programs, but then what? She had submitted an application for the Jonathan Daniels Fellowship from the Episcopal Divinity School to help fund her own hoped-for trip back to Brazil later in 1990. I was as direct with her as she was with me about Chomsky: "Mev, face it, you don't really want to come back to St. Louis and teach high-school. You've already done that. You should do free-lance work. You're already doing it part-time, just think of how much more you could accomplish"—I was deliberately appealing to her penchant for performance and productivity—"by working at journalism, photography and public speaking full-time."

"Fine, Mark, but how am I supposed to live off of this? Do you know what magazines pay for photographs? And Catholic publications often expect you to give your photographs for free. I'm just not sure."

"You could always do an occasional wedding. It could be your version of waiting on tables."

"And what do *you* plan on doing? As much as I think your program at Maryknoll has been good for you, what kind of job are you going to get? Or are you ready to start thinking about a PhD?"

"Well, it's a little late to be thinking of a PhD for the fall. How about this? Since we both graduate in the spring, let's take this next year to figure all this out."

"Hmm, sounds like you're making a commitment."

"I am committed to seeing where we want to go, singly and together." I was pleased with this both/and. And, happy to get the attention off of me, I encouraged her: "But you're the one under discussion here. I will probably be most happy pursuing my studies at some point in the near future, but you are a photographer. You can devote more energy to building up your list of contacts. Plus, isn't it true that you can count on your parents, too?"

This was a tender subject. Mev's entire education had been paid for by her parents. Plus, she had some investments ("Investments? What are investments?" I had asked naively), including one of at least five figures in some bank in Chicago devoted to community development. I knew she had access to resources if she was short one

month on paying her bills. At other moments when we were arguing, I thought, but did not say: It must be easy to be devoted to simple living when your parents are wealthy and you've got investments.

"I don't want to depend on my parents, Mark. They're generous, but I am just not sure if I could pull this off."

I smiled. "Ah yes, this sounds very familiar to me. Let me see if I can put it in context: 'Mev, I don't know if I can pull off this writing to Chomsky. It's pointless, and besides, he'd . . .'"

An embarrassed smile: "All right, what's good for you is good for me."

Mev needn't have been so concerned about generating income. Several weeks after this conversation, she had received a book contract from a publisher for her Brazil project. The editor had first proposed the idea to Mev after reading her interview with Gustavo in a Catholic magazine. He thought Mev had enough moxie to pull off a book of interviews with Latin American theologians and church activists. She was thrilled at this backing, but she was firm that she just didn't want to interview big-name theologians but people "at the base," the ones who were the roots of liberation theology. Also, she didn't want to go all over Latin America; she wanted to focus on Brazil. Her contract gave her an advance of $2000, and she was on her way.

Eventually, John Kavanaugh and Mev's book, *Faces of Poverty, Faces of Christ*, was published.[37] Mev was delighted, not least because her parents were impressed. The Puleos were sometimes conservative, though Mr. Puleo took some pride in reminding us that he had been suspicious of the Vietnam War all along. Among her siblings, Mev had been the most enthusiastic Catholic, just one of a different stripe than her parents. She could always count on a lively conversation with her parents about Catholicism, even though she and they often disagreed on how the church ought to address politics. But when her and Fr. Kavanaugh's book came out, the Puleos were pleased by the sheer tactility of it; they could hold it, show it to their friends, and say, in so many words, "Our daughter, the published photographer." Before, Mev felt they were baffled as to how to explain to their friends what their youngest child did: "Oh, she gives slideshows on the debt crisis in Latin America . . ." or "She just participated in another rally against U.S. military intervention with her Catholic Worker friends . . ." Now they could say, simply and proudly, "She publishes books." Mr. Puleo felt a special satisfaction, since he had trained Mev in taking photographs and initiated her into the mysteries of the darkroom. Not everyone, though, was so full of pride for Mev's accomplishments at her age. Distressed, she told me at this time that

more than one woman of her acquaintance had distanced herself from Mev, along these lines: "You love the spotlight, you're always dropping names of important theologians, who am I to associate with you? That's the feeling I get, Mev, you're just moving in too big of a circle for me." These remarks from some of her friends grieved her: "Am I really that full of myself, Mark?"

"Mev, I know you like to be at the center of attention, but you're also pretty scrupulous about it. I can understand that some people might be a little jealous of you. But why hide your light under a bushel basket?" I realized how hard it was for Mev: attractive, bright, vocal, talented and funny, she could unwittingly press the buttons of women (and men) less secure about their particular gifts and graces and then feel apologetic for being so on top of things.

Back at Maryknoll early in the spring semester, I checked my mailbox before lunch, and there it was—a two-page, single-spaced letter from Noam Chomsky, the opening line of which was: "I was, naturally, much interested to learn of your project, and would like to be of as much help as I can." I was thrilled as I read the letter five consecutive times, and I blurted aloud, "Mev was right!"

Later, I called her in Cambridge. "Guess what, dearie, I got great news! I got a letter from Chomsky. He'd be glad to help me, you were so right. How can I thank you?"

"I'll let you know."

Later on, she did. She eventually received word that she had been awarded the Jonathan Daniels Fellowship. She said I could express my thanks by coming to Brazil. After the previous summer's struggles, she could not conceive of going back alone. She told me that the Fellowship freed up other resources, which could be used to help me accompany her. I wouldn't need to stay the whole time, she assured me, but if I would come for part of it, especially the first few weeks, as she got her contacts lined up and her feet on the ground, it would mean a great deal to her.

The new decade was off to an auspicious start.

Well, not for the Panamanians. And the Salvadorans. And the Palestinians. And . . .

Uprising/I

While Mev was looking forward to her return trip to Brazil in August 1990, she was also excited that I headed to the Middle East. It could be an intensive crash-course in "tithing time" and learning not just with my head but with my whole being. Unlike Central America, where thousands of North Americans traveled on various missions of solidarity throughout the 1980s, Palestine had not inspired a comparable out-pouring of delegations, material aid and grass-roots monitoring of Congress. Our three-week mission was to participate in an international conference on Palestinian liberation theology in the specific context of the Israeli occupation and the *intifada*. This conference was a conscious effort to establish contact with those who were involved in one or another of the liberation theologies whose presence and power Mev and I had witnessed at Maryknoll. Marc Ellis and I traveled to Israel and Palestine during the month of March and visited Jerusalem, Hebron, Nazareth, Bethlehem, Gaza as well as Cyprus. We were able to meet many Palestinians from all walks of life who passionately shared their stories and hospitality with us.

Since December 1987, the Palestinians had initiated organized resistance to "throw off" the Israeli occupation. One of the most astute and articulate people we met was Dr. Hanan Ashwari, who commented that, while the *intifada* had captured the world's attention, it had not yet captured the world's conscience. The *intifada* included the tax revolt of the town of Beit Sahur (where we visited); social transformation and nation-building through youth leadership and alternative institutions; and political and diplomatic initiatives, such as the November 1988 Palestinian National Conference resolutions in Algiers.

The three-day conference was organized by Naim Ateek, an Anglican clergyman, Palestinian and Israeli citizen. We first heard of him at Maryknoll in July 1988, when he was working on his book, *Justice and Only Justice*, a Palestinian perspective on liberation theology.[38] In his presentations, he surfaced a number of issues that would be at the heart of this evolving Palestinian theology, which attempted to help the Christian community there deal with both their religious patrimony and political oppression. He identified several themes that Palestinians and their allies needed to

address and come to grips with. For example, in Israel/Palestine, God could almost be seen as an enemy: God was said to welcome the Jews back to the Holy Land, but at what cost to the indigenous Palestinians? Also, liberation theologians from around the world, and especially in Latin America, had utilized the Exodus story as the paradigm for liberation in the 20th century. However, in the Middle East, the Palestinians were seen as the "Canaanites" whom the Jews had a God-given right to subdue. The Palestinians also had their work cut out for them when it came to the central concepts of "Covenant" and "Chosen people." Naim faced squarely that the Bible itself could become an enemy of the Palestinian church. (I thought of how Mev shared her own acutely personal equivalent to the collective Palestinian Christian dilemma: how to hold on to the Bible when your own experience seems to overwhelm, if not negate, its relevance or meaning). Men and women at the conference also wrestled with how the Palestinians could face the overwhelming military power of the Israelis and which nonviolent options they could employ in their struggle. Finally, the Palestinians, Naim affirmed, recognized the Jewish attraction to the land: "We are willing to accept and share, as long as Israelis recognize that they don't have an exclusive right to the land."

On one occasion, the tireless Palestinian lawyer Jonathan Kuttab told Marc Ellis and me about Ansar 1 in south Lebanon, where the conditions had been so wretched and despicable that the Palestinian prisoners took to scribbling "Auschwitz" on the walls just to antagonize the Israeli guards. The Palestinians knew how to touch the rawest nerve in their jailers' guts. On the West Bank and Gaza Strip, the mental health of the children and adults was quite precarious, given the ongoing repression, the lack of experienced workers and therapists, the risks these few workers faced to aid those who were on the brink of madness and the likelihood of thousands of neurotic cases eventually becoming chronic cases due to these factors.

Because of the frequency and intensity of such meetings, this trip was a privilege and a burden. It was a privilege because I witnessed the strength, defiance and hope of a people who had been sorely tried. It was also a burden because of my own varied identities: as a person of Western Christian upbringing and experience encountering a very different Eastern Christianity among the Palestinians who had, of course, lived centuries in the Holy Land. As a person with some Jewish ancestry, I was acutely aware of the tragedies of recent Jewish history but aware, too, that the Palestinians were now being oppressed. As a U.S. citizen, I was ashamed to realize how much of the occupation and injustice it engendered was paid for and supported by the U.S.

The value of an experience like this was that these issues could not be cerebral or distant: They became much closer to me. Having traveled and talked with Palestinians, I saw (and smelled and heard and tasted) that these issues involved the lives of people who wanted the same things out of life that Americans often take for granted: life, liberty and the pursuit of happiness. For example, hardly a day passed that spring without us reading in the newspaper of the killing of a few Palestinians. Near the end of my trip, I met with a couple, a Palestinian married to an American, and they told me that just that day, a 75-year old Palestinian woman had died as the result of being beaten over the head by an Israeli soldier. I had been to Gaza, had met gracious, steadfast Palestinian men and woman and I had seen the misery that the people face there. My reaction was now much more immediate and visceral.

But I had also felt compelled to go to Yad Vashem, the memorial to the Holocaust victims. To see the displays and photos of how the Jews of Europe were systematically exterminated was gut-wrenching. And yet the irony was, as I was told by Kathy (our hostess and travel guide), Yad Vashem was built on land that used to be a Palestinian village.

The first night I spent in East Jerusalem I was told to set my watch ahead an hour, as the unified Palestinian leadership had decided to go on "summer time" a month earlier than the Israelis. This symbolic gesture—letting the Israelis know that the Palestinians were in charge in their own independent way—had been tried in the past. I heard stories of how young Palestinian men would be asked by Israeli soldiers what time it was, and they would defiantly answer with the "Palestinian" time. The Israeli soldiers responded by striking at the wrist-watches of these men with their clubs.

"What time is it?" (and its corollary, "Whose time is it?") was a vital question, yet one ignored by U.S. citizens concerning the Middle East. Marc Ellis had challenged me to face it and attempt an answer, because, for the Palestinians, the time was running out.

Reading/2
(Dissidents/3,
Writing/2)

I arrived home from the Middle East in late March with just enough time to put the finishing touches on my master's thesis on Chomsky, whom I had the good fortune to interview at his MIT office in Cambridge. On a drizzly day, I found the famed 20-219 office with no problem. He was just as Mev had assumed and I, too, had envisioned: down to earth, helpful, inquisitive, pleasant, even though he'd probably been interviewed only 12,000 times. I had read him so much over the years that when I asked him a question, I practically knew where he was going to go—which sources he'd cite, which questions he'd raise, which emphases he'd make. Having spent a significant part of my master's program reading Jewish theologians, I wanted to bring Chomsky's critical social analysis to bear on their works and perspectives. These theologians had grappled both with the Holocaust and the State of Israel. Though expressed with different emphases and characterized by various conclusions, most Jewish religious thinkers would agree that the current theological starting points were the death camps in Europe and the liberated Wailing Wall in Jerusalem in 1967.

Elie Wiesel was perhaps the best known exponent of remembering the Holocaust as a religious duty. He had written, "[a]nyone who does not engage actively today in keeping these memories alive is an accomplice of the killers."[39] The Holocaust was, in Wiesel's view, a transhistorical, mystical experience comparable to the revelation at Sinai. Wiesel saw an indissoluble link between the catastrophe of the Holocaust and the miracle of the State of Israel: "If Auschwitz marks the end of man's hope, Jerusalem symbolizes its eternal beginning."[40]

Richard Rubenstein had been one of the first Jewish theologians to ask critical questions about the Nazi genocide. His work, *After Auschwitz: Radical Theology and Contemporary Judaism*, confronted and found wanting the traditional belief in the Lord of history, the moral integrity of the rabbinic tradition and the authority of the

Jewish organizational leadership during the severest crisis the Jews ever faced.[41] In subsequent works, Rubenstein analyzed the dimensions of modernity that paved the way for the bureaucratic, rational goal of exterminating the unwanted Jews and other peoples regarded as surplus—expendable—populations. His chilling thesis in *The Cunning of History* is that

> the Holocaust bears witness to the *advance of civilization*, I repeat, to the advance of civilization, to the point at which large scale massacre is no longer a crime and the state's sovereign powers are such that millions can be stripped of their rights and condemned to the world of the living dead.[42]

Rubenstein focused on the dark aspects of both modernization and progress that went beyond the fate of the Jewish community and revealed the precarity any people must endure if they do not have sufficient political power to defend themselves.

These and other theologians and writers saw the State of Israel as a redemptive force in the political world, perhaps flawed but morally superior to other states that had committed far greater crimes against humanity. However, what I had been learning was that a Jewish theology based on the Holocaust had difficulty seeing the history of the Middle East from the perspective of the victims of Zionism, the Palestinians.[43] This theology suffered from a myopia in that it only focused on one side of the story—the triumph of the Jewish settlers in providing a viable refuge for the Holocaust survivors and Jews around the world. The lamentable fate meted out to the Palestinians since 1948 had been tragically downplayed, ignored or even denied.

Noam Chomsky's work was a thoroughly detailed remedy to this one-sided history. He recovered the unpleasant truths and framed them in such a way as to make one ponder the meaning of inextricably linked Jewish *and* Palestinian histories. Throughout his massively documented *The Fateful Triangle*, Chomsky reported how some Israeli Jews have made the connection between the suffering they endured as a people and the suffering the Palestinians faced at the hands of the Israeli state. For example, in his analysis of the 1982 Lebanon War, Chomsky quoted the Holocaust survivor, Dr. Shlomo Shmelzman, in a press statement announcing a hunger strike to protest the Israeli invasion of Lebanon:

> In my childhood I have suffered fear, hunger and humiliation when I passed from the Warsaw ghetto, through labor camps, to Buchenwald.

Today, as a citizen of Israel, I cannot accept the systematic destruction of cities, towns and refugee camps. I cannot accept the technocratic cruelty of the bombing, destroying and killing of human beings.

I hear too many familiar sounds today, sounds which are being amplified by the war. I hear "dirty Arabs" and I remember "dirty Jews." I hear about "closed areas" and I remember ghettos and camps. I hear "two-legged beasts" and I remember "Untermenschen." I hear about tightening the siege, pounding the city into submission and I remember suffering, destruction, death, blood and murder . . . Too many things in Israel remind me of too many other things from my childhood.[44]

Shmelzman was willing to go public with this connection between the degradation of the Jews during the Nazi years to the deplorable policies toward the Palestinians in the present.

Chomsky (and other Israeli Jews he cites in his book) made it clear that the Holocaust ought not be put in a hermetically sealed sacred space, apart from contemporary history. He accentuated the link between the suffering the Jews experienced before and during the Nazi years and the suffering of the Palestinians in the recent period.

Marc Ellis contended that Jewish theology had to wrestle with the dialectic of Holocaust and empowerment in ways that moved the community toward liberation rather than enthusiastic support of the status quo.[45] Thus, rather than setting up the Holocaust as *the* unique event in the human history of suffering, Jewish theology had to recognize that history has continued since 1945 and that the lessons of the Holocaust had been and were being ignored to the torment of many other people. Also, instead of seeing Israel as a mystical manifestation of redemption, Jewish theology had to reckon with the other side of Zionist history, the oppression of the Palestinians who, in their suffering and dispossession, could inform and reform the traditional Jewish emphasis on memory so as to be both dynamic and inclusive.

My own reading was that, without reference to theological language or sources, Chomsky's engagement in contemporary affairs was recognizably prophetic—his critique of the idolatry of U.S./Israel power and ideology, his intellectual defense of the oppressed and his consequent experience of exile from the community that resisted and resented this critical perspective. Whereas the overtly religious community often thoughtlessly (or thoughtfully, as the case might be) embraced the ambitions of

the expansionist Israeli state, Chomsky carried forward the prophetic mission that had so frequently in the past been met with derision and ostracism. Of course, in El Salvador, such dissidence resulted in death squad actions against the Jesuit intellectuals; in Chomsky's case, it was a matter of being subjected to ongoing defamation.

I submitted the thesis to Marc Ellis, concerned as to how he would react to my traipsing on the ground of *his* Jewish liberation theology. He approved it with enthusiasm, even as he wondered what direction I would take with my work in the future. I had been shaped by a Catholic social justice "cloud of witnesses," even as I had my own critical issues with Roman Catholicism; I was very interested in the Jewish tradition, but in no wise interested in any kind of formal affiliation.

It was an irony of my studies at Maryknoll: While I was very sympathetic to liberation theology, the Catholic left and Third World Christianity, I was also fascinated with Jews like Chomsky, Rubenstein and Wiesel. While I felt it was important to attend to Chomsky's political-cultural critique, I knew it was also important that Christians should attend to those who critiqued Christianity for its long history of anti-Semitism. Interestingly, Chomsky had an important insight, occasionally expressed with invective, that Elie Wiesel's own maxims against silence and for solidarity needed to be applied precisely in the case of the Palestinians, who were subject to Israeli administrative detention, collective punishment, torture, dispossession, harassment and humiliation.

What a thicket: U.S. Christians not only had to express a proper repentance toward Jews for their history of anti-Semitism, we also needed to express solidarity with Christian and Muslim Palestinians, who had now come under the oppression of our former victims. And yet, this sympathy for the Palestinians in no way afforded us the option of taking swipes at "the Jews" in toto (as I heard some Third World liberation theologians do at this March conference; one repeated the old canard about Jewish domination of the media). The tangled alliances and solidarities were too much for some: Some Christians sided passionately with the Jews and Israel, sensing in the latter something akin to a divine aura. A few radical Christians were unreservedly on the side of the Palestinians. Edward Said once commented on this lack of attention to the contemporary injustice in Palestine:

> Here, then, is another complex irony: how the classic victims of
> years of anti-Semitic persecution and the Holocaust have in their
> new nation become the victimizers of another people, who have
> become, therefore, the victims of the victims. That so many Israeli

and Western intellectuals, Jewish and non-Jewish alike, have not faced this dilemma courageously and directly is, I believe, a *trahison des clercs* [treason of the intellectuals] of massive proportions, especially in that their silence, indifference, or peals of ignorance and non-involvement perpetuate the sufferings of a people who have not deserved such a long agony.[46]

Chomsky, I believed, was one of those few who had been courageous and direct in facing this dilemma. Nevertheless, I presumed Chomsky would surely state, in his matter-of-fact tone, "You want to see real courage: Look at the young leaders of the *intifada*."

Nicknames/1

Note from Mev, Spring 1990

I love you, Marko, I really do! Doobers! Sweetie! Darling! Dear! Spidini! Sp'doodle! P'doodle! Scampi! Pun-kin!Yerachmiel! M.Y. Salzman! My Salzman! Study buddy! Goobers! Lover! Yeeehaah partner! Marko! Markie! Markus! Markarina! Markarooroo!Toto! Beautiful! Silly! Christy Brown! Jaaaccck!The Lightbulb man! M.Y. Salzmaneroni! Bodhisattva! Buddha! Buddhita! Yeraschimmel! Marcola! Eschaton/Parousia! Markhus Chmielraja! Mark Muhammad Chmiel! Mark C. Puleo! [how does that feel?] Doober-doo! Winnie the Pooh! Knishka! Spumoni! Gelati! Chmieloni! Chmielrini! Salzmanorni! Doobs! Precious! Presh! Marc! Buddah-full! Beautiful! Babs! Bubba! M.J. (Mark Jeffie!) Mark Geoffrey Chaucer Chmiel!

Writing/3

In April after finishing my thesis, I took a vacation with Mev to a bed and breakfast in Maine. There we plotted, planned and brainstormed our future. She helped me dream up all the ways I could realize my potential, from earning money to gaining professional experience and pursuing my doctorate. She told me there was a possibility of finding work at MIT in the library where more than one Weston student had worked; one, in fact, soon provided an "in" for me. I would investigate doctoral programs on both coasts with Mev giving me advice about proactivity (best of all, by her own example), while she decided to wing it as a free-lancer. Of course, we would also explore our relationship and see where we wanted it to go. We decided that I would move to Cambridge so we could see how we would fare living in the same city, an occasional bone of contention, more for Mev than me over the past year and a half. Being by nature a compartmentalizer, I enjoyed the Maryknoll zone of my life and my time with Mev in Cambridge; she, however, wanted more consistency and dailiness in our dealings with each other.

In May we celebrated the accomplishment of our studies. My Maryknoll graduation ritual was quiet, unlike Mev's Cambridge festival. Her parents flew up from St. Louis; mine congratulated me long-distance on the phone. After our graduations, I moved to Cambridge, to the miraculously (for me) rent-controlled building next to Mev, where I shared a second-floor apartment with a recent Weston grad. I also began work in the MIT Dewey Library, where I met and was befriended by a young Harvard graduate, Jennifer Parker. This aspiring writer from Mississippi would take me around to the various food trucks on the MIT campus, where we splurged on falafel sandwiches and had chats on the grass about our favorite writers. At this time, I also got to know a close friend of one of Mev's neighbors, Fran: Her name was Sheri Hostetler, and I was intrigued to meet her at Fran's insistence one evening, since Fran knew of my regard for Jack Kerouac, an enthusiasm Sheri herself evidently shared. Sheri was an aspiring writer and poet who was in a committed relationship with a Braintree theology student and religion teacher named Jerome. She also worked part-time at MIT. We began to meet on Friday afternoons at the

Kendall Square Au Bon Pain cafe, doing Natalie Goldberg-style writing practices and kibbitzing over the burdens of belonging to the historic "Just War" church (Roman Catholicism) and one of the historic peace churches (the Mennonites).

One of the things that intrigued me about Sheri was that, while she was a recent graduate of the Episcopal Divinity School where she got a degree in "Feminist Liberation Theology," she evinced enthusiastic appreciation for the Beat writers, including Kerouac. To my immense pleasure, it was Sheri who, in a library sleuth at MIT, found Kerouac's suggested list of prose essentials in an old issue of the *Evergreen Review*, which she jovially shared with me one Friday amid the lunch-time frenzy at Kendall Square. We exulted in some of our favorites:

I, relieved:	Submissive to everything, open, listening
Sheri, effervescent:	Blow as deep as you want to blow
I, puzzled:	Accept loss forever
Sheri, exultant:	No fear or shame in the dignity of yr experience, language & knowledge[47]

And then we'd be off on one of our long chatter-fests, which I felt could rival Neal Cassady and Jack Kerouac's, in which we considered with manic and mindful glee and penetration the looming conflict in the Persian Gulf, Buddhism's manifold attractions, the bewitching oddities of small towns, her and my Enneagram numbers (4 and 5, respectively), shrill political correctness among WASP radicals, class warfare, the varieties of anarchism, the vagaries of the Springsteen oeuvre, our brothers and their beauties and blues and what Jesus was all about anyway.

Just because I trusted Sheri with my writer's soul and was grateful to have my own friend in Mev's Cambridge, I once got a wild idea to challenge her to cut through a writing slump: "Just write almost 50 poems by April 1st. I know you can do it. Like Jack said, 'You're a genius all the time.'" When she showed me a bound collection later that spring, I smiled as I read them over a 16-ounce cappuchino and thought: "City Lights Pocket Poet series!"

Poem/2

To Write You Must Be a Spiritual Warrior
Sheri Hostetler

I learned yesterday words like "artist" and "writer" are not
 violet and blue silk scarves but steel edges that cut
I must be a spiritual warrior who can heal self-inflicted wounds
I must be a spiritual warrior who can stave off my own self
I must be a spiritual warrior who stands tall in my own non-usefulness,
 in my armor of ordinaire
I must be a spiritual warrior (this is the hardest thing I've ever done)
I must be a spiritual warrior who is content to be flotsam
 while friends become institutionalized, recognized
I must be a spiritual warrior who feels all deeply and
 deeply detaches from all feelings
I must be a spiritual warrior who toes the line of my own truth
I must be a spiritual warrior who, with diamond cutter of mercy,
 extracts the vein of truth from the shale of lies
I must be a spiritual warrior who does not feed to the pigs the pearl
 of great price, who searches for the Holy Grail and is never
 content to find it
I must be a spiritual warrior who says, simply:
 "This is who I am, I can be no other"
I must be a spiritual warrior who sees eternity in the present,
 divine comedy in suffering, tears in the facile
I must be a spiritual warrior who forgets about my self
 and is only bloody pumping heart,
 split open like a pumpkin grown too large on the vine

The Gospel according to Maria Goreth
(Accompaniment/2,
The Human Form Divine/2)

Mev threw a surprise 30th birthday party for me with my new Cambridge acquaintances on August 22. I didn't have much time or inclination, though, to brood, or kvetch about my age, since in a week, she and I would be out of the country. I had been able to get an extended break from the MIT library to accompany Mev on this part of her journey. Mev's asking me to go with her was a reflection of her increasing comfort in our relationship and my own commitment to entering more deeply her world of traveling and staying in touch with the harder realities of life.

"So, at last, I get to meet your Brazilian soul-mate. I've heard so much about her."

"And she's heard about you, Marko. I know she can't wait to meet you. After everything I've told her, she already feels as if she knows you."

One week after my birthday, I was amazed to be walking the streets of São Paulo which made Manhattan seem like a small Midwestern town. Two years before, I had heard Mev say that she had in mind a project for a book. A year later, I was helping her recover from the harrowing experience of weakness and weariness in Brazil. Now we were together, walking the night streets, searching happily for a bite to eat.

In São Paulo, Lilia Azevedo and Father João Xerri, who were exemplars of global solidarity in Brazil, helped out Mev tremendously in getting interviews for her project, as they were connected around the country with people committed to the preferential option for the poor. After staying in São Paulo, we traveled to Marabá, where Mev had a joyous reunion with Maria Goreth. When I met her, I recalled the old saying, "There's no word for old friends who've just met," as Goreth, working through Mev's translation, greeted and welcomed me warmly. We stayed in her simple home, along with eight other people, but Mev and I were given pride of place

in the *one* bed, while others hung up hammocks in the main room and slept two or more to a hammock. When I had heard Mev speak of Goreth before, it was clear that hospitality was second nature to her. And I, too, was taken aback by the ease with which she welcomed two more people into her already crowded "hotel" and hotbed of community organizing.

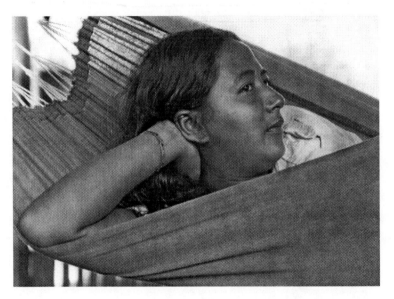

Maria Goreth Barradas; Liberdade, Marabá, Brazil; 1987
Mev Puleo

Staying at Goreth's in Liberdade was the most impressive part of the journey for me. There, I saw with utter simplicity the heart of Christian practice: Goreth and other poor women like her were models of the traditional works of mercy who combined a political savvy with an ability to help organize people. If they could live life with such pizzazz and commitment in such difficult conditions in Brazil, then we had no excuse for our inaction and half-heartedness in the land of abundance. Mev was very patient in translating for me, and Goreth and her best friend Toinha and the others in the neighborhood would intently look me in the eyes and direct questions

and listen to me. One evening, they invited the both of us to a women's group meeting, and then they asked me what I thought about their work and what was the situation of women in the United States. While Goreth touched me deeply by her availability to homeless and hungry people who would knock on her door right off the street, she showed me how straightforward Christianity was, and how demanding, too. Also, Goreth was a reminder to Mev that, regardless of the particulars of her "faith-crisis," the key issue was whether or not one cared about others. And Goreth cared. I was sure Thich Nhat Hanh would have recognized her: a Brazilian Catholic *bodhisattva*!

For those first three weeks of Mev's re-immersion in Brazil, I was there to help her along and to have my eyes opened. But even though I wasn't present for her spirited interviews with liberation theologian Leonardo Boff, Nobel Peace Prize nominee Pedro Casaldáliga or the feminist philosopher Ivone Gebara, I had been privileged to see why Mev was attracted to these people, this project and their struggle. In Goreth's simple words, in her resolute commitment to the underdogs— the *anawim* of her society and church amidst all of the daily hardships—she exuded both joy and defiance. And this was an encouragement to Mev.

The day Mev interviewed Goreth, I sat in the room of the school and listened to them talk, oblivious to the Portuguese but still mesmerized by Goreth and Mev's lyrical intonations. And this is part of what Maria Goreth—slum-dweller, community organizer, advocate for the elderly—said to Mev that one scorching day in September of 1990.

I learned to love this people! Today they're like family to me!

Now, when someone in the backlands gets sick, where there's no clinic and they don't have relatives in the city, they come to me, stay in my house, sometimes for weeks until we finally get medical help.

My house is always full, because the villagers say, "So and so is sick, send them to Marabá and tell them to find Goreth. She'll find a way to help!"

I don't only take people to the doctor, I conscientize them as we go, telling them that one day we have to change this situation, because it is a priority that all human beings have a doctor, health care and food.

When people come to me suffering, I suffer with them. I wait with them in long lines and say "This isn't right."

Every moment I am in these painful situations, I know: *I will never be silent.* I may

not see the world free before I die, but at least I can touch others who will help this happen . . . [48]

I work mostly with old people and children. They're so alike because they are the people who most need affection and care, yet they're the most looked down on.

Old people work their whole lives and have to beg to survive. In Marabá there are five or six elderly people begging on every corner. This is why I feel so much for my eighty-two year-old grandmother. I've been taking care of her for three years, though I can barely afford to buy her milk. Social Security isn't enough to survive on and it's so hard to obtain!

One day I was at the Social Security office to get some information, and I saw an old woman there signing up for benefits. The manager was so cruel to her, grabbing her arm brutally, shoving her to sit down. This shook me to the depths!

I got up and said, "Why are you doing that to her?" He said, "Who are you to talk to me that way?" I said, "I'm no one, just a human being with a heart. But since you get a salary here, you're obliged to treat people well! It doesn't cost anything to treat people with respect!" He grabbed me and threatened to call the police. I left there so hurt and angry. Yet it was his rudeness that brought me to the cause of the elderly! From then on, Toinha and I have been working to help old people get their Social Security.

These people are so poor! I want the people to organize themselves. I want to educate them to vote for a better manager, better services for retired people, clean drinking water at the office. Now, it's a scandal, a total injustice!

But when the poor elderly people try to give me a few cents, I say "I don't want this." You see, I don't do this work for pay. In my work, I never think of the future— what I'll eat or wear tomorrow. Even today, I don't have fixed employment, but people always find a way to provide. I work for the love of people who suffer, especially children.

When you work for money alone, love doesn't exist . . . [49]

Ultimately, the most important thing isn't religion, but a commitment with God and with the people, even if you don't know who God is. Today the church is turning towards liberation. For us, liberation theology is the point where a friend dies for a just cause, for an oppressed person. Their blood is like a seed among the people. It's

the leaven for a new life that will grow, a seed that will be born again. This gives us hope!

My hope is to someday see a country that's well-governed, to see all children with the right to school, health and play. I want to see every street child with a home to live in, where they can be joyful and live happily. Personally, my future is in the three children that I'm raising. All that I do is so that they will study and have a critical consciousness about right and wrong. I want my children to be someone in life. Free people with their hearts turned toward humanity. One day we will see true justice, when everyone eats from the same plate—rich, poor, Indians, whites. A new earth.[50]

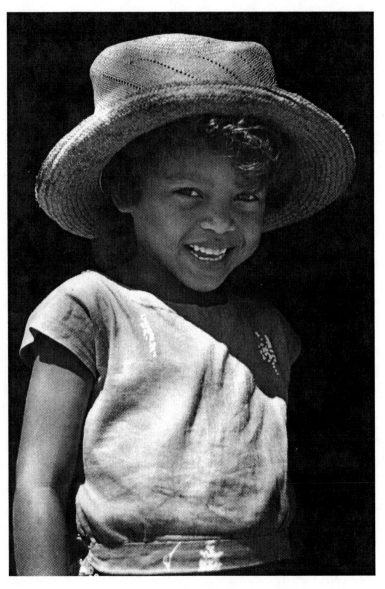

Alegria; Parà, Brazil; 1989

Mev Puleo

Love Letter/4

October 1990

Dear Mark,

How are you, Marko? WOW!! It was just 2 ½ hours ago that I got to talk to you on the phone!! I was going to call you 5 minutes before you called, but Tereza came up to talk about something, and she's leaving town soon, so I thought, *darn*—I'll call Mark tomorrow, or maybe risk prime-time to give him my number for Saturday. Buddhaful hearts think alike!!

Well, I'm sitting in the "yard" of PUC—the hot university of Rio, a bubbling (sadly polluted) stream whispering mischievously beside me, tall palm and bamboo and other exotic trees like lace strung around and above me. Mark, Rio is *beautiful*. It has the pollution, noise, crowds, traffic, poverty and crime (plus!) of São Paulo, but it is also nestled among these gorgeous lush hills, and rich with trees, flowers and even some green grass. So, I felt there are packets of fresh air amidst the big city.

Maria wasn't here for our 10 a.m. appointment—and I missed the opportunity to interview Ana—I guess I'll try both in written form, though Ana will be in NYC from the 17th to the 21st. Yes, this women's theology group is very white, Europeanish, and middle-class (I should feel right at home!). But I am touched all the same. Tereza is as gentle as Gretchen [back home]—simple, bright, kind-hearted and not condescending in any way. She is very sensitive to the needs and style of poorer people. But she is also a person who reveals herself slowly—like, the more I am around her, I think of new things to ask her in an interview. She is more like a flower that opens slowly. It has been a gift to be with her. Sylvia is a 28-year-old black woman theology student and she is a Toinhaesque dynamo! Mark, I am still "green" when it comes to issues of race, of the lived world of black persons. She commutes to Rio daily via 3 buses, lives in a neighborhood that is around 80% black—here I am at the Rio University, in a country over 50% black and can hardly see any black people except for janitorial staff!! Ana had to really struggle to get money for Sylvia to study. She is also a beautiful person, Sylvia! Good interview, but Mark I was so

tired for it! The commute, the dirt, poverty, smells of trash and urine, and on the bus home it was crowded, an old drunk man was screaming incessantly and a baby in the front started crying—I felt miserable. Was in bed by 9, weary to the bone when someone started practicing piano above me—I wept. I was so tired and desirous of *quiet*. This a.m. I did a brisk 1-hour walk up the hill by all the rich homes with security guard boxes every block because it was the only place to go to avoid pollution. I made it all the way up to the dense woods and this great view of the city—I stopped and did some prayer/dancing. And ate fruit all morning. You see, yesterday afternoon, I filled my tiredness and far-from-home hole with junk food once again. Ugh.

So, Marko, this wind is blowing and the sun shimmering and I am still so tickled and heart warmed that you called this morning! I love you dearly and look so forward to cuddling with you when I get home—less than two weeks! What good times these are in our lives, Marko. I think of Boston and Harvard Street and you running with Polly and having Pat and Jack visit you, and I think of my Cambridge friends, my computer, the comfort and resources of my apartment and I am so grateful. I wonder, too, isn't it in some way valuable that I am away for these 4 ½ weeks, so you can get buddies and familiarity in Cambridge not just through me? And, the gift for me is to be grateful for my health and the growth of the past year—to see the painting of my life and loves in the U.S. at a distance to appreciate more, understand more. I love you dearly and deeply, funly and playfully, appreciatively and "Thou"-ly, Mark. You are friend, lover, sparmate, playmate, mind tuner, jester, prophet, poet, thinker, clown. I love you and have much to learn with you and from you.

I MISS: you, my futon, frozen yogurt, VEGETABLES, salads, eating lettuce fearlessly, potable tap water, SWIMMING, Walden Pond, you, John Michael Talbot music, oatmeal, Elan frozen yogurt bars, you, the tree ½ block up Harvard Street, my bike, the peace and solitude of my apartment, and you.

Hugs,
Mev

Face to Face/3
(Community/1)

When I flew home to Boston, I was welcomed at Logan Airport by Christine, a friend of Mev's and a grad student at Harvard with Robert Coles, and Gene, who had only just returned from a summer in Africa. They wanted to hear all about Brazil, and since I was so happy to be home, I made it a point to inundate them with details. Christine was kind in checking in on me those first few days back in Cambridge; I had a few meals with her and discussed my rekindled appreciation for one of the living streams of Catholicism. I felt so grateful to have been challenged and inspired by the Brazilian Christians that I overcame my slacker Mass attendance and was accompanied by Christine at the Mass at the Jesuit Urban Center in Boston. I relished the intimate setting, and I was struck by how often the word "mercy" was used in the liturgy.

While Mev was still in Brazil, I was working at MIT, preparing for my GRE exam, and entertaining my friends from Louisville, Pat Geier and Jack Jezreel. And while I didn't see that much of the new Weston students in the Harvard Street apartments, I did hit it off with a sassy divinity student named Polly Duncan-Collum who, with her husband Danny, had lived in the radical Sojourners community in Washington, D.C. for many years. Danny intimidated me, as I found his writing so sharp and compelling, yet he was shy, so shy in these uppity, smug, SAAB-filled streets of Cambridge that I, a confirmed introvert, often felt like I was babbling when I was around him. Polly and I used to rise early in the morning and go for runs along the Charles River. As I breathed heavily during these jaunts, she peppered our conversations with exhortations to make a commitment to Mev.

"Listen, you Polack Jew boy, you better not let that Mev slip from under your fingers."

"Polly, I really like Mev. We're good for each other."

"Sure, but sooner or later, mister, you've got to take the step!"

"Whew, you sure are convinced about marriage," I said with some doubt.

"Of course, I'm convinced about it, as I am convinced of the one true holy Catholic and apostolic church. You and that honey of yours ought to get married, and soon! Someday, you'll be whistling Bruce's 'Walk Like a Man.' Marriage is unsurpassed."

Indeed, Polly was a convert. Her zeal for Bruce Springsteen and the eternal verities of Rome (and she was a radical, too—echoes of Dorothy Day) were matched by her enthusiasm for the blessed sacrament of wedlock. Mev returned home from Brazil in late October and, unlike the year before, she was exuberant and eager to work on the translations of her material, of which she had garnered some 50 hours of taped interviews. But even as we were thrilled to be reunited, Mev and I gradually faced our own struggles.

Despite Polly's enthusiastic sermons on conjugal bliss, I was relatively cool toward the whole idea of marriage. We agreed that we would see a therapist to help us sort through our interest in each other, work through our oftentimes roiling emotions and see how we could move forward. With no idea of the outcome, we started visiting Betsy in the suburb of Arlington, often twice a week, starting in late December 1990 until the following summer. We had many issues to address.

One was family. A good part of each of our twice-weekly sessions was devoted to fleshing out our family genograms, where we retrieved our histories and tried to discern familial patterns of relating. One consequence of this work was that it gave us greater compassion for our own family's difficulties as well as for our beloved's. Mev was quite skilled and percipient in helping me see better the graces and aches of my family, and I tried to reciprocate with her about hers. Of course, it was easier for me to be equanimous about Mev's struggles than about my own. The genogram helped us better understand the history we brought to the relationship; it wasn't just Mev and me in the bedroom, it was our parents, and grandparents, too! We began to see how crowded and congested it could be when we were having a misunderstanding.

Another issue we addressed was faith, and here we were gradually coming to a balance. We were fluidly Catholic and catholic, offering succor and challenge to each other. While I was grateful for Buddhist and Jewish teachers I had learned from, I was also trying to recover what Nhat Hanh called the jewels of my own tradition, including a deepening appreciation for the Jewish Jesus. Since her 1989 Brazil trip, Mev was also grateful for Nhat Hanh and engaged Buddhism as a parallel movement to the Base Community movement in Latin

American Christianity. We had different emphases, but we were coming to a mutually satisfying and supportive convergence.

We also confronted finances, a huge issue that included our class backgrounds, as I had grown up working-class and she was raised in an upper-middle-class milieu. Money, we realized, was a major source of potential conflicts over power in the relationship: who has it, who controls it, who shares it? We came to probe more deeply our different relationships with money: Mev, for all of her interest in simple living, had investments and kept track of every penny, while I had never made much money working in the church and lived more as if I did believe the sermon about the lilies of the field. And we began to see how we clashed. When we were arguing, one of the ways I knew how to give Mev her come-uppance was to snarl, "You just think you're *entitled* to everything!" which could scratch the soft spot of vulnerability inside her. One example of our back and forth on this was I had developed an interest in Martin Scorsese movies and the *Godfather* trilogy. Mev was sensitive to stereotypes about Sicilians and wondered why I so liked those movies. After seeing *Goodfellas*, she asked, "Mark, what do you feel so powerless about that you love movies like this?" My smart-aleck retort: "I suppose I am powerless about a lot of things, which is easy, given the fact that I didn't grow up in the cushy suburbs."

Next on our agenda was intimacy. Here was a world begging for communication, dialogue, understanding. We explored how much our physical expressions were both passionate and tender, like our practice of "kissering."

Finally, we often worked through issues involving friends: How did we handle each other's friendships, particularly of the opposite sex? We each had jealousy issues to confront and work through, often accompanied by tears. In addition, did I get along with her friends? Could she enjoy mine? We used to arrive at Betsy's office early and begin to process in the waiting room. We often had tense, defensive moments while inside Betsy's office, mostly about entangling alliances to third parties we were trying to unknot. For all of that, though, Betsy later told us that we were the only couple she could recall who laughed together before the sessions as well as after them.

Mev; Au Bon Pain, Harvard Square, Cambridge; 1990
Mark Chmiel

Yet, it wasn't all struggle and ache probing our familial inheritance and acknowledging our own obstinacies. The winter and spring of 1990-1991 were a rich time for Mev and me and our Cambridge community. Some new students had entered the Weston program and also the Harvard Street apartments. One was a vivacious woman, Sue Koehler, and another was a Sister of the Holy Child Jesus, Mary Clare Ryan, a former Wall Streeter who sought something better than the bottom line.

Within no time, Mev, Mary Clare and Sue had formed a trio which proved to be energizing for Mev, since she spent much of her day working on her Brazil manuscript. The threesome checked out movies, hosted dinner parties, went swimming and shared rich chocolate desserts. They also attracted a number of other students, including some Jesuit seminarians. They all decided to meet on Sunday evenings for common prayer and mutual support. I typically worked at the MIT library on Sunday evenings, so I missed these sessions, but by Mev's account, they were good for her soul in that they affirmed her on-going integration of spirituality and social justice. It was at this time that Mev and I discovered what would become our favorite movie, *Cinema Paradiso*. That winter and spring, we must have seen it at the theater four times. It got so the dialogue became part of our private language with each other. We savored

the last scene of the film during which the mature Toto watches Alfredo's preserved film clips of kissing and embrace.

In early January, Mev and I flew to Berkeley to investigate the Graduate Theological Union as a possibility for my doctoral studies. Marc Ellis urged me to contact his former student, Don Steele, who was in the GTU's program: "He will set everything up for you. You won't have a problem. Don's that way." Ellis was right. A Southern gentleman who had been active in the civil rights and the Central America solidarity movements, Don cheerfully got me appointments with a variety of students and faculty. On our first full day in the Bay Area, Mev and I went sight-seeing in San Francisco. As we walked in the North Beach area, I couldn't believe the weather, having just come from frigid Cambridge. The air was so fresh and cool, I turned to Mev as we were walking up Columbus Avenue and gushed, "If for no other reason than the weather, we have to come here!"

She shared my enthusiasm. Even though the GTU offered me the least attractive financial package (I could have asked Mev how to invest the vast sums of money Princeton offered me), I was very interested on matriculating there, and Mev was supportive of my choice. But beyond my and her vocational discernment, there was the rest of the world, notably the looming U.S. war against Iraq. While in Berkeley, Mev and I participated in a demonstration at the University's famous Sproul Plaza, and we joined thousands of others in a protest march down Telegraph Avenue. Because the crowd was so thick, I squatted down and Mev climbed onto my shoulders, from which she got a much better view of the proceedings as we marched southward on Telegraph. We flew back to Cambridge the day before the bombing began and were demonstrating at the Boston Federal Building the day the war broke out. We had joined an affinity group, and Mev, along with hundreds of others, chose to get arrested for refusing to budge at the Federal Building. I saw her loaded into one of the paddy wagons, singing with others in the group. She was held for several hours. Soon thereafter, she tried to get people at Weston involved in a response of both prayer and demonstration. A group with Professor Roger Haight began to meet weekly to vigil during the war. The Harvard Street community was also a support during this time. Having spent two months in Brazil and seen the misery there, Mev refused to sit mesmerized before the TV coverage of the "clean war," which devastated Iraq and killed tens of thousands of people.

But in addition to doing genograms and getting arrested, Mev spent most of her days working on her book, the title of which she decided upon as she was writing her introduction. It was her own way of putting her soul into the process, for she framed

the book in the context of her personal journey with faith, family, friends and me since 1989. She was struck by a passage from an interview with the grass-roots biblical scholar, the Dutch missionary Carlos Mesters. He had said to Mev,

There's a poverty in every human life.

When we're aware of our limits, we're more open to change and conversion.

If our limits are at the individual level, like alcoholism or alienation, our awareness can provoke a change so that we can grow beyond this.

Here in Brazil, our limits are very much at the social level—hunger, homelessness. We struggle to become aware and change these things. But sometimes after engaging in a long social struggle, we realize that nothing grew inside of us. Maybe in the U.S. your limits are more at the personal level. But sometimes when you are struggling individually, you realize that you have to address the social dimension to arrive at the personal dimension.

Without integration of the personal and the social, we won't be full persons.

We may start at different points, but we arrive together.

The struggle is one.[51]

"I've got the title, Marko!" Mev announced with vim.

"Do tell!"

"*The Struggle is One.* It comes right out of Mesters. It's exactly what I want this book to communicate."

"Bravo."

"It's perfect. You know, the manuscript should be done by July 1. Then we can have a big party!"

But Mev still had the work to do of fine-tuning the translations, paring down the interviews, selecting photos to accompany the text and printing it up to send to her editor. By the time it was over, Mev was weary with her transcription machine but she was ecstatic about the work, for it fulfilled her ambition to let the Christians committed to liberation speak for themselves. Of course, as translator and arranger of the texts, she was intimately involved in the whole process; it was not as if she could simply pass on the taped conversations she had to an American audience and

expect them to understand. All of her interviewees had given her permission to adapt and creatively structure the interviews, which Mev did by allowing them to speak about their own journey and conversion first. She then included topical questions in the second half of the interview. Mev was also adamant that there be photographs to go with the words, which is why she sub-titled the book, *Voices and Visions of Liberation*.

I myself read the manuscript several times, though sometimes not nearly as promptly as Mev wanted, thus generating yet another testy topic for exploration in our weekly therapy sessions. As with so much else Mev did, she brought to this project a burning intensity that sometimes singed those who did not or could not approximate her passion. And yet, there was so much in the book that warranted the attention of our friends and communities in the U.S. As I read and reread her translations, I was struck so often by the challenging voices Mev felt compelled to share with us.

Reading/3

Selections from Mev's Interviews

People were saying that it was a sin to wear make-up and short skirts, yet so many people around us were illiterate, dying without medical care, dying of hunger! No one said this was a sin!—Toinha Lima Barros[52]

The struggle is when I leave my house to go after what I need. If we don't struggle, we won't get anything—we'll remain prisoners, crushed under the heel of the powerful people. No one will come knocking on our door to give us housing, health care, education, food. Not the mayor, not the government. We have to demand our rights. We have to cry out—this is the struggle!—Maria da Silva Miguel[53]

For example, it's the women who lead celebrations and animate the CEBs [Base Christian Communities], but when it is a celebration of Mass, the bishop says women can't even read the Gospel! But it's the women who evangelize! They're the ones walking with the communities! . . . We know that in our church, women can't consecrate the bread and wine—yet it's women who bring life into this world! Women are almost always responsible for raising children! Women care for life— right? I believe this will change, starting with each woman who begins to know how to struggle, who knows that she has rights, that she's not impure, that she is responsible for life. I don't think I'm impure. I don't think I can't celebrate or share in this sacred moment.—Salome Costa[54]

We also came to learn that to be in solidarity with the poor we didn't have to give up everything or stop being who we were. I'll always be middle-class, even if I lower my salary. We're middle-class by the very way we understand society, our level of education, our access to persons and power. We can't deny our own history! But we do have to place our gifts and our work at the service of changing society. We have to use our goods to serve the grassroots struggle.—Lori Altmann[55]

For centuries, our raw materials and our labor served to enrich the U.S. and Europe. Today the time has arrived for North Americans to return, in solidarity, that which was taken from us by their governments and large companies.—Frei Betto[56]

In Brazil, it's usually the black women who stay at home, taking care of the house and children, so that white women can leave and be activists with feminist movements! So, even the feminist movements are made on the sacrifices of many other women—usually poor and black!—Silvia Regina de Lima Silva[57]

People must have in their minds and hearts, in their hands and feet this cause of life. If I studied to be a lawyer, I should place my studies at the service of this project. That doesn't mean that I have to abandon everything I own. If I give everything to the poor and there are 100 poor persons, tomorrow there will be 101—nothing changes!—Carlos Mesters[58]

I also do yoga and Tai Chi. I learned to drink tea in Japanese style, calmly, with serenity, without speaking about serious things. This is all so essential to recuperate our humanity—to liberate what is most fine, most noble, most profound, most human within us. Life isn't only struggle. It's struggle and play! Work and dance—like the Greeks and Spartans who prepared for war with ceremonies of music and dance! Five years ago we thought these things were bourgeois. Today we've rediscovered that they are good!—Clodovis Boff[59]

To deepen your solidarity you must first discover within yourselves, what are the oppressions that oppress you? Who is crying out? From there, think of a strategy for listening to the crying out and change things so that people won't need to cry out.—Leonardo Boff[60]

Yes, Raquel's birth was a purifying experience in that it empowered me to say, "this is important," and the rest becomes blurred. Her birth re-integrated things in my life. For example, when she was born I suddenly discovered that—absolutely—I would not spend another minute of my life writing academically. I broke with the academic style because I decided that life is very short, very mysterious, and I didn't have the time to waste with academics. I would only say things in the most honest

manner. If people like it, fine. If not, I can't help that. Today I couldn't write academically even if I wanted to!—Rubem Alves[61] *living with this abandon scares me*

Truly I've learned more theology in poor neighborhoods than in classrooms. At times I wonder if the questions of traditional theology have any meaning for the poor. And "the poor" here means eighty percent of the population!—Ivone Gebara[62]

When you have everything, you value nothing. I've seen people with ten brands of cheese in their refrigerators. Their biggest problem is choosing what kind of cheese they want! How many times I traveled by horseback in the backlands and arrived at the house of a peasant—and the only thing they could give me was a little cup of water! But, that cup of water is so valuable! So welcomed!—Pedro Casaldaliga[63]

Poverty and Riches/2

One of the themes of Mev's book hearkened back to her interview with Gustavo: How to live out the option for the poor. The Brazilians offered a variety of responses to this question, and one of the more provocative was the vision of Pedro Casaldalíga, a courageous bishop who, like the Salvadoran Jesuits, had long been on death lists for his defense of the poor.

~

Interview[64]

Mev: You have made a clear choice to live like the people you serve. For others, how might a non-poor person live out the option for the poor?

Pedro: Look, I myself, by the very fact of being a bishop, am not poor. Anyone who goes through a university or seminary or novitiate isn't poor, because we have more possibilities, a culture, a backing that simple poor people lack.

But I, or any relatively bourgeois intellectual or family, can and should "betray" our class and opt for the causes of the poor—the organizations, demands and movements of the poor who are trying to liberate themselves. You as a journalist can work for the International Monetary Fund, but instead you're trying to serve the Third World and the church of the poor, in solidarity.

Mev: Does this mean we must renounce our privilege or put it at the service of the poor?

Pedro: I'm not going to ask that First World families go hungry, but they can renounce certain privileges. We should simplify. For example, we get a lot of help from European groups who create a "self-tax," tithing part of their salary to help the Third World. They renounce trips, luxuries, foods. Solidarity isn't throwing a party to raise alms twice a year! The rich person shouldn't

merely giving alms, but truly have mercy and compassion on others, as Jesus himself did.

To the degree that I understand that every other person, every poor person is an equal to myself, I cannot retain my privileges because it is robbery. I cannot merely give donations, I must pay back what I owe. There's a difference.

Mev: Do you think that rich people also suffer a certain kind of poverty, from consumerism or a life of abundance?

Pedro: I'm convinced that consumerism, by definition, consumes humanity. It consumes freedom of spirit and creates insatiable appetites. If you have two, you want three; if you have three, you want four! We end up being well-fed, but empty within.

Also, consumerism kills cultural identities, creating uniformity. You can get the same the same cereals, shoes and music in the whole world! We're losing the ethnic and cultural richness of individual cultures. We end up becoming a uniformized humanity, which is the opposite of a unified humanity.

We're even endangering the health of our organisms and the health of our universe! But I believe that no one, by nature, kills him or herself. Humanity as humanity doesn't commit suicide. So I believe that humanity will begin to open its eyes, and return to a naturalness and a certain sobriety.

We need a civilization of love and sharing, a certain sobriety that will be a model for our children. Nature teaches us this. You see children of rich people who have lots of expensive, new toys in their house, and yet they get a stick, some twine and a tin can and make a horse! And all the toys that daddy bought just sit there!

I think that sobriety makes us truly free and happy.

Mev: So we also need liberation from our excesses?

Pedro: We need re-education for a certain sobriety and spiritual harmony, to respect our bodies, respect nature, respect others. Look how easily people kill or commit suicide. How easily people divorce. How easily people abort. How easily people sell arms. Arms factories are the most lucrative business in the world today!

I believe the poor person can offer the rich a certain liberation, because there's a liberty of spirit which poverty facilitates—the capacity to share, basic values, enthusiasm. When U.S. citizens or Europeans come to the Third World, they feel a certain liberty, sharing and simplicity here—a

spontaneous joy that they don't usually feel. Maybe you all have "everything" but are still lacking a certain "something."

The poor person should constantly be a sacrament for the rich person. God enters all sacraments, but the most universal sacrament God chooses is the poor. Even the person without Christian faith will be saved to the degree that he or she welcomes the sacrament of the poor person, their sister or brother in need.

Mev: For years you have been taking "solidarity trips" to Central America. What kind of solidarity would you like from First World peoples?

Pedro: Remember that I'm also from the First World!

First, people should open their eyes to see structural sin, which is the very existence of a First and Third World. As long as there's a First World, there won't be peace because there won't be justice or sharing. We should do away with both First and Third Worlds! We have created this situation, so we can also do away with it.

Secondly, since official organizations, like governments, the World Bank and multinational corporations, have no interest in changing this situation, we need non-official organizations in the First World—ecclesial communities, youth groups, intellectuals—with a sense of solidarity and social consciousness to break with this system of oppression. There are so many ways—interchanges, financial help, civil disobedience at arms factories.

Face to Face/4

That spring I fretted frequently about getting into doctoral programs. If Mev had been in my position, she would have just assumed that, not only would she be accepted into all the programs she applied for, she would also receive full scholarships. I, however, did not exude such confidence, and she often bolstered my flagging spirits. By March, I heard from several doctoral programs, and with each acceptance letter I received in the mail, Mev insisted, "We have to celebrate!" One morning, after I received word of a very generous offer from Princeton Seminary, Mev drove us to Nantasket, where we ate fresh seafood and walked along the beach on a gorgeous April day.

We took several sessions in therapy to work through balancing our respective vocational paths. She was interested in moving someplace that had opportunities for her work, as well as a good doctoral program and financial aid for me. When I first told her of my application to Union Theological in New York, she frowned. "Marko, I'm going to tell you up front, there's *no way* I am going to live in New York." She exercised the most severe suspicion about New York: the cost, the crime, the pace, the ugliness. And she wasn't that fond of Princeton either: "What can I do there? It's so small." She wanted something in-between New York and Princeton, and it became clear to both of us that Berkeley was the answer: There was plenty of activism, lots of schools where she could take some photography classes. Plus we already had a few friends living out there, such as our instant best friend Don Steele.

Breaking with the traditional proposal by the male, Mev and I decided that we would ask each other. And so we went to Service Merchandise and bought two engagement rings of white gold for $50, which would later serve us as wedding bands. We made cassette tapes with songs that echoed our declarations of commitment, and on July 1 we placed the rings on each other's finger in her fourth floor apartment. It was amazing to me then: I had decided on getting a PhD. Mev and I had been willing to go into therapy. We had committed to remain creative, constructive and critical Catholics. We had chosen to love each other in spite of all

our faults. We had resolved to go to Berkeley for the two of us. And we were going to be married the following June in St. Louis.

Through Don and Cynthia Steele, Mev was able to secure a place for us at the Berkeley Presbyterian Mission Homes, for missionaries returning from abroad who were in transition. She promoted her Brazil experience to get us to qualify ("And Mark also went to Israel/Palestine!") for the housing which—another miracle—turned out to be a two-story cottage for a measly $395 a month.

A few days after we became engaged, Mev finished her Brazil project and put it in the mail. She was so ecstatic to have finished her manuscript and to have her sister Laura in town visiting us that, while we ate a celebratory dinner at a Brazilian restaurant, she drank so quickly that she got buzzed for one of the few times in her life.

There were several farewell parties and lots of tears of joy and sorrow at departing. Our Harvard Street community helped us load our worldly possessions (mostly books and framed photographs) into a U-Haul one day in mid-July 1991.

Letting Go/1

Mev's Journal, 8 June 8 1991

First of my reflections on the celebration, grieving, leaving, commencing from the big "C," Cambridge. So, tonight as my lover is long out of town, I do one of my favorite things to do on a night alone (second to it is a ten o'clock movie at Harvard Square), that is, walking around the Square lingering at every band—the hammer dulcimer that sounds like misty Ireland and medieval elves and faint memories of pleasant dreams; the Ecuadorian dark-skinned elves blowing on pan pipes like the music from *Under Fire* but with passion and urgency and I hear in their mumbles and screams and rhythmic enchantment the declaration of revolution against all of us white uncle and aunt Sams; the rock group playing Beatles, though I lose interest with "Hotel California" and really lose it with the Bee Gee's "Staying Alive"—didn't know people still sang that in public, but, geez, this group knows how to rock, and the smokers and beer drinkers and guys with sweaty tattoos and gals with long blond hair hang out here and it reminds me of something of my past that is pleasant, the edge I played around in grade school, smoking by the creek; and the juggler on the tightrope loses me quickly, but it's good family entertainment and I admire the skill. So I wander into Wordsworth and buy Laura the perfect card—a black and white photo of 50s guys under the hood of the broken car while the 50s girls sit in the car gabbing, giggling, watching, admiring—so much for the 90s! And I buy an Italian almond cookie at the Italian pastry/coffee joint that's open till 2 a.m.

And then I stumble on the group, playing right there in the Harvard Cooperative Society alcove. The Christians. Nearby, a "Jew for Jesus" is handing out tracts. And they pull out their drums, electric guitars, tambourine, etc. And there's this young woman who reminds me of me—black hair, bangs and a shoulder bob, and a clean-cut high-necked fancy t-shirt, and she is just beaming—and it's me. That's me in high school. Me when I hung out with Sarah and Shelly and Barb. Christian Life Conference. Teens Encounter Christ. Retreats and praying in tongues and going to prayer meetings and reunions and youth conferences. That's me. And she is so happy. And I ask myself

what I am doing with my life. Looking at white gold rings with Mark. And who is this Mark? And who am I? And who was I? And they sing things like, "He is the light," "praise the Lord," and songs about the Holy Spirit and trusting in the Lord. And that was me. It is me. I am dead. Who am I? And I am mesmerized and see them really jamming—good music—good electric, GREAT drums. Better than the syrupy sappy Christian music I once listened to. And they are all really into it. And I can see myself. And Sarah. And Sarah's still there with her Sunday School meetings and Prayer Couples meetings and all. And where am I?

Did it really fall apart at Liberdade?

Or did it begin back in high school when Sister Karen told us about the murder of Archbishop Romero, then the four church women? When I wondered, why would they assassinate a bishop? And why would our country support this government?

Did it begin then?

Was it Catholic Worker? Stu Gilman? And Mark prayed the Jesus prayer today, the prayer of the Russian pilgrim. And I beg for the gift of forgiveness and mercy. And what does all of it mean?

I look at this young woman and I miss that bright smile I once wore almost all of the time. I miss the ease. I miss the simplicity. The camaraderie. Can I reach back for it? Or is it gone? Gone where?

And as the people hand out tracts, I want to ask one, "What do you think of the Gulf War?" But no one approaches me. So I listen. Groove to the music. Think of writing in my journal when I get home. And walking home near a woman singing the blues by Au Bon Pain—God, how she can sing the blues! That's religious. And the hammer dulcimer is weaving enchantments. And that, too, is holy. And the Christian music fades, too crafted.

But, still, these reflections are enough to make me stop in my lover's house to pick up "Slow Train Coming"—and what does it mean when even Dylan sings that Jesus died for me? "Wake Up" I can hear. Wake up. Wake up, Mev.

And all these reflections, musings, meanderings, feelings, melancholy make me think, feel and desire to be a better person.

Life is short, so short. I taste my pettiness, my cockiness, my peacockiness, my vanity, my mimetic desire, my control compulsion, my grudges, resentment, my manipulation, my playing to the crowds even without knowing it. And they are dust in my mouth. There is finer drink, living water. And I don't know if it's the easy Christianity, the smiling young Mev sings in front of the Coop, but it *is* that, and more—it's also the lady singing the blues, and the vets drinking beer jamming to the

rockers, and it's the grace of the tightrope juggler, and it's the gift of the 5,000 year old Persian hammer dulcimer, and it's the Iraqi orphan and widow, and it's the choice to commit my life in communion with Mark—this is all living water. It is bitter and it is sweet. It has suffered and it has triumphed. Life is so complex. Sing it, Bob: "How long can you falsify and deny what you need . . ."

I love Cambridge. I have sung and smiled and bled.

I met Mark on the East Coast. I got two book offers from publishers. And I asserted my own ego over and over again. I've had girl-buddies—Marcia, Fran, Megz, Sue, and Mary Clare. I grieved the death of Domingos Barbé walking along the Charles. I heard of the death of Mary Mullen, Ace Cain, Ann from Cambridge Camera. I met wonderful profs at Weston. And bumped heads with Weston officialdom. And took classes at Haaaaaaavaaaad. And bought a futon! And ate ice cream and had my first cappuccino. And swam, swam, swam at Harvard, at MAC, at Blogett and at beloved, Christine-scented Walden Pond. And I walked hand in hand with Mark to bookstores and cafes and parks and events and kissed him so heart-touchingly from the steps on Harvard Street.

Anti-war protest; San Francisco; January, 1991
Mev Puleo

I wept time and again. And at the lay commissioning.

I felt rage—especially with the Gulf war/massacre.

I felt ambiguity about men.

I met the skewed face of feminism. And the truth of it, too.

I met and loved homosexuals and homosexuality.

I drank Scorpion Bowls and got drunk with Mark and Laura.

Mark and I ate ethnic, frequented the North End, laughed our heads off and licked our heads into ecstasy mornings and nighttimes. We had "brigas" and reconciliations. We worked our buns and hearts and emotions out at therapy and reaped their sweet, deep, eye-moistening benefits.

So much. This is just the beginning. More to come.

Remembering The Dead/3

We spent the fall of 1991 getting acclimated to Berkeley, the Graduate Theological Union and new friends, such as Bob and Lynn Lassalle-Klein, community members of the Oakland Catholic Worker, a house of hospitality for Latin American refugees. I launched into my studies while Mev began to seek out photography opportunities: It was serendipitous that within a three-minute walk of our cottage was The Looking-Glass, an impressive and quirky photo store whose proprietor, Peter Pfersick, also taught photography courses in the Bay Area. Mev transformed one of the extra bedrooms in the cottage into a workable darkroom: "I'll save money not having to rent time at the Looking-Glass!" As we had in Cambridge, we quickly found our favorite haunts, from Moe's and Cody's Bookstores to the Coffee Connection cafe on Euclid, just north of the UC Berkeley campus.

Although we were happy settling into Northern California life, Mev was concerned to be away from St. Louis, as her grandmother, Rosa Puleo, had been getting increasingly weak. She had to leave her North St. Louis home of 40 years and move to St. John's Mercy Nursing Home, close to Mev's parents. That Christmas, we visited her, and Mev and I were both saddened at how abandoned some people seemed to be there. Rosa had not ever been the most gregarious person with me, which Mev cautioned me not to take personally. She was not the easiest person to get along with, Mev said with a smile, aware that she was making one of the great understatements of the twentieth century. But Rosa loved her four grandchildren with amazing gentleness. She lived at the nursing home less than six months before she died at the age of 95. Mev's family was in need of someone who could speak publicly at the funeral, and Mev was all too eager to respond. She had many warm memories of taking her Nana grocery shopping and observing with delight how she always tried to get the produce men to give her free apples, bananas and lettuce. Seeing that her granny didn't have many years left, Mev had also learned Italian with the hopes that she would be able to speak to Nana in Italian (her immigrant's English was not so good) before she died. Once in California, Mev began taking lessons from a native of Naples as well as classes through UC Berkley Extension. She did speak in

Italian with her Nana on the telephone that fall. And before the assembled Sicilians, family and friends at the funeral in January 1992, Mev spoke fondly and frankly about Rosa Puleo.

༄

The word I have most frequently heard used to describe our grandmother, Rosa Puleo, is stubborn. Nana was wonderful, but she was not perfect. Like many of us, she was sometimes more friendly to strangers than to family members—especially babies! In spite of her prejudices, she had a homing device leading her to babies—at ball games, in grocery stores, walking downtown streets—she would walk up and cuddle babies of any race or color. Of course, Nana as I knew her was built like a fluffy feather pillow, so the babies always cooed with delight!

Yes, Rose was a stubborn woman, stubborn in opinions and judgments, but also a woman of stubborn love—a love she did not always know how to express. In fact, she expressed her love in advice and warnings—shaking her finger, she would say, "You kids today wouldn't know how to survive a depression!" Or, my favorite as a boy-crazy teenager was "Men are fire!" Nothing else!

I believe it was stubborn love that led her to discipline her son and daughter, Pete and Mary, trying to teach them right from wrong, which sometimes was more "the old way" than the new way.

Yes, Nana was stubborn in holding grudges, but stubborn in her loyalty and fidelity; for example, she poured out her dedicated love in this lace tablecloth. Since we were children, almost every time we saw our Nana, she was crocheting these tiny lace circles—circle after circle. We grew up believing, "That's what Nanas must do— Crochet endless, meaningless but pretty snowflakes!" Only later was I told that she was making four large lace tablecloths with matching placements for her four grandchildren.

This is the beautiful face of Rose Puleo—her stubborn love, her dedication and devotion.

Rosa Puleo; Saint Louis, Missouri; 1983
Mev Puleo

You see, sometimes Nana expressed herself in ways that were offensive or painful to others—but as a whole, her life was made up of little acts of kindness, like tiny stitches of crocheting, that perhaps make more sense after her death, when we piece these little acts of kindness together:

— Whether it was cooking all those delicious Sunday dinners or delivering homemade pasta to the Visitation nuns;
— Whether it was her garden's gift of tomatoes and roses;
— Whether it was the dollar bill and blueberry yogurt she "tipped" me for driving her to Schnucks or the small chocolate eggs she slipped into our pockets as children;
— Whether the way she held babies or that piece of helpful advice or unwanted or inaccurate advice.

These are the little acts of kindness, each one like a single stitch, a single snowflake of lace, that perhaps we can only interpret rightly and fully appreciate, in their wholeness and beauty, after her death. May our lives today be blessed by such acts of kindness for and towards one another.

In closing, I saw Nana two days before she died. Her hand was too weak to clutch her rosary, so they put it around her neck. She strained for breath, but I sensed she was less depressed and sad, she was letting go, saying good-bye.

Leaving her, I thought about visiting Ron, Laura's husband, before his death, I thought of working at Mother Teresa's home for the dying people her Sisters found in the streets of Port-au-Prince, Haiti. For all the differences in culture and status—we humans are so alike when we die! All the money, medicine and technology in the world cannot save us from the fear, the sadness and the loneliness. Whether in St. John's [in St. Louis County] or Haiti's slums, all that dying people seem to want is a drink of water, someone to hold their hand, massage their skin, speak lovingly, reassure them, sing songs—as our whole family did on Christmas Eve. These are the little acts of kindness, for which we call Mother Teresa a saint—we are *all* called to be this kind of saint.

And, as pained as we are to see people we love so weak and diminished, these dying people are Angels to us, messengers, Angels of God's grace. They remind us to start weaving our own tapestry of kindness. You see, Nana was not just at death's door, but at heaven's gate. And I believe that in those weeks when she couldn't talk,

as she waited for her body to give way to God's peace, she, with God's help, made peace with herself and with the people in her life.

And so, she is an Angel of God reminding us: Make your peace with others now, don't wait! Make your life a tapestry! Weave acts of goodness and kindness among those near to you and, as Mother Teresa (herself now ill) reminds us, reach out in kindness to the abandoned, the poor.

Above all, Rosa, this Angel of God, reminds us that God's love is also stubborn, faithful, devoted.

Through God's Angels, such as Rose Puleo, God invites us to trust that God will weave each of our lives, will weave our heroic deeds and our tiny snowflakes of goodness, our failures and weaknesses, God will weaves our lives into something beautiful beyond our imagination.

అ

Mev often had spirited arguments with her father about poverty in Latin America, the social mission of the Catholic Church and the role of the U.S. government in the Third World. And yet they disagreed with each other for the most part with great affection; indeed, I think Mr. Puleo saw Mev as a chip off the old block, even if her views were very different from his, for she, too, had something of his entrepreneurial spirit in her. Anyway, after he heard Mev deliver the above address about his mother, Mr. Puleo said, "You know I've been against women priests, but then, Mev gave a great homily. She makes me think twice."

Giuseppe Puleo and granddaughter Mev; Saint Louis, Missouri; 1969
Peter Puleo

Meanwhile, Elsewhere in The World . . . /3

Testimony by U.S. journalist Allan Nairn, before the U.S. Senate, 1992

On Nov. 12, 1991, while in East Timor on assignment for the *New Yorker* magazine, I witnessed and survived the massacre at the Santa Cruz cemetery.

When I returned to East Timor in October of this past year, the air of terror was more intense [than during my previous visits] and the repression was greater still. The Indonesian army was sweeping through villages and towns rounding up Timorese who, the army suspected, might be preparing to talk to a UN-sponsored delegation that was due to arrive from the parliament of Portugal. The Indonesians were holding hundreds of meetings across the country, warning that those who spoke to the delegation would be killed. Bishop Belo told me that the army was saying that it would find the families of Timorese who tried to speak or demonstrate and hunt them down and kill them "to the seventh generation." The bishop said he thought that the army's threats were credible and that if the Timorese did try to speak out in public, the army would respond with massacres as soon as the delegation left.

As it happened, the delegation never arrived in East Timor, but the army staged a massacre anyway. Within days after the postponement of the visit was announced, the army stormed the seaside church of San Antonio de Motael. I arrived in Dili a few hours after the attack, and later spoke with numerous eyewitnesses. During the attack, the soldiers seized a young man named Sebastião Gomes. They executed him at point-blank range with a pistol shot to the gut. Gomes was one of a number of young men who had sought sanctuary in the church. He had been hunted by the army during the pre-delegation sweeps. Gomes' funeral attracted a crowd of more than a thousand people. The Timorese were clearly shaken by this attack on their flagship church.

The two-week commemoration of Gomes' death [culminated] on Nov. 12.

[The day] began with the traditional morning Mass at the Motael and continued with a procession to lay flowers on Gomes's grave.

It should be noted that the Catholic Church is the only Timorese institution. All others have been obliterated on orders of the army high command. There are no Timorese unions or press, peasant leagues, political parties or student groups. Their leaders have been executed and their existence banned. Timorese have been jailed and tortured for reading newspapers from overseas or attempting to listen on shortwave to Radio Australia or the BBC. Social organization can only take place under the army's control. Public speech and assembly are prohibited by army fiat. This means that the civic life of the East Timorese must be conducted underground.

Gomes' funeral was a breakthrough event because people turned out and dared to speak. Some held up their hands in the sign of the "V" and shouted "Viva East Timor." The commemorative procession on November 12 was even larger and more outspoken. As the Mass broke up, people assembled on the street. The army intelligence chief drove by. Along the route of the march there were soldiers and police, who carefully eyed the passing Timorese. This time a number of people were carrying hand-lettered banners supporting the church and the cause of Timorese independence. The banners said things like "Indonesia, Why You Shoot Our Church?" One was a plea addressed to "President Busch." There were young men, young women, children in Catholic school uniforms, and old people in traditional Timorese dress.

As the procession wound through Dili, many other people joined; they came from schools and offices and huts along the road. Sometimes young boys would break into a jog and older men would rein them in shouting "Disciplina! Disciplina!" People were chanting and giving the "V" sign and talking among themselves. By the time [the procession] reached the cemetery, the crowd had grown quite large. There were perhaps 3,000 to 5,000 people. Some filed in toward Sebastião's grave, and many others remained outside, hemmed in on the street by cemetery walls. People were, at that point, standing around, talking excitedly among themselves, when, suddenly, someone noticed that one of the exit routes had been sealed off by an Indonesian troop truck.

Then, looking to our right we saw, coming down the road, a long, slowly marching column of uniformed troops. They were dressed in dark brown, moving in disciplined formation, and they held M-16s before them as they marched. As the column kept advancing, seemingly without end, people gasped and began to shuffle back. I went with Amy Goodman of WBAI/Pacifica radio and stood on the corner between the soldiers and the Timorese. We thought that if the Indonesian forces saw that foreigners were there, they would hold back and not attack the crowd.

But as we stood there, watching as the soldiers marched into our face, the inconceivable began to happen. The soldiers rounded the corner, never breaking stride, raised their rifles and fired in unison into the crowd. Timorese were backpedaling, gasping, trying to flee, but in seconds they were cut down by the hail of fire. People fell, stunned and shivering, bleeding in the road, and the Indonesian soldiers kept on shooting. I saw the soldiers aiming and shooting people in the back, leaping bodies to hunt down those who were still standing. They executed schoolgirls, young men, old Timorese; the street was wet with blood, and the bodies were everywhere.

As the soldiers were doing this, they were beating me and Amy [Goodman]; they took our cameras and our tape recorders and grabbed Amy by the hair and punched and kicked her in the face and in the stomach. When I put my body over her, they focused on my head. They fractured my skull with the butts of their M-16s.

The soldiers put us on the pavement and trained their rifles at our heads. They were shouting, "Politik! Politik!" We were shouting back, "America! America!," and I think that may have been the thing that saved us. They had taken my passport earlier but Amy showed them hers, and the soldiers seemed impressed when they realized that we were indeed from the States. We were, after all, citizens of the country that supplied them with M-16s. For whatever reason, the soldiers chose to let us live. We hopped a passing truck and got away. The soldiers were still firing as we left the scene, some five to ten minutes after the massacre began.

This was, purely and simply, a deliberate mass murder, a massacre of unarmed, defenseless people. There was no provocation, no stones were thrown, the crowd was quiet and shrinking back as the shooting began. There was no confrontation, no hothead who got out of hand. This was not an ambiguous situation that somehow spiraled out of control. The soldiers simply marched up in a disciplined, controlled way and began to fire massively on the crowd.

It was quite evident from the way the soldiers behaved that they had marched up with orders to commit a massacre. They never issued a warning; they did not even pause or break their stride. They marched up and opened fire in unison. This action was not the result of their interaction with the crowd: The Timorese were just standing there or trying to get away. The soldiers opened fire as soon as their column turned the corner and got within a dozen yards of the Timorese.

After the Timorese had been gunned down, the army sealed off the area. They turned away religious people who came to administer first aid. They let the Timorese bleed to death on the road.[65]

Face to Face/5

In that first year of living in Berkeley, Mev was startled to get a letter from her publisher about *The Struggle is One* manuscript. The editorial board wasn't happy with the format she had decided upon. In their discussions, they preferred that Mev change her structure of the book to be more of a first-person narrative, like a *New Yorker* story, where she would weave together her travels and meetings. They also intimated that Latin American liberation theology wasn't selling so well, and they didn't think they could produce the book as it was constituted.

Mev stood her ground: "I can't change it, Marko. I don't want to muffle Goreth's voice. That's the reason I did this project in this way—I wanted to let those people speak for themselves, I wanted people in the U.S. to read and hear from the people themselves. That's why I began the book with those at the grass-roots, not the famous people like Dom Pedro or Boff. Besides, I am not the kind of writer who wants to write like the *New Yorker*."

When it came to Latin America and liberation theology, Mev was strongly committed. She had already invested so much work on the book: the travel, the translation, the editing, the final touches. And now, she was without a publisher. But she didn't worry for long and simply pity herself. She took the manuscript to Copymat, had several copies made and started sending it off to other publishers.

But publishers were far from our minds one warm summer morning in St. Louis, when our friends from Cambridge, Susan and Kevin, were staying at the Puleo's home with us. As we sat on the back patio, eating blueberries and bagels for breakfast, Sue exclaimed, "I can't believe you two are just sitting here with us!"

Mev responded with a smile, "What do you mean, Sue? It's breakfast time."

She asked in astonished excitement: "Mev, Mark, it's your wedding day! How can you be so calm?"

And so we were. Almost four years in the making, twice-a-week therapy for awhile, starts, stops, fits, doubts and delights, and on that June day we would celebrate this mystery that had been unfolding since an innocent ice cream exchange at Maryknoll. One of the reasons we were calm, besides just being happy, was that

we had agreed to attend to the liturgy, while Mev's parents would throw us a party in the style to which they and their friends were accustomed. Of course, we may have felt calm on the morning of our wedding, but, by then, the two big tests had already been met: the dinner hosted by my parents from Louisville, and then the rehearsal dinner the evening before. Mev and I were relieved all that was over, and we could concentrate on the liturgy, which we had planned and in which we had involved our friends, near and far. Several people were so gracious as to fly in for the occasion, at no small expense.

Among many blessings that day was the presence of John Kavanaugh, who celebrated the liturgy with us at St. Francis Xavier Church, home church of St. Louis University, where Mev had been an undergraduate. Also, as our witnesses at the wedding, Teka Childress and Jack Jezreel graced us with their characteristic aplomb and cheerfulness. Our gift to them at the previous evening's dinner were bells of mindfulness, which had held Mev and me in good stead since her troubled return from Brazil in 1989.

And what a beauty Mev was in her wedding dress. Once, at the grocery store check-out, I had bought for her, as a joke, one of the monthly bride magazines, the pages thick with endless detail and fashion nuance. I was so pleased to have accompanied Mev in Claremont, just north of Berkeley, at a second-hand shop to buy her wedding dress. Used. This was so Mev—she was not going to be out-fitted in a dress she'd wear once for a thousand or more dollars. The one she picked went down to her calves and was simple and becoming. And at a frugal $98.

Through her parent's generosity, Mev and I took a month-long honeymoon in Italy. We spent our first week in Rome before heading to Sicily to visit Mev's cousins. While in Rome, we stayed with a smiling and passionate laywoman, Margaret Mary Moore, who lived not too far from Villa Borghese. One morning after we had taken a walk through the park, we stopped at one of the hundreds of bakeries. As we sat there and sipped our coffees and nibbled on our pastries, Mev posed the question I could tell she'd been itching to ask someone in the know: "Margaret Mary, what about the Mafia?"

She then filled us in on Giovanni Falcone, who had been one of the fearless prosecutors of the Mafia and who'd just been assassinated that spring in Palermo. He had been having more successes with prosecutions and was getting so close to nailing the Mafia that they had his car and his bodyguards' cars blown up on the way to the Palermo airport. His wife and bodyguards all perished in the attack. I sensed some extraordinary agitation in Mev.

Later, we were greeted in Sicily by about 30 of Mev's cousins at the airport, who all came out to see the American cousin on her honeymoon. The older aunts were very curious, asking her in Italian if I was Italian. "No," Mev told them, "he isn't." "Is he Italian-American even?" "No," she grinned back. I told Mev, "Tell them I'm American-American." They smiled back, masking politely, I guess, their disappointment.

While in Sicily, Mev wanted to look up an old classmate of hers from Weston in Cambridge. Nancy was Sicilian on both sides of her family, and after getting her master's degree she and her husband decided to move "back" to Sicily. She was fluent in the language and really wanted to make her home there, even though her immediate family was still in the U.S. When we visited them at their rented house, we had another long talk about the Mafia. They were in the middle of Sicily, and they could feel the nerves of shopkeepers, grocers, their neighbors, the pervasive fear, and the corruption that seemed to spread like a miasma.

One day while driving back from Palermo, one of Mev's cousins pointed out the place along the highway where Falcone had been murdered. We got out to inspect the bouquets of flowers and stand a moment in silence, both of us moved at the outpouring of respect his death had occasioned. Falcone had taken a stand and had paid for it with his life. We were in Assisi later in July when we heard the news that a second anti-Mafia investigator had been blown up in Rome. We had spent the day at Francis's place, and had sat in quiet meditation like other pilgrims. As we walked around the town plazas that night, we processed over and over this latest outbreak of Mafia brutality.

Later when we were alone, far from her excited and solicitous cousins, Mev beckoned me from my reading of Antonio Gramsci's *Prison Notebooks*, which I had brought with me (on my honeymoon! Mev married me fully aware of my reading eccentricities and obsessions): "Marko, I've got a great idea."

"What, you mean to say you've been *working and scheming* on our honeymoon? Tell me, my bride and enchantress."

"It just seized me. I want my next project to be about the Mafia."

"You can't be serious."

"OK. I'm still trying to get *The Struggle is One* a publisher. I'm going to keep at it, with your encouragement. After talking with Margaret Mary, Nancy, and seeing where Falcone was murdered, I want to do interviews with church people who have been resisting the Mafia. Of course, I am really going to have to improve my Italian. But just think how exciting—Sicily and Italy are battling something similar to what the Brazilian church is struggling against. It's just a different form, but it's oppression

all the same. Just like *The Struggle is One* shows how the base communities resist the injustice of the landowners and the military, this book can explore how priests, nuns and lay people aren't silent before this intimidation and violence. What do you think?"

My new wife had never lacked what my mother called "get-up-and-go," yet I was still a little taken aback. "Lemme see. You want to interview priests, nuns and lay folks who speak out against the Mafia. So you'd interview the Sicilian and Italian Catholic dissidents, the ones that speak out again the mob?"

"Yes!"

"Here, in Sicily?"

"Yeah, would you come back with me?"

"I'd have to . . . I'd love to!"

I could see the exhilaration on her face as she was starting to shift into the fifth gear of practicality. "See, this is perfect. Once you finish your exams, we can come here, say, for six months, and while I am doing my research and interviews, you can write your dissertation. We'll get you a laptop, and I can improve my Italian. We could travel around on weekends. Wouldn't Sicily be a great place to live and write?"

She had it all figured out. This was the logical step in her personal and professional journey. As a Sicilian-American, as a Catholic, as a journalist. It sounded perfect.

Then I asked her: "Are we crazy contemplating this?"

She smiled her answer.

I quickly became enamored of Mev's vision. Yes, I could see staying outside of Cinisi, in a simple place, with my books and laptop near me, and maybe even learn a little Italian myself. I could see her pulling this off as she already had several church-related contacts in Italy, including, among others, an American Jesuit named Bob O'Toole, who was teaching at the Gregorian Institute in Rome and whom we shortly ran into—totally out of the blue—one Sunday afternoon in Villa Borghese.

I had met Fr. O'Toole early in Mev's and my relationship when I went to visit her old friends at St. Louis University. That afternoon in Rome as we were enjoying a stroll, I spied a familiar face. "Mev, do you see that gentleman in the hat? Could that possibly be Bob O'Toole?"

"Marko, you're right. It is!" And she bounded over to him with greetings and the enthused news that, yes, we had gotten married and were there on our honeymoon. "Fancy meeting you here."

Bob was a classic Jesuit gentleman-scholar, and he and Mev spent several minutes in unabashed nostalgia about the old days at the University. He had evidently

enjoyed having Mev in his Scripture class, but, happy to take a little poke at her, he confided in me, "Yes, back then in my class, she's was a veritable *tank*!"

Now, I had conjured many images of Mev and had heard others offer their own, usually admiring, appraisals, but the military tank image never occurred to me.

"I'm sorry, Bob," I said, "but why was she a tank?"

"I'd be speaking, and she'd raise one question. And five minutes later, another question. It would go on and on. She kept on rolling, she didn't stop."

"Well, guess what? Now, she wants to do a book on the church resistance to the Mafia. The tank rolls on!" Mev chuckled, embarrassed at how she had been so accurately characterized and named. "Really, Bob, it was a great class, you just kept me interested, that's all."

Bob left to continue his Sunday stroll, but not before adding with a wink, "I wish you the best, Mark. She *was* a tank. You have all my prayers."

And, after that night in bed, I gained a deeper appreciation of Bob's joking epithet. It's just that Mev was a tank with goosebumps.

Bearing Witness/I

Driving down from Florence back to Rome, Mev and I had one of our innumerable discussions about the future. Now that we were married, and I was in school, and she was getting better at her photography, we considered our options. We both agreed to join a local chapter of Pax Christi, an international Catholic peace movement. One of the great advantages of joining the Oakland group, besides already knowing several people, was that our increasingly dear friend, Steve Kelly, was a part of that community of peaceniks. Ever since I met Steve at the Livermore Labs on Good Friday in 1992, we were able to converse with a refreshing ease. Steve had a penchant, whenever homeless people came up to us as we were strolling on Columbus Avenue in San Francisco, to stop and say, "I can't give you money, but I am more than happy to buy you something to eat. Where do you want to go?" Steve was like Maria Goreth: availability was his middle name. One friend of ours observed that Mev and I seemed especially fond of Steve. In fact, she seemed taken aback. "Why is that such a surprise? Do you have some issues with Steve?"

"Let me say this about Steve Kelly. His heart is immense, but space and time are not his strong points."

She was right—Steve was typically late, which didn't endear him to fellow activists and Jesuits when he'd show up hours later. His smiling retort: "Hey, I'm trying to be a 'man for others,' like Ignatius. Am I supposed to ignore someone in need *just to be on time?*"

When we got back to Oakland, Mev would go for early morning swims with Steve and our good friend and neighbor, Dominican Sister KC Young. They all went to a nearby pool for the early-bird session. By that time, Steve was taking some courses from the Jesuit School of Theology in Berkeley, where Mev and I attended liturgies.

One night, after a Pax Christi meeting that September, Steve, Mev and I drove over to Piedmont Avenue, and at one of Mev's favorite spots, Just Desserts, we hashed over that night's meeting. One of the group members mentioned that the national Pax Christi was sending a delegation to Haiti. In September of the previous year, the recently elected President (and priest) Jean-Bertrand Aristide had been exiled in a military coup.

"So, what do you think, should we all go to Haiti?" Steve queried us.

"I would love to go. I haven't been since 1986. What do you think, Mark?"

"I think you should go, Mev."

"And what about you, Marko? Would you go?"

I winced, as I thought of two weeks off from classes. "I don't think so, Mev. It might be hard to catch up, plus, I am already starting to work with this new East Timor group here. This is plenty for me. And you, Étienne?"

"Of course, I can't think of a better way to go to Haiti than accompanying the Mevster. And you know me, Marko, I'm all too happy to get out of classes. But I will have to check with my provincial."

Mev chimed in: "It would be great if I could go and get some good photos. Somebody needs to document what's going on down there. It's horrible."

And indeed, it was. Right after Aristide had left the country, the vicious Ton Ton Macoute went into the Cité Soleil, a slum in Port-au-Prince that was home to many of Aristide's poor supporters, and had committed massacres. Any show of support for Aristide was met with repression and violence. Although the U.S. government had been quick to oppose Sadaam Hussein's invasion of Kuwait, it was considerably less interested in putting pressure on the Haitian military, since the U.S. had long backed the Duvalier family dictatorship that had been so ensconced with the military.

As it turned out, Steve's provincial did not grant permission, and so he stayed home, dejected, while Mev went with several other Pax Christians from the Bay Area on a two-week delegation to Haiti. It was a difficult journey for Mev, but upon her return she met several Haitian émigrés who were trying to do education in the Bay Area on restoring democracy to Haiti. Mev offered her photos to be used in placards at demonstrations, she gave slideshows to complement testimony from the Haitian refugees, and she brought the Haitian cause to a variety of church and civic groups. She also sent out the following letter to her friends and family on what she had experienced.

༄

Dear Friends,

I'm sorry it's taken me so long to report back to you about my trip to Haiti—I was flu-stricken for three weeks on my return! The trip was inspiring, exhausting and intense. It is hard to know where

to begin. The following background information (especially the 1990s) is important.

History of Haiti: Columbus landed on the Island of Hispaniola (Haiti and Dominican Republic) in 1492; and in 1642 Haiti became a French Colony. In 1804, the only successful slave revolution in history makes Haiti the first independent nation of Latin America. After a series of mostly poor rulers, the U.S. Marines invaded Haiti, remaining from 1915-1934.

In 1957, François ("Papa Doc") Duvalier comes to power, declaring himself "President for Life." He creates the "Ton Ton Macoute," a brutal paramilitary organization used to crush resistance (instead of a salary, they live from what they extort from the people). Papa Doc pressures the Vatican to allow him to *appoint Haitian bishops*, subject to Rome's approval. On Papa Doc's death in 1971, his son Jean-Claude ("Baby Doc") becomes President for Life—ruling brutally and corruptly—until a popular uprising deposes him in 1986.

In 1987, elections are aborted after the Army and Macoutes massacre hundreds of people trying to vote. A series of military coups follows. Finally, on December 16, 1990, Fr. Jean-Bertrand Aristide, a Catholic priest who serves street children and the poor, is elected President in internationally observed elections, receiving a landmark 67% of the vote from among 11 candidates. He is inaugurated Feb. 14, 1991. However, on September 30, 1991, General Cedras leads a military coup ousting Aristide and putting in Marc Bazin. The Organization of American States (OAS) immediately condemned the coup, demanding Aristide's return and a total embargo against the illegal regime. The U.N. also calls for the restoration of Aristide and recommends a trade embargo.

Immediately after the coup, 1,000-2,000 Haitians were *massacred*—many of them youth rounded up from the shantytowns where Aristide was popular. On our trip, we talked to people in these neighborhoods. We met people who were arrested and beaten, whose loved ones were killed—some simply for displaying pictures or posters of President Aristide. Thousands of people—youth,

community leaders, and religious—go into hiding. Under fear of death, these brave people met with us to tell us their stories.

It's so hard for me to find words to share what I saw and heard. At one meeting, a student and a doctor said to us, "In a day or two the military will come and harass or even arrest us for meeting with you today." And yet, people met with us—telling us their STORIES. So, that is what I will do—share stories. Verbal sketches. Receive them reverently, for the people of Haiti entrusted their stories to us, trusting that we will care and respond.

My first full day in Haiti was BAPTISM BY FIRE (translated: baptism-by-bus-breakdown). A rugged seven-hour public bus ride became a twenty-two hour adventure—or nightmare? The bus (that left Port-au-Prince at 6 a.m.) broke down outside a village, so we (four—mostly Washington Office on Haiti folks) hopped a ride on a huge cement truck. Then it poured rain on us, then the truck broke! A gracious Haitian family in a village welcomed us in, made fires to warm us and gave us dry clothes. Finally, at 1 a.m. the next morning, the truck dropped us off at a crossroads, saying "it's only a ten minute walk" to our destination—Jeremie. We walked and walked in the pitch black night, along the ocean, up rocky, muddy roads and arrived in Jeremie—at 3 a.m. Some "first day"!

That journey was a blessing in so many ways: We felt solidarity in our feet; we missed the military checkpoint because the soldiers wanted to sleep; and the bishop, Willy Romelus, introduced us to the people by describing our journey as "a holy pilgrimage." The people smiled and laughed—this kind of trip is everyday fare for them—and they welcomed us "pilgrims" warmly.

A word about "the Bishop"—Willy Romelus is the only bishop in Haiti—one out of ten—who speaks out publically defending the poor, and criticizing the violent regime. He has since been threatened with death, physically harassed and the army has ransacked his residence. Remember that Papa Doc appointed many of these bishops—Bishop Ligonde in Port-au-Prince is Michelle Duvalier's uncle! Well, in April of this year, the *Vatican* became the only state in the world to officially recognize the illegal regime in Haiti.

Anyway, about seven priests live at the bishops' residence in Jeremie—Fr. Samedi is hiding there because the army threatened and tried to kill him. His parish, St. Helen's, is only a 20 minute walk from the Bishop's residence, yet Fr. Samedi hasn't been able to return there since the 9/30/91 coup, because he will be killed.

The people of St. Helen's parish continue to meet and pray for his return—in fact, they are building a big, beautiful rectory for Fr. Samedi—a sign of resistance before the military's threats. Their pastor is alive in their hearts! Many people in this neighborhood were killed after the coup—again, the community supported Fr. Aristide.

The first priest we were able to talk with, Fr. Eddy Julien, told us that the hunger is so bad in Haiti that it will soon become a Somalia—bloodshed and hunger killing the people. The military and the local "section chiefs" (one in each of 500 sections of Haiti—they are mayor, policeman, judge, jailer and mostly strongman and extortioner—many are Macoutes) terrorize the people and crush *any* form of development projects—literacy programs, agricultural cooperatives, student organizations, peasant associations, etc. Having spent my honeymoon with Mark in Sicily at the time of disturbing Mafia violence, I've decided that Haiti is a cross between a dictatorship and a Mafia-state.

Fr. Eddy also informed us that the Haitian people want a real embargo, even if they suffer! We saw ships coming in and out of port, heard planes landing every night. We were told by more than one person that there are 30 new millionaires since the embargo, and six *new* gas stations in Port-au-Prince. Really, the black market and drug trade have simply added to the corruption and violence.

Each day in Jeremie, we join the local community for a 6 a.m. mass and two hours of afternoon prayer; Bishop Romelus presides at both. The people pray to survive the "difficult time." They pray for a new beginning in Haiti. They pray for the return of their president, Fr. Aristide. Romelus prays for unity, peace, and justice. He begs of God, "Convert us! Convert us! Convert us!" Amen, amen—convert us, God!

His voice was soft, but his words powerful. No wonder the

military has defamed him, ransacked his home and threatened to kill him. His faith is vibrant and contagious—he insisted, "Our weapon—the weapon of the people—is prayer."

Staying at the Bishop's house for three days filled me with a sense of reverence. I realized it is like the Jesuit residence in San Salvador where the two women and six Jesuits were assassinated. If the Haitian fire explodes—this is where the military will attack and kill. They cannot tolerate a church that defends the rights of the people, that threatens their right to extort and oppress at will.

During a simple evening meal, Bishop Romelus shared with us that the Saturday before we arrived in Haiti, a small airplane dropped flyers with a photo of President Aristide all over the major cities of Haiti. He saw a woman pick one up and kiss the photo of Aristide saying, "Come back! We wait for you! You are our President! You are our hope!" A soldier walked up and hit her twice with his rifle barrel.

This is Haiti: The hope of the people. The brutality of those who oppose social change. Joy and courage, violence and suffering.

Also, on returning to the U.S., I read a complete translation of the Aristide flyers—and I was really impressed that it called people to have hope and keep organizing. It asserts that Lavalas, the movement/party behind Aristide, is not against the army or soldiers—it only opposes the "small group of criminals" pitting the army against the people; it calls on merchants, factory owners and businessmen to see that the people aren't their enemy; it invites political opponents of Lavalas to work *together* in a democracy, with a common goal of stopping the drug dealers, the Macoutes, and ending misery.

I was impressed that it was so open and non-polemical. There was no sense of "us-them"—no condemnation of the military or the so-called "rich." Rather, it calls on all people, all sectors, even soldiers and factory owners to work against corruption and misery and drugs. This is Lavalas!

Fr. Francky Vilsaint, pastor of a church in Leon, in the Jeremie diocese, was arrested with another priest, on January

31, 1992, then released. On October 14, 1992, at 8 a.m., soldiers surrounded the Leon rectory where Fr. Francky was saying mass with his parishioners. The soldiers broke the door of the sacristy and searched the rooms of the rectory, one by one, confiscating posters of President Aristide and other Haitian heroes (Dessalines and Toussaint Louverture).

We met with Fr. Francky, who knows he may be killed. He talked to us about the need for lawyers to both educate the people about their constitutional rights, and to defend the people when they are falsely accused, swindled out of their land, or thrown in jail with no cause. Such a basic right! Yet, he sees his people attacked, defamed and tortured every day.

After Jeremie, we returned to Port-au-Prince. Peg Maloney, a new friend who works for the Archdiocesan Peace and Justice Office in Denver, and I took the little propeller plane back—we didn't want to lose a day or more if the return bus broke down! Such a stunning flight—we flew low and saw the contours of the whole, beautiful island.

Back in Port-au-Prince, we spent a few hours at the home for the dying. Massaging the withered skin of young girls dying of AIDS and TB put me in touch with the truth of Haiti. Premature death. Callous greed. The violence of hunger and disease; the violence of torture and bullets for those who wish to stop the hunger and disease. Yet, in every corner of Haiti there are people dedicating their lives to change this un-God-like situation—the priests in Jeremie, and the Missionaries of Charity, who enable the destitute to live and die with dignity.

Death lingers in the air, but there is such a spirit of LIFE—when people care and show love, it brings LIFE to the darkest situation.

After the Macoutes; Port-au-Prince, Haiti; 1992
Mev Puleo

Fr. Aristide founded "Fanmi C'est La Vie" ("The Family is Life")—a home for boys who lived on the streets of Port-au-Prince. Aristide created a family atmosphere where the boys could study, play, work and live in community. When Aristide was inaugurated, the boys carved his presidential chair and were very present at the celebrations.

After Aristide was elected President, his foes began attacking the orphanage. The week of his inauguration, some soldiers and Macoutes set this dormitory building on fire and four children died. This past June ('92) the already damaged building was burned to the ground. The military still terrorizes the orphanage by shooting into the compound periodically.

With Aristide in exile the one hundred plus children feel they have lost their father. Still, the boys were happy to see us and welcome us into what is left of their home!

Men work at gruelling, all-too-common labour, pulling carts filled with bags of charcoal. Haiti's minimum wage is only $3/day—these men often earn less. (Some people were enraged at Aristide for wanting to raise the minimum wage to $4/day!) Sometimes referred to as "Donkey Boys," it is said these men have a lifespan of only seven years after they begin this work because of the strain to their bodies. Charcoal production is the prime cause of deforestation in Haiti today. Charcoal is the primary fuel the masses use for cooking meals.

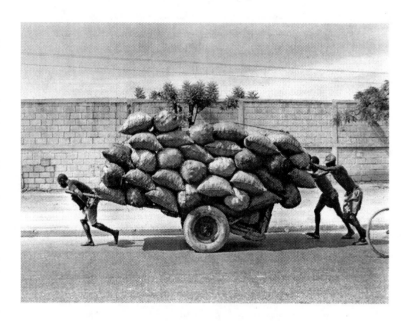

Workers; Port-au-Prince, Haiti; 1992
Mev Puleo

I hate to say it, but I had violent, disturbing dreams while in Haiti. Clearly, young women and men telling us about their fears, humiliations, death threats—their stories penetrate my skin and my unconscious as well. Mid-way through the trip, I call home to Mark,

sobbing, feeling that the well inside me is overflowing with stories of fright, suffering, struggle—and overflowing with awe at the hope and courage of these people that is both inspiring and challenging. My tears do not purge these people, but seal them into my heart. Stories like the priest in hiding, Fr. Gerry, who says, "They can take my body, but they cannot take my soul!"

When the Pax Christi group arrived, we were six, and four of us traveled to Cap-Haitien (CH), the northernmost city. The repression is worse here than anywhere. There were military checkpoints all along the road—the Haitians were harassed more than us; we tried to look like tourists as they go over our passports. The people we met with were hesitant to give their names, and we know not to take photos. They are teachers, catechists, lawyers, students, peasants, base community members, church youth group members. We learn that if two or more people meet, they can be arrested! In one high school, Phillipe Guerrier, immediately after the coup, they fired the school head and put in a Macoute. The military infiltrated the school, posing as students—and every student in a student organization, or those known to support Aristide, were expelled—some arrested and tortured, and now no school would dare accept them. The young women often must sleep with the school master or their teacher to be allowed into the school.

We hear similar stories about every town we visit.

Back in Port-au-Prince, we hear from more people—priests, organizers, young women and men from the base church. Near the end of our stay, we arrange an evening visit with the OAS [Organization of American States] team—we meet with nine out of the eighteen. They'd been in meetings all day, yet spent over an hour with us. Our six-person Pax Christi delegation reported on the conditions of repression, human rights abuses, trampling of the Constitution, persecution of the Church, the need for a real embargo and the urgency of restoring Aristide.

They listened, then told us how their hands are tied—they don't have official vehicles to travel in the countryside, they only have eighteen observers, the government is difficult to work with, etc.—besides, they are fearful for their own lives.

The point we drove home is this: "There are people out there—brave and persecuted people—who are willing to risk death to meet with you and tell you the truth of what is happening. You must respond in kind and get out into the countryside and see for yourselves what is really happening."

Some listened sympathetically, others considered us naive idealists. But, many of them stayed after to ask us more questions, details, share information. Well, this was our attempt to speak truth to power, and we learned that the "OAS" isn't as powerful as it seems. Yet it is one of the few hopes of the Haitian people! The OAS and President-elect Clinton—in every corner of Haiti the people were eagerly hoping Clinton would win, and follow through on his promises to receive Haitian refugees and work to return Aristide to Haiti.

We must do our part to see these dreams come true.

The most moving event of the trip was our meeting late at night in Cap-Haitien with eight nuns and twelve priests—remember, it's "illegal" to meet! They told us there is "a church within the church"—the bishop has "spies" to check on the religious. After the coup, the bishop "purged" the seminaries—kicking out every seminarian that had supported Aristide. A young priest said, "As for my faith before the stance of the hierarchy—I have no faith. What keeps me going is my belief in God and the calling I've received to work with my Haitian sisters and brothers. This is *beyond* the heads of the church."

Another priest said, "They don't just want to get rid of Aristide, they want to kill the DREAM. The church is participating in killing the dream, because the church fears democracy even more than they fear Aristide!" A nun told that a bishop actually prints anti-Aristide, pro-military flyers in Archdiocesan offices. A priest added, "Jesus didn't get along with the authorities of his 'church' and he died for it. But Christianity didn't die." A nun added, "The Bishop isn't the whole church—the Bishop can't stop the Holy Spirit! It's terrible they are kicking out seminarians, but the Spirit's more powerful than that!"

A nun spoke up, "We still risk working with the people because we believe in God, not because we believe in the church. This is a

God of life. The system here leads to death. The people here are struggling for life—the life of God."

"Just as we say that a small group in the country can't rule the country for all of the people, we cannot let a small hierarchy in the church lead us where we don't want to be lead. Aren't we complicit when we are silent?" (A priest asked.) A nun responded, "The poor have claimed their place in the church, and they can't be removed. If the big shots put the cross in front, we know they have a sword behind it. But the poor in the church know what they want and they will do what they need."

"The bishops sent Aristide away because he made them ashamed. Bishop Romelus speaks out to defend the poor and they want to do the same to Romelus," one nun added. Another said, "But the more they try to destroy the church, the more it rises."

"Something is very clear. We are in danger if we stop." A young black Haitian Sister said, "We know we will be arrested, tortured and killed if we speak out. We do not want this, but we are preparing ourselves. We must speak out."

"The struggle is a Christian struggle. You people in the United States also have to put on the pressure. Tell the people that Bush supported the coup. Tell them that more than 3,000 people have died since the coup. Cry out to the Vatican! Pressure your State Department to be just in its decisions about Haiti. Lobby Congress. And let the Haitian and American people know that we thank them very much for their marches on the anniversary of the coup—thank you!"

So, dear friends, I'll close here. We hope and pray for resurrection in Haiti—God knows the people today are crucified in so many ways. Thank you, all of you, for your support of prayers, donations and words of encouragement. Thank you for your lives that are in one way or another devoted to shaping a better world, dedicated to being a healing presence.

I am available to do slideshows on Haiti (I'll be in St. Louis around New Year's and again in the Spring—perhaps April or May). I will soon have a photo display on Haiti that can be shipped to schools or other display places. Call or write if you're interested!

Mev Puleo

Day in The Life/2

Mev and I knew we were privileged in lots of ways; compared to the Haitian refugees, we were living like Donald Trump. I was in my second year of PhD studies, and Mev was applying to the same program. Her parents bought us a new car, as they were beginning to give their four children part of their inheritance, and they were concerned about Mev's old Toyota, which she had driven for the past several years. I had taken out a couple of student loans as well as received a work-study position in the GTU library.

After our respective early morning exercise, she and I would meet back before 8:00 am and do silent meditation for a half hour. Often we would take turns selecting an inspiring reading, sound our meditation bell, which had accompanied us from those challenging days in Cambridge, and then we'd close our eyes and pray, or meditate, or reflect, or give thanks. There were times I'd open my eyes, and Mev's head would slowly be falling to her chest. Then she'd yank it back up as if trying to hide that she had nodded off, then flash a smile at me with eyes wide open—she'd been imitating my dozing off just a minute before. I would grin at her way of catching me. She meant no harm. In fact, she was not just impersonating me falling asleep, she was impersonating me the way I'd impersonate her and expose her and show her I knew her. Mev loved to be known.

We would have fruit smoothies for breakfast and read our respective papers, she the *San Francisco Chronicle*, I, the *New York Times*. I'd be happily reading the daily book review when I'd be startled: Mev had just pounded her fist on the table and emitted a incredulous scowl: "Look at what's going on in Haiti!" At which she would proceed to give me her slant on the latest machinations of the Haitian coup government, the de facto U.S. support of the military regime and even the Vatican recognition of the coup government. This last development so irritated Mev, she began including it in her presentations: "And the Vatican is the only diplomatic entity to officially recognize the illegitimate Haitian government."

She often spent her mornings taking a photography class with her mentor Peter Pfersick. She loved taking his courses at Diablo Valley College, as she was committed

to becoming more skilled in all the dimensions of her art and craft. Now living in Oakland near Lake Merritt, we once again made our second bedroom into a photographic darkroom, where she could work developing her Haiti negatives.

Early afternoon, when I got home from class, we might take a restorative nap together on the couch, spooning for about 20 minutes before we'd continue our afternoon work at our desks. We had a mutually agreeable rhythm: when Mev needed the computer I would read; when I needed to write up my study notes for my seminars, Mev would go to the darkroom; and when we tired of our heady chores, we might call up friends to come over and have dinner with us.

Mev and I realized how much time we got to spend together. The advantage of being students was that, unlike many couples our age who parted company by 7 a.m. and didn't often see each other til 6 or 7 at night, Mev and I would take our breakfasts and dinners together, and usually our lunches. I wondered how many times before they had children my mother and father napped together in the afternoon. Mev was easy to be with, even though I later heard from some of our acquaintances that she could be a little "intense" for them, too "self-preoccupied," and "full of herself." When I later heard these remarks, I wondered who they were talking about. Of course, I loved Mev's intensity, her slamming of fist on the breakfast table, and I found her self-preoccupation kept in check by a scrupulosity that concerned me more. Sometimes I felt sad when I overheard these intimations, or when friends commented on someone else's detractions of Mev (I never thought to ask what they were saying about me!), because, at my compassionate best, I felt that these nay-sayers didn't know the real Mev. And, at my carping, retaliatory worst, I thought they were just jealous of her, so talented, so attractive, so savvy. Their loss.

The Gospel according to Ann
(The Human Form Divine/3)

That fall, through the recommendation of Bob Lassalle-Klein, Mev became a board member of a Christian solidarity group for El Salvador, CRISPAZ. Given Mev's experience and photojournalistic skills, the group was glad to have her, and Mev was thrilled to be able to attend the annual meeting held in January in El Salvador. In addition to being the first time she would be able to visit the land of Oscar Romero, the other martyrs and the courageous base communities, she would also be able to drop in on Ann Manganaro, a doctor and Sister of Loretto who was working in one of the war zones. Ann had also been one of the founders of Karen House in St. Louis. She was a close friend of Mev's mentor, John Kavanaugh, besides being close with Teka.

While Mev was enthusiastic in telling me about her *rendezvous* with her old acquaintance, I hesitated briefly: "I remember you saying when we first met, Mev, that you always figured you'd die young, probably from a bus accident in a Third World country where the roads are so bad. I hope you will call me a few times while you are there." I had a lingering anxiety about her making this trip. But it would be a delegation with other people, she wouldn't be roughing it on her own and her white—well, olive—skin, would grant her a certain immunity—again, I hoped—from any violence. So often that's the case: Our white skins protect us from the ravages inflicted on the natives by the military our government funds so lavishly.

Mev felt great admiration for Ann, and made it a point to spend quality time with her, learning about her life in a war zone. She recorded their long conversations and later added an introduction, for a photo-essay on Ann's work.

Introduction[66]

I first met Ann Manganaro in the early 1980s when she was living and working at Karen Catholic Worker House in St. Louis, a community shelter for homeless

women and children. At the time, she was also the attending physician at the emergency room of Cardinal Glennon Children's Hospital. I was a student volunteer at the Cass Catholic Worker House through a program of St. Louis University campus ministry, and I also frequented Tuesday night Mass at Karen House. This January, after several failed attempts to visit friends in El Salvador, I attended a board meeting of CRISPAZ, Christians for Peace in El Salvador, in San Salvador. Before the meeting, I spent three days with Ann in the village of Guarjila where she has lived and worked for five years. I arrived by bus in the town of Dulce Nombre de Maria, where Ann, forty-six years old, was leading a course for health promoters. Her large hand-drawn posters of kidneys, livers, reproductive systems and childbirth decorated the walls. I arrived for the end of the course, where Ann led the young women and men in the song, "Mujer Salvadoreña"—praising the courage and strength of Salvadoran women.

ॐ

Interview

Mev: Ann, you were immersed in work with the poor in St. Louis, both through the shelter and your hospital work. What brought you to El Salvador?

Ann: For a long time I had wanted to work in a Third World country. That's why I switched from education to health care. This desire was in my mind throughout my medical studies.

I chose Central America and El Salvador specifically because it is a place where United States foreign policy has done so much damage to people's lives. My presence here is a way to put one small countervailing force against the real evil and damage that has occurred as a result of U.S. foreign policy. Our active policy throughout Latin America is to support any government that ensures there won't be left-wing governments in power. Concretely, what that meant in El Salvador was that the U.S. supported a very oligarchic government and a cruelly repressive military that caused the deaths of thousands of civilians even before the war began and thousands more during the twelve-year civil war.

Mev: Is there a story that illustrates what is most difficult about working here?

Ann: One night in 1988, I'd only been here a couple months, there was a beautiful sunset and stars in the sky, and I was walking home after dinner to where I live

alone. Well, no more had I gotten in and settled down for the evening when this combat broke out all around me. On one side of the house I could hear an exchange of fire between the army who was coming down the road and the FMLN up in the hills above them. I immediately sat on the floor and waited for it to pass. I could hear the combat go from one side of the house to the other—I could hear the soldiers shouting in the street. When it got farther away to the other end of the community, I opened the door to see what was going on. I heard these fighter planes who were circling over the community and started dropping these huge flares called "Bengal lights" that were eerily beautiful but horrifying orange lights floating down in parachutes to illuminate their targets. Then they started strafing with tracer bullets, which you see as little red lights crossing the sky.

The door of my house turns to the hills, like most houses here, because people consider the road dangerous—that's where the military passes. As I was watching this eerie, terrible light show, this little "compa" (FMLN fighter), only 13 or 14 years old, came up to me carrying his gun at his side and said, "Anna!" in this soft little voice. He asked for water and I gave him a drink. I was trying to be kind to him, but the whole time I'm thinking, if the soldiers come back and I have a FMLN soldier at my door, even a little kid, I'm in trouble. He stood with me and then he went off—I felt both a huge surge of relief but also sad for him.

There was no one hurt who was brought to me in this particular battle, but it was horrible to be in the middle of a battle.

Even worse than that was in 1990, when there was a massacre in a town called Corral de Piedra, now called Ignacio Ellacuría. The refugees had only come back to this village four months earlier. There was a lot of intense fighting around us, with helicopters, planes, mortars in addition to the ground combat. One morning at 6:30 I heard helicopters flying really low and heard ground shooting nearby. I saw them circling and firing rockets again and again. I thought they were firing somewhere between our two villages, but it looked so close.

My friend Cathy, who had spent the night in Corral de Piedra where she does pastoral work, drove up in her jeep honking and shouting, "Come quickly, there are dead and wounded!" I couldn't believe it could be civilians! I grabbed my emergency medical bags and headed off with one of our health promoters.

There had been a ground combat near the community and when helicopter support arrived, they started strafing the community. The house

they hit was a brick building where three or four families had gone in seeking shelter—thinking it would be safer than their little mud shacks. There were about twenty-one people in it, five were killed and all the rest were wounded, mostly children. One man was killed with his two-year old daughter in his arms. Of the three children, only two were recognizable—the third had shreds of his body all over the room.

We brought everybody who survived to Chalatanengo both for treatment, but also to document the massacre. It was all so horrifying—not just the event, but the public response. First the army denied that it happened, then they said the house was hit by an explosive from an FMLN catapult. Story after story after story, each one lies. I think it's only because Cathy and I took one boy and a little baby (whose father was killed holding her little two year-old sister) into San Salvador that the truth finally came out.

That was one of the most graphic examples of what war does to civilians. And this was such a tiny experience—I think of what happened in Iraq during the Gulf War where *thousands* of people experienced this. One little incident in one little country that nobody knows about. Five people dead, sixteen wounded, four of the dead are children, twelve wounded were children. No big deal, right? Unless it's huge numbers or people in the United States itself, those numbers are just trivial—no one cares.

One of the things that happens during the war is you don't have time to really absorb an incident like that, there's just another emergency afterwards. The next day, a little boy and his grandfather were walking along a river and hit a mine and were wounded. There is tragedy after tragedy you have to respond to. The village massacre was certainly the worst I saw, but not the only one. When you hear helicopters, you just gear yourself up to deal with the next thing.

When I made a retreat recently, I realized I had four years of tragedies suppressed inside of me. All of these memories started surfacing, one after another. This must happen to everyone in the war. You gear yourself up to just move on. It's no wonder people suffer from post-traumatic stress—you store up a lot of experiences that you don't adequately mourn or grieve or even feel!

Mev: How do you think living in a war zone for four or five years affects you?

Ann: One of the things that *worries* me—not only in this war situation, but a doctor friend of mine who works with AIDS patients in the U.S., or people who work with the homeless—there's a tendency to lose your human vulnerability

and responsiveness for those tragedies and become, not just hardened as in bitter or cynical, but aloof, or your compassion becoming an automatic response where you can be kind, but you are on automatic pilot, not from the heart, because if you let all that tragedy touch you, you might just fall apart. I've felt this way from time to time. The other thing that happens is situations where I would automatically in the past feel kindness or a capacity to respond, instead I would feel resentful for the intrusion in my life, and it was hard to find the resources from within with which to respond.

That's the challenge when we try to deal with human suffering. My hope is to somehow cast my lot with the poor long-term throughout my life, and if you cast your lot with the poor, that means exposing yourself and opening your heart to a lot of tragedy, a lot of human suffering, a lot of painful experiences that most people shield themselves from. How do you do that long-term? How do you keep your heart vulnerable and genuinely responsive and not just going through the motions?

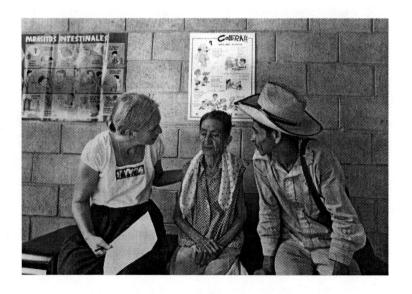

Ann Manganaro and campesinos; Guarjila clinic; 1993
Mev Puleo

Mev: What in your life has brought you to the decision to cast your lot with the poor?

Ann: From childhood, my parents were great lovers of Francis of Assisi—so that whole image of someone who lived poorly and tried to live according to the Gospel is an image I grew up with as an ideal person.

As a young adult entering the Sisters of Loretto at eighteen, somewhat naively, I spent a lot of genuine effort to read and take seriously the Gospel. What has sustained me over the long haul, from all the theology I studied in college as a young sister, was really scripture study. I really learned to turn to the scriptures as a source of life. When I was in my twenties, I began to feel quite skeptical about the church and about religious life—it was a real crisis of faith. I stopped praying and going to mass regularly. But later I realized, I wanted to live authentically this vocation I chose as a teen. I was twenty-four and I remember thinking—almost instinctually—of turning to scripture to see if the Gospel still made sense. I remember sitting under a tree in Forest Park in St. Louis and reading the Gospel of Matthew, coming to the Sermon on the Mount and thinking—yes, this is what I want to do with my life! This is real. This is true for me. I think this will always be true for me.

Mev: What message in Scripture most stood out?

Ann: It's something about *love God with your whole heart and love your neighbor as yourself, you have to lose your life in order to save it*—it's not just in any one phrase. It's not just the words of Jesus, but the example of Jesus showing that this is where the Gospel really gets lived. More than the Sermon on the Mount, it's the Last Judgment—that what finally counts when you come down to it—the test of faithfulness to Jesus is if you've fed the hungry, and given drink to the thirsty, and visited prisoners and been with the homeless. I think from when I was very young I've had my heart set on fire to try to make that real in my life somehow. In a very naive way when I was in my early twenties.

Another strong influence on me was the summer I spent at the Catholic Worker in New York when I was 22. It was just a summer, but the whole experience of learning how the Catholic Worker came to embody faithfulness to the Gospel through both works of justice and works of mercy, living directly with the poor, but always seeking a just society. That particular slant on the Gospel was a real source of revelation that has since been a strong source of nurturance for me.

Mev: How has your faith changed or been challenged since you've been here?

Ann: Being in El Salvador has been a real test of my faith. What nurtures me here is the courage and tenacity of the Salvadoran people I've come to know, and their faith, which is sometimes a very naive faith, but all the same very real in their lives.

Being here has sometimes been hard on my faith—sometimes I say, "Where is God in all of this? Are you really here?" Sometimes I get up in the morning and say, "Are you really still here with us? God-with-us, Emmanuel, are you really? Is your spirit really alive and working in the world?" Does the spirit of Jesus only work and live through the lives of those who are followers of Jesus—and is that what's wrong, that so few people really have found ways to take that seriously and embody it?

In the middle of a war, there are many times when you feel God is more absent than present. And yet, there are always moments of grace and revelation when you see people's incredible kindness, generosity and love shining through—not necessarily believing people, but you see human spirits rising to an incredible level of goodness.

But you also see the stress and the loss and the waste and the pain and the death and the unfulfilled lives, and the tortured, tormented lives, families separated. I think it's a real challenge to my faith—has been and still is. This is why I need a sabbatical, to say, "Where have you been in all of this, God? And what does it mean for what I am supposed to do with the rest of my life?"

Mev: What stories explain what makes your work worthwhile or what gives you hope?

Ann: Part of it is the whole *range* of things I do—training health promoters, for example. My reward is not only seeing their enthusiasm and joy of learning and seeing them concretely use their skills, but also witnessing how they develop as leaders in their communities. Especially these young women in my village, I see them grow and take responsibility—once shy people learning to speak at a meeting or even teaching new health promoters. Take Rosali—she has a real vocation to health care. She's only 22, yet she's been working in health for five to six years. She's an incredibly eager learner and takes in every opportunity—dental health training, a midwife course—asking questions at every chance. She has very limited formal education—only to the fourth grade, *Salvadoran* fourth grade—but she really synthesizes everything she learns and can even make accurate diagnoses.

Once there was a very wounded man brought to us straight from the battlefield during the war. The promoters were trying to get me the things I needed, but he lost a lot of blood, and we lost him. The promoters knew him, his name was David—and he was conscious just up until the moment he died, saying, "I'm dying! I'm dying!" I was so busy trying to do things to save him, he died in the middle of all the flurry. Rosali said later, "I have to learn more so that I can do something more to help." She took his death so personally—not that it was just sad, but that it was her responsibility and desire to respond. People here are very fatalistic about death generally.

Mev: Having worked among the poor and homeless in St. Louis, what differences do you see in the work in the U.S. and El Salvador?

Ann: Ironically, because of where I've landed in El Salvador I work with people whose consciousness was raised fifteen years ago in the campesino unions and the Base Christian Communities. There's a whole process that's gone on with poor people that's different than in the U.S. I don't know if this is true all over El Salvador, but I experience more dignity, more sense of self, of joy in life, determination, more sense of possibility and hopefulness here, even during the war, that I did *not* experience in the United States. I think there's more of a sense of community and more possibility of organizing and seeing it bear fruit. In the U.S., my experience of poverty was one of disintegration and isolation of individual people and families. I'm sure there are places in the U.S. where you could have another experience of poverty, but at the Catholic Worker you met people whose lives were disintegrated and they were chronically depressed or in despair. There is a lot more despair in the U.S. than here. Even in the hardest times people here have a sense of hope and a belief that *they* have a role to make things happen.

Mev: Do you think it's harder to work for social change in the U.S.?

Ann: Yes. And it makes me think there is something too passive about the way Catholic Worker accepts people how they are, over and over again, without really trying to make an intervention that will challenge people and call people to go forward. I think the Worker has done this through individual relationships. But, if I returned to the U.S., I'd have to be somewhere where I wasn't *just* responding to emergencies and crises, I would want some sense that what I was doing had a real impact on other people and their future—the "training for transformation" idea. Here we call it *capacitatión*.

There is also something to be said for direct service. People here tend to put down "assistentialism," but there's something to be said for it when you see this person walking who would have lost their leg, and this baby that would have died without an operation. So, I warn myself not to get into the perspective that the only important work is community organizing. People's lives can be totally transformed by medical aid. This is something I like about being a physician, you get to see concrete improvements—that's why I liked the emergency room, you really can help people in the moment—give stitches, medicine, etc. I'd be hard put to choose, but prefer to do both direct service and training others for social change.

Mev: What, ultimately, is the effect that your work has had on your faith?

Ann: It was hard for me during my residency to see babies who were born prematurely, who lived eight months or eighteen months and never left the hospital. Such a tragic kind of death makes you ask, "What kind of life was that?" Or horrible cases of child abuse and children who are murdered. But, maybe it's just the *volume* of deaths here, or seeing all of these young people going off to fight the war and being killed, or seeing the destruction of families and relationships divided and destroyed. This has really been hard on my faith.

It's not just seeing it happen here very concretely, but knowing it is happening all over the world. So, here in El Salvador, it's one little massacre in the next village, yet I know it's thousands and hundreds of thousands of people all over the world! Where is all of that *malice* coming from?

The other thing is dealing with the soldiers, seeing the malice in some of them. When the Atlacatl battalion came through you saw these men so brutalized, so cruel, so hateful in their way of talking, their way of being, their way of just *looking* at one, and I ask, "How did that much malice get into the world? And what are we called to do about it? Where is the grace of God working in all of this? Are we few measly little people who are trying to live according to the Gospel, or put our faith in practice or do God's will, or whatever you want to call it—Are we making any difference? Is there going to be liberation?"

That's another thing, looking at the whole geo-political situation in the last twenty years—I guess you can take hope from the fall of the Eastern bloc, but here in this stark situation, I felt my faith worn a little bit thin.

And yet, it does drive me back to pray every day, and I do try to make my heart open to God's presence wherever it is here and attend to people *as if* God is present even when I feel the absence of God.

I don't know how to say it, but maybe it is true that the most real way God is present in the world is through human beings mediating to other human beings the grace of God or the life of God. So, maybe the only way that God is going to be present is if I keep acting, and all the rest of us keep acting, *as if* . . . It's like, we have to *enflesh* God, just like Jesus, who, according to traditional Christian theology, is the most perfect embodiment and literal enfleshment of God's life and presence in the world. It's that whole thing about completing what is lacking in the sufferings of Christ—somehow each of us has to help God take flesh in the world right now, here in the 20th century.

So, even in my bleakest moments I've tried to cling to that sense that maybe the only way I know God is trusting that if I keep trying to give my life for others, that somehow God is being born in that. And sometimes it is only in retrospect, when you've gone through a really hard time, but you see the fruit that has continued to be born in your life and in other people's lives that makes you say, "YES, God's grace was working here even when I didn't feel it in the moment."

Poverty and Riches/3

In addition to making it a priority to spend time with Ann in Guarjila, Mev also traveled to the University of Central America in San Salvador where the Jesuit intellectuals had been murdered in November 1989 by military trained at the U.S. Army School of the Americas. Like hundreds, if not thousands by now, of North Americans, Mev had a profound experience visiting the memorial room that had books and photographs documenting the Jesuit assassinations. For Mev, looking at those photos was a heartrending, moving and inspiring experience. At that time, theologian Jon Sobrino popped in and offered hospitality to the North American pilgrims. Sobrino kindly gave a tour of the rose garden in memory of the dead. Mev also got some time alone to ask Sobrino, a native Spaniard, to reflect on the nature of his fidelity.

ॐ

Interview[67]

Mev: What inspired your own faith commitment?

Jon: I entered the Society of Jesus in 1956, at 18. At the time, it was a response to a call of God, but at that moment the poor weren't very present in my consciousness. Twenty years ago I moved to El Salvador. What brought me forward were the tiny miracles I saw in front of me, the poverty of the people made me say, "We have to change this reality."

And, in my case, I came here after Fr. Ellacuría and Fr. Rutilio Grande arrived. They killed Rutilio soon after I arrived, then I lived with Ignacio Ellacuría for 16 years! They began a road that I started to follow, as a priest and professionally as a theologian. I gradually began to interiorize this commitment. There was no one dramatic moment—it was simply a matter of living in this world and trying to do good. But then began the bombs at the UCA and the murders. Then one has to make an option and really define oneself.

Mev: What does the option for the poor mean for people who, like me, are born into a country or a class of privilege?

Jon: You mean a person like me! Simply put, this option can have various expressions. One of them is to live with the poor, but there are few who do that and it isn't what the poor most need. The option for the poor means to make an effort to see reality from where the poor are. Concretely, we must put our resources at the service of the poor. You know, in our country one can't be a priest without also gaining prestige, and this is a form of "wealth," as are buildings, books, intellectual development, etc. The point is that we put all of these riches at the service of the poor. This can be done in an immediate form or in a structural manner.

Mev: One of my American friends working in El Salvador said, "I am one of the oppressors because I have a refrigerator." She considers herself rich because she has material things.

Jon: In a country of such poverty, one can certainly feel this way. But I feel that in a country like this poverty for us is practically impossible! We are not poor. What I ask of us is a bit of austerity. And then, we should use those resources we do have at the service of the poor. But I don't have any scruples about having a refrigerator or TV—on a TV we see the news and learn what's going on. Sometimes on Sundays, I relax a little bit. This doesn't bother me.

Monsignor Romero was not poor—he knew this clearly. But he was austere. He lived very simply and modestly. But the nuns brought him an orange juice every day! In our country, that is not poor.

Mev: Do you think that our strongest connection with the poor is in the circumstances that we do not opt for, our own personal sufferings, such as loneliness?

Jon: I would formulate this differently. Loneliness for me is worse than an option for the poor. Solidarity with the poor is working and being with them so that they stop being poor. And how do we feel, I who am not poor? I feel most like the poor not when I go without a car, but in the most existential struggles of life, such as loneliness.

But I distinguish between poverty and human suffering. Poverty is *one* human situation that produces much suffering. The poor suffer. We see this in famine victims in Africa. There is also much suffering that is not from poverty. What matters to me is to say that we have solidarity in our struggles, but my suffering is very distinct from the poverty that poor people suffer.

Mev: Gustavo Gutiérrez writes that spirituality comes before theology. What spirituality sustains you in your life work?

Jon: I am 54 years old and many things have already happened in my life. For me every day is more simple. More than anything, what sustains me is love. I've received love and affection from simple people, who don't know me but animate me. But to speak more specifically, Rutilio Grande and Ignacio Ellacuría were good people who truly loved. I felt from Ellacuría not only our friendship, but I saw that he *truly* loved people. Not just the love of friendship and tenderness which we experience at a personal level, but the sweeping current of love in history.

I feel I also belong to this current of love in history. There are also currents of hate in history. But I have seen these strong currents of love coming from other people to me, but I also have been able to love other people. This is personal but also structural. This is a strong source of meaning.

Also, when I see love, I see hope. To have hope in this world is absolutely absurd! In spite of that absurdity, we have hope. Now, to put all of this in a context of Christian faith, the mystery of Christian faith is like a reserve of love, hope, tenderness, solidarity, and although history negates this, it still journeys on!

In other words, like Micah says, "Acting justly, loving tenderly, walking humbly with God." This, for me, is the truth, the fundamental truth. We live as well as we can, but I try to live by this.

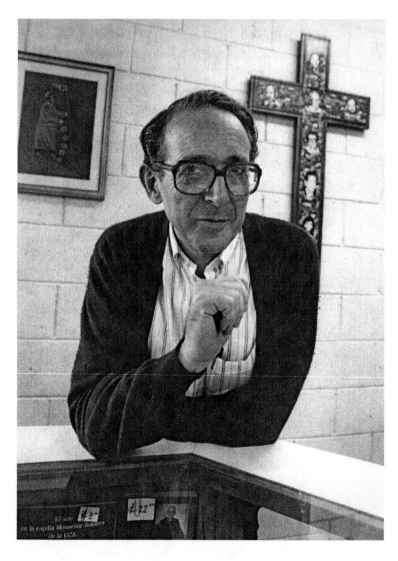

Jon Sobrino; San Salvador, El Salvador; 1993

Mev Puleo

Face to Face/6

Two of the best times of the day were waking up and going to bed with Mev. It is not that the intervening hours were boring, flat or uneventful. It was just that these times with Mev were preciously playful.

Mev woke up much more easily than I did. It was as if her face would go from sleep to blossom in a matter of seconds. She would wake alert and so damn jovial. She would typically nuzzle me and whisper, "Marko, c'mon, get up, the sun is shining. It's a new day, what are you waiting for?" I'd usually feign irritability and turn back over on my side.

At which point, she'd remind me in a most unnervingly non-nagging fashion, "You know, Tagliamento [one of her many nicknames for me], it wouldn't be so hard to spring out of bed if you didn't drink coffee in the afternoon."

"A lapse in judgment."

"No, c'mon, it's going to be a fun day. Spoon me! Play with me!" she would entreat. As I would relent, she would climb on top of me and breathe into my ear some Haitian Creole or Portuguese expression, the literal meaning of which I could not understand, but its figurative meaning was quite clear. I would be wide awake. There were times it seemed so bizarre to me, but the Mev of 6, 16 and 26 years of age were all present during these morning rituals. Such innocence, zest and passion.

Likewise, I looked forward to going to bed because Mev's energy did not lag. I would often turn in first, with book in hand in case we wanted to read a little while before turning off the lights. Mev announced from the bathroom that she would be in two minutes. She would wash her face, put on skin lotion and brush her teeth. With a squeal, she would come jogging into the bedroom and hop-plop herself onto the bed. Her night wear was either of two T-shirts I'd given her years before: a red t-shirt and a faded pink and blue tie-dye shirt. She would also wear white footies, often keeping a second pair under her pillow in case she got chilled in the middle of the night.

"Oh, Marko, you can't read Chomsky before bed, that's not bed-time reading. It will get you all worked up!"

And I had thought she wouldn't notice. I was always wrong on this score.

Book then placed on the night stand, we would do our gratitudes for the day and give thanks for Steve, our dear neighbors K C, Rich and Dana, and Jerome and Sheri, and remember our parents and siblings as we evolved into one of our favorite positions, I spooning her from behind.

It was not at all uncommon for Mev to whisper to me as my chest was pressed against her back, "Marko?"

"Yes, Mevvie?"

"I'm not very sleepy. Are you?"

"Actually, I'm not as worn out as I felt 10 minutes ago. Why?"

And then she'd wiggle out of the spoon, and turn on her side to face and kiss me.

A couple of minutes later. "Mmm, how fun. Thank you Mev, I didn't need that tongue anyway."

"Marko?"

"Yes, Mevinsky?"

"Enjoy me."

I loved her imperatives.

Remembering The Dead/4

Mev's Journal, Summer 1993

I was exhausted from a long day in the darkroom.

It was almost May first, and I had promised my friend, Ann Manganaro, that I would send her the photos of her Salvadoran neighbors and their clinic before she left the village of Guarjila for her sabbatical in the States. So, I gathered more negatives from my January visit to El Salvador and holed up for another day in the darkroom. Standing on weary feet in the dimly-lit room, I flashed light through negatives, dodging shadows, burning highlights, calling images forth from the film.

As the chemicals sloshed back and forth over the photographic paper, memories and stories took shape before my eyes—Ann playing with a little girl with Down's Syndrome, Ann calming a child on the operating table before removing the stitches above her eye, Ann patching up the shoulder of a young man who fell off the back of a truck, Ann gently probing the chest of a frail old woman who wears the look of near-death. Every image true to my experience of Ann—bright eyes, gentle smile, healing touch, lively face—each gesture revealing compassion and vibrant life.

I did not know then that the frail, old woman with lung disease would live longer than Ann.

Before my January visit, Ann and I were acquaintances—she was a close friend of my close friend. But somewhere during our bumpy jeep rides, clinic work, photo sessions and late night talks in her thatched mud hut, a friendship took root. We talked long into the night about our work, our vocations and our struggles to have faith in the midst of war and death.

The day after my darkroom marathon I began transcribing my interviews with Ann, hoping to publish a photo-essay on her inspiring work. Like the photographs, her tape-recorded voice brought me back to El Salvador where I first heard Ann describe her beliefs and desires and concerns. A phone call interrupted my work. I was delighted at the coincidence: Ann's and my mutual friend Teka calling from our home town of St. Louis. "What timing! I'm just listening to Ann's voice on my tape

recorder!"Then Teka told me: "Ann came home early to go to the hospital. She's really sick."

Cancer. The cancer from six years ago had returned. Teka's report buzzed in my head: liver, bone, fluid around the heart, surgery, tests and more tests. A heavy grief wedged itself like a brick between my throat and stomach, leaving me speechless and queasy. Off the phone, my tears erupted, flowed, subsided into sniffles, then silence, but the wedge of grief remained and still makes its presence felt today. Gratefully, I was able to visit her a few times in St. Louis in May and early June before she died on the 6th of June. I was able to share with her family and friends the photographs that so reveal her kind spirit.

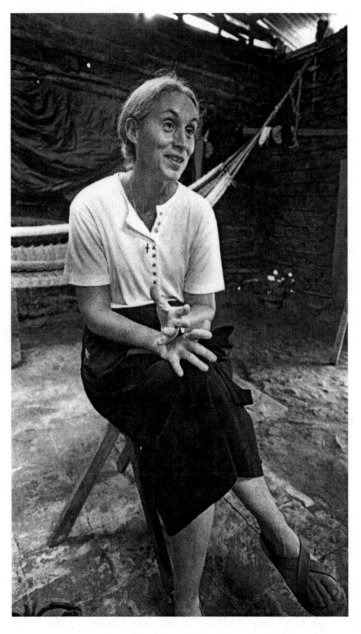

Ann Manganaro, at home; Guarjila, El Salvador; 1993

Mev Puleo

Bearing Witness/2

A few weeks before our wedding and honeymoon, I received a phone call from a San Francisco lawyer, Anne Tresedor. She had heard that I had expressed interest in learning more about the situation of the people of East Timor. At the time, I told Anne that I was soon to be married and would be gone for the summer, but that I would happily meet with her when I returned. Anne had long been involved with and enamored of the Portuguese people, who were her initial link to East Timor, a former Portuguese colony. Like me, she had been shocked by the blatant brutality of the Indonesian military that had massacred scores of East Timorese people at the Santa Cruz cemetery in the capital city of Dili in November 1991. One reason this atrocity generated publicity was that two U.S. journalists—Amy Goodman and Allan Nairn—had been attacked along with the Timorese, and they were able to get the story out. In the months after the Santa Cruz massacre, small groups of U.S. citizens organized to protest U.S. policy toward Indonesia. Anne was organizing a Bay Area chapter, and I met with her and a few others in August after our Italian vacation. She was hoping that I would "organize the Catholic community," since I was Catholic and studying at the Graduate Theological Union. She was brimming with ambition—for herself, and for me as well.

We did the usual kinds of activities: lobbying Congress, educating the community and demonstrating. On November 12, the anniversary of the Santa Cruz massacre, we had a prayer vigil outside the Indonesian consulate in San Francisco. I had invited Steve Kelly to the demonstration, and he offered a very powerful reflection on the murdered and disappeared of East Timor. He immediately grasped the urgency of the situation, having worked in El Salvador, where he had stood up for the *campesinos* and had been kicked out of the country by the military earlier that year.

Then, in the spring of 1993, four young East Timorese students were on a national speaking tour. I was able to secure them an engagement at the Graduate Theological Union, as well as a private meeting with Oakland bishop John Cummins, who was a close personal friend with the bishop of East Timor, Carlos Filipe Ximenes

Belo. For years, Bishop Belo had received death threats for protecting the Timorese people from the depredations of the Indonesian occupying military forces.[68] It was at this same time that the documentary on Noam Chomsky's work, *Manufacturing Consent*, premiered in the Bay Area.[69] The film contained a strong segment on the U.S. government and media's role in the persecution of the East Timorese, so the Timorese students also spoke at the intermission of that film in San Francisco and Berkeley.

At this time, I was deepening my study of Holocaust survivor and Nobel Laureate Elie Wiesel. I learned that, in 1978, Wiesel had accepted President Jimmy Carter's nomination to chair his investigative commission on how best to remember the Holocaust in the United States. A little over a year later, Wiesel and his commission presented four proposals to the government. Three of these were accepted and proved to be steppingstones for what eventually became the U.S. Holocaust Memorial Museum on the national mall in Washington (which opened in April 1993).

The fourth proposal, which Commission member Hyman Bookbinder strongly pushed, called for the creation of a Committee on Conscience to be comprised of prominent citizens who would act to mobilize U.S. citizens in defense of human rights whenever and wherever such abuses could be detected. The U.S. State Department and Carter White House strongly opposed the formation of such a committee. Bookbinder was angered at this rejection and charged that "[o]ur proposals were fine as long as they did not ask the government to extend the lessons of the Holocaust to our current foreign and national security policies."[70]

Also in 1978: The Carter Administration increased arms sales to Indonesia, which was then engaging in a massive slaughter in East Timor. Indonesia had invaded East Timor in December 1975, and, with the military and ideological support of the United States, had illegally annexed East Timor. Through vicious bombardments, repression and hunger, Indonesia caused the deaths of approximately 200,000 people. As if this horror wasn't enough, East Timor, the population of which is overwhelmingly Catholic, had been the victim of a further injustice—the Western media preferred to focus on the crimes of the Communist Khmer Rouge, rather than on the comparable villainy of a trusted Western ally.

Indonesia's invasion was an act of aggression condemned by the principles established at the post-World War II Nuremberg trials. And U.S. support for Indonesia was a clear-cut case of the U.S. government refusing to extend the lessons of the Holocaust to its own foreign policy. The East Timorese were like the Jews of the 1930s and 40s in that they were considered utterly expendable.

In mid-summer of 1993, I received a call from Bishop Cummins who informed me that Bishop Belo was visiting him on his way back to East Timor. The amiable Oakland bishop wanted to know if Mev and I would like to meet him. I said sure, and we went over to the chancery the following morning. I had gotten more involved in the East Timor issue, as Mev and I had begun brainstorming about making a trip there and returning to give presentations—so this was a magnificent opportunity to speak with a person who had been immersed in life there.

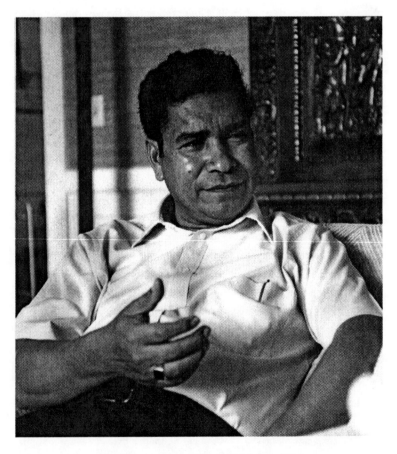

Bishop Carlos Belo; Oakland, California; 1993
Mev Puleo

We arrived at the Cathedral at 21st and Martin Luther King in downtown Oakland and met a writer from the local Catholic press who was there to do a story. We were able to have an informal discussion with Bishop Belo for about 30 minutes. He was taken with Mev, especially the fact that she was able to speak Portuguese with him. I told the Bishop about our fledgling work with East Timor, and Mev informed him of her work with the Brazilian church. Gentle and gracious, Bishop Belo was open to our questions.

"Do you think it is important for us to go to East Timor?"

"It is not just important—it is necessary and urgent. There need to be people who go and return to the United States to tell the true story of East Timor."

We told him we were thinking of going the following summer, but Bishop Belo responded, "Next summer is so late, anything could happen. It would be better in November, December or January."

The bishop was reminding us of our extreme privilege that we were wanting to fit the East Timorese into our lives a year from now (how many people would be murdered by the Indonesian military in the next year?). He went on to urge us to visit but to come as tourists. He suggested applying for tourist visas, spending a couple of days in Bali, then going on to Dili and staying at the Hotel Tourismo on the beach. He stressed that it was imperative to go as tourists, not fact-finding journalists, which would raise immediate suspicion and endanger the Timorese if they were to be seen talking to us.

Bishop Belo indicated that the best approach would be to play up our Catholic connection: We should contact him when we arrived, attend Mass, meet with people afterwards. But this was a very different approach than, say, Witness for Peace in Nicaragua back in the 1980s, where North Americans were welcomed to the war zone and talked freely with ordinary Nicaraguans.

"And no meetings at night," the Bishop added, "that's very dangerous. When you are thinking of coming, write me a letter, stating that you are young married Catholics who are vacationing and want to meet the bishop and other Catholics while you are visiting. Of course, all the mail is opened and read, so do not write about your intent in your correspondence with me."

We thanked both Bishop Belo and Cummins for their time and willingness to meet with us. As we left, I said to Mev, "He's under a lot of pressure. He could end up like Oscar Romero."

"Mark, we need to keep talking about this option. If we go, I could take pictures, you could remember what people say, we could come back here and do

some organizing. Like I've been doing with Haiti." It was exciting to think of working so closely on a project with Mev and exacting to remember what the project was all about.

Even though the Bishop urged us to come soon, given our plans—Mev starting at the GTU in August, I studying for and taking my comprehensive doctoral exams in the winter and spring—it didn't look like we could be traveling to East Timor until the following June, at the earliest.

A Few Words with The Pope

Mev had spent the spring of 1993 finishing her application to the GTU doctoral program in art and theology. Around this time, she was startled to receive in the mail an invitation from Washington, D.C. She had sent her CV and sample photographs to a contact at the National Catholic Conference, in case they wanted her to go on assignment or to print any of her images. She seemed a little perplexed.

"Mark, did you know that this summer there is going to be a huge festival in Denver, called World Youth Day? It's a gathering of young Catholics, with the Pope coming."

"No, dear, I haven't checked the Vatican travel schedule lately. Is that so?"

"Yes, and Catholics from everywhere come to meet each other and celebrate their faith. And I have been invited to be one of three emcees."

I teased her, "How perfect for an Enneagram 3! The crowds, the attention, you'll be in seventh heaven!"

"I don't know if I want to *do* it. You've heard me say 50 times the Vatican is the only diplomatic entity to recognize the coup government in Haiti. That still pisses me off! Plus, while I like a lot of the Pope's social message, he's so conservative on some issues."

I nodded in affirmation.

"They want the emcees to be as fluent in as many other languages as possible because there will be Catholics there from everywhere."

"Are you the first they've asked?"

"No, they've already got an African-American man and a Hispanic guy. I guess they needed a woman."

"Call them back, see what it entails. Let them know who you are, what you stand for, what you're willing to do. When is it anyway?"

"Second week of August."

"You'll have a busy summer—GTU starts in August. Mention it to some friends, see what Kavanaugh says."

The next few weeks Mev and I and friends had long discussions about whether

she really wanted to do this emceeing. She knew they needed a woman, and the fact that she could speak Spanish, Portuguese and Italian certainly helped her out. But she was trying to discern how closely she wanted to align and affiliate herself with the church as an institution. She had no qualms about, indeed passionate enthusiasm, for the church as servant, or the church as prophet. In fact, that was what *The Struggle is One* is all about. She decided to work as an emcee, and she insisted I accompany her (echoes of Brazil trip 1990). But I needed no coaxing; I was happy to have a change of pace in studying for my comprehensive doctoral exams the following April, and I could study as easily at the Comfort Inn as in Oakland. I was delighted at this time to have come across an apt line from George Steiner, "I'm at home anywhere I have a desk." So Denver was home for five days.

In late August, Mev handed me several sheets of paper. "This is my journaling on World Youth Day. It really helped me to write all this down. Would you please read it and tell me what you think?" This is what she wrote.

Mev's Journal, World Youth Day, Denver, Aug. 11-15

An extraordinary experience

I mean, so out of the ordinary, I feel like I was beamed up to Mars for a week! Secret Service agents, Vatican officials, hoopla beyond imagination, speaking in front of 50,000, then 90,000, then 200,000, then 400,000 people. What's going on here? Me, spending a week with church officials, schmoozing with cardinals, bishops, Opus Dei numeraries, kids from Catholic parish youth groups, and speaking twice to the Pope! This isn't my normal week!

I am so excited that I actually got to make "a-change-a-day"

Day 1 / Opening Mass, inviting people to pray, I altered the pilgrimage statements to include, "We are on a pilgrimage, *not to a single shrine or church, but to honor and celebrate the presence of God in one another, women and men of many races, languages, nations & cultures.*" In talking about Jesus' gift of abundant life, I stressed that it continues *through* us.

Day 2 / Papal Welcome, with the permission of our producer, I changed, "Our God, the Creator of this world, remind us that there is 'Room for Everyone' in our world" to "Our God, the Creator of this world, *Mother and Father to us all*, reminds

us . . ."What a joy that was! To break the gender idolatry and acknowledge God as Creator, Father *and* Mother!!! To 90,000 people! I wonder if they even noticed—did the Vatican officials?

Day 3/Stations of the Cross, where asked to read, "In our prayers and reflections, let us remember the many victims of discrimination, abortion, religious persecution and illness, all of those who cannot be with us this night," I asked our producer and changed it to, "Let us be in solidarity with the many victims of discrimination and religious persecution; victims of abortion, *rape and domestic violence*; the sick, *especially those with AIDS and other life-threatening illnesses*; those who cannot be with us tonight—the World Youth Day pilgrims who couldn't make it here, but also those who are *oppressed or excluded in any way.*" This event was the best event of the week!

Day 4/The Papal Vigil was a highlight for me in some ways. I was asked at the last minute to read the words to the Magnificat between the sung Taizé Magnificat refrain. I asked around if I had to use the Taizé version or the Vatican approved translation, finally, M. told me to do it anyway I wanted—and I read it in inclusive language! (Obviously, there was plenty of "God the Father" language all week, no balance with "Mother"). I read, "The Almighty has done great things for me, Holy is God's name! *You have shown mercy . . . You have cast down the mighty from their thrones, and have lifted up the lowly . . . You have filled the hungry with good things, and the rich you have sent away empty . . .*" This, truly, was the peak experience of the week for me personally. To read these words, and in a way that made God more personal and accessible. AMEN!!!

Day 5/The Closing Papal Mass, in my final good-bye to the crowds as they were departing, I expressed gratitude for being there and hope that, " . . . inspired by the many testimonies we have heard, *may we go forth from here as instruments of God's peace, struggling for justice and equality in our church and in our world.*" How liberating to just say the words, "justice and equality in our church"!!—wondering if anyone even heard, yet people did applaud, and three female youth forum delegates immediately thanked me and expressed their own dismay at the youth forum message to the Pope. (I found it more conservative than anything that the Pope said!).

Just for these changes, call them small or significant, I am so very, very grateful and glad that M. issued the invitation and that I finally accepted. Thank you God!

And TWICE I was able to say a brief message to the Pope. The first time I greeted him, on Thursday, I said, "Please, listen to the people of Haiti. Please,

hear the cry of women. Please." And as he walked by me, "Hear my plea." He said, "Yes, yes." Then, on Saturday, I said, "Please, listen to the poor people of Haiti, listen to Bishop Romelus, he is a *good* man. Do you understand?" He responded, "Yes, I understand."

Surprises, Lessons Learned and Telling Signs

Interesting though, I was not to change *any* text once the Pope was on the stage. Every word while the Pope on the stage is pre-approved by the Vatican and can't be altered. I added a line, "Holy Father, you have come here to strengthen us in our faith, *and you have kept our spirits high, even in the rain!*" The crowds went nuts with cheering! This shows something—how LIVELY and good it is to acknowledge and respond to the CONCRETE REALITY of the people. A pre-approved script gets so boring, it is a "dead" script because it doesn't respond to the very life of the people. Something as simple as acknowledging the rain brought shouts of response! Such a simple thing!

The same was true when the Holy Father took the microphone and spoke without a text from time to time . . . those were the most exciting, interactive times that really elicited a response with the audience.

Interesting that at the end of the Papal Vigil, the Pope prayed the Our Father in Latin—in song. And *very few* people knew the Latin words! Such a symbol—of the Pope speaking to youth, yet losing them with Latin. This is a post-Vatican II generation. Such a telling incident.

Interesting at the Papal Welcome that they had a wide screen behind the Pope's chair—a monsignor or two was hustling and bustling behind it, orchestrating things, showing the Pope what to do, etc. I ask, "Who is the man behind the Pope's chair? What a symbol! We see the Pope, but there are others who pull the strings." One is a monsignor and I want to know if he is Opus Dei. That is a chilling thought to me. Who is he? Who are they? What is the nature of their position, their influence, the work?

Interesting that at the Stations of the Cross, the section whose seats are least filled is that of the bishops and cardinals. Is it that they didn't want to come to this event? Because the Pope wasn't here? Or there wasn't a Mass to concelebrate? Or was it because there are fewer vocations? Fewer priests? Fewer bishops? Because they didn't want the bishops that close to the youth? The youth couldn't use those close-up seats? What?

Surprising to be interviewed on TV, radio, newspaper and to be photographed on the sidewalk and mobbed in the hotel lobby by a bunch of young Mexican girls. They grabbed and touched me, exclaiming and begging me to talk with them, tell them my life story, talk about my faith, saying they would stay up to any hour of the night to visit, and what was it like to touch the Pope, and what did he say to me. So, I told them what I said to him, about Haiti, explaining about Haiti—that the Vatican is the only State to recognize the military dictatorship, etc., and they seemed to understand and be with me. I then said I asked the Pope to "listen to the voices of women"—and they were so excited, and I went on to explain that I believed that women should share fully in the ministries of the church such as ordination, and they looked blank, dismayed, and their two adult women leaders shook their heads and fingers and said, "this isn't right," looking very disapproving. One said she would give me *una hoja* [a sheet] to explain it to me, and I gave a hearty laugh saying, "Great! Maybe you can 'correct' me!" They walked away, and later one of them gave me a little Msgr. Escrivá card.

So, this was very paradigmatic of World Youth Day—Opus Dei was very present. Yet, they looked to me as a spiritual presence, a spiritual person who was able to embrace the Pope. I am sure my views on women created a *choque*—cognitive dissonance. A stumbling block. Maybe they'll never think of it again, and maybe they will remember it and someday hear something else in that direction. Who knows! God, it is in your hands!

Concerns and Critique

It is true what some of the people I interviewed in Brazil say, that the Pope is so protected and removed from the reality of the poor and from the reality from women. It is true. Everyone at these events with "access" to the Holy Father—that is, those showing him around, holding the microphone, telling him what to do, sitting beside him on the stage or altar—they are all men. Bishops, cardinals, Vatican functionaries. A few looked like Italian big-business men. All men, usually clerics, mostly Italian, most rigid, stern, with an air of self-importance or "I'm-running-the-show."

When asked by Channel 4 in Denver what I would say if I could talk to the Pope, I said I would tell him to spend time at the margins, with people who are excluded from systems of power, the poor at a soup kitchen, the homeless at a shelter, women at a battered women's shelter, etc. To leave the confines of security

and protection and elites and mix with those at the margins. Conversion comes through the grace of relationships—as Leonardo Boff said, you have to feel the skin of a woman; as Clodovis Boff said, you have to kiss the leper. Being around the Pope for three days confirmed this view.

Surprising and painful Wednesday night, to be involved in the pre-mass animation. When I said, "By coming here we are telling the whole world that we believe in Jesus . . ." the crowd, thousands of young people broke in with applause and cheers! I was so moved that I got chills! That many people happily proclaiming their belief in Jesus! I was both moved by their faith, and moved because of how hard it is for me to have faith sometimes. My whole Brazil '89 experience, shattered pieces of glass, that's how my faith felt for months. " . . . and his promise of abundant life. We believe that through us, Jesus continues to share this abundant life with all people, everywhere." They cheered. So moving!

Then we invited the people to silence, to listen to the voice of God. Then the bells. Then the music. Then the procession of cardinals and bishops—hundreds and hundreds of white hats and robes, filling the aisles, altars and front seats. A strong feeling of pain and dissonance traveled through me, compelling me away from the stage, the altar, away from the mass. Our part was over. The youth cheering back at our words, over. The front seats half occupied with cardinals, bishops, priests. One thousand concelebrants. The youth became the spectators. The celebration becomes a spectator event. The clerics take over.

Sad. Disturbing. Excluding. A vision of church I don't hold. I am a part of this church, I choose to remain a member, but there is something very flawed in this order, this structure, this theology. Even with an all-male clergy concelebrating, imagine the symbolism if there was a half-circle of seats for bishops right in the middle of the thousands of youth—a more inclusive image of church. Not to happen.

All men on stage, in robes and hats and crowns, their time had come. We can do the warm up, but the youth, women, blacks and Hispanics become spectators to the spectacle of the male. To be a part of this multicultural worshipping community is a joy, but who and what are we worshipping? It is so top heavy, so male, such a pyramid. This is our church. Not amen.

Again, the Papal Welcome, how AMAZING to see 90,000 young people just explode into cheers any time the Pope's face even appeared on the video screen. They exploded into shouts and cheers when the helicopter came in view, and they exploded again when the Pope Mobile started its rounds! This is 1993, most of these youth are American (U.S.), this is modernity, and they are going

nuts over the Pope. Thousands of camera flashes, cries, tears, euphoria, cheers, "John Paul II, We Love You!" And "El Papa! El Papa!" over and over and over. "Mexico, Siempre Fiel!" Utterly amazing.

And I was filled with such ambiguity. At times I couldn't clap, I wanted to go back to my chair. Encouraged to see young people "of faith," but disturbed that this all goes towards the Pope—knowing what the Vatican has ordered in Brazil, the stands it has taken in Haiti, the exclusiveness and elitism of the structure. And I think, this is too much power. This is too much power for any individual to have. And if an individual has this much power, they should use it to be more prophetic. To denounce and announce.

And that is what I wanted from him—flesh out those statements more—what do you mean by a "culture of death"? What do you mean by "defend life"? But at Sunday mass he was clear: "Defend life—of the unborn, the poor, the vulnerable, the homeless, the unemployed, the immigrant, the refugee." OK. But Thursday night, I wanted more than platitudes about "Believe in Christ." What does that mean? What does it mean to stand on a stage in front of 90,000, 200,000, and 400,000 and let them cheer you, swoon, cry, "worship" you???

Gratitudes and Appreciations

Best event was the Stations of the Cross, the only event of the youth for the youth, prayerful and filled with social justice themes, that wasn't up-staged by the Pope's arrival or by a Mass concelebrated by hundreds of White Hats. Very prayerful—a bit too much "man/he" language, but otherwise, very good and meaningful themes. Beautiful ending, also, when everyone doing the stations joined hands in prayer around the cross—and Cardinal Pironio (from the Vatican) joined in the circle. Nice also that they had a woman mime playing Jesus!

Several times the Pope interrupted pro-Pope cheers to direct people to Christ. At the vigil, he said, "We have confidence in Christ." (A few cheers) Then he said it louder, more cheers. Then he said it a third time, quite loud, many cheers. But, in the silence that followed, the youth broke out into pro-Pope cheers ("El Papa!" and "John Paul II, We Love You!") And he said, it is not the same. He spoke about Christ, the Good Shepherd, One in Christ, Abundant Life—pointing people to Jesus Christ, not to himself.

Sadly, though, the structure is set up in what I find to be an idolatrous way—the build up when he enters a stadium, etc. It promotes Pope-worship! And look

how in the first few centuries Christians were put to death for denouncing and resisting emperor worship. Looking at him so close on the stage, I still think—He is just a man. A kind, lovable, endearing man. But a human. When people say he is the closest thing to God, when people ask me if I think he is a truly "holy" man, I respond that I believe the structure he lives in is a real impediment to holiness! I do believe that. Surrounded by men, power, prestige, etc.

My mini-conversion came at the Papal vigil—two things: First, I realized that it is a *great* thing the Pope is doing, bringing these young people together, that they could pray the Stations of the Cross together, or read aloud to 2,000 people the letter of Diogentus. Very moving, compelling, important.

Second, to be able to pray the Magnificat in front of so many people, all gathered in the name of their faith. Very moving, inspiring, humbling.

I really had a thrilled, happy, humbled and grateful, grateful heart that night, closing with "Thank you God! Thank you Mark P.! Thank you!" Disturbed by the U.S. news coverage—looking at several papers that continually gave headlines to the Pope speaking out against abortion, then the article quotes him calling for us to "protect life, defend life." It seems that in reporters' heads, "life" means the life/fetus of the unborn. But, on Sunday, surely, the Pope fleshed that out as "the life of the unborn and those close to death, the poor and the most vulnerable, the sick and the unemployed, the immigrant and refugee." It is more a seamless garment. What, is this a problem with the press? Or a more over-arching problem with U.S. society and values, that we don't see the grave ways life is sacrificed to our idolatrous culture of death?

K. calls asking, "Could it be possible that I heard that you said, 'Holy Father, please give us your blessing'?"Yes, K. it's possible.

Then John Kavanaugh reminds me that I want to work in/with the church, that being around the Pope and Mother Teresa (who didn't show up) will either inspire me or deepen my critique of the church (the whole experience has done BOTH!). Encourages me to be open to all that may happen there.

P. tells me that she doesn't have the energy anymore to work at that level, so much "within" the structure, at this type of thing, but encourages me to go with all of my energy and try to be a presence—surely a presence who will make it "less bad" than if they chose someone reactionary. But she warns me not to expect to make any kind of a difference in the events, other than being a bridge to the youth. (Unfortunately, our schedule left us very little time with the youth! And fortunately, I felt I did make a tiny, but meaningful difference at the events!)

Very, very interesting! A mix of voices! My younger friends are more shocked that I would dare commune so closely with the hierarchy. The older voices see more the shades of gray and the need to be in dialogue with the various levels of the church.

So, why did I go?

1) When I was in high school, in Christian Life Community, I would have *loved* to participate in this kind of event! Not to "meet the pope," but to meet other Christians from around the world! To party, travel, pray, sing, play, etc. A delightful reminder of this is that Michael Simon was present at 2 of these events and Gene Klosner was singing throughout the week—friends I made at a CLC conference 16 years ago!!! In that memory, I said yes.

2) I have chosen to remain a Catholic Christian, to marry and worship and study in the Catholic Church. I am not a member of Women's Ordination Conference, though I am sympathetic with their concerns, nor of Dignity, though I am sympathetic with their concerns. This is *my* church, and I am *of* this church. I will not relinquish it to "those I disagree with," nor will I close myself to a respectful dialogue with them. Moreover, I am extremely *grateful* for all the church has done for me!

 The church is my COMMUNITY—Catholic Worker, SLU, Weston, our prayer communities in Cambridge and Oakland, the Christian Solidarity Project, etc. The hierarchy and Vatican is only one dimension of this church. I am no purist, nor am I pure. The church is not pure, nor am I. Other religions and institutions carry other sins and failings; I do too! I want to work in this church.

3) The main event for me is World Youth Day, not the arrival of the Pope. When I read up on the stage, when I greet and encourage and interact with the thousands of youth, I am not afraid because I recognize that they are my sisters and brothers. I am not speaking to or for the cardinals and pope alone, I am speaking to and with the youth. This is the important thing. When people compliment me on my reading or speaking skills, my voice or diction, I tell them that my training is from reading the Scripture in Church and from preaching. This is a church event, not a media event or publicity event or a rock concert or spectator sport. It is church. It is for and by and with the young.

And what difference does it make now?

1) I feel, hope, pray I did make a difference. First, all of those "change-a-day" things! Small but meaningful, sowing seeds.

2) I believe it is important to have spiritual leaders who reflect the different faces of God—men and women, Hispanic and white, African-and Native-American, disabled and able, married and single. So, I feel honored, grateful and joyful to be a woman of spirit, a woman who is alive with the spirit, a presence that says to the gathered community that women are alive with the spirit! Interesting, also, how on the last two days, so many bishops complimented me on my presence and speaking and language skills. Hmmm.

3) I feel a renewed and deepened (refined by fire!) commitment to work in the church, with the church, for the church, though it sometimes feels like "against" some dimensions of that church. For example, just meeting Luke and Tom—such kind people who are Opus Dei numeraries. The theme song, "We are one body, one body in Christ"—it is true. Luke and I are in the same church. Now, maybe he would exclude me if he could—from ministry, I'm nearly positive he would; from participating in the church, I don't think so. It is a complex world of many shades of gray, and the one bright spot of white is the One who is the giver of abundant life, the includer of the excluded, not the judging sword of death. I, too, must be open to seeing Opus Dei members as my sister and brother, the Pope as my brother, Vatican functionaries as my brothers—as I must also name sin, challenge corruption, denounce oppression and exclusion, speak truth to power.

I ask also that others challenge me, and may I have a humble heart to hear it and open myself to conversion, to God's grace, throwing myself on God's mercy.

A School/2

After the exhilarating World Youth Day experience, Mev jumped right into her doctoral program at the GTU in Religion and the Arts. Early on, she became acquainted with Maria Bowen, a doctoral student in spirituality, with whom she increasingly spent time. She also continued her Haiti solidarity work with local activists Pierre LaBoussiere and Nancy Laleau. But even as she began her study, her experience earlier in the year in El Salvador was raising all kinds of questions to her about higher education. She sent the following letter to St. Louis University President Father Lawrence Biondi.

6 September 1993

Lawrence Biondi, S.J.
St. Louis University
221 North Grand Boulevard
St. Louis, MO 63103

Dear Father Biondi,

Greetings from a SLU alumna living in California. I hear good words about you from both my father, Peter Puleo, and from some SLU faculty with whom I keep in touch, such as Sr. Dolores Greeley. Congratulations on your good work.

I am writing in response to the "Campaign for St. Louis University" materials. You and those who worked on this produced a beautiful publication with an attractive layout—which I appreciate as a professional photographer. A while back, when I was heading to El Salvador for a meeting, Fr. McGannon gave me some literature on *both* the SLU Campaign and for the UCA-El Salvador Campaign. (I imagine you are familiar with that publication as well, put out by the AJCU in D.C.).

As a graduate and great fan of SLU, and as a person who has been active in solidarity work with Central America for more than a decade (which I began during my student years at SLU), I was jarred by looking at the two campaign booklets side by side. I am very impressed with the UCA's attention to "Social Outreach," their ongoing analysis of the "national reality," their attention to institutional violence, defense of human rights, and to bringing together people from across the political spectrum to try to encourage a more just, humane society. They are explicit in their aims to educate the privileged (the literate and college-bound) to lead and serve the needs of the majority of the country. While the SLU booklet mentions community service and scholarship funds, these themes of immersion, analysis and engagement in the local social reality are absent.

Clearly these positions have been shaped by the national reality of El Salvador: wealthy elites and impoverished masses, civil war, corruption, brutal disregard for human rights. The philosophy of education developed by Ignacio Ellacuría, Ignacio Martín-Baró, and, since their deaths, by Jon Sobrino and Dean Brackley, was and is in response to that reality. Specifically, they sought and seek to be a *Christian* university and to make the option-for-the-poor *universitariamente* (*as* a university). Because of this vision, the six Jesuits and two women were killed in 1989, but their successors still struggle to keep the vision alive at the UCA and in post-war El Salvador. In fact, there may never have been peace negotiations without the leadership, vision and moral courage of Ellacuría and others.

Well, this brings me to the question: What would it mean for St. Louis University, as an *institution*, to more fully embody the social dimension of the faith and make an option-for-the-poor *universitariamente*? There have been good efforts throughout SLU's history—community service, scholarships, shaping the public debates. My own moral consciousness was shaped at SLU—through the example of professors and campus ministers—in a way that inspired me to devote my energies towards building a more compassionate and just world community. And yet, I suspect this is

not the case for most SLU students. During my four years at SLU, it was a small group of a lot of the same faces who joined Pax Christi, SLUCAP (volunteering in the inner-city), Amnesty International, etc. I wonder, institutionally and in our own local St. Louis community, what more is being done? I believe we have so much to learn from the UCA experience! One place to begin might be the writings of the Jesuit martyrs on the social role of a Christian university.

Might it be possible for SLU to generate its own such vision—rooted in a context of St. Louis and the United States—a vision that analyzes the national and *local* reality, that seeks to understand the institutional violence in the U.S., that promotes social outreach and defends human dignity in the St. Louis community. While our national reality is far from that in El Salvador, the levels of drug dealing, the conditions of prisons, the numbers of murders, unemployment, poor public education and other afflictions in urban St. Louis, especially on the Northside, are really tragic. This is *our* national/local reality. This is where we are called to be Christian as individuals and *as* a university.

Dolores Greeley told me of several projects where St. Louis U is trying to be of service to the local community. I am writing both to ask what is happening in this area, and to ask that the University (administrators, staff, faculty, students, alum) really listen to the example of the UCA and join in more dialogue with our local community to try to be a truly *Christian* university, a sign of God's reign of justice, peace, dignity and compassion in the world.

By way of concrete suggestions:

1. Perhaps select members of the SLU community could invite Dean Brackley and/or Jon Sobrino to help them shape a vision for a university in the U.S., to adopt a similar, though indigenous, vision.

2. Perhaps the University could establish regular dialogue with SLU alumni who are truly immersed in the life of St. Louisans who struggle with poverty, unemployment, homelessness and neighborhood violence. (The Catholic Worker Karen House on Hogan Street comes to mind as it is staffed by several SLU

alum. I also think of urban churches—in particular St. Matthews and the neighborhood center they participate in, since it is a Jesuit parish!)

3. Perhaps the University could begin "listening sessions" with the actual disenfranchised who live within a certain radius of the University—again, the unemployed, young people, the homeless, struggling families who have to cope with neighborhood violence and drugs.

I would love to take part in something like this or at least be kept abreast of such developments, and I could recommend other wonderful alumnae and faculty for this kind of project. There must be other similar initiatives happening somewhere in this country. Any such initiatives would have to include both women and men, religious leaders and African-Americans and community members from Midtown and from North St. Louis. Given the location of Parks College, more dialogue might begin with East St. Louisans.

Again, I write this imagining that many efforts similar to this are already underway, but the very difference in the campaign booklets reminds me how far we at SLU (and overall, we in the U.S.) need to grow in our vision. A bold project in this direction at SLU would not result in Jesuits and their friends being shot in the middle of the night. Rather, a bolder vision and a more courageous response to the "signs of our times" would build up the St. Louis urban community *and* the University.

Father Biondi, I thank you for your time in reading this letter and for your dedication to shaping the future of SLU. I have studied some of the writings of the Salvadoran Jesuits and was very inspired by my visit there in January. As a theology student and photojournalist, I have also been inspired by the academicians I have met in Brazil— Catholic theologians who teach 6 months in the university and spend 6 months in the Amazon building up Christian communities, or working with labor unions in urban areas. So, I have been shaped by this vision of socially-engaged-academics *and* the socially-committed Christian university.

These campaign booklets have been on my desk for 10 months now, and I am finally getting around to actually writing these thoughts to you. Perhaps, oddly, my delay in writing reflects how crucial I believe these issues to be for the future of SLU and our community. I wanted to wait a good while to see if I still felt as strongly as when I first saw them, and I do. In fact, I just spent three days working with and visiting with Fr. Gustavo Gutiérrez, the Peruvian theologian, and in hearing about the direction of theology and pastoral practice in Peru, it stirs me to want to do more to foster truly Christian social commitment in our U.S. practice and institutions as well.

If these thoughts provoke reflections or reactions in you, please contact me at the address on the first page. I would be glad to hear from you. In any case, I continue to wish you well in your ministry of administration at SLU.

Peace be with you and may God continue to bless you!

Most sincerely,
Mev Puleo

Seeing The World/3

While I studied for my doctoral exams for the following April, Mev kept up her commitment to submitting her manuscript to various publishers. One morning, as she came back into the study having gone through that day's mail, she sighed, "Another rejection letter, Mark. The count is now 20."

"I'm sorry the publishing world, Mevvo, is full of idiots."

"Maybe we can 'publish' it ourselves, make a lot of copies, and then when I give talks and slideshows, I can try to sell it."

Disappointment was slowly giving way to strategy. I could see it on her face.

Mev had been enrolled in the Graduate Theological Union's Worship, Proclamation, and the Arts program, and she was not convinced that she was in the right place. She was having difficulty finding faculty in the department who would work with her in her admittedly wide-ranging interest of linking photography (arts), with social justice, theology and spirituality. But in her first semester as a doctoral student in Berkeley, Mev excitedly told me that her favorite photographer, Sebastião Salgado, was going to give a talk in San Francisco on his work. "Will you come with me?" she squealed.

"Mev, maybe you can meet him."

"Meet him? I'm going to interview him."

Her photography teacher, Peter Pfersick, invited her to a reception before the public talk at which she went right up to him and began speaking to him in his native Portuguese. When I met up with her just before the public lecture, she told me that she had made an impression: "He was so caught off guard that I knew Portuguese. He said so many journalists just assume that English is enough."

"So did you interview him?"

"No, but he told me to come to the hotel tomorrow, and we can talk. I told him I was in a doctoral program, and I was hoping to do my dissertation on him."

"He must have been flattered."

"He said he'd be glad to meet with me, but he wasn't sure what his photography had to do with theology. I told him I was a photographer, too, and I asked him if I

could show him some of my stuff. He agreed! Marko, can you believe it: tomorrow I am going to hang out with Salgado!"

It was if I were going to spend the morning with Noam Chomsky at Au Bon Pain in Cambridge. "Mev, you never cease to amaze me. Is there anyone you won't approach?"

"Mark, you're too bashful. Really, people are willing to talk, you just have to make a little effort."

"Mev, not everyone who goes up to Salgado gets such a welcome and an interview."

"Maybe I *am* a little pushy."

"Pushy, smushy. You got the interview." We hugged in the crowded lobby of the Herbst Theater.

And the next day, Mev interviewed Salgado. When I later saw her, she gleamed, "I showed him my photos, and he told me they were really good. Some, in fact, he said were great. I was swooning."

They had a long conversation in which Mev began by telling Salgado about her work in liberation theology in Latin America and her interest in his work.

ᔕ

The Interview[71]

Mev: I did a masters in theology and I'm now doing a doctorate in theology. I want to focus on theology and photography—which is difficult, because there's not much written on this that I know of. I'm in theology and the arts, but the classes often deal with old paintings, religious paintings, the masters. I want to do something more contemporary, how photography reveals something about the meaning of life—if not explicitly religious, at least it is linked to the meaning of life.

I want to ask you—I have read very many articles about you, and in so many of these, they often speak of "religious iconography," your images are compared to scenes from the Bible, or a Crucifixion, or a Madonna, or the Virgin. It seems that many people, or at least those who write about it, who view your images, see a religious meaning. I have read that you don't consider yourself a religious person. What do you think when others see religious meaning or Biblical stories?

Sebastião: It's that they have something in common—a common vision. What is in the Bible is in my photographs. Persons. The Bible, and all religions, deal with human persons. Even in the Christian religion, God is represented on earth by his son, a human being. So in people's minds, God exists as human person. If you have a personal God, this God is in the form of the person. Since I am dealing with and photograph the human person, I think there does exist a great tendency to link one thing with the other. There is only one common denominator, and that's the human person.

 I have worked very, very much with religious persons, just as I've worked a lot with political groups, doctors, with everyone. Every one of these has a link to a social community, that is, they work together with other human persons in the hope of finding a solution to the problems of human communities. I worked a lot with Dom Pedro Casaldáliga, with Monsignor Proaño and with Dom Fragoso in Crataeus, but I never worked with one of these bishops in the sense of doing a religious work. I never thought of it this way. I never intended to do religious work. What interests me much more is the political work of these religious people. Later, there arrives a moment when this political work begins to be put into practice. Working in the Base Ecclesial Communities was really political work in many ways. I worked in Brazil with the Workers Party, the party that began to inherit so much of the political work that began in the church.

 Personally, I don't have anything to do with religion. But, I have this in common with some church people: working with social problems. And really, the church, at the core, has always worked in this field.

Mev: You say that you have nothing to do with religion, but do you consider yourself a spiritual person? Do you see a difference between religion and spirituality?

Sebastião: Absolutely. There has to be. There is a big difference between *believing* in definitive references of religion, and having at the core a certain social behavior that the church, also, often shares. Surely, for religious persons, more than mere religiosity is demanded, but there is still a great difference between religion and spirituality.

 It is possible to behave in a way very similar to religious people—especially because the church has a very social stance. More than mere religiosity is demanded, but it is very different.

Mev: Explain.

Sebastião: At heart, as persons we are very similar, very compatible and very close to one another. At the level of our concrete behavior and work. But a time arrives when we take different directions, where one believes in the dogmas of religion and the other doesn't. I don't believe in the dogmas of religion. This isn't my way, it doesn't work for me. I walk on the journey with my religious friends to a certain point, but I don't go in their direction.

Mev: So, you don't follow the dogmatic path, but your practice is very—

Sebastião: Our practice, our lived practice isn't all that different! But, I'm not a Jesuit or a religious, someone who doesn't deal with money. I earn money, I spend money, I have a job, I have some savings for my family, I have an apartment, I have all of this. I give away some of what I earn. But I also have to invest a little of everything I earn for my family's sake. I want to provide for and protect my children.

 So, at times, I take on commercial work. And I don't have this militant religious behavior of seeing things through to the absolute finish, of commitment to the very end. I do photography to survive. This is a difference that's very clear inside. But we have many moments when we are very close!

Mev: Do you consider yourself to have a spirituality?

Sebastião: I have, sure, I do.

Mev: You have said that photography for you is a part of your spiritual life, or a spiritual thing for you.

Sebastião: Basically, I attempt to do all of my photography in reference to the human being. This is the most important thing for me. Really, I am profoundly *egoista* [selfish or self-concerned].

Mev: Why?

Sebastião: For me, everything turns around a concern for the survival of my species. I am concerned about the survival of my species, of my children, the survival of my wife, the survival of my friends. This is a very deep and serious thing in the world! Thus, my spirituality revolves around this, and because of this I have had a great amount of work alongside religious persons, including Catholic persons who are vowed religious and don't have families.

But there is a big difference between my behavior and theirs, because I have a family, I have my neighbors and friends whom I love. I am very linked with my friends and neighbors. My great concern is to save myself and my species. In saving the human race, I save myself. So, when I look at religious people, especially Catholic ones who live in religious communities, I see how we are different. For example, I think of Dom Pedro Casaldáliga and Monsignor Proaño, these men that truly surrender their lives, the whole of their person, without any selfishness. They don't have this element of selfishness or "self-concern" in their love for their neighbors or friends. I think that theirs is a more universal love. Theirs is a very pure journey. But, at that point they leave my reality and enter into religion. I respect them, though, very much.

For me, the key difference is the element of selfishness in my concern for those I am close to, my family and friends. This is a very subtle difference, because really, up until a certain point we walk the same road.

Mev: You speak about selfishness, but you have a tie, a commitment with the whole world, that draws you out of yourself.

Sebastião: This *egoismo* [selfishness] is also very subtle. It's not a selfishness that focuses solely around me as a person. It is my selfishness as a human being because I am worried about and concerned for humanity. I am concerned for the future of my son, who has Down's Syndrome. My other son is in college, and I am concerned for him also. So, my great preoccupation for the whole of humanity is very linked to my more specific concern for my children, my family, my friends.

This isn't a stingy selfishness. It's just that my religious friends ultimately are accountable to God, and I am accountable to the people I am responsible for, those who are dependent on me. I think they don't have this kind of self-concern because they lack the close integration with real, concrete life. Though we go our different directions, we have much in common, and I have profound respect for their work and commitments.

The great part of my book about Latin America, *Other Americas*, was made from inside the Base Ecclesial Communities. I worked within these church communities to get most of these images—especially those in Brazil and some from Bolivia. I worked a lot with very militant Catholic activists.

Mev: Where does your hope for the future come from?

Sebastião: Look, I have hope that in the final hour we are going to return to that which is essential for our survival as a people, as a species. Throughout the history of humanity, we see that in the most difficult times human beings return to form a human group, a human community.

But, today, for example, there is a part of the world that is rich and developed that has more than is necessary to survive, and they have in common a strong individualism. They are very alone, very individualist, very selfish. This is an *egoismo*, a selfishness very much in the stingy sense.

We live in a very big urban community today. The Brazil of my childhood was an agricultural society by 70%. Today, urban Brazil is 76%. So, we used to live in community, very close to one another, but we are becoming more and more separated in this age. Why is it that people tell me, "You take photos of misery." I don't take photos of misery! The people that I photograph are not miserable because they live in groups, they live in community. I am very interested in human communities. Community is form of human richness! All human wealth comes from community! All the support you receive truly comes from the community. When you are in need, the community protects you spiritually, they comfort you. And they also comfort you materially. Even if you only need a little bit, they comfort you and support you.

For me, true human misery is the lack of community and the life of individualism. Look at a city like Los Angeles, with such a great number of people living alone, completely isolated. They lose their faith in life—not even a religious faith, but faith in *life*, faith in human beings. They don't believe anymore. They are *completely* alone, *completely* isolated. For me, these people live a life of *total* human misery. The level of need here is terrible.

When I went out last night and the night before to eat at a nearby restaurant, I see people who are so alone in this society, abandoned, living on the hard streets, cold winds blowing, other human beings passing by them on the street without doing anything about it. Me included! Because these people are completely dissolute. And I am not a part of the community of this person! And this person isn't part of *any* community. *This* is a truly miserable person!

Waiting; New York City; 1991
Mev Puleo

I believe that if we don't resolve our essential problem—that of living in groups—we will not survive as a species. And our species is a very recent species.

Mev: We have to learn to live more in community.

Sebastião: Absolutely. Community is our primary meaning! Our history *began* with the history of communities five or six thousand years ago. I'm not talking scientifically, but our history really emerged when we began to live in groups. All of our references—our written texts, music and all art emerged when humans began living in communities! Persons existed many years before this, but we didn't really exist because we didn't exist in a group.

And if we don't manage to overcome this problem of total individualism, we are going to disappear from this planet as humans, as a species. There were species before us, robust and physically much stronger

than us, like the dinosaurs. But, you know, I do *not* believe that our capacity to build sophisticated goods, electronics and technical equipment will resolve our human problems.

Mev: So ours is primarily a problem of human relations and nothing technology can fix.

Sebastião: I believe that the only solution to the human problems is that whether we humans love each other, or we don't exist and we destroy one another.

And these days our problems are progressing to a very serious level. Like I told you before, Brazil is an urban country of 76%. The whole *world* is becoming an *urban* world very, very quickly and bringing serious problems such as a deep individualism. Twenty or fifty years ago, we lived in a more social world. We have traded that for a more individual world.

Mev: Do you have a sense of community in your own life?

Sebastião: I try to make my friends really a part of my world. They come to my home, we go out together. I have a great number of friends. Look right here at the people of the Mother Jones Fund for Social Documentary Photography—I've worked with them for years now! They, too, are a part of my larger community. This is my true concern! I have a family and an extended group of friends that includes Dom Pedro Casaldáliga! He makes part of my family! For years and years, we've all been friends and even family with one another. Yes, I am very linked with community.

Mev: What do you consider the most important idea in your images, what would you most like to communicate to people through your images?

Sebastião: I hope that my photographs serve at least to provoke a debate. I want people to raise the issues! I want people to enter the photographs and not leave them without looking deep inside themselves to understand that they, too, are inside the photographs. This is also *their* history.

The workers I have photographed in recent years, this is *our* history. *His* father is there inside the photograph, because his father worked in a factory. *Her* parents are there inside the photograph because they worked in agriculture. And *my* father is also there because *he* also worked the fields! Understand? My brothers and sisters are there inside. This is our *family!* I want people to look at these photographs and realize that they are part of this human family.

Mev: I read a criticism of the religious significance of your work. The critic said that when you portrayed the blind woman in Africa as a veiled Madonna,

you made a universal symbol out of her, removing her from a historical context.

Sebastião: Look, those who wrote the Bible two thousand years ago were very, very wise in the sense that it is one of the greatest works in sociology and anthropology ever made in human history. So much is condensed in the Bible! The Bible isn't a religious book, it's anthropological!

So, for example, if you begin to get to know a certain human group today you will come out saying, "This isn't very different from what's in the Bible." And the content of the Bible is not very different from what is in the photographs of these human communities.

They are similar in that they both work very much in symbols. Symbology is very great in my work! Look at the computer—it's all encoded in symbols, but very condensed. In the past, symbols were very open, but in today's computer age, symbology is becoming more and more restricted, the doors are closing much more.

These symbols—in the Bible and in my images—seem similar. When you look at one of my photos of the gold mines of Serra Pelada, I didn't take any of these photos *intending* to create symbols! I never wanted to tell a story from the Old Testament! But these stories are repeated over and over throughout history. Look at the photographs of the depression by the Farm Security Administration. Certain paintings repeat the stories of the Bible, but these stories aren't *just* in the Bible! When you live within a social group, this history continues because it is the history of social groups. These are very important *human* stories!

Mev: I want to work on the theme of photography, and especially your work, as a door to a theology of incarnation. This is the same thing that you say—you don't need an explicit religious symbol in a work, but if we believe that God dwells in and among human beings, that human history reveals something about God. And human dignity is more important than church dogmas. I am more interested in starting with anthropology than theology, and core to a theology of incarnation is a reverence for human dignity.

Sebastião: Look, I believe that most essential thing in life is dignity. The *only* important thing you can lose is human dignity. Ultimately, *nothing* in human life beyond dignity is truly important. But if you lose your dignity, you cease to exist. You are finished. You die.

Mev: You call yourself a documentary photographer, but instead of documenting, you are ultimately concerned with communication more than documentation.

Sebastião: When you say document, what you want is to communicate something. A documentary photographer, for me, is a *vector*, linking one side with another. It is to be a bridge, to provoke a debate. You aren't going to document only to document. You have to have a reason, a motivation to document! And my motivation is social, is human. The purpose is to create instruments of debate, of communication.

Mev: You often say you don't take these photos to bother someone's conscience but to invite compassion. Do you think it's more important to stimulate a sense of responsibility than a sense of guilt?

Sebastião: Yes, much more. Because guilt creates a defensive stance where you attack. I try to create a situation where you can discover how you can help with these problems.

Mev: Do you think that photography has a role to play in conscientization?

Sebastião: Certainly. Photography is a form of conscientization. At least, this is a great hope. In fact, if I don't believe that photography is a form of conscientization, it isn't worth it to photograph. But it *is* worth it.

 I think that many different windows have to be utilized—the press, slide presentations, museums, art galleries. *All* channels of human expression have to be used. I don't believe I have to protect some people. When I showed some of my photos from Africa here in this country, people were shocked. Because people here are very protected. People here are living a certain lifestyle, while 95% of the human population isn't living this way. In this context, I believe we have a very great responsibility to communicate this reality. To communicate and communicate.

Mev: To wake people up . . .

Sebastião: Absolutely.

Mev: Do you have a last message to share with a student of theology? For me to take to the world of theology?

Sebastião: The most important thing is that we are all from the same family. This is really important. We are from the same human family.

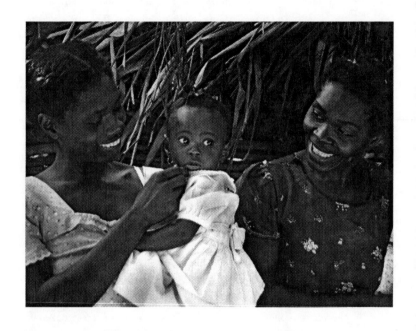

Together; Port-au-Prince, Haiti; 1986
Mev Puleo

Hair/I

In the fall Mev received word from Lois Patton, an editor at the State University of New York Press, that the Albany publisher would be delighted to publish her manuscript sometime in 1994. Mev's persistence paid off, and she was affirmed by Lois's belief in the importance of her project.

I had a conversation with her about how she should certainly submit an author photo, not surprisingly one of my photos of her (of which I had accumulated several hundred—it got to be so that I would boast to friends, "There are two photographers in our family; Mev photographs the world, and I photograph Mev"). She didn't immediately see the point until I reminded her, "Well, are you sure that people will know that Mev is a woman's name?"

"Ah, you're right. I still get mail addressed to Mr. Mev Puleo, or even Fr. Mev Puleo. The assumptions people make!"

"You could just have them put in the author's bio, something like 'Mev Puleo is a photojournalist who works primarily with the religious and alternative press. She received her master's in Theological Studies at the Weston School, blah, blah, blah . . .' So, they *could* use words to indicate your gender."

"Hmm, I get your point. Which photo do you think would be good to use?"

"What an embarrassment of riches!!"

I had thought of the hundreds, no, thousands of books I'd held in my hands in libraries and bookstores across America, and, always, in my initial inspection, I'd check for the author's photo. I'd wonder about the face, the smile, the eyes beyond the tome, tract, manual, novel, history I was weighing in my hands. I'd ponder the connection between the ocean of words and the physiognomy of the creator who strung those words along, page after page, coffee cup after coffee cup, missed family meal after missed family meal.

And here was Mev's book on liberation theology, another work on the subject. It had, in its own way in theology, become somewhat popular, considering the number of books published on the movement from 1975 to 1993. But this time, a book on liberation theology had been done by a beautiful young woman! (I remember

a Maryknoll missionary telling me once about an American journalist he knew in Guatemala; she was brilliant and stunningly attractive, a combination which, along with the requisite chutzpah needed to get along in Guatemala, served her well in getting stories from high-ups in the military. The missionary admiringly said, "She didn't bat an eye when she was talking to some officer. And, believe me, they paid attention to her.") I knew that Mev was very attractive and that a photo of Mev might catch a person's attention—male or female—in the bookstores, when they were browsing.

Mev warmed to the idea, and we eventually agreed that a photo I had taken of her a few weeks before our wedding would do just fine. Actually, we had a debate about this. There was a series of shots I'd taken of her outside of the cottage of the Berkeley Presbyterian Mission Homes where we lived our first year in Berkeley. One of my favorites was of her after I told her to lean over and shake her hair vigorously to the left and right so as to poof it out. She preferred an earlier one in the series, more tame to her eyes, although this rejected photo become the cornerstone of my personal gallery of wonderful Mev shots.

As one added joke to the whole proceedings, I told Mev I wanted photo credit, since that had been one of her pet peeves in the religious journalism world: "These places think that I work for free, they expect my photos for $10 or $20. And often they don't even give me credit." Mev sensitized me to this justice issue for photographic laborers; I invariably check when I see an arresting photo in a magazine or journal if there's a photo credit given. (I should note that Mev often gave her photos at a reduced rate for progressive, if not marginal, magazines that didn't have much money or experience in working with photos.)

"I don't want any money for the photo, that's fine, but I would like the credit to go to my photographic pseudonym."

"OK, let me guess, Marko." Dramatic pause. "Well, there can only be one credit for this photo."

"You're reading my mind." I'd written Mev many postcards and letters using a variety of aliases and nicknames, but one had a special appeal to me, one based on my paternal grandmother's maiden name.

And so when her book came out, there was a respectable pre-wedding shot of Mev, and the only extant credit given to a photographer whose work is quite good in its circumscribed field: M.Y. Salzman. I, however, enjoyed the one that didn't make Mev's cut, as well as many others I'd taken of her.

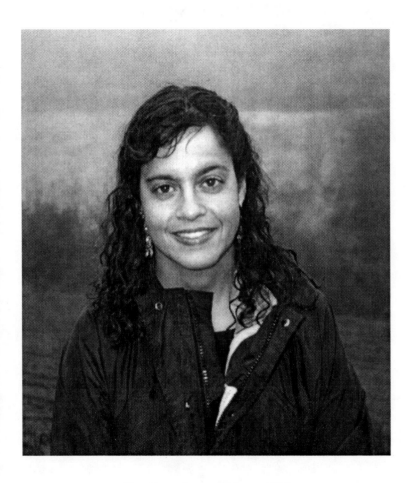

Mev; Marin County, California; 1993
Mark Chmiel

Meanwhile, Elsewhere in The World . . . /4 (Uprising/2)

Letter from Mexico

January 6, 1994

Here we are, the dead of all times, dying once again, but now in order to live.

During these past ten years more than 150,000 indigenous have died of curable diseases. The federal, state, and municipal governments and their economic and social programs do not take into account any real solution to our problems; they limit themselves to giving us charity every time elections roll around. Charity resolves nothing but for the moment, and again death visits our homes. That is why we think no, no more; enough dying this useless death; it is better to fight for change. If we die now, it will not be with shame but with dignity, like our ancestors. We are ready to die, 150,000 more if necessary, so that our people awaken from this dream of deceit that holds us hostage.

Subcomandante Insurgente Marcos
from the mountains of the Mexican Southeast[72]

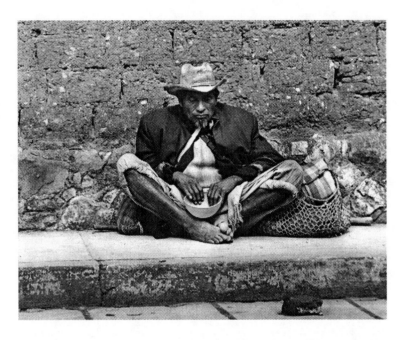

Empty Bowl; Chiapas, Mexico; 1983

Mev Puleo

Letter/I
(Mutual Aid/2)

Dear Mevinsky,

So, about your PhD. I know there's already been a few roller coaster rides around the GTU theme park of academic hoo-hah's. And there's a time for everything a season and so forth, and there were times in which I cranked out a pep talk when all you really wanted and needed was a nice Nhat Hanhian deep listening. You know, we've had our discussions while walking down and up Grand Avenue, about things like mission, goals and vision. See, I am not bullshitting you—you've got, it seems to me, a clear vocation, that of bridging. You yourself have used that as shorthand for years. Now that's not to say that the image can't be further illuminated by reflection, brainstorming and praxis. But it's way more than a lot of people have; plus, there's a strong case to be made for the moral/practical/political necessity of bridging.

Also, you've got the threefold typology, or classification, of your own interbeing skills: photos, to make us see; education, to raise awareness; social justice, to take to the barricades, or better, to stand up for something in a world given over, as the John Dears and Dan Berrigans might suggest, to death and death-dealing (and covering up, as Sobrino would say). Interbeing would further reveal, in your situation anyway, how each one of the 3 contains the other two. Taking photos is contributing to raising awareness and social justice; social justice work and issues—the world as we know it—gives you your arena, and *conscientizaçao* gives you your dynamism (as opposed to narcissistic ego wanting to get hung in swank museums).

Now, how can the GTU help you out in all of this? Well, it seems to me that there's good work to be done clarifying the nature of photography/social justice style; see, what you need to do is pair off the three elements and see what connections and possibilities you can come up with to make the GTU experience zing and hum—you've got three and a half more years at least to continually refine this vision.

Again, I can't stress enough how unique your *weltanschauung* slash praxis is; well, I take that back, Bob Lassalle-Klein seems pretty rooted in the whole UCA experience and a theology of solidarity etc., and he's just starting to learn to academically put it out there.

So, photography [Salgado] and *conscientizaçao* [Freire]—there's an essay right there, simply applying the Freirian method vis-à-vis photography. There's a place therein for critiquing the speed and commodified eclipse of the Other, of the face-to-face connection. In your own work as a photojournalist, there are more and more slideshows you'll be able to give, combining fresh narrative brought from the margins, along with visual prompts to Buddha/shine, and drawing on preaching/public speaking efforts because you know, it's not so easy to be a riveting speaker, there's so much inner work that needs to be done, and that's why I am glad you've got Jude Siciliano to help nurture those questions you have about proclaiming prophetically in sites other than the usual liturgical scene.

Also, don't get me wrong; the point is not really you writing essays for essays' sake. I think you may forget how much already you are a Peak Learner—you're naturally thinking of a class as a structure for you to do a project (such as your trip to Chiapas this semester). But if you feel stuck sometimes with writing your own stuff, your own passion and questions, etc., then do this crossover between the pairs of your triad. This is also the way you work with faculty: "So and so" can help you with one or two parts of the triad but no one can do all three. OK, that's for you to create. But use people like Bill O'Neill in a lunchtime conversation to brainstorm, allow yourself to be in the fog, to be in chaos, remember that's what Fellini always tries to touch down into, because out of that mess, something decisive and audacious can emerge. Fear it not (geez, I sound like an artsy-fartsy preacher). Barry Stenger, too, rap with him about solidarity, images, etc. Make appointments with seven faculty, and then you can say you've tried that. But you've also already done well to go way beyond the GTU orbit, connecting with A.D. Coleman (that was a great idea), Salgado himself, Vicki Goldberg, and there are probably four or five others you can talk too, or I predict you will soon discover them in the next 6 months or so.

Part of what you need to keep in mind, in balance: (1) you've got your own creative photo work—slideshows, shows, jobs with mags, etc. & (2) you've got your own creative logos on photography, religion, theology, etc. No need to force the former to the margins as you do the latter. You should try to set things up so that they are each constantly feeding each other, i.e., your work with A. D. Coleman should help you see Salgado in a fresher, more critical, more appreciative light, while at the

same time teaching yourself along the way how to emulate or avoid Salgado's respective strengths and weaknesses.

Again, you are not only a photographer (and don't forget how far you've come since spring 1991 in Cambridge): the Brazil book, of course, but also Impact Visuals, courses with Peter Pferisck and your friendship with him, not to over-Bourdieuize, but that is some important social capital, in the field of photography, you've nurtured with him, the whole Looking Glass connection, your friend Merle and the darkroom, you've become more professional in the disciplined sense of the word, and that's all to the good, plus a zillion contacts and requests from coast to coast (while you've been away this week, calls from Nan Cobbey and the *Covert Action Bulletin*). Yes, you are your entrepreneurial father's daughter, BUT you are also a critic, student, and academic. No need to split off. Both need to be nurtured, and you have to think a little more systematically about how to do this, especially academically, since I have never heard you say that you want to get out of this whole photography business.

I mean, obviously, Sobrino's right: Be a liberation photographer. But by the same token, be a liberation critic. In your own way with photos the way Kavanaugh works with films in the *St Louis Review*. What is he doing? He brings his own theological vision to interpret the world of Hollywood, both in its stupid excesses and its rare moments of revelation. Again, as a theo-photo critic, your task is to help others critically and considerately take in and respond to the pervasive visual image. Simple as that. But of course, you need a theory and method and all of that and that will come (again, I stress that Bourdieu would be worth getting to know to help you critically understand what's going on in the field of photography. The important point being the social context of the reception—or dismissal—of certain kinds of work and photographers). But I think you will be smart to keep one foot in the academy and one foot in Chiapas or Brazil or East St. Louis or the Looking Glass on Telegraph Ave. You know that score.

As far as photographers you really wanna get to know, their work, their lives, their mission, their motivation, etc., fall in love. That's it—like Sister Karen told you about teaching the high school girls, "just love them," the same with your doctoral studies. Fall in love with your photographers, which is a natural extension of (à la Kerouac) falling in love with your own life (and doctoral program). And naturally, when you are in love with something and someone, you'll wanna talk and talk and talk, it gets you going and excited. So find people to talk with on a regular, sane, and enjoyable basis: Betty McAfee, Gordon, Michael, Peter, and Vicki. I'd love to see you swooping around here, with a mag in hand, exclaiming or denouncing, taking it out

to the street corner and saying to the guys hanging in front of Seven Eleven, "JeZZuss Christ, look at this image! How does this make you feel?" And Gerald down there, he'll be nodding, coughing, uh-huhing and seeing your point and telling you about some billboard he slept under and then asking you for a quarter but you give him a dollar in gratitude for talking with you as if you are not out of your mind.

And the challenge to you is to find your own voice in all of this. That's why I encouraged you to go to be with Coleman, because you said you loved the way he wrote about photography. Great. Now he's an example for you to find your own voice, your own *bête noires*, your own proclivities, your rages, your delights, and pass them on to others—in all kinds of media: From *Praying* magazine to *National Catholic Reporter* (why don't they have a monthly theo-photo-critic, even Danny Duncan Collum is writing about TV, why couldn't you slowly work your way into photo criticism) to *The Way* to the AAR to *America* etc. Plus, there are all kinds of media-culture-commodity aesthetics type journals.

Let's have a conversation about any of this. I'd be happy to write again in response to your response as well as chat endlessly at Coffee Mill. Also, I'll be happy to talk about mission, etc.

Mev, I love you. I love your career as it's unfolding. I love how you passionately move in this world, how you deeply give a shit about others. The PhD is a tool, a steppingstone, a gentle boot camp, a workshop, a cave, a playground and a darkroom. I love you.

Markuse

PART TWO

Accept loss forever

Jack Kerouac

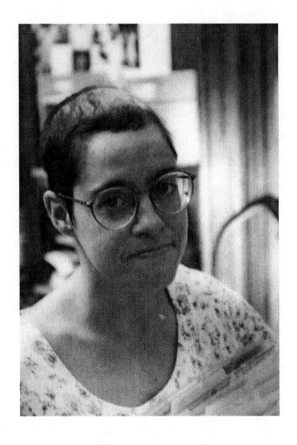

Mev; Oakland, California; 1994
Mark Chmiel

Peril

Spring 1994 was blooming in the Bay Area. We participated in a Good Friday demonstration at the Lawrence Livermore nuclear laboratory with Steve Kelly and our Pax Christi friends. The following week, we welcomed Noam Chomsky to our campus. On several occasions, we had both heard Chomsky fill the huge lecture hall on MIT's campus when Mev and I lived in Cambridge in 1990-1991.

Chomsky had a slew of engagements. He was kind to include the GTU in his overbooked schedule, which has been overbooked for the last decade and a half, as he is constantly on the road, all over the world, giving talks. That's what he does best: explicate the nature of U.S. foreign policy in a way that ordinary people can understand. This has long earned him scorn and dismissal by those with the proper PhD political science credentials. When I interviewed him in Cambridge, he said to me, "When I enter the Harvard faculty club, you can feel the chill from those professors." And even though he personally had no use for organized religion, he still had strong appreciation of the Catholic militants in Latin America whom he had met and stayed with throughout Nicaragua on a speaking tour there in the mid-1980s. His anarchist convictions were interwoven with his personal practices: Even though he was known world-wide as a linguist and philosopher of first rank and a radical political activist, he was eminently down-to-earth. He talked in as many monosyllables as possible because he believed that political commentators so regularly tried to make their specialty arcane and above the heads of folks. Chomsky was different. So, although I was delighted that he responded to my late letter of invitation, I wasn't so surprised. He's a *mensch*, I told Mev. Or, as my friend Angela, a Reform rabbi, exclaimed, "He's my rebbe!"

"Well, maybe *now* we can have him over for dinner. How long will he be here?" In resurrecting a plan she had while we lived in Cambridge to have Noam over for a simple dinner and chat, she was as relentless in thinking that we could entertain the world-famous Chomsky as Chomsky was relentless in pursuing the perfidy of American power in Central America. As if! I was back to my old standoff-ishness.

"Mev, I think he's got barely enough time to take a shower in the five days he's here, much less have dinner with us. Besides, Bob Lassalle-Klein told me the Catholic Worker wants to have him and his wife over for dinner before his fund-raiser talk for them that Friday night. So, then, we can visit with Noam."

"At last, it will be so nice to get together," she commented, as if she were talking about Steve Kelly.

I was responsible for picking up Chomsky from his previous appointment in San Francisco, a radio talk show interview. I arrived 15 minutes early, not wanting to allow some traffic snafu to throw off our event. When he came out of the interview room, clad in his brown corduroy jacket and blue oxford cloth shirt and khakis, I introduced myself and said, "You're so generous to come over to Berkeley to speak to us. We're all looking forward to it."

"Great. Think we have time for a sandwich before the talk?"

"Sure, let's get to Berkeley and hang out before the talk at 1:00 p.m."

As we drove over the Bay Bridge, Chomsky was quite interested in who the audience was for his talk. I felt somewhat apologetic, too, since I'd heard him say in interviews that he is often asked to speak on intellectuals and political responsibility. It seemed so elementary that it was amazing this issue was in such need of clarification. "Yes, our group of Doctoral Students for Social Responsibility tries to keep things lively on campus, even though most of us are swamped with preparing for exams or working on dissertations. This talk is open to the broader community. We'll have Haiti activists, Central America Sanctuary workers, disarmament folks, as well as professors, lots of students, maybe some administrators, and so on."

"So, what exactly do you want me to speak about?"

I was caught off-guard by his asking me that question. What, didn't he have it all down-pat in that genius brain of his? "I mean," he clarified, sensing some apprehension in me, "What do people need or want to hear?" I told him that I thought his basic framework of how intellectuals behave and how they ought to act is one that would be most appropriate to the academic environs, which, given its utter simplicity, would nevertheless be a challenge though not totally unfamiliar.

We went down to Euclid to a cafe and we ordered falafel sandwiches, while he reminisced about being in Berkeley where he lectured in the mid-1960s. Soon thereafter, over 100 people jammed into the GTU Board Room for Chomsky's talk on intellectuals and poltical responsibility. It was a wake-up call to us to find ways here to think, write and speak critically about our own national reality, as the Salvadoran Jesuits sought to do in their own context.

He was scheduled to give a talk on Thursday evening on the Middle East, but since I was going to the Catholic Worker dinner and talk later on at our church, St. Augustine's, I thought I could pass. Plus, I had my exams coming up in less than two weeks, and Mev had recently been experiencing these vexing eye aches, which required her going to the doctor.

At the UC Berkeley opthamologist office that Thursday, the doctor told us what might be causing the eye aches: "Stress." Mev wasn't satisfied.

"Tell me, doctor, what's the worst thing this could be?"

"The worst?"

"Yeah, the absolute worst."

"It could be a brain tumor. But I wouldn't worry about that. We need to set you up with a neurologist next week. He'll be able to give you a better take on this problem."

Early the next morning, Mev awakened me.

"Mev, what time is it?"

"I belong to Chomsky."

"You what?"

"I belong to Chomsky."

"Oh, you had a dream about Chomsky. I'm going back to sleep, dear."

She clasped my arm and responded, "I belong to Chomsky."

"That's fine, Mev, you belong to Chomsky. It's 5 a.m. I'm going back to sleep."

I turned over and tried to close my eyes. It was way too early to get up, even to study for my imminent exams.

Then Mev shook me: "I belong to Chomsky!"

"Mev, what are you talking about," I barked, as I agitatedly turned on the light.

She looked at me with a furrowed brow and quivering lips. She entreated once again, "I . . . belong . . . to . . . Chomsky."

"Mev, you were pissing me off, now you're scaring me. What do you mean you belong to Chomsky?"

She held out her hands, palms up, as if to say she meant me no harm: "I belong to Chomsky . . ."

"Mev, something's terribly wrong here."

And then, after a couple of minutes more of this repetition, she was finally able to blurt out something new: "Marko, I don't know what was happening. I couldn't stop saying that. I was trying to tell you something, but that's all that would come out."

I was stunned and thought back to an evening a month before, when Mev had tried perplexingly and in vain for 30 minutes to tell me to take breaks when I was studying. There was something on the tip of her tongue that she desperately wanted to tell me, but, to my bafflement, she could neither it say nor let go of the desire to say it.

"Would you call that neurologist for me? I'm so scared."

"At this hour?"

"Yes, I've got his home number, the Cal doctor gave me both numbers." She got up and went into the study and brought back her day planner phone directory.

"Mev, who calls a doctor at 5:30 in the morning?"

"Mark, *this* is serious."

"OK."

Naturally, I woke up Dr. Friedberg. As he shook off his grogginess, I tried to explain to him what had just happened.

"Do you think this is something psychological with your wife?"

"Psychological? What do you mean?"

"Is this a psychological problem, or do you think this is physical?"

"Dr. Friedberg, this is physical."

"All right, then. I will set up an EEG for her this morning at Alta Bates. I will call you back shortly and let you know when."

On the basis of that EEG later that morning, Dr. Friedberg recommended that Mev get an MRI. "When can I get one?" she asked him.

"I can try to get you one for early next week."

"No, no, *no*, Doctor, I want one today. Can you see about getting me in sooner?"

"I'll see what I can do."

That evening, we skipped the dinner with the Catholic Workers and Chomsky because we were awaiting for a phone call from the MRI center. At 8:30 p.m., we received word that they had an opening.

Mev's best friend, Maria, had been over to our apartment and, for the comfort of the familiar, we had just started to watch the Bergman and Bogart movie, *Casablanca*, which we had seen so often in Cambridge. We later drove down to Telegraph Avenue where the clinic was located, and Mev had her MRI. A physician was called over from his dinner in San Francisco to look at the scans. Mev overheard him use the word "lesions" when he was looking at them.

She turned to stare at me: "Mark, I have a brain tumor."

"Mev, we don't know yet what you have."

"Doctor, isn't it true, you used the word 'lesions'."

"I think it would be best to see Dr. Friedberg in the morning and let him interpret these with you. Yes, there are lesions here, but he's the one you will need to speak with about what your options are."

It was 10 p.m. Just down the street, Chomsky was probably into his second hour of questions and answers at the Catholic Worker fund-raiser. But Mev and I had just entered into an entirely new world.

Hair/2
(Letting Go/2)

The next day we met with Dr. Friedberg, who recommended we see a couple of neurosurgeons to see what could be done about the brain tumor Mev evidently did have. The second one we saw, Dr. Robert Fink, shared the various options, and we decided that Mev should undergo a de-bulking surgery as soon as possible. We came to this decision on a Tuesday and the surgery was scheduled for three days later. Family began to arrive day after day to offer their support and love. Friends from the Jesuit School of Theology held an all-night prayer vigil for Mev the evening before her surgery, while at our apartment, Steve Kelly presided at a liturgy with much appreciated grace and calm. One of our friends, who wasn't religious at all, came, and said to us afterward, "If all Masses or services were like this one, I could see why people would wanna go, even *I* was moved."

That April Friday morning, Mev and I, her parents, her sisters, our friends in Berkeley and a few from St. Louis all arose at the early hour of 5 a.m. to make our way to the Alta Bates Hospital at the corner of Ashby and Telegraph Avenue in Berkeley. After checking in at the hospital, we prepared ourselves for a long, uncertain morning. One of the necessary preludes to the surgery was the shaving of Mev's hair. Soon after that, she would be taken away for the surgery. I wanted to be with her as long as possible, so I stayed in an adjoining room as the nurse kindly and soothingly prepared Mev for a haircut unlike any other she had had. One of the hospital staff told me the previous day that nurses were quite sensitive and skilled in this part of their job, since many women about to have Mev's kind of surgery would go to pieces at the thought of losing their hair. Mev appeared quite steady as I gave her a kiss before leaving her with the nurse for the few minutes it would take to cut off her hair.

A few minutes later, I entered the room where the damage had been done. Even as I expected Mev to be full of dread—in a short time, her skull would be opened,

and Dr. Fink would literally have her brain in his hands—I was wondering how I would respond to her shorn of her loveliness. And when I came into the room and saw her, I gushed:

"Mevvie, you look so beautiful."

"Really, Marko?" she asked with hesitation and doubt.

"Oh yes! Let me feel." I ran my hands over her smooth, buzzed scalp, and stepped back again to consider.

"Let me see what I look like."

I thought: She looked gorgeous. Nothing had changed in an hour. She still radiated (oh, poor word choice given the weeks ahead) beauty. "Look, there's a mirror."

It was a small square of a mirror, and Mev went up to it.

I braced myself as I asked her, "Well?"

With her back turned to me, I could hear a giggle. No tears, no outbursts, no screams. She enjoyed a hearty chuckle at the sight of her new hair-style.

In a few minutes, she was taken away. Hearing earlier in the week that there was a 3% chance she might not make it back from the operating table, she suggested that we had to be ready to say our farewells when she left for surgery. We did.

The next time I saw Mev, about eight hours later, her gorgeous head was wrapped in bandages.

We all beat the 3%. And I say "we" because there were many people at the hospital and, as I later found out, people in remote places in El Salvador, Brazil, and Haiti, as well as people in cities in Europe, and people coast to coast praying for Mev's well-being.

Facing The Facts/I

After Mev's surgery, she was moved to the Intensive Care Unit and then spent a good two weeks in the neurology wing at Alta Bates Hospital. Her surgery had been on a Friday, and Dr. Fink informed us that he couldn't have the pathology report until the following Tuesday. He had gotten about half of the tumor, which had been the size, he said, of a California navel orange.

You've got to wonder. I did—an orange of pestilence nudging Mev's brain, encroaching upon its infinite mysteries? And he only got half of it? It was an occasion, I thought, of a "sorrowful mystery."

I spent the weekend at Alta Bates, getting familiar with the pay phones as I called people across the country to let them know that the surgery was "successful"; that Mev was able to speak; that, in fact, right after her surgery, she had reportedly asked a nurse for her beloved Carmax.

I was relieved that Mev had made it through one dark wood. But there was the prognosis ahead, which she and I did not fret over verbally in those three days before Tuesday, when Dr. Fink informed us, "It's a grade 4 glioblastoma."

"What's the prognosis, Dr. Fink?" we both tremulously asked him.

"For this kind of tumor, it's six to nine months."

Mev and I exchanged yet another look of disbelief. Then, Dr. Fink said, if he hadn't operated, Mev might have been dead in two weeks. He had said that the only way you knew was to take out the entire tumor and then see what it was composed of. Besides, the section they got for the biopsy revealed four elements, and that's why he gave the worst prognosis. Anything that might come up different from that would just be a pleasant relief.

"But you should know that that's just statistics. It's not a prediction. It's numbers. So many people who have this kind of tumor, the statistical average is 6 to 9 months."

Mev probed her neurosurgeon: "But aren't there statistics for people who live longer; I mean, what's the possibility for living two years?

"The stats say about 10-15% of people. But you should bear in mind—both of you—that you have a lot going for you that mere statistics can't take into account. You're young, you're very healthy."

"Except I have a malignant brain tumor," Mev interrupted.

"You have a remarkable disposition, plus you've got plenty of support. These are all factors in your favor for not being chained to the prognosis."

Dr. Fink left Mev and me alone in her room. Her head was bandaged, she had IVs in her arms, and she looked at me and said, "Marko, I am *not* going to be a six-to-nine month statistic." I could feel her verve on the rise.

"Mevvie, like Dr. Fink said, you have a lot going for you."

"I do, and I am not going to throw in the towel."

I addressed her, "You're loveliness."

"Marko, how can you say that? Look at me."

"I am and you are. When I call you 'loveliness,' please just accept that that's what I feel."

"You're the 'loveliness.'"

I remembered that the evening before her surgery, less than a week before, Mev had said to all of us assembled in our Oakland living room, "I've led a good life, I'm ready to say good-bye, or to say hello." And this was the roller coaster we became experienced in traveling: equanimous acceptance—and defiance.

Prayer/3

When I got home that evening, there were about 30 messages on my answering machine. I'd asked Pat Geier—who came in from Louisville—to take care of the phone lines (we had two, Mev had insisted, one for phone and one for fax, especially important for communiqués from Haiti and Brazil), and she presented the pad with wonderfully cursive and detailed messages. One interested me immediately—mesages of love from people from St. Cronan's parish in St. Louis, where many of Mev's old friends went to Mass. They were praying for her, this being the second cancer shock they'd received in two years, the first being the death of Ann Manganaro.

The folks at St. Cronan's had prayed long and hard for Mev that she would make it out of surgery as well as recover. A few of them suggested to John Kavanaugh that he write a prayer, and they would distribute it on a little card that people could put in visible places in their homes and say on a regular basis. So the message was from Bill Miller, saying that when Kavanaugh returned from Berkeley—he, too, had flown out for the surgery and was scheduled to leave on Wednesday—they would ask him to write up a prayer if that was all right; also did I have a photograph of Mev that they could use for the prayer card? I called Bill back and got his wife, Ellen, who admitted, "Mark, I don't know what to say to you. I can't believe this is happening again." I appreciated her straightforward inarticulateness and told her I'd send her a photo of Mev the next day with Kavanaugh (who, I found out later, had also been in touch with Bill Miller and had been jotting down thoughts while waiting those interminable hours in the hospital while Mev was on the surgery table).

This was the prayer that John composed, after he had revised it according to a suggestion Mev made:

> Good and Gracious God of all the heavens and the earth. In Jesus
> Christ, our savior, our brother and your Son, you have revealed the
> healing power of your love and your will that death be overcome. We
> pray that, if it is according to your will, your glory shine forth in the
> miraculous healing of Mev Puleo's incurable brain malignancy. With

the intercession and solidarity of your servants, Dorothy Day, Archbishop Oscar Romero and Dr. Ann Manganaro. We ask this through Jesus Christ our Lord. Amen.

Prayer is a mystery, to be sure. Both Mev and I would question what prayer was about, in dark afternoons of the soul, during which it was hard for both us to utter the prayer aloud. For one, it locked us into the whole inscrutability of "God's plan." There were scores, no, hundreds—who knows maybe more—who were reciting this in the U.S. and beyond, who were beseeching Oscar Romero (in Spanish?) and Ann Manganaro (in English?) to beseech the divinity and see that Mev was totally cured. But we would think perverse things like, well, what if Mev lives only three months, then what? What were all those prayers about? Would they just be for naught? And if Mev were healed, was that a result of (a) the sincerity, (b) the quantity and/or (c) the frequency with which people prayed and pestered the Almighty?

One day, a few weeks after Mev's surgery, she confided in me: "Mark, sometimes I have a hard time praying. And I feel so bad because so many people are praying and I can't always find any words. I'm not sure what I think of prayer or if I can even pray."

Tears were in her eyes. And I remembered how—suddenly—we'd had many people come by and visit, share a home-cooked meal with us, offer to help or run errands or just listen to Mev when she was more energetic and eager to engage, and I was so often struck by how quietly people left, how moved they were, how their faces were so awake as they left our apartment.

"Mev, you don't have to worry about words or any formula. Say what you feel like, if you feel like it. But have you noticed how attentive people are to you when they visit?"

"Yeah, sometimes."

"You're evidently giving them something without even knowing it. You're just being you, and I can see how people are touched not by your words . . ."

"By what then?"

"By your presence to them. It touches them so deeply. Think of it this way: your presence is your prayer. Don't worry about the words, OK?"

For that day, that was enough for Mev. She didn't have to—and moreover, she knew she couldn't—figure it all out. In late May and early June, she could just sit with me and our friends, grateful to have survived surgery, and be at home, and be able to walk again and eat Ben and Jerry's chocolate chip ice cream.

Crisis/2

Our friends rallied to our side, offering to do anything to be of assistance. KCYoung and Don Steele took on the formidable task of organizing people to do errands, cook dinners, and sit with Mev. Victoria accompanied Mev to the Women's Cancer Resource Center, while Bob and Lynn shopped for us week after week and bought our groceries. Terry put up our bedroom-darkening shades and our spice and vitamin rack in the kitchen. She and Maria eventually went with Mev to a seminar, "Cancer as a Turning Point." Eliana, a young, vibrant Brazilian woman with whom Mev had worked on solidarity issues, was beside herself in grief at Mev's illness; she begged us to let her clean our apartment, saying, "I have *to do* something!"

One evening Kathryn and Victoria brought over dinner. Victoria took the baskets with bowls of fresh pasta and salad into the kitchen while I took a chance to catch up with Kathryn. "Mark, I want you to know, I realize that so much of all this attention is going—rightly—to Mev. But I identify with you in all of this, what you are going through."

"Oh, thanks, Kathryn, that's so nice to hear." I took her by the arm for a more private exchange and walk down the courtyard path away from the apartment. "You know, it's so comforting to hear someone tell me that I never realized it, because my attention is—justly—on Mev, too. But this is taking its toll on me!"

"Yes, you have to be taken care of, too, and I want you to know, I am happy to help out in any way given my time constraints"—she was studying for doctoral exams, too—"but I am here especially for you."

We lingered in front of the giant redwood tree that marked the entrance to our apartments. It was about 5:30 p.m., and Victoria was still inside, likely telling Mev about her own dramatic theatrical piece about women surviving breast cancer. Kathryn looked at me and said, almost in a whisper, "You know, Mark. This illness of Mev's, it has really made me think about life, and death, and what we're here for. To tell you the truth, it's thrown me into a crisis. I am asking some hard questions about doctoral studies. Is this what I really want to do? Academics, publishing, conferences, gaming, climbing, especially for a feminist and an out-lesbian in the Presbyterian

church. Seeing what has befallen Mev—*and you*—makes me realize how short life is and how much academia is full of games. Anyway, I wanted to let you know that. I don't know what I'm going to do."

"But Kathryn, you've got to finish your comps, anyway, don't you? You're so close."

"Perhaps."

"You might as well at least get to the ABD stage."

"But hasn't this made you question your life, Mark? How can you think about comps?"

"I am not thinking about comps now. I'll resume them later on this summer, because I've got to help Mev in this stage of recovery."

Mev and I had not had extensive planning discussions at this time, but I had a sense that I knew what her aspirations were. Time management specialists often pose this question to their clients: You've been told you have six months to live before an incurable illness kills you. What do you do? People take their time brainstorming and prioritizing, and then they present their list to the consultants. Immediate question posed to the clients: If this is what is most valuable and vital, then how much of this are you doing now, short of the catastrophe? If you are not doing these things now, why not?

Even though Mev herself had some doubts about the PhD program at the GTU, her vision was clear. The forthcoming publication of *The Struggle is One* provided a much needed precedent and boost to her confidence that such book-projects were her future, however long her life was. I remembered that she had wanted to accompany me to East Timor, and during our honeymoon, she was excited at the prospect of doing a book on church-based resistance to the Mafia in Italy.

Mev had been struck with this tumor, and yet, two months after her surgery, I could discern no dramatic departures. She was planning on continuing at the GTU, doing her work on Salgado, promoting her book and seeing how things went with the radiation and the chemotherapy.

Others besides Kathryn spoke the same way: "Mev's brain tumor has changed the way I look at life. What am I doing with myself?" I pondered Mev's life: If she had six months, nine months, or three years, as we were hoping, she would continue being a photojournalist, giving talks and slideshows on Haiti and Brazil and traveling, health permitting, to East Timor or Sicily.

Being Present/3

During the late spring and early summer of 1994, I or a close friend would accompany Mev on her daily regimen of radiation. We were struck that the machine in which Mev laid for her treatment was called a Mevatron. Initially, she was nervous. "Marko, I'm so afraid, what if this doesn't help?"

"We can hope that it will do some good. I will hold your hand as long as I am able."

"Thank you, schoochers. Maybe I could pray while I am getting radiated."

"What do you have in mind?"

"Oh, a little gatha, something to keep me focused."

"Maybe you could combine some visualization imagery, too."

"Yeah, something like, 'Breathing in, I am growing calmer. Breathing out, I see the tumor getting smaller."

"Excellent! Nhat Hanh would be so proud of you!"

"Breathing in, I entrust myself to God, Breathing out, I see the tumor disappearing."

Her brain may have been under siege, but Mev had presence of mind.

Mutual Aid/3

Soon after surgery, we had faced the decisions of what next. The de-bulking surgery was a temporary relief, and there was no definite cure. It was all a matter of time. Dr. Fink recommended that Mev pursue radiation and chemotherapy thereafter, but this was her—our—decision, since Mev made it clear to all of us that she was interested in having a high quality of life. And for Mev, this already meant a very high standard of vitality.

One day just after her radiation treatment, one of the nurses told Mev she needed to check her blood count. When the nurse applied the IV, Mev responded immediately.

"You know," the nurse remarked surprisedly, "you just growled at me."

"I'm sorry, it's just that that hurt!"

The nurse was smiling. "I never had someone growl at me like that before."

From then on, whenever Mev or I was disenchanted or pissed off by something someone said or did, our code was the growl, "Grrrr," in a low rumbling voice.

But Mev wasn't averse to investigating alternative therapies to complement the standard approach recommended by Dr. Fink. And California was a haven for such exploration. She had always been a fairly healthy eater, except for her chocolate binges, but she became even more scrupulous about her eating. We bought a juicer, and she began drinking fresh fruit and vegetable juices daily. She tried acupuncture for a couple of sessions. The point was to see if there were ways of "mobilizing her life force," a theme she had heard from a psychotherapist and which was right in sync with her own *modus vivendi*. The basis of the approach was that if the immune system could be bolstered through energetic, enthusiastic and positive living, then Mev's chances of duration, if not of survival, would be significantly enhanced.

As we were driving from my family's home in Louisville on the way to St. Louis that summer, we listened together to a tape from a doctor, who posed this question to his audience, "What did you most want to do when you were 13?" That is, before school and responsibility and duty got in the way of dreams. Mev answered immediately: "That's so easy! I wanted to be a veterinarian and a pianist!"

"What are we going to do, what do you want to do about this now?"

"I don't know how this will sound to you, Mark, but I would love a kitten."

Now, this was a surprise. Mev had a beloved cat that had died years before and, since then, she'd been unwilling to get another one.

"I'd love to have a pet, especially a little kitten. Can we get one when we go back to California?"

"Mev, of course, whatever you want. Hmm, I've never had a cat before."

"No, Marko, a *kitten*! They're so much fun!"

"Yes, but kittens become cats, don't they?"

"Yes, I'm so excited!"

"But what about the pianist part?"

"That was the great thing living at the Mission Homes. I loved playing that piano. I hadn't had a piano like that since I left St. Louis."

"Mev, if you want a piano, we can get one."

"I will talk to the folks about it. They said if there's ever anything I need, to talk to them."

"Mev, I plead ignorance. How much does a piano cost?"

"Depends. I'll see if Mom and Dad would be willing to help us out here. If not, we've got the money."

Upon our return to the Bay Area, we made a trip to the Berkeley Animal Shelter, where we picked up a four-week-old kitten with beautiful gray, brown and white markings. We were puzzled about a name, until I spontaneously offered, "Cinisi," the same of the Sicilian town from which Mev's grandparents came.

"Perfect, Cinisi it is!"

And Mev wasted no time in going to downtown Oakland and selecting a Campbell and Koehler upright piano, which soon found a place in our bedroom.

But in addition to such alternative therapies of diet, acupuncture and life-force mobilization, Mev also was exposed to (or exposed herself to) other therapies that weren't her cup of herbal tea. For example, there was the man who recommended regressive past life therapy to see what had been going on then that might have led to this tumor now.

Upon leaving that office with Mev, I was fuming. "How ridiculous!" Mev agreed: "You know, Mark, I want to do all I can to beat this tumor, but I think I'll stop short of his proposal. What do past lives have to do with cancer now? Is he implying I've caused this cancer somehow?"

It was a case, I believed, of California New Age shenanigans, at least to Mev and my parochial, prudent midwestern ears. But then there was also the mailing we received from someone who guaranteed remission of the tumor if only Mev would consent to coffee enemas, twice a day for two years.

Mev's Sicilian cousin Andrea once said, "Everything in America is an exaggeration." In the U.S., healing and illness had been commercialized, and there was no shortage of people willing to make a buck off of restoring you to optimal health, if only you subjected yourself to their worldviews, elixirs and *bona fide* cures. But we drew the line: no regression therapy, no enemas.

Facing The Facts/2

A Reflection from Mev, 1994/1995

I am an extrovert trapped inside an introvert's body.

I've always been an expressive person; but, I've never experienced this wide of a range of emotions, since being diagnosed with a malignant brain tumor—a fatal disease—a mortal illness—a—?

There are so many different ways of shedding tears: from whimpering to wailing to tears that just gush, & I couldn't control them if I tried!

PAIN & LOSSES & FEARS

I whimper at my losses or fears. Like when losing my hair during radiation. Like when the radiation burnt my scalp to a crisp, and I could only sleep in one position lest I cry out in pain. Like my realization over and over again that I was terrified of going to conferences where I had speaking engagements because I was so afraid of being overwhelmed—by crowds, noise, even well-wishers. (You see, I can only focus on one person at a time—it's amazing how I can look back and see . . .)

My husband Mark has helped me to see what I had considered "losses" as "diminishments"—I haven't "lost the capacity" to express abstract thought, I have diminished ability and that will be compensated for in some other way.

ANGER

The explosive anger at *%@#*! Too much for words! The anger first came in many of my dreams, the worst: I'm on a train headed for Auschwitz and a Nazi woman soldier holds a huge knife then starts stabbing the children to death. Soon after that dream, my best friend Maria happened to be with me—Maria, who has led retreats, gives spiritual direction, and has a great gift for "facilitating the expression of emotions." With her help, I finally decided that stacking up the pillows from our

couch and whacking them with a big long piece of wood would help me express my anger. It made a great sound—*SMACK!*

She coached me so that in addition to whamming the pillows I said out loud specifically *what* I was angry about. Just a beginning: I'm so angry that I'm losing control over so much of my life! *SMACK!* Losing control emotionally, & physically— I can't even drive! *SMACK!* I'm afraid to stay alone! *SMACK!* And so *SMACK!* Much *SMACK!* More *SMACK!*

I'm angry with myself for being so damned "good natured" through this! *SMACK!* I'm pissed off that God hasn't cured me yet! *SMACK!* I'm angry at the f——ing tumor for disrupting our lives! *SMACK!* I'm angry with my friends—no—angry that this disease forces me to reach out so much for help—I'm tired of asking for help! *SMACK!* I'm pissed that my hair has fallen out unevenly & isn't growing back on the scar side! *SMACK!*

Believe me, I beat the shit out of those pillows—yelling at the top of my lungs, cursing, smacking away—I was *beyond* tears. When I felt I couldn't go on anymore more, I collapsed on the pillows. Then the rage started bubbling over again, so I beat the pillows & screamed some more. When I was finally spent, I collapsed into Maria's arms and cried in her loving embrace.

I slept *so* soundly that night and woke with renewed energy. At first I was puzzled as to why I felt so good. It was as if I had been enclosed in a hard shell and I smashed it away. Sunlight! Fresh air! Trees! My zest for life had returned! And so the cycles went. And what is most puzzling is that when I'm depressed, I can't imagine what it was like to feel vibrantly alive, and when I'm so happy to be alive, it's hard to imagine what it was like to be angry.

My next "anger-attack" literally started in my body, which was quivering with rage. I thought I was having a seizure, yet it was anger shaking my limbs. I was at my neighbors, Rich & Dana's house, and I told them I thought I was having a seizure— or maybe it was anger—could Dana come back with me to our apartment and be with me? (It's a very intimate thing to slam pillows & express anger in front of someone!) Lo & behold I whacked those pillows once more! Same process as before— yell what I'm angry about—*SMACK!* When I thanked angel-Dana for being willing to accompany me through that, she said with a tear rolling down her cheek that it was an honor.

My most recent attack happened with Mark present. I was carrying our new kitten, Cinisi, in my arms, when the cat suddenly needed to get away, he scratched me. I cried out, Ah! Ah! Ah! Mark jumped up in a panic because he

thought I was having a seizure, "You scared me to death!" I was so grateful that he responded so quickly imagining my harm. But I just "lost it" because I realized how much the tumor-and-all-it-brings had affected our lives. As my crying built up, Mark instinctively piled up the couch pillows and I whacked them over & over, cursing over & over, "I'm so f—ing pissed that this has disrupted our lives!"

Mark heard the neighbors in the apartment above us were having a dinner party, and invited me to go out driving with him. The deal: he would play loud music and I could scream my lungs out (his form of therapy!) He led me out of the apartment to the car & played Sinéad O'Connor full blast. Eventually I screamed with the music, slamming my hands on the dashboard. But, you know what happened then? I ended up wailing, in tears, as I pounded the door: "I don't want to *leave* you! I don't want to *leave* you! I don't want to *leave* you!" On and on. Mark had to keep control of the car but tears were streaming down his face.

That was the last time I had an anger-attack, but our friend Dan gave us a wiffel bat for the next one.

Anger isn't just sadness that can't be expressed. It's a feeling all it's own. My spiritual-director and dear friend helped me to re-name it "Holy Rage."

GRIEF

A whole other kind of tears is of grief. My whole body moves and I eventually sob. Grieving everything from the loss of hair to the burning & peeling of the skin on my scalp. I grieve my death to come. I'm having so much fun! I savor life so very much! Grieving friends who I'll miss so much; knowing their lives will go on without me. Grieving my leaving Mark.

ABANDONMENT

Tears when I feel alone or abandoned. These tears seem to stream out of my eyes involuntarily. I feel like I'm looking at the world through a distorted glass—like if I reach out to someone they won't be there! I know I will see more clearly another day, but it feels so awful to *feel* abandoned.

So I carry around 2 index cards with names & phone numbers on them, one for friends in town that I can call for help, accompaniment; the other, of friends out of town that I can call for consolation. Both cards are in my wallet.

But sometimes I'll call almost every single person on the whole list, and all I get are answering machines, no one will be home. And sometimes I'm too depressed, too scared to reach out.

FRUSTRATION

The tears of frustration build inside of me and explode! When I can't express something in words, when I have a clear "sense" of what I want to say but can't form it into words! Arghh!! My frustration builds, thus I can only speak louder & slower: "I-can't-say-what-I-mean!!"

I'll storm outside and pound the streets of our neighborhood—in a contained rage—feeling trapped within my head, body. It feels like anger building inside, but when the tea kettle blows its steam, it's frustration!!!

Resentment: "You all get to keep on living!"

Sometimes when acquaintances—folks I don't know as well—show their grief, tears or anger at God—whatever, I turn into a small child in my imagination, looking up to them, tugging at their sleeve, I say, "I'm not dead yet! I'm alive! This isn't a funeral scene! Don't mourn me while I'm still here!"

TERROR

This is a horrible fear that comes over me, like that morning in October last year. I felt like I was being electrocuted—even as I knew my whole body was thrashing, I felt cut off at the neck, paralyzed. I heard myself inside my head exclaiming, "Ahhh! Ahhh! Ahhh!" But I couldn't speak! I thought I was dying!

I opened my eyes to see Mark's face stamped with terror, screaming at me, "Mev! Can you hear me?! Mev! Oh my God!" *He* thought I was dying!

The most frustrating thing for me at that moment was that *I couldn't even let him know that I heard him*; I couldn't even say "Good-bye."

When it was over, Mark and I wept in each other's arms—we both thought this was the end.

It was a grand mal seizure. We both concluded that this was the single most frightening event in either of our lives—and both of us have some inner city and overseas stories to compare it with. After we realized it was a seizure, we both felt, "Well, if it happens again, at least we will know it is *only* a seizure."

It wasn't 'til an hour after it that I could speak, and it took months to regain my health and energy to where it had been after the radiation.

Joy

It is hard to describe the moments of joy, even days of sheer bliss! I feel like I'm in rapture! Just as I have bouts of depression, I also have bouts of elation. I've felt this way before, as if every tree, flower, blade of grass is in bold relief. As a young girl I recall vividly, walking home from Our Lady of the Pillar grade school and seeing the trees on my lane *as if for the first time.* They stood out in all their beauty, splendor—and "treeness." I was overwhelmed, in awe of Creation—marveling that I could not make a tree!

Ever since then, I've had moments of feeling, "What an honor it is to be alive and looking at this tree! This flower! This marvelous blue sky!" What joy! Ecstasy! Orgasmic delight!

I have more of them now.

Mev; Oakland; 1994
Mark Chmiel

DEATH

I've had a few close calls with death; the closest being when I was walking back from visiting the Maryknoll sisters in São Paulo. Two of them walked me towards to the bus stop. Lots of folks were on both sides of the road. My two friends waved goodbye to me from the one side.

When I was in the middle of the street, (*without* looking both ways) a car sped towards me—slammed on its brakes, swerved, honking, yelling. If he had swerved the same direction as I jumped, I would be dead now—and the driver wouldn't be at fault. The crowds on both sides of the road were aghast, and my two friends were beside themselves at my near miss.

When my family has expressed concern that I will be killed in crossfire in Haiti, Brazil, El Salvador or, most recently, Chiapas, I say it's far more likely I'll be killed in a public transport disaster—as the Haitian ferry Neptune disaster bears witness. Bus accident recently—young, vibrant high school girl from St. Louis—

There are three feelings that surface when I think about my death—fear, sadness and a sense of adventure.

I have a vivid memory of myself in grade school, walking across the parking lot between the church and school—it was one of my "I'm so in love with the beauty of Creation/Creator!" days—and I felt like I had one foot on earth and the other one in heaven. And I longed to take that next step! It was almost a disappointment to remain on earth, but I was happy "*anyway*" to be alive.

Fear—Sadness—

Folks in Latin America often are saying "I'll see you tomorrow, God willing." I used to respond, "Of course God wills it!" Now I know why they say it—they live much closer to suffering and death than we do. Contingency.

SOLITUDE

After months of needing someone with me all the time, I first feared being alone, then craved solitude. A few times in the evenings when I am alone in the living room, I light our many different candles, listen to Pachebel's Canon—and I feel so still, so secure, so . . . I want more of these times, and yet I hold them at arms length because I'm aware I cannot choose which feelings will surface—the joy or depression, gratitude or grief, faith or fear. But I have learned that if I'm still long enough,

whatever emotion washes over me I can remember that I entrust myself to God. Grace. Falling into God.

When Mark is excited about his writing and thinking projects, I delight in his enthusiasm and I marvel at his gifts.

Then I wonder how he will do without me.

Mark, Maria, Dana, Dan and so many others are angels in my life. They are blessings, messengers of God's presence.

Reading/4

A Book Review of *The Struggle is One*
by Mary Ann McGivern
First published in *The Round Table*
(Karen Catholic Worker House Journal)

I finally got a copy of Mev Puleo's *The Struggle is One: Voices and Visions of Liberation* the week before Christmas. I started reading it in the airport on Christmas night. I've read slowly, studying all the pictures, finishing one person's conversation and setting the book aside, picking it up the next day, looking at the photos or perhaps rereading the poetry, and then reading the next interview.

Mev's account of sixteen Brazilians immersed in the struggle for justice is a straight-forward presentation of each person's experience while destitute in the favelas; a broom-maker; a grandmother poet; a student theologian with a sick baby; a silenced theologian; a bishop. But Mev's own delight in the conversation shines through and they sparkle with intellectual verve and compassion.

Each person's story evokes joy in me because they all openly discuss their faith, not as theory, but as wellspring, roots, and the very ground they walk on. Their theological understanding of God and church shapes their lives and informs their daily prayer and work and friendships. That's true of you and me, too, but we don't speak about it much. The talk in every chapter of *The Struggle is One* satisfies me, like a delicious meal or vigorous exercise.

In his interview, Leonardo Boff says, "Theology alone doesn't convince anyone. Only those words which are pregnant with action, theology that is born of suffering, of struggles, of the poor—this theology is a testimony. This theology leads to conversion." Mev's book is a collection of that kind of testimony, and it can serve as a model helping us share our stories of conversion.

Accompanying the interviews are photographs of the subjects, mostly standing, directly facing the camera, smiling. Mev's choice of these posed photos over candid

action shots is deceptively simple. She allows us to look straight into their faces as we read directly into their hearts.

Beyond each personal account, the interviews have common themes: the relationships between people and the hierarchy; economic and environmental justice; the role of women; the role of the middle class; the role of the United States. It's in that discussion of the U.S. role that Carlos Mesters says, "The struggle is one—we're not enemies in this!" and Tereza Calvacanti says, "We share the same struggle."

Mev conducted these interviews in Portuguese in the fall of 1990. She says that "each person generously granted me full permission to translate, edit, and employ a creative style of presentation. It is difficult to convey the lyrical quality of the human voice, the ebb and flow of conversation. People don't speak in paragraphs or outlines! I have tried to present the material in a way that is faithful to the spirit of each person. I hope the photographic images add texture to the voices."

In other words, the artistry of *The Struggle is One* did not happen by chance. Mev has crafted particular accounts of Brazilians' work to build God's realm. They glow with humor and passion and give us heart to keep doing our work.

Mev grew up in Saint Louis, attended Saint Louis University, taught one year at Visitation Academy, and volunteered at Cass House starting in her high school days. Many of us count her as a friend. She is struggling now against brain cancer. We are praying for her cure, seeking the intercession of other friends, Ann Manganaro, Dorothy Day, and Archbishop Romero. Mev's particular struggle for healing is also our struggle.

Perspicacity

Mev had long been geared to performance and productivity: the way she walked—hers was no mindful, Buddhist-taking-it-slow gait. She was on the move to get these photos out, send that interview to another magazine, call those contacts regarding delegations. She was calmly and genially possessed.

And yet, even though Mev was talented, and ambitious, and personable, she and I both began to wonder about the honorifics that were coming her way. For example, in May 1995, she was awarded the U.S. Catholic Award "for furthering the cause of women in the Church." *U.S. Catholic* is a monthly magazine put out by the Claretian order in Chicago; one of the members of the nominating committee for that year's award knew Mev and had evidently heard about or read in one magazine or another Mev's straightforward yet relatively respectful plea to John Paul II to listen to women.

For Mev, the defining issue was the fact of the rich and poor. It's all in *The Struggle is One*: She poses the question: How can we (that is, the privileged Mevs of the First World) be in solidarity with you (the poor and their allies facing misery and repression)? At Weston, this preferential option was Mev's preoccupation, even as friends of hers were much more adamant about women's rights in the church than Mev was. Perhaps this was a matter, too, of the degree programs these women had chosen. Mev was taking a master's in theological studies, while several of her friends were getting master's of divinity, in which they were being trained in exactly the same way as the Jesuit seminarians who were their classmates. For them, the contrast in treatment and status was jarring. They would attend ordination ceremonies, and when it was announced, "Would those who feel called to ordination please stand?" the women would stand up at this moment when the Jesuits were to come forward.

At the U.S. Catholic Award ceremony in May 1995, with most of her family present, Mev was excited at being the center of attention. But she was able to discuss the program with the staff at the magazine and, as part of her acceptance, she wanted to give a slideshow of some of her work. She wanted to capitalize on this teachable moment. The award from the Claretians made sense in that, even though Mev had

not preoccupied herself with issues of women's ordination and inclusive language, her photography and her interviews could be seen to further the cause of women in the church. Mev showed their faces and amplified their voices, particularly to a U.S. audience: the compassion of Maria Goreth, the courage of Ivone Gebara, the dedication of Ann Manganaro. There are many ways to further the cause of women who have been so looked down upon by men, clerics and Popes, and see the vital work they are doing (have always done) among the sick, the destitute and the forgotten of this world. In certain obvious ways, and Mev realized this herself, she comported herself in traditional "male" ways of moving up in the world. She was brash, willing to announce herself, did not take a back seat, wasn't shy or retiring. You knew she was in the room; she radiated a public confidence (though I got to see the trials and insecurities that were well hidden from this public posture). In addition to the U.S. Catholic Award, Mev also received the annual Bay Area Pax Christi Award (for her solidarity efforts), the 1995 Pedro Arrupe Award (given by the Jesuit School of Theology at Berkeley), and her high school's Alumna Achievement Award.

It's not that Mev was ungrateful for the recognition; even after radiation and chemotherapy, she still wanted to be around people and to assert herself. She, who had often excoriated herself—in private, in her journals, in person with me—for her ambition, now wondered if these awards, rather than being tokens of achievement, did not simply presage something else.

She would often wryly muse, "They're just giving me these awards because I'm going to die soon."

God/3

There was a weird set of reactions to what Mev had been going through. One friend expressed her frustration to Mev this way: "How could God let this happen? Why you?"

Mev responded without batting an eye: "Why not me?" She had held children in Haitian clinics, seen Guatemalan refugees who fled the terror and torture of their homeland, witnessed the anguish of her Brazilian friends—all of them innocent. And the innocent suffer and die and are brutalized, forgotten and ground under.

Our notions were so antiquated, weren't they? Did we really expect thunderbolt interventions via a Hollywood *deus ex machina*? Nhat Hanh would remind his readers: "40,000 children die every day from hunger in the Third World." I so rarely heard the question, "How could God let this happen? Why *them*?"

We might not ask this question because those children don't concern us or because we know, of course, that God has nothing to do with their premature deaths. However, we do.

Letting Go/3

So many transplanted Midwesterners come to regard the Bay Area as nirvana. They're typically folks like me, my friends and acquaintances who swear they will never return to the parochial, pedestrian, plebeian Midwest. Indianapolis? Louisville? Kansas City? Get serious. They're too taken with the mocha and latte shops, the diversity, the bookstores, the tolerance (admittedly, for our gay and lesbian friends, this is no small attraction).

One friend, though, from New York had gotten her Master's degree in Berkeley, had gotten married and started to have kids, then she began to have a hankering for home. "Lynn," we asked her one Saturday morning at the monthly meeting of our Christian Solidarity Project, "why on earth would you want to go back to New York? All that dirt, that crime," we began to lay it on thick, "all those muggings, all that summer heat, all that winter slush, c'mon, can you be serious?" And she replied with a straight face, "There are four seasons." That simple observation was enough to put us in our place.

And so, I shared the usual self-hating Midwesterner attitudes of many of our friends. But while they were in a position of staying at least a few more years in paradise (as they finished their dissertations on Habitat for Humanity, Bread for the World or Leonardo Boff), Mev and I were contemplating the big break.

"Marko. I know I'm better. But I don't know for how much longer. I can walk better, I don't need that cane anymore. But remember what Fink said: 6-9 months. I want to move back to Saint Louis."

It was obvious. Mev wanted to move back to St. Louis where her family was. With one of her sisters still living close to her parents, along with her brother, Mev felt connected to St. Louis. Quite simply, she wanted to die at home. As wonderful as our community in California was, it was time for a sort of homecoming: We'd be moving back to Saint Louis. For Mev, it may have been "back," but I'd never lived there before, a point Mev must have made 46 times to our various friends and family who were either ecstatic that we'd be moving back there (the St. Louisans) or else melancholy (the Oaklanders). I can't say that we suffered from a lack of attention or

affirmation. The first step was talking to Teka: "Teka!" Mev squealed, "We want to move back to St. Louis!" I could tell from the glow in Mev's eyes that Teka must have been exultant. "Would you see if there are any apartments in Forest Park Southeast, with the Kopavi community?" Kopavi was a loose community of several families and a couple of single people that had lived in this transitional neighborhood for at least 15 years. Mev knew many of these people when she was a student at St. Louis University in the mid-1980s, and she shared a common vision and camaraderie with them. Plus, there was another loose amalgam of friends and church folks that lived in the same area, as well as an apartment building that had served as a sanctuary for Guatemalan refugees.

Teka didn't hesitate. She told Mev that just that day she'd been at a meeting with some local organizers on Arco Avenue and she knew that Cathy Nolan had a first-floor apartment that was available: Our friends Ellen and Bill were moving one block over to a bigger home, since they were expecting their second child.

But before we went to St. Louis that summer, Mev insisted that I accompany her to her therapist because she feared I would resent her for this move. Having also been meeting with a death and dying therapist, Ahna, I was ready to share with Mev my own fears and hopes. Before her therapist, I said, "Here's my greatest fear: We will move to St. Louis, and in one month you will die, and then I will be in St. Louis when my community is here, Berkeley."

Immediately, Mev offered: "Marko, there are so many people in St. Louis you'll love to get to know—Karen House folks, plus you can talk philosophy with Ellen Rehg, and there are activist guys in the neighborhood, too."

But I interrupted Mev: "Dear, I don't want you to fix anything here. I just want you to hear me. It's just a fear, a feeling that comes across me, and sometimes it's all more than I can take when I realize what could happen sooner rather than later."

Mev realized that we had shifted our once historic roles: *I* didn't want problems solved. *She* just needed to listen. The problem-solving could wait.

Nicknames/2

Dear Mev, Mevelyn, Schoochers, Chloe, Zoe, Mindy, Lindy, Maeve, Mevinsky, Mevakov, Mevini, Marvel, Mevs, Mevo, Po, Popopo, Mevita, Tagliamento, Badalamenti, Baby, Meverly, Mevsky, P'Doodle, Play Partner, Mary Evelyn, Tank, Mevster, Million electron volts, Zuzu, Italian boy, Divine Ms. M, Mevvie, Mevstein, Pixie, Trixie, Vixie, Voluptuous, Maria, Poochers, Meverific, Meverick,

Happy Valentine's!

Letter/2
(Community/2)

Dear Family & Friends,

In what has been the most disorienting, fearsome and hard time of our lives, we have depended upon the kindnesses of family, friends, acquaintances and strangers. Because we have received so much mail, we are hoping to give you a brief update on what's been happening.

Mev was diagnosed on April 9th, 1994 with a malignant brain tumor. On April 15th, neurosurgeon Robert Fink was able to remove half of the tumor (the other half was too intermixed with her motor strip). After several days in ICU, more than a week in the neurological wing, Mev came home to face familiar surroundings but challenges were awaiting: She needed to use a cane for walking at first, was heavily medicated and suffered terrifying nightmares due to her withdrawing from the drugs. During this time we were most blessed to have Mev's parents and sisters (with brothers-in-law visiting on long weekends) on an extended stay (her brother and sister-in-law were home in St. Louis awaiting the birth of their twins—who were born two months premature but healthy!). Mev's mom stayed almost a month and was amazing in her constant concern and know-how. We're grateful for the family and friends from out of town who continue to visit us and call us from time to time!

The next phase was Mev's slowly gaining her strength back. After the middle of May, she began swimming (at first in the slow lane, now she's back to the fast lane). The doctors' prognosis varies from 6-9 months to a 15% chance of 5 years. (Though Mev has no intentions of dying "on schedule"!) We are hoping for the best, trying to be realistic about the worst. We are told that Mev's health will be strong up until the very end, without any severe physical anguish. We both value the preciousness of life more than ever before. Mev reminds me that she is not convinced that she will die from this brain tumor, and we are both determined to "live until we die."

Mev finished radiation therapy in early July, after seven weeks of treatment (she received the maximum safe dose of radiation over this period of time). We've continue to explore recommendations we've received about alternative methods of healing, including nutrition, diet, massage, acupuncture, herbs and vitamins. We also got a four-week-old kitten at the Berkeley Animal Shelter—now we have 2 kittens!! They play together and lift our spirits so much! Mev's parents also gifted us with a new piano—Mev enjoys playing it so much and I'm learning also! Also, we begin and end most days with prayer and mindfulness meditation.

Though minor discomfort (especially fatigue!) is still a feature of Mev's life now, the challenge has shifted more to include—for both of us—the spiritual and psychological facets of Mev living with this tumor. We go when we can to brain tumor support groups in San Francisco, I am seeing a death and dying therapist periodically, and Mev alternates seeing a neuropsychologist and a very skilled spiritual director. She did a few sessions with a speech therapist in early summer. As the tumor is in her front left lobe, it affects her speech—affecting her ability to do her slide presentations or preaching—it takes so much time/energy in preparation, and she needs time/help organizing her thoughts. Her conversation skills are quite good now. Still, this language hurdle is quite frustrating for her because of her history in public speaking and "passionate" speech.

I was preparing to take my doctoral exams the day before Mev went into surgery. But things moved pretty quickly—Mev was only diagnosed 6 days before she was underwent surgery. So I had to gear up to revive my doctoral work. In December, I passed my comprehensive exams with distinction, and I've just submitted my dissertation proposal (it has to go through several committes, which takes a few months). In November, both of us presented papers at the annual American Academy of Religion meeting in Chicago. (Mine was on Elie Wiesel and Noam Chomsky, Mev's was on the Brazilian-born photographer Sebastião Salgado). Also last fall, Mev took a GTU course, "Photography as a Tool for Social Change." Her main project this spring is making a video of her slide presentation on her recent book (read on!). This spring, I am working on a research fellowship I have put together on: "Dissidents, Prophets & Visionaries: The Global Practice of Civic Virtue," as well as continuing to write and publish reviews and articles in academic journals and the religious press.

Mev is now in the 2nd of 6 rounds of chemotherapy, which began in mid-December. This was a major transition in her recovery, as she was at last sufficiently distant from the traumas of surgery and radiation to consider this next, demanding step. We are grateful that it has shown some results. We are planning to move to St.

Louis in late May. Mev's family lives there, we have many friends there and it's close to Louisville, where my family and more of our friends live. Mev visited St. Louis recently to check out an apartment in a neighborhood where we know about 10 to 15 couples; many of them moved there years ago to form an intentional Christian community. We are hoping to travel to Lima, Peru as soon as Mev has had sufficient time to recover from her chemotherapy. More as that evolves!

Throughout this time, we have been blessed by many people's prayers, thoughts, visits, phone calls, letters, postcards, Mass intentions, networking, advice, books, audio-cassettes, meals and chores (house-cleaning, grocery shopping, etc.). Rev. Don Steele, KC Young, Donna McKenzie and Mary Charlotte Chandler have helped to channel folks' love and support into the concrete tasks we've needed.

We hope that this note assures you of our gratitude, affection and prayers as we continue to regain some normalcy in our lives. We are also delighted to announce that Mev's book, *The Struggle is One: Voices & Visions of Liberation*, was released by the State University of New York Press last July (1994). We are enclosing a flyer on the book in case you are interested yourself or may know of someone to pass it on to. We are patiently trying to discern what else the next period of our lives is to hold; if these recent months are any indication, we will be much blessed by a vast prayer circle of concern and commitment, as well as humor and healing.

<div style="text-align: right">

With much love,
Mark & Mev

</div>

Good-bye

Before we moved to St. Louis, we made sure to have one last visit with Dr. Fink. A brilliantly sunny day in Berkeley, we enjoyed our drive down Shattuck Avenue as we brainstormed appetizing delis we could go to for lunch after the visit.

Dr. Fink realized that this was, in all likelihood, the last time he would see Mev, see us, and he was quite relaxed, personable and open. He asked about the St. Louis team that would be taking care of her, and he seemed confident.

There was just one thing.

"Could you tell us—as far as you can, we know you can't predict—what the end is likely to be like?" Mev had been itching to ask this question; while it was important, it also clashed with the beautiful day and her own brimming spirit. But she was intent on facing the facts.

"Let me tell you. My first wife had a brain tumor and her symptoms recurred one evening, and the next morning, she died. It was that fast. Another patient of mine, he'd gone through the same treatment as you, debulking, radiation, chemotherapy, and he had a high quality of life for a good year. Then symptoms started to come back, he had to leave his job at the post office, and within two weeks, he died."

"So it can happen pretty quickly?" I asked from my ignorance.

"Think of it like this, it's like falling asleep. But I wouldn't give that any thought right now, you've got a lot to look forward to."

So we did.

Letter/3
(Dissidents/4)

In August 1995 as Mev and I were getting settled in our new home in St. Louis, we learned that Steve Kelly had been arrested for a Plowshares action in California on the anniversaries of the U.S. atomic bombing of Hiroshima and Nagasaki. Steve and his friend Susan Crane went to the Lockheed-Martin Corporation in Sunnyvale, California and, inspired by the biblical call to "beat swords into plowshares," used a hammer to beat on missiles; they also poured blood on them. They and their partners on the East Coast issued a statement, which read, in part, as follows: "The period of August 6 through 9 marks the 50th anniversary of the nuclear destruction of Hiroshima and Nagasaki, Japan . . . Since August 1945 the entire world, led by the U.S. has been held hostage by nuclearism and the exponential rise of military violence. This violence permeates every level of society . . . Disarmament is the necessary first step to Christ's Jubilee. We refuse to see violence as inevitable, injustice as the order of the day, and death dealing as the only way of life. Join us in this declaration for disarmament to announce the jubilee for the poor, relief for the children, and peace for us all."[73]

<div align="center">

August 25, 1995

The day of your sentencing

</div>

Dear Steve,

What? No book? Are you *meshugah*? No way—Mev and I have already pledged that we will edit your letters and postcards, and have contacted Robert Ellsberg at Orbis for a deluxe edition. Mev's going through her negatives of you for the appropriate cover shot.

I miss you, Steve. So you were preparing us for the big civil disobedience action by driving us over to Lockheed in San Jose—I shoulda known better with a resister like you/that I would love every action that you do/and I do, and I do, hey hey hey.

Is it at all likely that if he gets busted again, the hardest working man in show business, James Brown, will be your cell-mate? "I feel good . . ." Yeah, but it isn't that easy to feel good in jail, is it James, unless you have a *schlemiel* around to make the hours seem like eternity.

You are a brave man. I don't mean this action of civil disobedience, I mean going to the GTU library to read and research—what rough terrain for one such as you who so easily sees the shining idol of academics who'd rather read about evil than confront it—at Lockheed, at shopping mall, at our major Jesuit universities.

I bet Max is pleasantly envious of your action. We will honor you—"blessed be his memory"—when we sup with Dan Berrigan and Jim Reale in a couple weeks at Apartment 11-L in NYC.

Then Mev and I go to Block Island, and I plan on having a perfectly miserable time there. How can I enjoy myself there when you are baking away in jail, with the TV on 24 hours a day, the smoke, the blabbering (verisimilitude details, stolen from John Dear's prison journal, *Peace Behind Bars*)?

My beloved is slowly losing her gifted speech pizzazz. There are few things imaginably sadder than this—to be with the Mevster as she struggles to say what she knows she wants to say but can't find the words. I know you share in this agony.

I turned 35 this week and flatter myself by aspiring to be 1/10th of the *mensch* you are. I know you despise me, Steve, but it's for this reason that I trust you and want to tell you about certain letters of transit that may be of interest to you. They cannot be rescinded, even by the Jesuit Provincial, something even our friend Bob Lassalle-Klein himself has never seen. Maybe one day you will be impressed with me.

I love you and wish I could hang out with you. Maybe I'll see you in October. Please let me know if you need anything (re: books). I showed John Kavanaugh the photo of you when you were a young Abraham Joshua Heschel-looking scholastic. He liked it.

Yesh Gvul!

Shimmel

Love's Mansion

One October afternoon in St. Louis, Nora had gone to hang out at a cafe to have some time alone. An old friend from Berkeley, she had been an immense help, and later on, as the fall wore on, I would wish that she was still around. As it was, she stayed with us for a good week, and her silent, receptive, unflappable presence was a godsend. The day before, Nora had given us a special treat: When I had talked to her on the phone several weeks before to schedule her visit (little did she know how much worse Mev was getting week by week), she asked if there was anything she should bring from the West Coast. I insisted, "Bring your clarinet." Nora had always impressed me with her musical gifts, and I thought that a clarinet would come in handy while she was visiting us. She brought Mev to a wobbly standing ovation when, at my urging, she played the opening to Gerschwin's *Rhapsody in Blue*. She hit the high notes with such perfection, that Mev, Angie O'Gorman, a new neighborhood friend, and I laughed with delight. It was so unexpected, like the arrival of an old, cherished friend. In her younger days, Mev had played *Rhapsody* on piano for hours at a time.

While Nora was away, Mrs. Puleo was out investigating the possibilities for a speech machine at the St. Louis Speech Center. With each week, as the tumor grew, Mev had been losing—how do I calculate? I don't know, I still can't fathom this—hundreds of words and phrases. It was painfully clear that we were going to have to resort to some kind of crutch, if she didn't die first, which in October seemed an imminent possibility, given the neurosurgeon's anecdotes of how quickly the end would likely come. Somehow I managed to ignore his essential word, "likely."

So, Mev and I were home alone, which was rather refreshing since we had had several out-of-town visitors as of late: We were both reminded of how it had felt only two months before at the first of July, when we had unpacked our boxes and organized a new home amid the St. Louis summer swelter. She decided to take her 2 p.m. nap a little early, so she pulled down both sets of shades. I smiled as I pondered my wife's ability to know exactly what she wanted and needed and not apologize for it. Her mother had gotten expensive "room-darkening" shades so Mev could have the

most restful nap possible. What was going on, I wondered, in my mother-in-law's mind? With each purchase she made at Mev's request, did she think that this might possibly contribute some small burst of healing energy that might rescue her daughter from the statistical odds?

I went out to my desk to open the last several days' mail. Brain tumor support groups, American Friends Service Committee, Catholic Network updates, oh, but most exciting, a letter from a Brazilian friend. I immediately got up to take it into her, but I decided, three steps away from my desk, that it would be best to let her sleep. Though she was losing her speech, syllable by syllable, her comprehension was excellent, reading-wise. At least, I thought so.

As I sat back down at the desk, I heard the bell she kept by the bed to summon me, and then I heard a loud groan. I sprinted to the bedroom, not knowing what even to fear, and I flipped on the light switch. There was Mev on the far side of the bed by the window, writhing very slowly. I went over to her and was immediately caught off-guard by the foul smell of excrement.

"Oh, Mev, what happened, dear?"

"Ooppa . . . Marko, I . . . pooped in my pants." With that, she did her joking trademark of covering her face with her hand to indicate her embarrassment.

Now, this was a first. I could see she that she was more miffed at herself for not being able to read her body's signals more quickly, but this was no a big deal, I told her. "Just let me pull your pants down, and then I'll clean you up."

I pulled her cozy pink workout pants down off her legs and turned her over on her side, and then removed her panties. The defecation came dripping out, and I was repelled backward. The smell was like a martial arts chop to my lungs and nose.

"Whoa, let me figure out what to do here. Hmmm . . ." It was as if there sprang up a wall between Mev, laying in her crap, and me wishing to protect my nose and my guts from being wrung out like a wet beach towel. She perceived my disgust, and she offered a comforting, "Oh, Marko, I'm so sorry, I . . . couldn't get to the bathroom . . . in time."

I knew she wanted to be clean as soon as possible, so I headed for the door, adding, "Don't worry, Mev, gimme two minutes, and I'll get someone to help me."

Just then, I heard the front door open and a breezy, "How's everybody doing?" chime up the hallway. It was Sharon from next-door. I met her in the kitchen and said, "Mev had an accident, and I need some help getting her cleaned up."

"Let's see what we can do," Sharon said, with dispatch.

We went back into the bedroom. As I got to within a foot of Mev's bottom, I again felt like vomiting, and instinctively put my hand over my mouth and staggered

backward. Sharon cut in right before me, and said, "I'll clean her, you get me some paper towels, two warm, wet washcloths and couple of your big towels."

"No, no, Sharon, I can do it, here let me," I reached over helplessly.

"Don't give it a second thought, I am used to it. Being a mother makes it second nature."

Discouraged and feeling like a betrayer of Mev at her hour of great need, I went and did what I was told. When I returned to the room there was Sharon, sitting beside Mev, and telling her, "When I was on bed-rest with Mariposa, this happened to me all the time." What Sharon proceeded to do amazed me: She scooped up Mev's shit with several paper towels, wiped her with a wash-cloth and then wiped her bottom and front with the other with smooth, sure wipes. She handed the paper towels to me to dispose of immediately, and in less than 20 seconds it was over.

Throughout Sharon's handling of the mess, Mev was joking and grinning, and then acting serious, too, for she felt she had drawn Sharon into a sphere that a next-door neighbor of less than three months typically doesn't get to know. I heard the front door open again, went out in the hall to see who it was and saw that Mrs. Puleo was walking in.

"Mom, Mev was not able to ring the bell in time to get me to help her to the bathroom, and she pooped on the bed in her clothes. And Sharon—you wouldn't believe it—she just walked right in, and cleaned it up without blinking." This so impressed me. As Sharon came out with Mev, she was abashed, as if to say to me: "When you have changed your own child's diapers 400 times, then you, too, will be skilled at poop removal." Mrs. Puleo encouraged Mev to take a shower—"You'll feel so much better, dear, and then you can get a real nap"—and Sharon and I proceeded to talk.

"Sharon, I am so sorry. I couldn't help. I was there, I should have been able to get beyond the smell, but it conquered me. Shit!"

"Shit *is* right. See, here's the thing, we're so used to our own smells and nobody else's but kids get you over that really quickly. Well, let me say, my kid got me over that. I can stand any odor coming from my kid's behind, but I have changed our neighbor's kid more than once when I was baby-sitting, and it never fails to make me wretch, well, you know, I stifle it as best as I can. But it's so hard."

"Hard" was right: My own wife, and I couldn't even overcome my nausea and fear of my own puking. At that moment, I felt like putting a sign over the front door: Embrace Being a Screw-Up, All Ye Who Enter Here.

In the next months, I would get lifetime's practice of this embrace.

Bearing Witness/3
(Community/3)

A Letter from Nora Archer

October 12, 1996

Dear Mark,

The color of autumn-almost-winter sky in the afternoon as I bike home, and the bare silhouettes of certain trees are becoming familiar as I see them each day. My eye is caught by the movement of a red leaf on the pavement when the wind turns it over, as if for my delight. These things bring me back in a reflective state of mind to last year when I awakened in a new way to the conviction that life is precious and beautiful.

I visited you and Mev last October (October 13-19), and before I left, you asked me to write down some of my experience, and I said I would. I thought I might write to you one year later, and so I am, because it seems like the right time for me. I hope it is good timing for you, too.

I left Saint Louis treasuring the lessons in compassion, companionship and grace, which I felt I had experienced in no ordinary way. I felt so blessed to have been brought to Saint Louis and present in that week of your lives. This was the time when Mev could talk, but only with effort, except for a few things such as your name, and an infinite number of inflections of "Yeah," (which she kept for a while longer, I understand from you). Many were cooperating in the rush to put together the [speech] books, and hope was put in the talking machine as well. However, it was not clear what would happen, and I sensed that before I left you two were debating the usefulness of the drugs, and ready to try something new perhaps. I think a lot of people had felt Mev had reached a plateau in her condition, but I remember watching her use the wall as a support at the end of the week, in a way she hadn't at the beginning. It was such a full week. It was hard, but infused with so much hope and commitment to life.

The following reflections are really just journal entries from my visit, and I hope that the "I" is not in the way.

Friday 13 October 1995

I saw Mev and Mark at about 12 noon. It seems natural to be here with them. Mark is moving very slowly and carefully, fielding so many people's concerns and their questions, their need to talk; their "needs" to care for him and Mev.

Mev's mother took me to her sister Laura's house to pick up the massage table, and I learned about some of what the Puleo family has been going through in the past couple of years: death of a son-in-law, twin babies born premature, fear (and preparation) that one baby would have Down's Syndrome, and Mev's cancer. It is a blessing that Mev's parents are able to pull each other up through it all. I must acknowledge my blessings, too: past, present, and the promise of a future profound support from my family and Jeff and the people I am meeting now.

I am staying down the block on Arco Avenue. When Jean Abbott came home, she made me dinner. Jean is a therapist, and works with the Hispanic community in Saint Louis—difficult work because the people suffer degrading circumstances. She described her moment of realization that if the repairing will happen, God alone can do it. Her job makes me ask: How to let God work? How to bear witness, and bear witnessing the suffering?

Sunday 15 October 1995

The gift of being here is watching Mark and Mev together: at home, privately—conversations, kissing, understanding what Mev needs, working together on *The Struggle is One* video, at church touching hands, Mark fixing Mev's shoes. *Love is attention.*

Today after church and walking home, it was agreed that Angie, Mev and I ("just the girls") go out for brunch. We drove to a place where Angie knows the family who owns the restaurant (Palestinians, but from Iraq, whom she helped to get visas when the Gulf War prevented them from returning home). We hoped to see autumn leaves on the trip, Mev has had the beauty of Fall trees on her mind, but there weren't many to be seen. We were treated royally at the restaurant and given food not out on the buffet table, and, as it turned out, everything was on the house. Mev talked a lot and wore herself out. On the way back, frustrated, she got out: "I am an extrovert." Since it was a long drive, we got back a little later than planned and Mark was a little worried (that something might have happened, or that Mev would be too tired

out?). It is a struggle to pay attention to the big schedule, and not wear Mev out, so that she can do the next thing to be done. The supply of physical and mental energy is rationed, and can't be taken for granted. (I know spiritual energy can't be taken for granted either, but it seems to be the greatest and most constant here, making up for shortages of others).

Tuesday 17 October

At Mocafe on Euclid while Mev and Mark are at a physical therapy appointment.

I changed my return date to Friday, thankful for the uncommon situation where no commitments wait on me.

Mev and Mark are my profound teachers. I am content, and time moves at the right pace. A rare feeling: that it is right that I don't try to change what happens as time passes, and I give better attention to what is happening. However, this perspective is probably only my own, a special gift for the guest.

I wonder, as probably everyone does, in an anguished way, why Mev doesn't seem to easily find ways to make signals (even such as nodding yes) and act things out so she can communicate better. I wonder what Mark thinks. He is patient and loving and does not tell Mev "to be more clear." Someone can say "Be more definite" but to Mev, she is being definite, in fact, it makes her shake her tense and open hand as if the sentence could be born there if she labored enough. And I am amazed at her capacity for good humor, even so. Her laugh does not lose its Mev-ness, nor is it ever unclear, the way a word might be.

I was there when Mev and Mark made the last changes in the video—music, volume, timing. It was exhilarating to be there. Yet no outward drama—Mark and Mev, sitting on the bed propped with pillows, Mark armed with the remote control, paper and pen. Completion, but not yet. Mark will take the changes to the film maker, and we are full of anticipation for Thursday night when it will be shown at the College Church.

Was this the night when some balloons got loose and caught in the ceiling fan? Such a racket and such a scare, where a noise like that could mean something so bad as a seizure.

That evening

Mark and Mev had a full day so they didn't go out for mass at Karen House. On the way over to Mass, Ellen asked me how I liked the monastery and it made me cry a little—still this happens, and unexpectedly. The tears are a treasure in that they

express my love for that time, because of the love I learned there. And that matters here because I consider this my second lesson on God's love.

I especially like the end of the homily when other people spoke their reflections—people are so prayerful! I'm so happy to come across moments where I can see it because it encourages and instructs me. Simplicity and brevity are most powerful.

Wednesday 18 October

I called Mark and Mev at 9:00 and left a message to tell them I'd be going out (to the Botanical Gardens) and wouldn't be back until about 4:00. First I went to Soulard's market—just a few stalls open on Wednesday. I was glad to see it empty and quiet, it suited my mood. I can imagine well enough the commotion and crush of people on the weekend. I got a pear which staved off my hunger and bargained two cantaloupes down from $.70 to .50.

It was a hard day for Mev and Mark. Mev had tremors in her face and hand at 5 am and again at 11. Mark had to work on the video in a nearby town and a neighbor took Mev to the doctor for blood tests—Mev was really frustrated by her inability to talk and came home beside herself. I think it was at this point that I noticed she was noticeably weaker and unsteady on her feet. This was understandable considering the exhausting day. I helped her go to bed and stayed until Mark got home. Laura was with me from 6 p.m. on. Mark came in the door with his calm, ready face and attitude. I am amazed; no visible trace of anxiety, just loving attention to Mev.

I have still been thinking about Mev—holding onto words, not finding ways to act out what she'd like us to know; her triumph with the strange and difficult sign language sign for "love"—that is just a word translated into a hand position, another language. The way she holds her hands together and looks and smiles is the natural way for her to say all that love is. In fact, she talks about love in so many ways. She doesn't need the sign language and it is almost painful for me to see it. It seems like a detour—for something already *in* her. She will lose the ability to make that sign, and I don't want it to be another loss.

Her pleading face when she looks at you with a message trapped inside sticks inside my mind; the hand or arm motion which means to her something real, but to us is meaningless and has no context to let us guess; Mev holding up two fingers to mean that she wants to say two things, not that what she has to say has anything to do with "two." Like charades, of course.

How can we know what is raging inside of her? And yet almost all of what she struggles out we do already know, and intensely. We do not need her to say it.

(Although, somehow, that is not true, either). She is convinced that she needs to say it, and therefore cannot be persuaded to rest. I'm not sure, in fact, I doubt whether I am learning to minimize my own struggle. Yet up close to such an intense and honest struggle to live, I learning to ask myself (a struggler), a new consciousness: Do I struggle for that which I rightly desire and consider worthwhile, or instead, vainly struggle for something else?

The love between Mark and Mev is tangible: you can see it hovering or sharp-shooting through the air between them. Ellen said in the car on the way home from Karen House: "It's amazing how God puts people together like that."

Mev is so incredibly beautiful. Mark—talking to Mev as they look into the mirror, "How can anyone be so precious?" Looking at her sitting on the couch, "It's a mystery" and Mev, with her hands, "I don't have the answer," and me—at this moment, how can I have the grace to be content without the answer, which we will know at the right time; to feel my happiness as I witness a rare love, and know that that is at least part of it.

Last night, another version of the question: Angie said to me, what many people feel, how frustrating that such good people have such hardship and they are taken away from us when it seems the world needs them most. However, I have the sense that whatever else is happening, Mark and Mev have been taking care of our needs ever since the battle with Mev's cancer began.

Thursday 19 October

I went along to Mev's Physical Therapy appointment to care for the car. I left them afterwards, to come back at 1:30 to give Mev a massage. It turned out that the tremors on Wednesday seemed to be due to accidental overdose of anti-seizure medicine rather than eruptions of their own. Sometimes Mev makes a joke of seizure tremors with her arm and head. Mark asked her not to do that because it wrenches his heart, and just can't be part of a joke. This exchange touched my heart, too, because it is an example of their coping which I don't often see.

Thursday evening

Mev showed her just completed video for the "Third Thursday" program at College Church.

I came over to get a ride with Mev to the church. I helped her put in her contacts, which at first wasn't easy, but then "happened"—more laughter than frustration. She wasn't able to give a talk, but in the video she speaks. Talking about

it tonight, Mev said she "glowed." (I agree). Mev was just in awe at this finished product. I saw her father wipe away tears at the presentation. I know he is not comfortable watching Mev grow weaker. I imagine he doesn't cry easily. I think Mev saw him. I hope I am not reading in too much when I believe it was a fully accomplished communication.

Downstairs at the reception Mark sat next to Mev and they "received" the greetings by friends and well-wishing audience members for at least an hour; more, I think. It took Mark's absolute attention to stay with it, absorb the energy from the well-wishers, and make sure that Mev was doing all right. Mev accepted the compliments so graciously, with such gratitude and animation. Her face and arms opening up in welcome and thanks, her happy / surprise look with mouth in an "O," hand covering mouth and eyes twinkling in an "I can't believe it" expression as she turns to Mark.

It suddenly started to rain as we were leaving the church to go home. It rained quite hard with winds that turned our umbrellas inside out. I loved it. There was so much energy there. Though I don't look for God's spontaneous message in the weather, to me that's exactly how it felt.

At home, Mev was so energized that she brought out all the sweet stuff she had in the freezer and refrigerator. Angie, Mev and I feasted until about 11:00 pm. Mark was exhausted. Sheri called, and he got to play a different role, think of different problems, and, like stretching a different set of muscles, be other aspects of his natural self.

Friday 20 October 1995

In the airport waiting from a connecting flight.

Still trying to make sense of Mev's experience. If I understood, I think part of her passionate response to injustice included regarding injustice as incomprehensible: Why? How can a human being act this way to another human being? One terrible aspect of injustice is that it strips away the dignity of the one who is abused. But the opposite of injustice, love, affirms human dignity. It is so clear that even though Mev becomes more and more vulnerable, she is also totally surrounded by love. The process of a grave illness does seem to rob one of dignity. It may bear a resemblance in that the "Why?" is never answered. But I think injustice and sickness must be different categories with regard to real dignity. So really I am trusting, even with an illness which takes away absolutely everything, that since this is not due to the evil absence of love, Mev's dignity is at all times preserved by the great love for her.

Exchanges/3

"Mev, is there anything you need right now?"

"Yeah."

"Do you want me to get you something to drink?"

"Yeah."

"Would you like water . . ."

"Yeah."

"Or fruit juice?"

"Yeah."

"Which? Which do you want?"

"Yeah."

"OK. I'll do it this way. If you want water, just point to my left hand. If you want juice, point to my right. OK?"

"Yeah."

"All right then, I'll bring you a glass of water."

"Here you are."

"Yeah."

"You're welcome. Mev, I know this is very hard on you. But it's not easy for me, or Teka, or your Mom to understand you. We can't read your mind, we don't always know what you want."

"Yeah."

"Forgive me if I get rattled."

"Mmmmmmmmmmmmm."

"I'm sorry, this just gets to me sometimes . . ."

"Yeah."

"Especially when I remember . . ."

"Yeah."

Letting Go/4
(Facing The Facts/3)

I thought of Beethoven. Admittedly, a thought that was bathetic, but it still came to me: Of all people to lose the faculty of hearing!

There was Mev—spilling over with words and bursting with explanation and curiosity. She was so skilled and assured, especially before crowds, in speaking, in offering eloquence, in arguing a point with her father at the Italian restaurant dining table, in writing in scores of journals and then free writing on the personal computer, in giving slideshows and talks and presentations to fulfill her mission of being a bridge between North and South, rich and poor.

And how important those words were to her bridging—and these were Spanish words, Portuguese words, commingling in and out of English words (how Mev had been a bridge to her Nana with her newly acquired Italian). Along with her photos, the words, the captions, the descriptions and context were vital to this mission, too.

Mev was a talker, she loved to shine with her words, with her ability to captivate her interlocutors. They found her, invariably, charming, interesting, so passionate. I heard it over and over again. There is testimony to this in her journals and letters, what Steve Kelly noticed as her WOOSH! exclamations, which multiplied in letters dashed off to an extensive, growing circle of friends, acquaintances, allies, networks and publications; her desire to sit across from me and talk about "how we're doing"; our practice of check-ins on Sundays to deal with conflicts that had arisen during the week and to plan the upcoming week's schedule so we could spend plenty of time together—talking, comparing notes, brainstorming.

What a profusion—of energy, articulation and enthusiasm. I later came to have the audio-image in my head of Glenn Gould's playing of the 5th Goldberg Variation as the perfect musical accompaniment to Mev's pace of walking and talking. I would not say she was equally fluent in Spanish, Portuguese and Italian, but she, over the years, she disciplined herself to begin to think deeply and deftly in these other tongues.

I often pondered during the autumn: Mev was so polylingual, convinced of the importance, religious and political, of the word, the Word, especially the word from the Other (the Third World, the poor, the Afro-Brazilian, the persecuted Haitians, the Salvadoran *campesinos*). How she wrote me magnificent, affection-saturated letters and postcards, evidence of her fluency and fun at speaking her mind, "putting it out there," a classic Mev expression. Hers was a torrent but a gentle one—a tank, but one giving off all kinds of communiqués, notices, alerts. In her private life, for she took refuge in the blank page, occasionally adding colored pencil sketches of her dreams and feelings. And she often wrote in a kind of blank verse, going over her day, listing her gratitudes, examining her conscience with words.

And these words were taken away from her by the brain tumor. From the time of our vacation at Dan Berrigan's cottage on Block Island in September, Mev gradually, increasingly, irredeemably, lost her power to speak. This happened week by week, so that by the end of October, she could only speak one word, "yeah," and she was reliant upon my feeble attempts to comprehend her mind, or on the speech books of Berlitz-like sentences she could point to (so thoroughly prepared by her assiduous mother), or on a speech machine with 40 buttons Mev could press to play a sentence, request, or question in the gentle, generous voice of her sister Annarose. I could only smile and hide my wince when Mev would press the button that produced Annarose's voice, saying the line I once heard from Mev's voice a thousand times: "I love you, Schoochers."

It was heart-breaking to many of us to see Mev go from the possibility—as we all have, and so much take for granted—of infinity, an endless flow of sentences, ejaculations, declamations, inquiries, all uttered anew, clichés forbidden!—to the mystery of losing a thousand words a week—or was it five thousand? Her ability to understand everything was undiminished, but the speaking part of her brain was immobilized. Held hostage.

Her greatest strength was taken away from her, week by week. She was robbed of her facility, stripped of her verbal wardrobe, and was left only with "yeah," as in: "Yeah" = "Can you believe this shit is happening to me?" Or, "Yeah" = "I really wish you would escort this well-meaning person far away from me." Or, "Yeah" = "I'd love another sip of Frangelico." Or, "Yeah" = "I have had enough of you, too, Marko, I need to rest." Or, "Yeah" = "I would like to hear Pachebel's Canon in D again, please" (even though the rest of us had heard it nine times already that day, in various versions, all loaded into her CD player). Or, "Yeah" = "I am so sorry for you to have to see me like this, will someone comfort Marko now?"

I couldn't read her mind, and I had to imagine and interpret from her eyebrows, arched or relaxed, her eyes, so full of sparkle or liquid sadness, her mouth, twisted or tight, ravaged by the tumor's advance, her left arm and hand, still capable of making a shadow of their former Italian gesticulable commentary with a slash, a wave, a shake. I and the rest of us attempted to fathom the unfathomable syntax and thought-patterns quivering in Mev's mind, her body a prison now by the tumor, her tongue colonized into submission by the tumor, Mev whose tongue graced our world with her indignations, connections, excitement. Silenced.

Silenced by "natural causes," but silenced all the same like so many she had photographed in Cité Soleil or Marabá or maybe Maybelle, too. Mev was silenced. And I think maybe even blind at the end, but then that didn't last as long and so didn't make as much of an impression on me. Later, I pondered it as well: Mev lost her vision, too.

Where Mev had shone, she was slowly being eclipsed.

Letter/4

Dear Laura,

Just a note. I am glad you got to see Mev before the month of October. For this was the hardest month of all—she has lost her voice, the right side of her body deteriorated so much that she needs a wheel chair to get around. The speed with which she lost ground was unbelievable, I described it to a friend as our world was being destroyed syllable by syllable. I literally pulled my hair out that month, screamed and ached with utter powerlessness: To watch Mev— eloquent exemplar, prophetic visionary, garrulous gal—lose her speech, and realize there is nothing I can do but offer a caress, be patient and try not to let my desolation overwhelm her as well. In a Molly Bloomish way, Mev has retained the word "yeah," which she has managed to inject with 45 different meanings or nuances as she exclaims, exudes, gesticulates, . . . as if to say "yes I know what I want to say yes it's a beautiful day yes take me outside yes come close to me yes . . ."

You'll soon get a mailing from us as well about Mev's video, an earlier version of which you saw on September 30. But I wanted to tell you I have the fondest of memories of witnessing your visitation with Mev in our living room, as she beheld you, her beaming face was all light, her arms open in an expansive arc, I hope you know how delighted she was to see you after all these years.

If you ever have cause to be in Saint Louis in the upcoming weeks, you are of course welcome to drop by. We entered a Hospice Program last week: Mev's finished with treatments. Like Saint Paul, she has run a good race, and fought the good fight for over 18 months (32 years). I have encouraged her to rest now that her video is done and to allow ourselves to be surrounded with beauty, music, beloveds, and calm as we enter that next, last stage.

It was a pleasure to meet you in September having heard much about you over the years. Glad to see that your heart is content in marriage and work. Hope that you and Steve have had a chance to enjoy a beautiful fall.

Best,

Mark Chmiel
4525 Arco Avenue
Saint Louis, MO 63110

Letting Go/5

Mev, with sisters Rose and Laura; U.S. Catholic Award, Chicago; May 1995

Peter Puleo

Mev, with friends Sharon and Ann; Arco Avenue, Saint Louis; November 1995
Mark Chmiel

Accompaniment/3

I had been going to my Wellness Community meetings alone for at least a month. While I initially went to please Mev, I eventually looked forward to the meetings, for my own sake. There in the meeting room were 10 to 15 people who were going through what I was going through: They were giving care to spouses, children or significant others with cancer.

I noticed that, at home when there were increasing numbers of people milling through our apartment, I often felt I had to mask my weariness and despair. I didn't want to "infect" others with my sagging spirit. But once a week, on Thursday evenings, I could go and be with people who *knew*. Some of our older friends had been through this kind of excruciation, but not many of our school friends who were, after all, like us, relatively young and not yet used to watching parents suffer, much less spouses.

One young woman I came to appreciate was Penny, whose husband, a professor, had been diagnosed earlier that summer and was declining rapidly. Though it complicated her life to come to the Thursday meeting, she made the sacrifice because she left two hours later, that much more sane for our sharing.

Soon after her husband died, Penny still came to the meetings, for the support of the group was crucial to her. She said shortly after his death, "You know, he was suffering so much at the end, I am relieved—for his sake—that he finally died. I wouldn't wish him a minute more of that agony."

At that meeting, I spoke. I had heard about how much anguish this process entailed—for our loved ones, and for us, and though I rehearsed it over in my mind before I actually spoke, I realized that it did seem a little callous or unseemly on my part. "We talk about the misery in all of this, and that's true. But you know, one of these days, we are going to know freedom. That's the other side of this: We, too, will be free of this disease."

During the next two weeks, Mev's diminishment continued relentlessly, and I had forgotten all about my musing. I, too, was run down at the next Wellness meeting. Penny was still coming. At that meeting, she was beside herself: "I'd give anything for ten minutes with him."

I don't know what got into me. I just felt like saying whatever popped into my head. I reminded her, and the rest of the group, that only a little while before, she sounded so relieved that he had died.

"I know I said that then. And even if he was unconscious, drugged, laying in the hospital, I'd give *anything* to be with him."

Penny was free. And miserable.

Crisis/3
(Community/4)

At last, a little quiet and stillness. Judy Gallagher and her daughter Sarah brought over the evening's delicious dinner. With a candle I had lit, Mev and I sat at the table, she in her wheel chair, and I in one of the rickety chairs I had brought with me from Louisville to New York, Cambridge to Berkeley, Oakland to St. Louis.

I knew Mev did not have her speech machine with her; I didn't want to go into the bedroom to get it. I had a negative appreciation for that contraption. I wanted to see how much we could communicate without it.

I said the grace: "We give thanks this Thanksgiving Eve, for our love, for our families, for our friends who share their food and time with us. I give special thanks for all the love you have given me this year, Mev. I love you, I really do."

She smiled, but I could tell she was exhausted. There were days she craved company, and the tumor was too much for the two of us. So at lunch that day, 12 people had come over to share Chinese carryout from the Silk Road restaurant. Then John Kavanaugh came over and played guitar to lull Mev into her afternoon nap. Her father was then working on a wheelchair to put a special neck backing on it and so make Mev more comfortable. Also, that afternoon, a couple of the Sisters came by from Visitation Academy.

It was quiet now, though. Most folks in the neighborhood had left to join their extended families in the county or out of town altogether. Our next-door neighbors, Sharon and Danny, had left for Ohio after our lunch.

Mev poked at her food. She was still trying to eat with her left hand. I began to feed her when the dressing dribbled out of her mouth down her chin. After I brought the spoon to her mouth, Mev backed up the wheelchair from the table, and started moaning. I asked, "What is it, Mev? Are you in pain?" I couldn't make out the look on her face, and she started to scream. I worried that her medication was all messed up again. I asked her if she needed morphine. She replied with a scream that garbled, "Yeah," but I wasn't sure. She started to slowly move her wheelchair in

a circle around the kitchen—"Uhhhh . . . Ahhhhhhh . . . Arrrggghhhhh . . .
Uhhhhhhhhhh"—and her voice became more insistent and fearful. I literally pulled
at my hair for a second, before I decided to call the Hospice nurse on duty, with the
hope that she could tell me what was happening.

I got a new nurse, one I had not spoken to before. She told me to make sure Mev
was comfortable and to go ahead and give her another decadron. This reassured me,
for I just wanted her to stop wildly gesticulating.

As I hung up the phone, Mev circled her wheelchair in the kitchen three more
times and then peed on herself. "Was that it? You needed to go into the bathroom?
Oh, but why . . ." I began to say, but then censored myself. I was about to point out
to her, "Why didn't you just point to the sentence in the speech book?" when I
remembered a recent time that Mev had screamed viciously at her mother, who had
suggested the same commonsensical strategy at one indeciperhable time.

It was taxing to take off Mev's clothes, move her out of the wheelchair and
clean up the urine, so I called Cathy Nolan, who lived upstairs. She wasn't at home,
and I left a message asking her to come down as soon as she got that message, if she
arrived in the next several minutes. After I had gotten her dried, Mev started to
scream again, this time from the top of her lungs. It went right through me, but now
I was utterly clueless about what to do. Her earlier discomfort had evidently been
that she needed to urinate, but for some reason she couldn't get that across to me,
and I couldn't guess it. I thought maybe she wanted to lie down and be more
comfortable, so I wheeled her back into the bedroom. As her screaming continued,
I lost control. There she was, naked, and I placed her on the bed, and threw the
blankets off in a fit of bewilderment, and started my own screaming refrain to her
incomprehensible agonies: "What does it mean? What does it mean?" Again, I yanked
at my hair.

Just then, Mev crapped in the bed, and I felt broken beyond repair. My screaming
stopped as I looked at her quivering and sobbing, and I started weeping. Cathy then
arrived and started to comfort Mev, as I was moaning, "I can't keep doing this." Cathy
got a hold of one of her community members, Mary Beth, and asked her to come
assist me. A few minutes later, she arrived and held me in the hallway as I babbled, "I
can't live alone with my wife anymore. I can't manage this." She soothed me as Cathy
took care of Mev, calming her down and cleaning her up. How the two of us slept
that night is a mystery to me.

Facing The Facts/4

Reminiscence from Sister Marian Cowan, Mev's spiritual director

It was with deep pain that I recall the two calls in which Mev informed me of her brain tumor and subsequently asked me to be present with her in California for the surgery. I was humbled once again to be one of the few persons Mev really wanted to bring out to be with her. I am so grateful to have been included. We celebrated Mass, we prayed, we waited, we walked and we waited some more. Not until Mev had come through the surgery and we saw her sitting up and talking were we able to leave her and return to our own cities again.

During the time that Mev and Mark continued to live in Berkeley, we chatted a little more often, and I was always filled with sadness afterward. Then they moved to Saint Louis. This gave me greater opportunity to see Mev and visit with her. I traveled a lot during that time, and I was also assisting another friend as she moved through cancer, so I was not able to see Mev as often as I desired. Mev's disease continued to take its toll on her body, so that each time I saw her, I was shocked at the progress of physical debilitation. Yet her spirit was radiant, as always. This does not mean she did not feel all the emotions proper to her condition. She did. And Mark and others helped her to express them. For most of November and December, I was at last able to take a regular time to sit with Mev and assist in her care. This was a privilege for me.

My other friend became very ill while she was in Arkansas, and she died on November 10. I gave myself a week to deal with this reality before again trying to be with Mev. I became so frustrated when each time I went to the house I was met with the note [sign on the front door] asking folks to come back later. I felt a great urgency to see Mev and to spend some quality time with her. Mark responded to the notes I left, telling me to come on in the next time, which I did. This was the day that is impressed in my memory for all time.

When I arrived, Pat Geier from Louisville was sitting on the couch with Mev, who could no longer form words and whose right side was now paralyzed. But Mev

knew what she thought and felt and did her best to communicate. She was delighted to see me, and we tried to do a little sharing. After a while Mev began making a movement with her head, laying it down on her left shoulder and closing her eyes. She would then lift her head, open her eyes and fasten them on mine, asking me with her look to grasp the meaning of this gesture that she kept repeating. It dawned on me that she was trying to talk about her death. So I asked her, "Mev, are you trying to talk about your death?" She smiled assent with her eyes, nodded her head vigorously and said, "Ahhh." Still fastening her eyes on mine, she implored me with her gaze to go on. I ventured, "Mev, are you telling us you want to die?" She looked so relieved and smiled as she threw up her left hand in assent, again with a firm nod and "Ahhhhhh!" I looked at her with all the love in my heart and responded, "I want you to die, too, Mev." Mev's reaction to this was so embracing that it left no doubt in my mind, or in Pat's, that we had finally got to the heart of the matter with her. She threw up her left hand, looked extremely relieved and sighed her "Ahhh" as if to say, "At last someone understands."

At this point, I looked at Pat, and we realized that this was a moment of profound significance that the three of us shared. We continued to talk a little bit. And Pat brought us back to the conversation we had just had. She (or I, I do not remember) asked Mev if she needed at this point to have people tell her she could go to God whenever she was ready. Mev nodded and rang her bell to summon Mark. She indicated to me that she wanted me to repeat for Mark what had just transpired. I did and was very touched with Mark's response: "Oh, Mevvie, I can't tell you I want you to die, but I can tell you I am ready for you to die." Mev seemed relieved and even more loving of Mark for his willingness to let her go.

Hardly had we finished this when a neighbor came over. She sat down on the floor and was happy as usual to be there. Mark asked me to repeat what I had just told him. Mev agreed. When I did so, the neighbor was shocked and said, "Marian, you can't expect us all to be at this point. A lot of us aren't ready to let Mev go." I glanced at Mev and spoke for her, saying, "It is Mev's life we are talking about. It is unfair to ask her to wait until everyone is ready to let her go. We are the ones who need to make an adjustment, not Mev." Looking again at Mev, I saw her confirm what I had just said. This was one of the hardest days and yet one of most blessed days of my life. I was so grateful that Pat had been there with me. We were all quite spent by this time.

A few days later, the community of support gathered around Mev, and we all spoke to her, giving her our permission to leave us through the doors of death. I will never forget the sight of Mev in her father's arms afterward, just sitting on the couch and resting in the union of wills with that of God.

Powerless

By mid-December, Mev had grown very quiet. I'd estimated she was knocked out for 20 hours a day. Was she asleep? Did she dream? Was she in aggravation? Or was she just so doped up and out from all her medications? What went on in her consciousness?

I found it incredible to realize that less than two weeks before had been the Visitation Academy Award ceremony, at which Mev appeared with grace and dignity and that, in the near future, it would be Christmas. I was always polishing my penchant for understatement: It sure didn't feel like Christmas, even though our neighbors were kind enough to get us a tree and encourage other neighbors to bring ornaments.

The Puleos had slowed down in step with their daughter. Since Mev now rarely used her wheelchair, her father's adaptations and refinements were no longer utilized. Unlike three weeks before, Mev was now confined to one place, there in the bedroom: in a hospital bed, surrounded by people who were wiping her forehead with clean and freshly chilled washcloths, or who were rearranging the pillows and cushions around her arms and legs and head, so as to prevent bed sores and to allow her some comfort and change in the face of being stuck there.

So often we judge others from our own narrow personal perspective, so I, as Mev's husband, could see many things that others could not (and vice versa). As I tended more towards observation, I knew my father-in-law was more a man of action—an engineer for heaven's sake, those people who get things built. In his case, he got things done so well that he had become affluent after growing up poor in a St. Louis immigrant slum. He was a classic man of his World War II-era generation: Their love was expressed in actions, in providing. Mr. Puleo was nothing if not a problem-solver.

Up until the first part of the month when Mev had obvious needs, he did what he could, but at this stage of Mev's illness, there wasn't much to do except sit with her, chill the washcloth for her feverish forehead, change her diaper and give her morphine with white grape juice, a Mev favorite. Mr. Puleo was not up to these

activities as much as other practical endeavors, for it was too heart-breaking. But he was able to keep me from going insane when he offered to handle all the insurance bills and papers and filings. It almost drove him crazy, but it freed me up to spend much more time with Mev. He was clearly uncomfortable with a Mev who could not respond as of old: with vim equal to his vigor, with cheerful announcements of new gems uncovered in the dark room, with ever-spirited political contestations about U.S. foreign policy on Haiti. Now, only silence.

But he was faced, as we all were, with that vast, impenetrable, bafflingly local, resistant-to-analysis mystery: Mev's life was leaving her; we were witnessing it hour by hour. One day, I simply said to one of the new recruits who had come to give us a breather, and who was afire with the desire to help and serve, "You can come sit and be powerless like the rest of us." I did not mean this harshly.

Parents' Love

Right before Christmas, a Hospice nurse had told us, with all good intentions, "It could be any day now." And I had thought that that was the case since late September, when Mev's language capacity began to decrease dramatically. Actually, I had fallen into a delusive trap. Dr. Fink had told us two stories of how "the end" came to two people. For some reason, both Mev and I believed (a strong emphasis on belief here) that this would also be the case with her. It would end relatively quickly and painlessly.

We were surprised.

She was going on three months already, had endured the weekly stripping of her most natural and cherished faculties (she was 32), she had been rendered unable to walk and had been confined to a wheelchair (she was 32) and then to a hospital bed (she was 32), she had to be fed with syringes and have her diapers changed (she was 32). All this over many weeks.

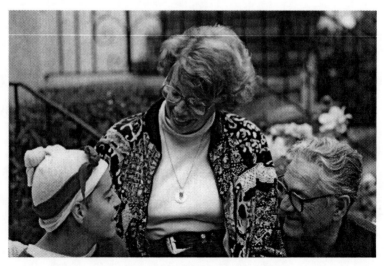

Mev, Evie, and Peter Puleo; Oakland; 1994

Mark Chmiel

The toll this was taking on Mr. and Mrs. Puleo was certain; still, my mother-in-law had the steely ability to face the worst without flinching, or so it appeared to those friends, neighbors and volunteers who came in and out of our apartment for two or three hours at a time. She pulled me aside from the crowd one afternoon and said, "Mark, we are going to have to plan for the funeral. There is no telling how long Mev will hold on. But we might as well prepare for what is inevitable."

"I agree," I said out of fatigue and the realization that it would be better to anticipate. I knew it wouldn't hurt to have some sense of the next stage of saying good-bye to Mev.

"I will call Kriegshauser and set up an appointment with them. We'll need to pick the casket and see what services are involved in this."

I was so grateful to her at that moment. "Mom, you're amazing. How can you keep yourself together?"

"I've been through this with Peter's parents and my parents. I've done this before."

"Mom, I was wondering. Do you think it would be possible to have some photos of Mev at the funeral home for the wake? Could you ask them?"

"I'll talk to them and then sit down with you, and we can go over what needs to be done. It could be five days or five weeks, we have no way of knowing."

True, we didn't.

After meeting with the Kriegshauser staff, Mrs. Puleo came back and gave me the details. About the photos, she said, "This is becoming more common at funeral parlors. He told me that families often have collages of photos of the loved one."

At that point, during the Christmas festivity, my father-in-law had been in a difficult way.

"Mom, what do you think about Dad doing one of those collages, you know, photos of Mev, from all different times of her life? Think he'd do it?"

"I don't know, but I think that would be good for him to do. Let's ask him. Peter?"

My father-in-law came into the living room. "Peter, Mark and I have been talking, and we think it would be a good idea if you were able to do some kind of collage of photos of Mev for the wake."

His brow grew deeply furrowed. "Oh, Evie, I don't think that's appropriate." He, the former owner of a photo store, an amateur photographer who taught his youngest daughter the art, seemed incredulous that we could be serious. "What do they say at Kriegshauser? I don't think this is done, is it?"

"Yes, Peter—" I was staying out of it for the moment—"Kriegshauser told me more families are doing this. Do you think you could get together something simple?"

"Well, I've got the time, but I don't believe they go for these kinds of things."

"Dad," I interrupted, "I don't know who the 'they' are. The wake is for us, and I think plenty of people would love to see any photos of Mev you can come up with."

"OK, I'll think about it and see what I've got. I do have a lot of photos of Mev in the basement. I've got hundreds down there. Do you have any photos handy you'd want me to include?"

"Oh, just a few."

"And I've got those of yours that I was making prints of for the Visitation nuns. When I get home, I'll see what's available. How big do you think?"

Evie told him, "Peter, whatever you want to do, it doesn't have to be huge, it can be whatever you want it to be. Mark, do you trust Dad's judgment?"

"Of course, Mom, I think that it would be a boost to people at the wake."

We didn't see him as much in the next several days. Often, he was in the darkroom, immersed in images of Mev from birth, grade school, adolescence; there were photos of Mev at the piano, Mev with her sisters and brother, Mev with her husband and various friends, Mev in her master's graduation gown. There were a few photos of Mev in her post-tumor life, even a couple revealing how much she had been ravaged (but there she remained with a smile on her face, standing next to one of her Sicilian cousins, Rose Alu). But in those days, Mr. Puleo was literally and figuratively someplace else. In between his visits at the apartment, his reckoning with Mev's diminishment, he retreated to the black and white and Kodachrome paradise of Mev. In most every photo, she was beaming, as if announcing, "I'm ready for the future."

I saw him in early January. I didn't want to be pestering him, but I'd ask, "How's it going in the darkroom?"

"I've been spending a lot of time there. Are you sure this is acceptable at funeral homes?"

"Yes, it's whatever we want. And Mom and I think it's a good idea."

I couldn't wait to see the fruit of his labors.

I could wait to see the fruits of his labors.

Day in The Life/3

I ask, "Can you stay another 15 minutes, so I can get a shower?"

I remove Mev's shower seat from the tub so I can shower.

I make a mug of French Vanilla coffee with 4 tablespoons of the powder to give me yet another morning kick.

I tell Mev she's loved.

I listen to Benny Goodman's small-group version of "After You've Gone."

I stack up all the mail on the desk.

I look ahead to section B of the *New York Times* to see which books are being reviewed.

I pick up a pair of boxers and take them from my dresser, now located in the kitchen (the hospital bed in the bedroom necessitated this dislocation), to the bathroom.

I go on-line to check hopeful email messages.

I say hello to Beth Obertino who usually crosses my path at one point or another ("She's so congenial!").

I put the cats down in the basement after they've mangled the ornaments on the Christmas tree.

I listen to Shane MacGowan and Sinéad O'Connor's duet of "Haunted" five consecutive times.

I calculate how much money there is.

I uneasily notice the healthy smile of J, the luscious hair of M, and the girlishness of S.

I thank at least 12 times one or another group of persons.

I summon the same old shower fantasy.

I wonder when I will be able to resume my work.

I say, "Would you please stop whispering, I'm going crazy around here."

I drop the latest stack of opened (and read to Mev) mail into the full mailbox between the printer stand and my desk.

I grind down Mev's decadron for easier use with the syringe.

I look at my desk's array of dictionaries, readers' companions, digests, and literary texts and wonder if I should just put them all away on the shelves.

I put on for the sixth out of seven days my black jeans.

I use my electric razor.

I pop some kind of anti-biotic, decongestant, Tylenol, Sinu-tab, or I gulp Robitusson.

I cough and blow gunk out of my nose.

I envision liberty and license.

I forget to say my gathas.

I change Mev's diapers.

I write down seven messages from the answering machine.

I remove people's coats, scarves, purses, etc. from my desk, the last private property I feel I have.

I don't move the three cameras on the most disorganized bookshelf.

I lift Mev to and from the bed, wheelchair, couch and portable commode.

I look at the piano with eyes of longing.

I notice that visitors don't put back glasses where *we* had them.

I let other people take Mev's temperature, give her pills, sit with her in her hospital bed.

I crave distance from this.

I don't have the desire to reignite email correspondence with people far away.

I don't have the energy to go to the Simon Rec Center and do Stair Masters (my life is one long Stair Masters).

I observe that I don't have the time to read my desired "one book per day."

I do not drive much.

I clean Mev's face at night with a hot washcloth.

I say "Thank you!" to the mailman who, if the front door is open (it typically is), drops the mail on the floor and cries, "Mail!"

I don't believe I am holding Tylenol suppositories in my hand.

I grind to a halt, and I sigh heavily.

I look at how unevenly clipped my toenails are when I am sitting on the toilet.

I climb into bed with Mev and enjoy her stroking my hair with her left hand.

I climb on top of Mev, and we engage in kissering.

I try to envision Steve Kelly in jail trying to imagine Mev dying.

I reach to crank the stereo and play "Ticket to Ride" full blast; I don't care what anyone thinks.

I blow my nose.

I don't go Christmas shopping.

I cut off the last syllable of words or names to conserve breath: "Want some yog, Shar?"

I don't feel hungry.

I imitate Nana Puleo's shrug with an upturn of the mouth so as to indicate, "What can you do?"

I dream and dread and deny.

God/4

A perfectly bleak wintry December day. Ten people or more, it seems, invaded (that's what it felt like that day, though later that feeling would give way to relief that they were all there), and I needed a break from all the people who assembled to help and be close to Mev.

Out on the front porch my three-minute solitude was broken by a friend who stood with me in silence for a minute or so. He and I both knew that Mev didn't have much time left. It was startling to recall that, just four months earlier, she and I were riding bikes around Forest Park. As we zoomed down the Skinker hill, Mev was cheering, she was so thrilled to be moving so fast (I often tormented myself this way, with odious comparisons: "OK, five weeks ago, we were making love in a frenzy and now, nothing, except holding a weakened hand.") The friend then looked up at me and said, with gravity, "Mark, we just don't know why God is taking Mev away from you."

Pause.

"But who knows? Maybe in a few years He'll give you somebody else."

Reading/5

As I've grown older, I have become more obsessive about reading. The caveat of our national sage of reading, Harold Bloom, haunts me: "You cannot teach someone to love great poetry if they come to you without such love. How can you teach solitude? Real reading is a lonely activity and does not teach anyone to become a better citizen."[74] And so, like many bibliophiles with no sense of proportion, or danger, I've read Noam Chomsky while driving my car, *The Brothers Karamazov* at red lights, *Silva Mind Control* (the only paperback in English I could get my hands on) while standing in a crowded bus on the back roads of Guatemala, and an ever-changing assortment of books, tracts, catalogs, magazines and anthologies in all of the bathrooms of my living spaces over the past two decades.

And so it was during Mev's decline into passivity that there was precious little time to read, although before she became bed-ridden and drugged/knocked out in December, she was always supportive of me going away to a wonderful St. Louis bookstore, The Library, Ltd., to breathe, to journal, and, as Bloom puts it, to read not "for easy pleasure or to expiate social guilt, but to enlarge a solitary existence."[75] I had put my dissertation on Elie Wiesel on indefinite hold, and I rarely read at home, as there were too many exigencies to attend to—except in the sanctuary of the bathroom. And, in those weeks, with rotating shifts of people living with us around the clock, I would savor the three or four minutes with a quick perusal, a famished binging, a selfish craving to have endless hours in solitude, in silence to read. (That wish would come true soon enough.) But one night, around Christmas, I pulled off my shelf en route to the bathroom, *The Portable Blake*, and left the volume there at the window sill next to the toilet (who among the community here, I wondered, would chance to pick up this volume and read "The Garden of Love"?).

A couple of nights later, exhausted, enthroned there, I picked up William Blake and turned spontaneously to a page—as some fundamentalists claim happens as a biblical modus operandi for discernment and I just happened to land on *The Marriage of Heaven and Hell*. As my eyes scanned the proverbs, I was thereby illumined:

Reader, have you ever stumbled, accidentally overheard, or discovered a few words that provided you with such anchor that you were freed to look on tempests and not be shaken? That spoke so personally, directly, unerringly to the emotionally constellated you at that exact moment, that in such breaking of verbal grace (or, if you prefer, musical phrase) your cup overflows with one sustaining truth you knew you needed but could not yet name?

So, for me, that night, Blake's three words: "Exuberance is beauty."[76] Mev! This is Mev. I mistook the signs on the page for the enfeebled fleshed spirit 20 feet away from me in the bedroom. We had already begun funeral preparations (Mev having laid out in advance her preferences), and my mother-in-law's organizational powers were taxed but not trumped by the horror of her daughter's imminent demise. But this was the truth of Mev, to which too many people testified to me long before she was diagnosed: She exuded life and brought forth life in abundance.

A thing of beauty is a joy for a few weeks: I'd found Mev's epitaph. Accurate, upbeat, to the point, brazen in its succinct assertiveness, even.

Poem/3

The first week of January was bright and bitterly cold. Pat Geier and Cristobhal, our friend from Guatemala, had spent Christmas and New Year's with us and had already left for Louisville, but she was at the ready. Surely it would be this week? Surely it would be this week.

As it was, we spent the evenings vigiling around Mev's bed. On a Tuesday, there must have been eight of us. Mev's breathing had become labored, and her heart rate could go as high as 180. This must be it, the onset of the death rattle.

At one point a friend wanted to offer comfort, we were so eerily silent having to listen to Mev struggle to breathe. So he started to read from a passage from Saint Paul. As I listened to my friend read, I silently reacted: "This just doesn't do it for me!" In the broken-hearted spirit of Mev's 1989 breakdown in Brazil, I wanted to snatch that Bible away from him and slam it shut: "There's nothing you can read now that would do any of us any good!" Ah well, he likely wasn't reading it for me, but for Mev, or himself even.

I caught myself. I didn't want to make a scene—after all, Mev was likely dying before our very ears. But I wanted something more appropriate for what I was feeling (and all that I had felt, so at home with Mev in her and our nakedness, how at home she was in her body, especially during the siege). So I requested the Bible and opened the book, not knowing what I would find, mumbling something about a husband's prerogative before his dying wife. As I held the tome in my hands, flipping through the pages, I became inspired: Of course! Exactly!

We had wondered if Mev had become blind—she was asleep most of the day—or even if she had become deaf. She seemed so out of it and unresponsive. As an experiment, at one point I played a Sinéad O'Connor song blaring from the CD player next to her bed, and it made no reaction on her whatsoever. I didn't know for sure if Mev heard me as I said to her, "Now this is something from the Bible *I* want you to hear." And I read a passage from the Song of Songs, chapter 4:

Behold, you are beautiful, my love,
Behold, you are beautiful!
Your eyes are doves
Behind your veil . . .

Your lips are like a scarlet thread,
And your mouth is lovely.
Your cheeks are like halves of a pomegranate behind your veil . . .

Your two breasts are like two fawns,
Twins of a gazelle,
That feed among the lilies . . .

You are all fair, my love;
There is no flaw in you . . .

You have ravished my heart, my sister, my bride,
You have ravished my heart with a glance of your eyes,
With one jewel of your necklace.
How sweet is your love, my sister, my bride!
How much better is your love than wine,
And the fragrance of your oils than any spice!
Your lips distil nectar, my bride;
Honey and milk are under your tongue;
The scent of your garments is like the scent of Lebanon.[77]

Some time later, I whispered to Mev as I bent down to her, "Mevvie, I love you very much. I am going out for a little lunch. I'll be back soon." And as I lowered my mouth to kiss her, she suddenly strained her neck up to meet me in a kiss. I was startled: So she could still hear! So she could still move! So she could still kiss!

As I returned from eating lunch at the Silk Road restaurant, I could hear Becky Hassler blurting out, "Someone, quick, go get Mark. I think Mev is dying right now!"

Becky was right.

PART THREE

Believe in the holy contour of life

Jack Kerouac

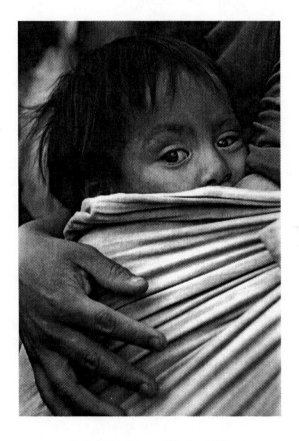

Holy Child; Chiapas, Mexico; 1983
Mev Puleo

Accompaniment/4

Sharon was in charge of organizing the funeral liturgy, as I had come to trust her judgment and *savoir-faire*. She had asked Michael Bartz, a neighbor, high school teacher and silk-screen artist, to do a suitable cover for the program. I remembered that the week before, Michael had been over at the apartment and was staring at a photograph I had up on the side of one of our bookcases. It was a black-and-white photo taken by Mr. Puleo one Easter when Mev and her sister Annarose must have been four and five years old, respectively. They both had Easter baskets draped over their heads. As Michael and I were sharing the silence, which was a frequent pastime on Arco Avenue, he asked me, "Do you mind if I borrow this?"

"Not at all. Oh, but please be sure to return it. It's one of my favorites." I wasn't sure what he had in mind.

I saw it the midnight after Mev had died. I came back into the apartment after joing the Arco angels for revelry and decompression at McGurk's Pub. (This was after the funeral home personnel took Mev's body away at 7 p.m. The apartment now empty, I turned to my friends and said, "What now?" And I just as soon answered, "Let's go to McGurk's," a pub where Irish singers mesmerized St. Louisans with their beautiful and haunting ballads.) There in my kitchen was Sharon, John Foley, a Jesuit musician, and Michael. They were still busy planning the songs and the program, and I was surprised to see them. "You all are amazing to be up doing this. I'm so grateful for everything you are doing, you must be exhausted." With her usual aplomb, Sharon stated matter-of-factly, "This is what we do." About the arms race, Dan Berrigan once commented, "There's very little we can do. But that little we must do, and that can make a big difference." In the context of their daily lives, our Arco friends lived by this creed in yet one more way by putting together what is termed the "Mass of the Resurrection." I asked eagerly about the program cover. Michael showed me the draft he had crafted with his friend, printer and fellow golfer Greg Stevens. And I cried, tears of joy at last after tears of exhaustion, despair and bewilderment. "Oh, it's perfect, it's so beautiful." Michael had taken the photo, cut out Annarose, and zoomed in on Mev's face and eyes. A Grateful Dead devotee, he culled a line from one

of their songs to accompany the vision of Mev: "Wake up to see that you are the eyes of the world." His handiwork and eyework lightened me considerably.

"Ah, the way you've arranged it! You've captured her! Thank you."

Community /5

When Mrs. Puleo had said that the wake would be from 2 till 9 p.m., I didn't bat an eye. I presumed I would be ready for the tasks at hand. But what were they? Sure, I had been to several wakes and funerals, but I was now at a complete loss as to what to expect. Where do I stand? Where do the in-laws stand? Where do the flowers go?

I arrived at 1:30 p.m. with Pat Geier and Sheri Hostetler. I was relieved that they were both here to accompany me, since both of them had played such important roles in my life and marriage with Mev. As we walked into Kriegshauser, I smiled at the director and went straight back to the room where Mev's body was. No one was there yet, and I noticed that Pat and Sheri lingered back, letting me go into the room alone, for some privacy.

I knelt before the casket. I touched her left hand folded with a rosary in it. And as I touched a bead, I gave thanks for Mev's infectious laugh, another for her ethical indignation, another for her empathy, another still for her playfulness in sex. And then I pondered what must have been done to her to get her to look like this. "Her lips," I moaned aloud. I am sure the embalmers did the best they could, but the lips were the obvious dissent from the regular comments I'd be told or I'd overhear: "Oh, she looks so good." Yes, so good after a 21-month siege, after losing her hair, after becoming a cripple, after losing her speech, after being in diapers for six weeks, after being blind for a while, after being deaf, after four days of a heart rate around 180, she looks very good.

The in-laws arrived. I was concerned about my father-in-law, whom Mev had seen cry only a couple of times in her life. I wasn't surprised when the two of them came in and we three stood there, arms linking, and struck into silence, a silence that we would share many times in the future. The funeral director came in and said people had started arriving. "No need to worry about anything. We will arrange the flowers, as they come in, and we have just received several arrangements."

"Well, Peter, shall we do this?"

"Yeah, I guess I'm ready. How about you, Mark?"

"Yeah, let's welcome our visitors. Where do I stand?"

And my mother-in-law, thank God for her savvy, even in a funeral home: "Daddy and I will greet people first, and then you can be next and closet to the casket." That was fine by me.

I was surprised to see a line form at the main entrance to the room. They'd given us three huge rooms for the wake. I tried to see the forest and not the trees, because I didn't want to know who had come until they got one or two down from my in-laws. I knew it was going to be a long day and night. A long life without Mev.

I was on the lookout for the pallbearers. It had occurred to me to ask eight women to assume this traditionally strong male role. The ones who graced Mev in her last months in St. Louis—from Molly (who was 10) and Myrrah (who was 12) to Becky and Joanie in their 30s—they all humbly, kindly welcomed this as a privilege. But it was each of them who had graced Mev and me in one way or another.

With a wake like this one, where I met 400 people or so over several hours, the faces did get blurred. I don't know how many nuns in purple and blacks habits I hugged and thanked for coming. Then there were Mr. Puleo's business associates, fellow University trustees, Sicilians from the extended family, teachers from Visitation and some of Mev's former students.

My first jolt was seeing Michael Whiting, an old friend from Louisville. I had glanced back at the line at 2:30 p.m. and saw him there, with a blank gaze. He hugged my in-laws when he got to the front of the line, and then as he approached me, I let out an inscrutable groan as we embraced and kissed. He held me for what seemed like 15 seconds, a year, and then we looked into each other's eyes. Michael, who had gone further on the spiritual path than anyone I'd ever known, didn't say a word, for his tears and touch communicated what he needed to express.

I welcomed other old friends who made the five-hour drive from Louisville, Kentucky, including Jack Jezreel, who'd been my witness at our wedding a few years earlier. I was a little surprised at the number of priests in Roman collars. I got reacquainted with octogenarian Sicilian aunts whose English I could barely comprehend but whose tears I readily understood. I began to cry when I saw our old-time Cambridge *compañeras* Francine Cardman, Sue Koehler and Mary Clare Ryan at the far end of the visible queue. They had all flown in from Manhattan and Boston and patiently waited their turn in line speak to Mr. and Mrs. Puleo and me. I so wanted to hold them all, but I stayed put and focused on the person next approaching us.

Danny had come up to me, fiddle in hand, and I whispered, "Please play whenever you want, I am sure everyone will be grateful." So in the adjoining room, he began with my favorite, the Hebrew melody, "The Hope." It was perfect for how I was

feeling, and I didn't mind at all—no strict examination of conscience here—that it was my need to have him play, he who'd played one Friday night in December for Mev, before she was put into the hospital bed. As best she could with one arm in a sling and the other free, she clapped to indicate her enthused gratitude for Danny's folk renditions.

What did I know about wakes? But I did want music, and yes, the flowers were a comforting touch, and I wanted people milling around. I wanted it to be serious, but not so solemn; after all, in her journal, Mev had written, "I want everyone to have fun. Maybe even tell some stories about me." Again, I chuckled to remember her as the extrovert and performer. Of course, she'd want people to be talking about *her*. What else were we going to do?

About 4 p.m., my family showed up. They'd made the drive that morning from Louisville. Since my mom's cancer had returned in the past year, I knew that my family would need to drive very slowly and take plenty of stops. While I had been preoccupied in St. Louis with all Mev was going through, my brothers, Jim and Dave, and my dad were heroic in caring for all my mom's many needs. They came to the front of the line, a move arranged by Pat, and they cried as they hugged Mev's parents. My mama said to me: "Son, I don't know how you've managed to keep yourself together. I loved her so much." And as she crumpled into tears, Jim took her from me, and they sat down on one of the couches, as my father said to me the exact words he said to me on the day after our wedding: "Son, you just don't know . . ." And he, too, broke down, and Dave escorted him to sit down and restore himself.

An elderly, habited nun, scarcely five feet tall, forcefully clasped one of my mother-in-law's and my hands and, with the most cheerfully confident exclamation, informed us, "She was such a saint! It's true!" At that very moment, my mother-in-law turned to me as I instinctively did to her: This wasn't the first time she and I had heard such a testimony from the hundreds who had taken the time to spend part of their Sunday afternoon with us. The giddy nun continued: "In fact, she did more in 32 years than most people who live three times that long!" Mrs. Puleo said to the beaming, bestooped Sister, "She was a lovely daughter." As the nun still fervidly gripped my hand, as if I were the Pope himself, I quickly added, "She was a most beautiful wife." But the good Sister was convinced: "She was a *saint*. And now she's praying for all of us."

At 5 p.m., I noticed that the line was still long and that we had not moved for three hours. I motioned to Sheri to come see me. "How many people are out there?" Sheri took both of my hands, as if to brace me for another shock. "Mark, they are lining up in the parking lot." I laughed, and said, "Oh, my feet hurt." Sheri offered to

bring me a chair, I asked my in-laws if they would like to sit, "No, no, we can't sit when we've got people to meet. But you go ahead." There was no way I was going to sit in a chair while my in-laws, 72 and 63 respectively, were going to remain standing. Here's where they shone. They had had so many receptions, gatherings, events, openings, and they were smooth and assured at this one, too, even the wake for their daughter. So I told Sheri, "Forget it, I'll stand if they're going to stand."

Several times during the course of the wake, I turned from the crowd and kneeled down to do a gatha, such as, in-breath: "kneeling here before you Mev," out-breath: "I begin to count my blessings, Mev," in-breath: "your life and love live in me," out-breath: "so must I live and love in the present moment." After a few breaths like this, I would be introduced to someone deemed important, like a high church official who dropped by. The official said to me, "We need more people in our church like your wife, who practice such charity."

I was miffed. I didn't want to be contentious, the way Mev would have been at one of the restaurants with her family, by saying, no, shouting, at the hierarch, "Mev was a practitioner of *justice* and charity, and, as you may know, she was interested, passionately interested in justice for the poor, not charity for the poor."

"Yes, well, we will surely miss her," I said.

Angie O'Gorman came up to me and said, "Mark, that's a beautiful flower arrangement on the casket." I had not even noticed it: The words read *For my beloved wife*. I had no idea.

I turned to my mother-in-law: "Mom, did you . . . ?"

"Yes, Mark, I knew you had plenty of other things on your mind after Mev died, and I knew that you would appreciate this, so I went ahead and ordered them. They are quite lovely, aren't they?"

"Evie, how are you holding up?" Angie asked. I shifted aside to give them a few moments together alone amidst the mass of folks, since they had forged a unique bond during Mev's illness. Now it was about 6 p.m. I headed over to a couch to sit down and rest my feet, as the visitation had thinned out during the dinner hour. I saw a married couple looking at the photo collage my father-in-law had spent the last two weeks of Mev's life making. I stood behind them with my arms around each of them, and said, "Which is your favorite photo?" The woman said, "Oh, this one," which didn't surprise me, as she pointed to one of Mev and me embracing on a front porch in Boston's North End. I sighed, "Kissing is so important." At which point, they kissed each other's lips.

Fortitude

How he could stand up there?

I was distracted: I was breaking down and coming apart, but I wondered if or when John Kavanaugh would come undone.

Here he was, "celebrating" the funeral Mass of one of his brightest students, his co-author, his devoted disciple, his friend, just as he presided three and a half years before at the funeral of his dear friend, Ann Manganaro. Was there something in his Irish temperament that prepared or steeled him for calamity? Or was he just barely holding on, because the liturgy must go on?

I thought of how often he came over to the apartment and witnessed Mev's deterioration; how he was inducted one afternoon to help her take a crap on the portable toilet we had close by in our living room; how he would bring his guitar and play songs for her, including, one time, a stirring rendition of "The Lonesome Death of Hattie Carroll;" how he offered her the Eucharist and helped us with the anointing of her when she wanted our blessing and "permission" that it was OK for her to die; how he looked out for me and engaged me in intellectual discussions as a relief from my horror at witnessing the tumor's treachery; how he took me to McGurk's pub just before Christmas to let those Irish musicians help me forget, if only for two hours, and aid me in remembering that there is beauty still in this world; how, when Mev was having difficulty swallowing, he offered her sponge swabs dipped in water or white grape juice.

He amazed me even more as he delivered, with his customary passion, the following homily:

The Poor and Love.

But most of all, love is all: "Yeah, yeah" she could say and when she could no longer say even that, she would give the sign-language of the deaf: for love.

It is a love linked, as Isaiah sang, to the poor, the oppressed, the hungry and planted so early in Mev's own heart and grounded in her marriage to Mark with these readings from their marriage Eucharist.

In her last months Mev led us more and more deeply into poverty. It was, as Saint Francis De Sales called it, a destitution of love.

She had wanted to give the poor a face, a voice. She always wanted to be identified with them. And so it came to pass: By the time of her last days, you could see them all in her face—the poor of Bosnia, the hungry of Haiti, the powerless of Brazil. She who gave them voice, lost hers. She who helped us see their faces, could finally see no more.

It was such a long dying, such a terrible, long divestment of her riches. She became the poor she loved. And now, the Kingdom of Heaven is hers: So nothing of her grace and beauty will be lost. No goodness or charm will fade away. We believe, after all, we Christians, in the resurrection of the body, in life everlasting.

As her friends and family saw her great relinquishment, their love was kindled all the more. They entered love's powerlessness, its pain, its joy, its happiness. In her death as in her life and labor, Mev brought us more fully into the mystery of it all. Is there anyone who has ever led us more deeply into the poverty of the Cross?

Surely Mark knows this, Mark, whom Mev named her dearest life companion, deep and laughing, she wrote, intelligent and true, bound to her in weakness and failures as well as bliss and the joy of the spiritual journey.

Surely Peter and Evie know this, entering the wide wound of love and poverty that every parent must feel: In an assignment she did 11 years ago for a woman theologian, Mev composed a letter to her parents (which I'm not sure they ever have seen):

"I lack the words to communicate my thanks and love for you . . . Having children, bearing them. Birthing them. Raising them, letting go of them, providing and caring for them—this is truly the act of 'making love.' You gave me Peter, Laura and Rose as brother and sisters.

"You educated me; you taught me courage, YOU taught me compassion for the poor. Mom, with Our Lady's Inn; Dad, with your civic work and service, taking blankets to poor people and shut-ins: YOU showed me what it means to believe in God. What a marriage is all about. You taught me social responsibility. But most of all, you taught me LOVE."

Thus, it was her family, just as it was her Mark who brought her with the poor, to Christ.

Mr. Puleo on the phone Friday said to someone on the other end: "Well, the one Puleo who did great things for God died today." But it was not accurate.

For the loving spouse who prays the Song of Songs into his wife's ears on the day of her death—he does great things for God;

The father and mother who entrust their precious gift of God into God's own hands—they do great things for God;

Brother and sisters, bearing spouses and children steadfastly to her side—they bring great news of God;

Mark and Mev's dear friends and community, from Boston to California, and the Angels of Arco Avenue, who spent weeks of vigils and prayer and comforting and nursing—surely they did great things for God. Surely they were clothing the poor and feeding the hungry. Surely they felt the beatitude of love's poorness, their love's great strength.

Mev was like us, actually; and she was like the poor. She was just more of it, intensely so. When she applied to Maryknoll, she wrote: "I have an energetic personality. I love and want to get along with people. I am unusually joyous. I have strong convictions. My weaknesses are the flip-sides of my strengths. I can be domineering and not invite others. My extrovertedness can squelch others' initiatives. I often interrupt others in heated discussions. Often times I am proud rather than grateful. I am prone to seek admiration."

What an imperfect jewel, what a sinner she was. Oh, but what a diamond, what a flame, what a joy, what a bearer of the word made flesh.

Has there ever been a day we have not been happy to see her? No one will ever take her place. And if we learned from her, we will realize that no one will ever take our own place.

As a college student, she wrote: "When I was in my early teens, a thought took hold of me. Jesus didn't die to save us from suffering—he died to teach us how to suffer, to be with us in our every anguish and agony, to give meaning to our pain. Sometimes I actually mean it. I'd rather die young, having lived a life crammed with meaning than to die old, even in security, but without meaning."

Such are the dangers of our high and holy desires. Such was the plentiful danger of marvelous Mev Puleo, spouse, daughter, sister, uncommon friend and teacher of the church.

Remembering the Dead/5

Teka Childress's Funeral Reflection, January 15, 1996

Mev had beautiful eyes.

Just look at Michael Bartz's program cover.

And later, even with her hair lost to radiation and chemotherapy, she was stunning.

She communicated with her eyes—great joy or great frustration.

But she also saw with them.

As most of you know, Mev opened the introduction to her book, *The Struggle is One*, with a description of a bus ride up a hill in Rio de Janeiro with her family when she was 14.

She describes looking to one side and seeing beautiful beaches and expensive hotels, while on the other side seeing tremendous poverty, all the while approaching the top of the hill where the statue of Christ the Redeemer loomed over the city.

This experience sparked for Mev a crisis of conscience, which she spent her life responding to.

She came to a resolution about how to respond to this crisis and she describes it later in the introduction to *The Struggle is One*:

"Yes the way up the hill to Christ the Redeemer is a bumpy, sometimes dangerous ride. And I have come to believe that we, the privileged are invited to get off the bus and plant our feet squarely beside the journeying people, walking with the God who is present in those on both sides of the road."

To be a bridge between the people on both sides of the road, to bring the faces of people struggling in Brazil and Haiti, to us here—this was Mev's vocation.

She devoted her tremendous talent as a photographer (inherited from her father), her ability as a speaker and writer and the great passion of her heart to this task. And for this we are grateful and often in awe.

wake up to find out

that you are
the eyes of
the world!

Michael Bartz's funeral program cover; January 15, 1996

Yet, it is important that we not make an icon of Mev, for to do so we would miss Mev in all her wonderful humanity, in all the particular concrete ways that she was Mev.

Mev taught me something very important: She taught me that when you go to Ted Drewes you could mix all different kinds of frozen custard flavors together. I

Letter/5
(Gratitudes/2)

Dear Teka,

You were here & there, making hundreds of calls over the weeks securing help and company as we went down that last dark road.

You were here, sleeping over & keeping watch & tending to Mev's minutest and demanding needs.

You were here, looking out for me and listening to my rage at this disease & taking in my wonder at my wife.

You were there, celebrating Mev in all loving honesty at the College Church the day we buried her.

You were here, acting naturally as Jewish mother caring for the multitudes under your wing who came to be with us.

You were there, smiling at me at Kriegshauser & holding my tears throughout that weekend.

You were here, accompanying Mev through the time-honored path of learning and loving ever more deeply.

You were there, praying for us at Karen House.

You were here, drinking beers & watching raptly *ER* & telling jokes and stories & nurturing the normal.

You were here, advising me & checking with me & running interference & guarding Mev and me.

You were there.

You were here, living the truth of Dorothy's last lines, sharing our long loneliness & offering the salvific non-solution of your magnificent love & birthing that of this beloved community.

For your presence, I am most grateful & I love you.

Marko Sparko

Accompaniment/5
(Letter/6)

Dear Angie,

And so. Three weeks ago, we buried Mev. So we did. So she is gone. Vanished. Not palpable. Or at least, most of the time.

I think I've been pretty good at telling you over the course of the months what was expressed in yesterday's homily, namely, as far as my theology goes, such as it is, you have been Christ, you showed me that, yeah, it's maybe, likely that God is love, because you are love, you loved Mev, you loved us, and therefore you are in and of God. Shocking, isn't it? If you are in and of God, I wouldn't sweat so much my paper for the American Academy of Religion.

But Mev summoned you. And you responded. And with a delicacy and determination intertwined, you made your mark, you left your mark, for as Mev deteriorated, of this I am sure: she knew you loved her, and she loved you.

Such is the mystery you and I share—for you may wonder, "why did Mev choose me to accompany her on this via dolorosa?" And I often wonder, how and why did Mev choose me with whom to share the rest of her earthly days? But not to get too cocky, Mev chose *us* and we were so wonderfully, thoroughly loved. And trusted. Mev entrusted herself to us in ways that she didn't to others, and I don't mention this to be invidious or to short-change others' marvelous contributions. Not at all. But from my vantage point, a quite all too fallible point, that's the way it looked and looks to me.

And though you, too, messed up royally at times, you exuded a simple, strong grace which I think evoked the same from Mev, from me, from Evie, and from so many others who have said to me something roughly as follows, "You know, since coming over to your apartment, I really want to get to know Angie. I mean, I've known her for years but never realized what a gem she is."

You gave us so much and I know you know this and are amazed at your own capacity for change and for endurance and for stick-to-it-iveness, as I have been amazed and gratified. For you were a proverbial Rock of Gibraltar, you embodied love in action, such tenderness, such vital vigilance, such bodhisattva beauty in extremis at 4525 Arco.

I knew I wanted you to do something special at Mev's funeral—so along with her oldest, best friend Teka, I wanted you to share whatever you wanted about the time, the trauma, the treat, the terror, the triumph that was your experience with Mev. And I am grateful so much for your willingness to give a voice to that depth that was nurtured in you over many months. On such a cold day three weeks ago.

But as much as was obvious to me how Mev keyed into you and you into Mev, I also want to say thanks for sharing the most heart-breaking time of my life, for you made it easier, more able to bear. You let me swoon over the wonder of all things Irish, you did my dirty work of phone calling running interference so I wouldn't have to waste energy on vexing encounters, you saved Mev and me many more conflicts over the medications by taking that on and doing it with such fastidious care, and then your Noble Peace Prize efforts at dealing with the pain patch! Your ability to josh and joke with me, your presence—silent, absorbent, chastened—when Mev and I were working through the shit and soaring in the delight of marriage amidst these trials, I could go on for pages, you know this, don't you? Such was how you inserted your life into ours and you touched and helped to heal and lighten my gradually breaking soul.

You are a wonder. You have my deepest gratitude for the literally countless ways you accompanied us, a journey that will continue with Mev's absence. Ah, you know how to love, and in my own way, I love you, too.

Mark

Community/6

Sheri Hostetler's Reflection
Graduate Theological Union Memorial Service, March 1996

Mark has asked me to speak on his behalf today since I am a close friend of his and since I was one of the few people from this area to be in St. Louis after October.

Mark liked to say that those months before Mev died were the best of times and the worst of times. Which means that the good times were almost as good as the bad times were bad. And the bad times were really bad. Mev gradually had everything stripped away from her. In October, she lost her ability to speak and in November the right side of her body became paralyzed. Mark called November the Month of Screams. Mev, in her terrible frustration and anger and inability to articulate words, would just scream, sometimes a few inches from Mark's face.

December, on the other hand, was the Month of Silence. I was there the first week of December, when Mev took a turn for the worse. The first days I was there, Mev was still Mev to me, despite her inability to speak. She had that vitality and that will that was so unmistakably Mev. The night before I left, one of the patches containing painkiller came off, and Mev was in a lot of pain. She wet the bed twice, vomited once. For some reason, the alarm on the house went off twice in the middle of the night. But the thing I remember most is that sleeping in the other room with the door closed and earplugs in, I could hear Mev wailing. I've never heard wails like that before. Mev never really came back after that. She stopped eating, became blind, and eventually lost even the ability to swallow water. When people would come by the house and ask what they could do that last week, Mark would say, "Come sit over here and be powerless like the rest of us." There was a lot of pain in that house.

But it was also the best of times. Mark said when I was there in December that he didn't need any arguments for the existence of God; he had seen God in the community of people that gathered around Mev, a group of about 30 people called the Arco Angels. After Thanksgiving, there were always one or two people at Mark and Mev's house 24 hours a day. All the meals were brought in, people changed Mev's

diapers, bought the groceries, did odd jobs around the house and more than anything accompanied Mark and Mev in Mev's dying.

People who didn't know each other very well beforehand were a community by the time Mev died. The gift that Mark and Mev gave to that community was to invite them into their most private pain and brokenness and ask them to be there with them. Not many people make themselves that vulnerable. In doing that, individuals—and a community—were transformed. The whole experience broke everyone's heart—broke it wide open.

Now transformation is a big word that might give you that wrong idea. When I say transformation, I'm not talking about the spectacular. There's a tendency when talking about Mev—at least her public image—to engage in hyperbole. Mark was often trying to deflate that talk and bring things back down to the ordinary and simple. As Mark said, the public Mev will be around long after she has died. It's the private Mev that's gone forever—the Mev he sleeps with every night—and it is that loss of that Mev that he mourns. Instead of talking about how Mev was a saint or a star or a crusader for social justice, Mark would want to talk about her beautiful skin.

And so when I say a community was transformed, I mean changed in the simple, ordinary ways that truly make up our lives. The kind of transformation I'm talking about is perhaps best exemplified by this little incident: There was a man in that community who told his wife for the first time in their marriage that she was beautiful. He had seen Mark say that so many times to Mev as she lay on the couch with head wrapped in a scarf, the right side of her face slightly twisted from her paralysis. So he saw the beauty of his wife in her own brokenness and pain, just as Mev also was beautiful in her brokenness and pain. And he felt free to tell her so.

Then there's the simple, everyday transformation of being present to the beauty around you. Mev had a great gift for being present those last few months. I remember being out on the front porch with her, soon after a snowstorm. She pointed up to a red leaf, still on a tree that had lost almost all of its leaves. The red leaf was frosted with snow, silhouetted against that blue, blue sky. Mev said, "Ahyee," which meant "Amen" or "Isn't it wonderful!" I also remember the night a neighbor came over to play violin for Mark and Mev. Mev said "Ahyee, Ahyee" over and over again; she loved hearing his music so much. What a gift she gave to the violinist that night.

It was this simple, private, ordinary outgoingness of heart that took place in that community on Arco Avenue as a result of how Mev died—and I suspect this is what Mark wanted me to share with you.

Lamentation

There was the wailing wall in my study: How many minutes did I mediate on those photographs of Mev, how many tears fell, how many screams of mine ascended to Cathy Nolan's ears upstairs, how she kindly let me be. Here I am, crying, remembering, wailing. Only a year or so before, I had begun to learn with Mev by enrolling in Screaming 101, and then rapidly graduated to the advanced seminars in screaming in solidarity. So, I was not shy about cutting loose, but it did make me a little self-conscious: "Was that last wail too loud? Am I disturbing Cathy?"

Then, I'd crank the soundtrack from *The Piano*, the music that Mev and I listened to when she was recovering from surgery in the Alta Bates Hospital. So this was the long loneliness of Dorothy Day. So this was being ground under with grief. So this was hitting the wall, howling before my wailing wall, the photos of Mev divided by six months: May 1995 beaming as she received the U.S. Catholic Award, and November 1995, seated between two old high school classmates, besieged, drugged, muted, crippled. So many times, I chanted Bob Dylan's lines from "All Along the Watchtower," about how there had to be someway out of here, I couldn't get any relief.

Relief, there was none, and Mev was not coming back. Father Kavanaugh reminded us of the resurrection of the body, as he preached one night at the Karen House Mass, looking directly at me. John was trying to offer me some comfort, but, say it's true, there *will* be a resurrection of the body, Mev's body, my body, Aunt Leah's body, 6 billion, 12 billion, 18 billion human bodies to be resurrected as Christ oversees it all. When is this supposed to take place, the resurrection of Mev's body? It's supposed to sustain me, give me something—what?—to look forward to? When? When I die, is that when the resurrection kicks in? OK, I grant, I should know my Catholic doctrines better. And then knowing them, believing them, will that make me cheerful on a night where the void has knocked on my front door and invited itself in, a night when I am struck by an absence, and voila, the resurrection of the body, God in God's good time is going to settle the scores, and since the Incarnation's a big deal, the body's a big thing, and we've been told this is the way it will turn out? So

Mev's in heaven (one friend wrote to say that she knows Mev is in heaven conversing right now with Jesus—what? In Aramaic or English or Italian maybe?) right, O.K., I'm trying to follow, and she is now presently resurrected or will be when Christ comes in his glory, and which body will it be, Mev's pre-tumor body or her post-tumor body, how will it be glorified?

But I was alone that night. There was not going to be any spooning, there was not going to be any legs intertwining as we drift into sleep, there was not going to be any bells ringing even signaling a pee necessity—I'd give anything even for one of the repeats of Thanksgiving Eve, to be able to look into and rest in those eyes that have tracked me, tucked me, touched me, resurrected me.

Ah, an Arco angel. I phoned one down the street and admitted, "I'm so miserable, I miss my wife," sobbing, babbling, and the Angel asks, "Do you want to come down, we can talk?"

"No, thanks, I can't."

I hung up, feeling I was exposing myself and others to the emotional vomit that was a fairly constant companion in the weeks since Mev died. Why puke on someone else? I made another resolve to stick it out.

Five minutes later, I broke down and called my next-door neighbor Sharon. "Sharon, I miss Mev."

I was crying uncontrollably, when she said, "Oh, there's just no comfort for you tonight."

Like a Zen Master, Sharon kicked me in the mud of reality, and, in a few seconds, I exclaimed, "Yes, that's it, there's no comfort for me tonight. That's exactly it!"

In five seconds, I went from immersed in misery to a named liberation. "There's no comfort, Sharon, but I feel so much better. No comfort, and I feel so much better." I thanked her, hung up, and looked at my wailing wall, there's no comfort. The truth set me free, a little more. I took it.

Reading/6

And so I read, in the manic, delirious desire to find a line here, a paragraph there, that spoke to me and that whispered a truth I could fathom for five minutes. More than once, I thought: How odd! Here I was, a theology doctoral student, and I couldn't bring myself to read the books given me by friends on spirituality and religion as pertains to grief, loss, God and prayer. I had grown weary of those words, yet still needed others. So I turned from the stacks of theology tomes in my apartment to literature. I devoured poems, novels, essays, memoirs, letters and biographies. I spent way too much money, forgot such institutions as libraries, scribbled in the margins, took copious notes, culled innumerable passages and mused, meditated and memorized.

We loved with a love that was more than love, I and my Annabelle Lee.

Bind me as a seal upon your heart, a sign upon your arm, for love is as fierce as death, its jealousy bitter as the grave. Even its sparks are a raging fire, a devouring flame.

The smithy of my soul.

It will be the silence, where I am, I don't know, I'll never know, in the silence you don't know, you must go on, I can't go on, I'll go on.

Let [the knight-errant] seek out the nooks and corners of the world; let him enter into the most intricate of labyrinths; let him attempt the impossible at every step; let him endure on desolate highlands the burning rays of the midsummer sun and in winter the harsh inclemencies of wind and frost; let no lions inspire him with fear, no monsters frighten him, no dragons terrify him, for to seek them out, attack them, and conquer them all is his chief and legitimate occupation. Accordingly, I whose lot it is to be numbered among the knights-errant cannot fail to attempt anything that appears to me to fall within the scope of my duties, just as I attacked those lions a while ago even though I knew it to be an exceedingly rash thing to do, for that was a matter that directly concerned me.

The beauty of the world; the paragon of animals; and yet to me what is this quintessence of dust?

We would rather run ourselves down than not talk about ourselves at all.

If I could detain them for a little while, I would surely make them weep before they left, for I would say things which would reduce to tears everyone who heard me.

You never get over anything, you just get through it—once, you surrender to the fact that you can't get over it, you're already through it.

And summer's lease hath all too short a date . . .

Appreciation is the sacrament.

God knows I often retire to my bed wishing (at times even hoping) that I might never wake up: and in the mornings I open my eyes, see the sun once again, and am miserable.

Those friends thou hast, and their adoption tried, / Grapple them unto thy soul with hoops of steel.

Everything in the world exists to end up in a book.

Comforter, where, where is your comforting? / Mary, mother of us, where is your relief?

I am sorry that I cannot say anything more comforting, for active love is a harsh and dreadful thing compared with love in dreams. Love in dreams thirsts for immediate action, quickly performed, and with everyone watching.

Your eyes! Turn them away for they dazzle me.

Worlds of eloquence have been lost.

I have sometimes dreamt that when the Day of Judgment dawns and the great conquerors and lawyers and statesmen come to receive their rewards—their crowns, their laurels, their names carved indelibly upon imperishable marble—the Almighty will turn to Peter and will say, not without a certain envy when He sees us coming with our books under our arms, "Look, these need no reward. We have nothing to give them. They have loved reading."

I like kissing this and that of you . . .

At that time of my life, all sorts of changes were taking place, and in particular I came to the realization that ever since I had first begun to write I had been living a real neurosis. My neurosis—which wasn't all that different from the one Flaubert suffered in his day—was basically that I firmly believed that nothing was more beautiful than writing, nothing greater, that to write was to create lasting works, and that the writer's life ought to be understood through his work. And then in 1953, I came to the realization that that was a completely bourgeois viewpoint, that there was a great deal more to life than writing. All of which meant that I had to rethink the value I placed on the written word, which I now felt was on a whole other level than where I had previously placed it. From that point of view, I was, somewhere 1953-54, cured almost immediately of my neurosis . . . And so wrote The Words . . . Had I been more honest with myself, I would still have written Nausea. Then, I still lacked a sense of reality. I have

changed since. I have served a slow apprenticeship . . . I have seen children die of hunger. In front of a dying child, Nausea has no weight.

If the book we are reading does not wake us, as with a fist hammering on our skulls, then why do we read it? Good God, we also would be happy if we had no books and such books that make us happy we could, if need be, write ourselves. What we must have are those books that come on us like ill fortune, like the death of one we love better than ourselves, like suicide. A book must be an ice ax to break the sea frozen inside us.

Do I contradict myself? / Very well then I contradict myself, / (I am large, I contain multitudes.)

So till the judgment that yourself arise / You live in this and dwell in lovers' eyes.

True books should be born not out of bright daylight and friendly conversation, but of gloom and silence.

It's no near midnight and this unchartered narrative winds its way unchecked—no chronology, structure, sequence, or form, other than the nuances of my mood and mind at whatever instant of this solo sing.

Suddenly I stood still, unable to move, as happens when we are faced with a vision that appeals not to our eyes only but requires a deeper kind of perception and takes possession of the whole of our being.

For Mercy has a human heart, Pity a human face, And Love, the human form divine, And Peace, the human dress.

Il pleure dans mon coeur / Comme il pleut sur la ville

There is no need for you to leave the house. Stay at your table and listen. Don't even listen, just wait. Don't even wait, be completely quiet and alone. The world will offer itself to you to be unmasked; it can't do otherwise; in raptures it will writhe before you.

I too think the intellectual should constantly disturb, should bear witness to the misery of the world, should be provocative by being independent, should rebel against all hidden and open pressure and maniupulations, should be the chief doubter of systems, of power and its incantations, should be a witness to their mendacity. For this very reason, an intellectual cannot fit into any role that might be assigned to him, nor can he ever be made to fit into any of the histories written by the victors. An intellectual essentially doesn't belong anywhere; he stands out as an irritant wherever he is; he does not fit into any pigeonhole completely.

There was my patrimony: not the money, not the tefellin, not the shaving mug, but the shit.

Much madness is Divinest Sense / To a discerning eye

The presence of a noble nature, generous in its wishes, ardent in its charity, changes the lights for us: we begin to see things in their larger, quieter masses, and to believe that we too can be seen and judged in the wholeness of our character.

But Love has pitched his mansion in / The place of excrement; / For nothing can be sole or whole / That has not been rent.

Keep your mind in hell, and despair not.

And she answered me: 'There is no greater pain than to recall the happy times in misery . . .'

But the truth, even more, is that life is perpetually weaving fresh threads which link one individual and one event to another, and that these threads are crossed and recrossed, doubled and redoubled to thicken the web, so that between any slightest point of our past and all the others a rich network of memories gives us an almost infinite variety of communicating paths to choose from.

These fragments I have shored against my ruins.

Seeing The World/4

Naturally, I often felt as if I had been specially appointed to suffer the loss of Mev. But there were times I had a clear sense of how many other people were wounded by her disappearance from our lives. One was her photography teacher, Peter Pfersick. Some time after her death, he would still give me an occasional phone call, I think to feel some connection to Mev. Though many of her friends admired her photography, Peter had the historical background and photographic insight to know how well Mev was doing what she was trying to do. In moments of acute ache, I considered, beyond my own personal loss:

All the books never birthed.

All the Guggenheim honorifics and cash never granted!

All the never recorded visions of the damned and defiant!

All the Third World glimpses we're blinded to in the United States of Amnesia!

All the black-and-white epiphanies of dignity, *pace* Bob Dylan!

All the darkroom hours of creative exegesis never spent!

All the mattes and frames never thereby graced!

All the interviews with the great and the obscure never recorded!

All the passionate reportage ever to be silent!

All the moments of life's burden and beauty never captured!

In one letter, I wrote Peter the following:

> Having just gone through Salgado's new book, *Terra: Struggle of the Landless*, I felt compelled to send you this note. It brought me back to a deep sense of misery and dignity that I, too, had witnessed when I was in Brazil in 1990 with Mev as she was doing her own photography and interviews which formed the core of her book, *The Struggle is One*.
>
> And it brought me back, like Proustian madeline in tea, to my

life with Mev, her working in the darkroom, her highly honed sense of indignation at injustice and appreciation for ordinary people under the boot of a corrupt system. And I just wanted to say this to someone who would understand, because I think you know how much promise Mev had as a photographer (you know, as well, I hope how much she valued you as teacher, mentor, exemplar), and as I ponder and meditate upon Salgado's work, I can't help but imagine what Mev might have gone on to achieve in her work: In a startling way, Salgado connects me back to Mev's eyes, eyes which as things of beauty are a joy forever, but these were eyes tested and transformed by such scenarios of deprivation and determination as captured by Salgado. I wonder what wonders are in Mev's negatives, what hidden revelations that she had not the time to bring to light and so to illumine us further.

And, perhaps, this is how it will be: with each new book or photo-essay by Salgado, I will be led into a deeper confrontation with the mystery of our world, and of my wife, and of our task to treat one another as guests, to offer the deepest kind of hospitality to those whom we meet.

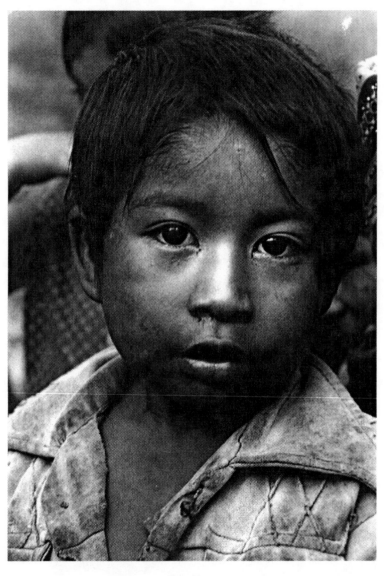

Guatemalan Refugee; Chiapas, Mexico; 1983
Mev Puleo

Prayer/4

Saint Teresa of Avila

Christ has no body now on earth but yours,
no hands but yours,
no feet but yours,
Yours are the eyes through which is to
look out
Christ's compassion to the world;
Yours are the feet with which he is to
go about
doing good;
Yours are the hands with which he is to
bless men [and women] now.[78]

God/5

A Reflection from Ivone Gebara, Recife, Brazil, 1990

If you want to call God love, as in St. John, I call God love. But I don't have a fixed image. Rather, I feel encircled by the energy and mystery of life. I intuit that this universe, of which humanity is a small expression, is much greater than all the theories about God, even Christian theories about God!

Prayer is being with myself in the presence of a greater mystery—but I don't know the name of this mystery!

I can call it God, but I'm afraid to speak of God, because immediately God is identified as the God of Christians, or Yahweh, or God with a man's face and beard, the common image that I also once held.

So I am living through a very difficult period.

In the hardest moment of life I cry out, "God help me!" But I don't know the face of the one who helps me. With this cry, I'm gathering all of the human and cosmic forces, forces of friendship.

I'm more likely to speak of God as Vital Force, Greater Mystery, Love or Justice. I see God less as a being and more as a value, an energy that dwells in us that I can't limit to a theory . . .

It strengthens me to see myself as part of this earth, neither more nor less, but part of it. I am seed, daughter, fruit, earth. This earth is my soul and body.[79]

Accompaniment/6

The week Mev died, my brother-in-law Ken arranged to get me tickets to hear Bruce Springsteen, then on tour following the release of *The Ghost of Tom Joad* CD. I asked Jennifer, one of Mev's students, to accompany me. They were good seats, and I cried much of the concert.

Later on, I had a musical diet to complement the visual wailing wall. In my apartment, there were certain songs I'd listen to, and they would inevitably make me agonize, but I didn't care. It's almost as if I wanted to hurt. And the effects of the music often exceeded that of the photographs that I had so often meditated upon. I must have listened to Mahler's sixth symphony 50 times that year.

Only gradually did I let go of mourning as a full-time job and resume work on my dissertation on Elie Wiesel. I realized how weirdly lucky I was: I had the time and resources to be able to grieve, ache, commiserate; I didn't have to return to a job two days after my spouse's funeral. So I made good use of those early months, but at some point, I realized I need to get out of my own stuffy apartment.

I thought of Rebekah. A former Sister of Mercy, a Karen House community member, a nurse on the way to becoming a nurse practitioner, she had so often offered a steady hand to me, a gentle smile, a silent encouragement to hang in there, as she moved into our lives of affliction. She walked with us, had seen me raw, angry, broken and had cared for Mev with true mindfulness, from administering enemas to massaging her body so she wouldn't get bed sores.

"I want to help Becky at Karen House"—That was my aspiration! It wasn't so much to be of assistance to the women and children who took temporary relief and shelter there. It wasn't to be so deliberate as Mev had once been, that of "tithing time." I just wanted to tithe time with Becky, not the homeless. Becky accompanied me/us, so I wanted, in a small way, to accompany Becky back.

What this meant was that I joined her in one of Karen House's basic practices: "taking house." The running of this House of Hospitality is divided into three shifts: 8 a.m. to 1 p.m., 1 p.m. till 6 p.m., and 6 p.m. till closing at 10:30 p.m. Becky took the Saturday afternoon shift, so I started going to work with her every other Saturday.

She kindly helped me lose some of my vast ignorance and inexperience: She instructed me in answering the phone ("Are there this many people without homes in St. Louis?"), getting guests their medicines ("What's this drug for?"), giving out sandwiches to the men and women in the neighborhood who came by between 1:30 p.m. and 3:30 p.m. ("You don't like bologna? You're a Black Muslim? OK, peanut butter and jelly coming right up"), playing with the kids ("Sure, I'll pick you up"), breaking up scuffles ("You bitches have got someone to look after you, what about me?" snarled one man, who resented what he deemed the lavish treatment of some of the female guests), accepting donations ("Gee, thanks for all these sweaters" to a huge drop-off in mid-May), making sure the guests do their chores ("Um, you think you'll get to sweeping the floor today?") and simply listening to tales of triumph and woe.

Oddly and accurately, Karen House grew on me. At one point much later, Virginia had to let go of her Friday evening shift, and I was asked by Celestia, resident wise woman of the community, if I would consider doing it. I said sure. At a little reunion of some of the Arco Angels, Jean Abbott said that the experience of being with Mev in those last months reminded her of when she was working in Central America. She referred to the intensity of working "in the mountains" where life was so under siege and, consequently, everything and everyone was so precious. When volunteers came back to the U.S., they missed that experience of intensity, of not taking things for granted. Spending time at Karen House was like being in the mountains or being on Arco during Mev's last months: It's not that it was always heavy with grief, but it was both delight and disorder: life on the edge.

Decreasingly as time went on, people asked me if I missed Mev. And I would, cornily, think of Springsteen's song/echo of Steinbeck, when Tom tells his mother that she'll see him when she sees people struggling for a new world.[80] Over time, I invited my students from Webster University and St. Louis University—Elizabeth, Erin, Jason, Eric and Jenifer—to come take house or tutor or hang out with the guests and community. A couple of them eventually joined the Karen House community and moved in.

At Karen House, I got to know women and children who had known the violence of poverty, the winter desolation of sleeping outside and the frightful agony of breast cancer. As we ate dinner or washed dishes or sat in the office together, they got to hear my stories of living with a wife who was slowly dying. So many middle-class, educated people presume there's such a huge gulf between themselves and people who live on the street or in shelters. After being at Karen House, I was not able to countenance such a presumption. For it is indeed true: "We have all know the

long loneliness and we know that the only solution is love and that love comes with community."[81] It had all happened while Mev was laying there dying on Arco, and it was still going on at Karen House, and I imagine it is going on in hundreds of thousands of places at this very minute.

Poem/4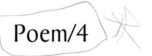

Karen House
Elizabeth Madden

and then i fell awake

numbers grew faces
statistics spat breath
slavery was law
and masters were indifferent
wealth strode in ties while
poverty swung in nooses
and i felt God must vomit
while we sleep.

and when i felt
the gentle giggle
falling me awake
i laughed.
because i thought if God was so smart
God would have come up with a better plan
than me

skipping zig zag lines to nowhere
praying to be peace
and searching for clean socks
the absent student
cradling three open books
and a premenstrual pen
created in God's image,
so is God disordered too?

we lose

in this standardized world

divided by disorders

with shrugging shoulders

that laugh a very little

while we creep behind the wallpaper

and i hate being stuck like a snooze button

when i cry

that the lie of our logic

has stolen true justice

dubbed over mercy

and my knees are black because

God damn us to hell

for letting His children go hungry

for killing Her loveliness

in our sleep.

God damn us to death

In the standardized world

that keeps Christ prostrate.

God Be

Mercy

Be

the Life

where We meet

thank God for dwelling

in touchable faces with sweaty souls

and scattered eyes

like mine

who cannot rest

and have no chair

if they could.

thank God, the little boy
can't sit still either
with disorder in his eyes
learning the torture
of being held captive
by chains of red ink
in a world with too many windows
and no doors

some dare not dream in slumber
he dreams while he's awake
life pulsing
through his body
he wrestles
against the chair
and loses his spirit to boredom.

we meet
in the pavement of standardization
where the lost of us
go hungry
and are filled
in learning to feed each other
while we trip along
the joyful Otherworld

where i can jump on my chair too
and twirl in zig zags
laboring my soul
living as peace
thanking the Boy
for falling me awake
to witness
that God is disordered too.

New Life[82]

There have been times when strangers or acquaintances would come up to me and say something about Mev. For the most part I was curious, but there were times when their timing was off, or mine was. "I just loved your wife's photographs!" "Your wife was so committed to the poor!"

And sometimes I experienced envy in her death that I had not experienced when she was alive: Was Mev really that good? Was she really that committed?

And then I'd catch myself and realize what Pat Geier had said: "You or I could get sick and some people would care; but only Mev could inspire such an outpouring of love and affection."

Mev had appeared so vivacious and fun to be around, people remembered her as having such passion that they would often stop short, being unable to describe her. So often, they would just smile, and I realized anew how deeply she had affected so many people.

Because I was in a state where I was frequently remembering what I and we had lost, I was often melancholy, pensive and stricken with sorrow, such that I knew people were concerned about my well-being. One of them was Joanie, a gracious, mature and attractive woman, who would kindly call on me to see how I was doing. I came to find out that she had suffered greatly in her life, and I noticed that there was so much compassion concentrated in her face.

And so, because I was often so miserable, I let myself cry in front of her, and she was so soothing with me. I then remembered I saw her at Mev's funeral simply weeping, stirred with empathy. In that period, I would talk with this compassionate woman, and she shared how often her heart, too, had been broken. I could see it in her blue eyes how deeply she felt my loss.

Truly, the sight of this woman had such a powerful effect on me that my eyes began to look forward to seeing her, with the consequence that often I grew guilty in my heart and interrogated myself. And too often I beat myself up over the vanity of my eyes, and I would say in total lack of compassion for myself: "Oh, so ready to forget

how much Mev suffered, you fool, now that there is someone who looks at you with such fondness! Hey nonny nonny!"

But then I thought of the conclusion to the film *Harold and Maude*, when Harold is beside himself accompanying Maude to her impending death at the hospital. He screams his profession: "I love you, Maude!" To which, with the gentlest of smiles, Maude responds, "Go and love some more." The thought arose within me: "After being in the valley of the shadow of tumor, how about a little ee cummings, for heaven's sakes? Why not savor the gifts of beauty and kindness in this dear woman?"

Around this time, I remembered an old expression, "negative capability," which I learned from Allen Ginsberg, who borrowed it from John Keats, the British poet who characterized this capability as "when a man is capable of being in uncertainties, mysteries, doubts, without any irritable reaching out after fact and reason."[83] Ginsberg's comment: "This means the ability to hold contrary or even polar opposite ideas of conceptions in the mind without freaking out—to experience contradiction or conflict or chaos in the mind without any irritable grasping after facts. The really interesting word here is 'irritable,' which in Buddhism we take to be the aggressive insistence on eliminating one concept as against another, so that you have to take a meat-ax to your opponent or yourself to resolve the contradictions—as the Marxists took a meat-ax to their own skulls at one point, and as the neo-conservatives at this point may take a meat-ax to their own inefficient skulls."[84]

And so I gave myself utter permission to not resolve any contradictions and not to get bogged down in guilt. I reflected on two short sayings, which became veritable mantras for me:

"To forget is to prolong the exile; to remember is the beginning of redemption." Israel ben Eliezer, founder of Hasidism

"Forget the Alamo." Pilar Cruz, to Sam Deeds, in John Sayles' *Lone Star*.

I wanted to remember.

I wanted to move on.

I did.

A School/3

In the fall of 1997, I had begun teaching as an adjunct in the theology department at St. Louis University. In late November, Pat Geier called to tell me about one of the most amazing activist experiences in her life: She and several Louisvillians had attended a commemoration of the murdered Salvadoran Jesuit intellectuals. The setting was Fort Benning, Georgia, the home of the U.S. Army School of the Americas.

Pat and I had been through a lot, long before Mev's illness, during which Pat frequently came for long weekends to help out, hold my hand and rub Mev's body and make me laugh. We'd traveled together to the war zone in Nicaragua in 1984, committed civil disobedience in Congressional offices after the passage of more money for the contra terrorists in Nicaragua and spent a month together traveling around Guatemala in 1986.

She mentioned that a couple thousand people had converged at the School of the Americas, which had trained the murderers of Oscar Romero, the Jesuit professors, and Maura Clarke, Dorothy Kazel, Jean Donovan and Ita Ford, not to mention thousands of other victims throughout Latin America. Originally located in Panama, the SOA moved to Georgia in 1983. Pat and her friends had gathered there because the school trained Latin American officers and soldiers in counterinsurgency and commando tactics. Through assiduous research, activists had exposed the use of torture manuals by the school. Nevertheless, the Army denied the severity and extent of the "accomplishments" of its (in)famous graduates. Over several years, a movement grew to close down the school, sparked by the SOA Watch, led by Roy Bourgeois, whom Mev and I had heard in Berkeley in 1993. Bourgeois had spent a few years in jail for his acts of interfering with business as usual at the school; moreover, he, like so many of those gathered in 1997, believed that the whole direction of U.S. foreign policy had to change from one concerned with insuring stability for the local elites and U.S. corporations to one emphasizing what Subcomandante Marcos in Chiapas had claimed for the Zapatista movement: Democracy, Liberty, Justice.

Pat had been inspired by the solemnity of a mock funeral procession on that Sunday, when activists marched onto the base as they carried coffins and crosses with

the names of those killed or disappeared by SOA graduates. She joined in this action to remind SOA officialdom that it was indeed death that was the result of their teaching: grannies and anarchists, nuns and doctors, punks and profs, Catholics and Buddhists, indigenous and unionists all joined together to remember and resist the normalcy that had allowed the school to operate so long without a fuss from ignorant citizens. Pat urged me: "You've got to come next year. The music, the speakers, the silence, the marching, the festivity, the spirit—you've got to be a part of it."

Evidently, many of those who went in 1997 told their own friends back home the same thing. In November of 1998 and the following three years—along with some of the Arco Angels and friends with whom we recently formed a grass-roots collective—the Center for Theology and Social Analysis, I traveled to Fort Benning, where I happily saw many of my St. Louis University and Webster University students. On the Sunday of commemoration, we were each handed a cross with the name of a victim, and we linked arms four across and marched onto the base. As we did so, the musicians chanted the names of the victims, and the assembly responded simply with "Presente!" "You are here with us!"

The naming of the victims, like the crossing onto the base, lasted hours. No one knew how many people would "risk arrest" but, as it turned out, thousands of people did so each year, stating with their bodies that we were willing to be processed by the authorities, receive ban and bar letters, or be detained. As it was, no one had expected such a large response, and the Army simply could not deal with so many trespassers.

Many people there had had some direct experience or contact with Latin Americans: We'd either traveled there or worked with refugees in our own cities. I could not help thinking of Mev so many times during the protest and vigil at the SOA. It was easy to do when I would see some young photographer crouching low to get a good shot of the crowd facing off with the police. And having had such a powerful experience burying Mev a few years earlier, I felt the chills, too, of the symbolic funeral march.

And I remembered the challenge Angie O'Gorman had issued to the hundreds of mourners gathered at the College Church the day we buried Mev:

> Yes, our hearts are breaking, but the great grace of how God is with
> us in our pain is that the breaking need not be a breaking apart. It can
> be a breaking open: open to the poor whom Mev's photographs
> allows us to see, open to the reality of injustice that creates and

sustains such poverty, open to responding in relationship with those who are suffering.

We will honor Mev best not by our grieving—although we will grieve for a long time to come—nor with tributes and awards, although she will receive many. We will honor Mev best by taking her life seriously and allowing her passion for justice and her commitment to the God who struggles with us to become our own.

Meanwhile, Elsewhere in the World . . . /5
(Dissidents/5,
Remembering the Dead/6)

Mr. And Mrs. Puleo gave a generous amount of money to Mev's alma mater, St. Louis University, to promote the work she had believed in. The first year, we invited Brazilian feminist Ivone Gebara to spend a week at the campus and address a variety of campus and community groups. Ivone was a joy to be with, as she offered strong challenges to us (I am sure no one else had ever said in the College Church that the policies of the IMF and World Bank were "structural sins"). But she had such a friendly, humble manner, students and community activists took to her immediately. A couple of years later, to commemorate the 10th anniversary of the assassination of the Salvador Jesuits, St. Louis University hosted some Jesuits, including Dean Brackley, who still worked at the UCA, to reflect on the legacy of the martyrs. Then in early 2002, a university-wide conference was held on the sanctions in Iraq.[85] Former U.N. official Hans Van Sponck and activist Kathy Kelly shared their perspectives on the terrible fate experienced by ordinary Iraqis under the U.N./U.S. sanctions regime. Kathy Kelly had traveled many times to Iraq, breaking the sanctions law by taking medicines to the Iraqi people. Long involved with the Catholic Worker Movement in Chicago, she was no stranger to civil disobedience or the works of mercy. A mesmerizing story-teller, Kathy cut through the politics, and revealed the human face of misery and courage from the people in Iraq. As in the following reflection . . .

A Testimony by Kathy Kelly on Iraq, 1998[86]

Just one month ago, U.S./U.K. bombardment of Iraq seemed almost inevitable. Even though the most comprehensive economic sanctions ever inflicted in modern history have already crippled Iraq, slaughtering over 1/2 million children under age 5, the U.S. and the U.K. were poised for further assault. Today, the U.S. still threatens

air attacks upon Iraq, massive strikes that would heap more agony on civilians who've endured a seven-year state of siege.

On February 9, our small delegation of eight, two from the United Kingdom and six from the U.S., representing thousands of supporters, traveled to Iraq carrying 110,000 dollars of medicines. We were the 11th Voices in the Wilderness delegation to deliberately violate the sanctions as part of a nonviolent campaign to end the U.S.-led economic warfare against Iraq.

From previous trips, we knew exactly where to find overwhelming evidence of a weapon of mass destruction. Inspectors have only to enter the wards of any hospital in Iraq to see that the sanctions themselves are a lethal weapon, destroying the lives of Iraq's most vulnerable people. In children's wards, tiny victims writhe in pain, on bloodstained mats, bereft of anesthetics and antibiotics. Thousands of children, poisoned by contaminated water, die from dysentery, cholera and diarrhea. Others succumb to respiratory infections that become fatal full body infections. Five thousand children, under age five, perish each month. 960,000 children who are severely malnourished will bear lifelong consequences of stunted growth, brain deficiencies, disablement. At the hands of U.N./U.S. policy makers, childhood in Iraq has, for thousands, become a living hell.

Repeatedly, the U.S. media describes Iraq's plight as "hardship." Video footage and still photographs show professors selling their valuable books. Teenage students hawking jewelry in the market are interviewed about why they aren't in school. These are sad stories, but they distract us from the major crisis in Iraq today, the story still shrouded in secrecy. This is the story of extreme cruelty, a story of medicines being withheld from dying children. It is a story of child abuse, of child sacrifice, and it merits day-to-day coverage.

A Reuters TV crew accompanied our delegation to Al Mansour children's hospital. On the general ward, the day before, I had met a mother crouching over an infant, named Zayna. The child was so emaciated by nutritional marasmus that, at 7 months of age, her frail body seemed comparable to that of a 7-month premature fetus. We felt awkward about returning with a TV crew, but the camera person, a kindly man, was clearly moved by all that he'd seen in the previous wards. He made eye contact with the mother. No words were spoken, yet she gestured to me to sit on a chair next to the bed, then wrapped Zayna in a worn, damp and stained covering. Gently, she raised the dying child and put her in my arms. Was the mother trying to say, as she nodded to me, that if the world could witness what had been done to tiny Zayna, she might not die in

vain? Inwardly crumpling, I turned to the camera, stammering, "This child, denied food and denied medicine, is the embargo's victim."

I felt ashamed of my own health and well-being, ashamed to be so comfortably adjusted to the privileged life of a culture that, however unwittingly, practices child sacrifice. Many of us westerners can live well, continue "having it all," if we only agree to avert our gaze, to look the other way, to politely not notice that in order to maintain our overconsumptive lifestyles, our political leaders tolerate child sacrifice. "It's a difficult choice to make," said Madeleine Albright when she was asked about the fact that more children had died in Iraq than in Hiroshima and Nagasaki combined, "but," she continued, "we think the price is worth it." Iraqi oil must be kept off the markets, at all costs, even if sanctions cost the lives of hundreds of thousands of children. The camera man had moved on. "I'm sorry, Zayna," I whispered helplessly to the mother and child. "I'm so sorry."

Camera crews accompanied us to hospitals in Baghdad, Basra and Fallujah. They filmed the horrid conditions inside grim wards. They filmed a cardiac surgeon near tears telling how it feels to decide which of three patients will get the one available ampule of heart medicine. "Yesterday," said Dr. Faisal, a cardiac surgeon at the Fallujah General Hospital, "I shouted at my nurse. I said, 'I told you to give that ampule to this patient. The other two will have to die.'" A camera crew followed us into the general ward of a children's hospital when a mother began to sob convulsively because her baby had just suffered a cardiac arrest. Dr. Qusay, the chief of staff, rushed to resuscitate the child, then whispered to the mother that they had no oxygen, that the baby was gasping her dying breaths. All of the mothers, cradling their desperately ill infants, began to weep. The ward was a death row for infants.

Associated Press, Reuters and other news companies' footage from hospital visits was broadcast in the Netherlands, in Britain, in Spain and in France. But people in the U.S. never glimpsed those hospital wards.

I asked a cameraman from a major U.S. news network why he came to the entrance of a hospital to film us, but opted not to enter the hospital. "Please," I begged, "we didn't ask you to film us as talking heads. The story is inside the hospital." He shrugged. "Both sides use the children suffering," he explained, "and we've already done hospitals." I might have added that they'd already "done" F 16's lifting off of runways, they'd "done" white U.N. vehicles driving off to inspect possible weapon sites, they'd "done" innumerable commercials for U.S. weapon displays.

While political games are played, the children are dying and we have seen them die. If people across the U.S. could see what we've seen, if they witnessed, daily, the

crisis of child sacrifice and child slaughter, we believe hearts would be touched. Sanctions would not withstand the light of day.

I felt sad and shattered as we left Iraq. A peaceful resolution to the weapons inspection crisis was reached, at least temporarily, but Iraqi friends were intensely skeptical. "They are going to hit us. This is sure," said Samir, a young computer engineer. "Anyway, look what happens to us every day." Feeling helpless to notify anyone, we had left the scene of an ongoing crime.

Upon return to the U.S., customs agents turned my passport over to the State Department, perhaps as evidence that according to U.S. law I've committed a criminal act by traveling to Iraq. I know that our efforts to be voices in the wilderness aren't criminal. We're governed by compassion, not by laws that pitilessly murder innocent children. What's more, Iraqi children might benefit if we could bring their story into a courtroom, before a jury of our peers. We may be tempted to feel pessimistic, but Iraq's children can ill afford our despair. They need us to build on last month's resistance to military strikes. During the Gulf War, I wasn't in the U.S. (I was with the Gulf Peace Team, camped on the border between Saudi Arabia and Iraq and later evacuated to Baghdad). I didn't witness, firsthand, the war fever and war hysteria. But people told me, when I returned to the U.S., that the war had often seemed like a sporting event. Some people went to bars, raised mugs of beer and cheered when "smart bombs" exploded on their targets. "Rock Iraq! Slam Saddam! Say Hello to Allah!" they shouted.

I think of Umm Reyda when I hear those accounts, a mother who lost nine of her family members when, on February 12, 1991, two astonishingly smart bombs blasted the Ameriyah community center. Families in the Ameriyah neighborhood had gathered to commemorate the end of Ramadan. They had invited many refugees to join them and had made extra room in the overnight basement shelter so that all could huddle together for a relatively safe night's sleep. The smart bombs penetrated the "Achilles heel" of the building, the spot where ventilation shafts had been installed. The first bomb exploded and forced 17 bodies out of the building. The second bomb followed immediately after the first, and when it exploded the exits were sealed off. The temperature inside rose to 500 degrees centigrade and the pipes overhead burst with boiling water, which cascaded down on the innocents who slept. Hundreds of people were melted. Umm Reyda greets each of our delegations, just as she greeted me when I first met her in March 1991. "We know that you are not your government," she says, "and that your people would never choose to do this to us." I've always felt relief that she never saw television coverage of U.S. people in bars, cheering her children's death.

Last month, on February 18, 1998, a vastly different cry was shouted by college students. They didn't cheer the bombers, and in Columbus, OH they may well have prevented them from deadly missions. "One two three four, we don't want your racist war." The lines confronted Ms. Albright, crackled across Baghdad. People on the streets smiled at me, an obvious westerner, and counted, "one, two three four . . ." A week later, U.N. Secretary General Kofi Annan, at the conclusion of his remarks introducing a peaceful resolution to the weapon inspection crisis, urged young people around the world to recognize that we are all part of one another, to see the world not from the narrow perspective of their own locale but rather from a clear awareness of our fundamental interdependence. What a contrast between his vision of a new generation that wants to share this planet's resources and serve one another's best interests, globally, and the vision that Ms. Albright offers: "If we have to use force, it is because we are America. We are the indispensable nation. We stand tall. We see further into the future."

Ms. Albright's reference to "use of force" is the stuff of nightmares, given the ominous comments some U.S. military officials have made about preparedness to use even nuclear force.

I doubt that other nations will accept that the U.S. "stands tall." It's more likely that international consensus will conclude that the U.S. lacks the moral standing to be prosecutor, judge and jury in the dispute over Iraq's policies. Most people in the Arab world believe that the U.S. favors Israel and is unwilling to criticize its actions, even when they violate international agreements or United Nations resolutions. People throughout the world point to the hypocrisy of the government of the U.S. in other aspects of international relations. The U.S. is over $1 billion in arrears in payments to the United Nations; it has ignored judgments by the World Court and overwhelming votes in the U.N. General Assembly whenever they conflict with its desires; and despite its rhetoric about human rights, the U.S. record of support for ruthless regimes is shameful.

Is it outlandish to think that courage, wisdom and love could inform the formation of foreign and domestic policies? Is it overly optimistic to think that we could choose to ban the sale of weapons of mass destruction? Is it too much to ask that economic sanctions against Iraq be lifted and never again used as a form of child sacrifice? For the sake of all children, everywhere, lets continue sounding a wake up call to U.S. officials. They must stop punishing and murdering Iraqi children. The agreement negotiated by U.N. Secretary General Kofi Annan offers a basis for continued weapon inspections and the earliest possible end to the deadly embargo of trade with

Iraq. The deeds of one leader, or even of an entire government, cannot be used to justify an unprecedented violation of human rights. Umm Reyda, through seven years of mourning, still forgives U.S. people. It's time that we respond with remorse and regret for the suffering we've caused and a commitment to end this racist war.

Writing/4

In addition to teaching as an adjunct and being involved in the various projects around the Mev Puleo Conference, I also finally finished a book on Elie Wiesel. I had started reading Wiesel in earnest back in 1989 as Mev and I had begun dating, and steadily pursued his oeuvre in the years since then. My perspective was different from Robert McAfee Brown's *Elie Wiesel: Messenger to All Humanity* in that I was critical of Wiesel's collaboration with U.S. and Israeli power. Finishing that book was definitely the closing of a chapter in my life that had involved Mev, Marc Ellis and my years of activism going back to the 1980s. The conclusion of *Elie Wiesel and The Politics of Moral Leadership* is one that is indebted to Mev, who so often expressed the urgency of injustice in places like Haiti, Brazil, Chiapas and El Salvador. Those last lines of the book could never have been written without my knowing, traveling and learning with Mev.

President Bill Clinton once rightly observed that the Holocaust should be "ever sharp thorn in every national memory." The same ought to be said of the U.S. bombings of Hiroshima and Nagasaki, not to mention the long-standing U.S. support for oppression and repression in Central America. Wiesel's critique in the opening epigraph to this chapter retains a timely pertinence to our situation today: "Where are the humanists, the leaders, the liberals, the spokesmen for humanity"? Indeed, the Holocaust may be one of many sharp thorns in our national memory. But citizens and religious believers today ought not simply denounce Nazi crimes, horrific and unforgettable as they were, but also contest U.S. policies that victimize innocent people today. Such grass-roots communities, NGOs and ever-growing networks of concerned citizens can certainly see the connections between the Holocaust victims with the past and present suffering of Japanese, Vietnamese, Timorese, Salvadorans and Palestinians and thus subvert the self-serving rhetoric of state power by practicing a self-critical solidarity with our victims.

Liberation theologies have emphasized the importance of making a preferential option for the poor. This option has earned the Christian churches much ill-repute, if not persecution, in many places. In Europe before and during the Second World War, for Christians to act in solidarity with Europe's historically unworthy victims, the Jews, would certainly have exacted a cost, from defamation to harassment to execution. While "the world remained silent," in Wiesel's earliest formulation, Europe's Jews were exterminated. There was no ecclesial preferential option for the poor European Jews during the Holocaust. The tremendous suffering of those unworthy Jewish victims still ought to compel us to ask questions so rarely raised in the U.S. intellectual community: Who are our unworthy victims in this present moment, how we can assist them in surviving, and how can we resist the temptations of silence and respectable status? For if we remain silent, if U.S. power goes unchallenged by its own citizens, if the elite manufacture of consent proceeds without citizen interference, far too many innocent people alive today will join the ranks of the Jewish abandoned, damned and dead, still so mourned by Elie Wiesel.[87]

Bearing Witness/4

After six years of teaching theology and religious studies as an adjunct professor in Saint Louis, I decided in early March 2003 that it was time for a sabbatical. Pat Geier and I had been talking about working with the International Solidarity Movement in Palestine. We told each other it would be a way we would celebrate twenty years of friendship. I committed then that ISM was how I would spend the fall semester. ISM nonviolently challenges the 37 year-old Israeli occupation of the West Bank and Gaza Strip and accompanies the Palestinians in their daily lives.

A week after this decision, the American student and ISM activist Rachel Corrie was bulldozed to death in Rafah. In an email to her mother while she was in Rafah, Rachel wrote:

> When I am with Palestinian friends I tend to be somewhat less horrified than when I am trying to act in a role of human rights observer, documenter, or direct-action resister. They are a good example of how to be in it for the long haul. I know that the situation gets to them—and may ultimately get them—on all kinds of levels, but I am nevertheless amazed at their strength in being able to defend such a large degree of their humanity— laughter, generosity, family-time—against the incredible horror occurring in their lives and against the constant presence of death. I felt much better after this morning. I spent a lot of time writing about the disappointment of discovering, somewhat first-hand, the degree of evil of which we are still capable. I should at least mention that I am also discovering a degree of strength and of basic ability for humans to remain human in the direst of circumstances—which I also haven't seen before. I think the word is dignity. I wish you could meet these people. Maybe, hopefully, someday you will.[88]

As it got closer for me to leave in the fall of 2003 for the West Bank and Gaza Strip,

friends expressed wariness of me going. Marc Ellis, my former professor at Maryknoll, had written many books on the need for a critical solidarity with the Palestinian people. I thought he would be supportive. But he, too, was concerned about my well-being on such a mission. He invited me to come to Baylor University for a Roshashana retreat in September just before I was to go to Palestine. Gustavo Gutiérrez was invited to be a speaker at the retreat, and I was grateful for his outgoing heart and exuberant memories of Mev. I also had time with Marc and he expressed serious doubts about me going at this time: "Shim, it's not safe." He requested that I write him my rationale for going. I shared with him the following reasons.

I am going because Palestinians issued a call for internationals to come since U.N. won't send anyone.

I am going because America's brass-knuckled hands are all over the Middle East.

I am going because, like you, I have brooded on the historical period in Europe, 1933-1945, and wondered: Why didn't more people stand up?

I am going because I would rather be an instrument of peace than an armchair cynic.

I am going because Dan Berrigan wrote in his commentary on the Hebrew prophet Isaiah:

> Where are the Isaiahs of our day? Could they be found among the outsiders—a prisoner or a widow or an orphan or a homeless one or an illegal alien or someone driven mad by the system? The vision often starts among such persons who can cut to the essentials in matters of life and death, of compassion and right judgment, while the rest of us know nothing.

I am going because a spiritual teacher once advised, "Go to the places that scare you."

I am going because a "cloud of witnesses" accompanied me when Mev was being drained of life, I want to be part of a cloud for others.

I am going because if not me, who? Waco's own Mr. Rappaport? If not now, when? 2008?

I am going because I want to look in the eyes of a five year-old prophet.

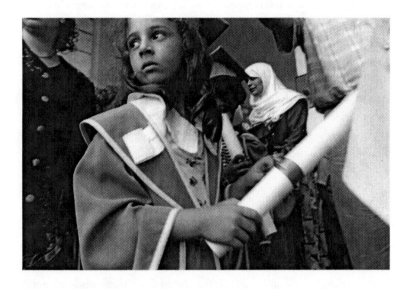

Kindergarten graduate, Latin Patriarchate School; Gaza; 1997
Mary Kate MacIsaac

I am going now because I know neither the hour nor the day, this life is over so quickly.

I am going because, to contextualize Gustavo Gutiérrez and liberation theology in the United States, someone has to make a preferential option for the Palestinian people.

I am going because I want a sabbatical and I always tell my students, "You gotta leave yr comfort zone."

I am going in the spirit of Dr. King:

> I am cognizant of the interrelatedness of all communities and states. I cannot sit idly by in Atlanta and not be concerned about what happens in Birmingham. Injustice anywhere is a threat to justice everywhere. We are caught in an inescapable network of mutuality, tied in a single garment of destiny. Whatever affects one directly, affects all indirectly.

I am going because I want to chant, "Just like me, the Israelis want to be happy; they don't want to suffer."

I am going to celebrate the ordinary miracle of falafel sandwiches.

I am going because I want to do my part to challenge terrorism, state-sponsored and paid for by the U.S. government.

I am going because I need to learn how to open up, 264 times a day, day after day.

I am going because Vietnamese Buddhist Thich Nhat Hanh teaches me:

> Do not avoid contact with suffering or close your eyes before suffering. Do not lose awareness of the existence of suffering in the life of the world. Find ways to be with those who are suffering, including personal contact, visits, images and sounds. By such means, awaken yourself and others to the reality of suffering in the world.

I am going because I have been blessed with health, a woman who loves me and a community that sustains me.

I am going because of my students who have opened my heart and illumined my mind.

I am going to celebrate twenty years of friendship with Pat Geier, where else should we go, the French Riveria, Rio, Florence?

I am going because friends at the Catholic Worker Karen House have taught me that "the only solution to the long loneliness is love and that love comes with community" (Dorothy Day).

I am going because Palestinian beings are innumerable, I vow to save them all.

I am going because American delusions are countless, I vow to cut through them all.

I am going because Edward Said wrote:

> I think the major choice faced by the intellectual is whether to be allied with the stability of the victors and rulers or—the more difficult path—to consider that stability as a state of emergency threatening the less fortunate with the danger of complete extinction, and take into account the experience of subordination itself.

I am going because Bono hasn't gone yet.

I am going because I have no career to endanger.

I am going because I had the nerve to write an article on Elie Wiesel in *Tikkun* and I quoted Israeli professor and activist Baruch Kimmerling as follows:

I accuse those people, of all ranks, who follow their unlawful orders. The late philosopher Yeshayahu Leibovitz was right—the occupation has ruined every good part and destroyed the moral infrastructure upon which Israeli society exists. Let's stop this march of fools and build society anew, clean of militarism and oppression and exploitation of other people, if not worse.

I accuse everyone who sees and knows all of this of doing nothing to prevent the emerging catastrophe. Sabra and Shatilla events were nothing compared to what has happened and what is going to happen to us. We have to go out not only to the town squares, but also to the checkpoints. We have to speak to the soldiers in the tanks and the troop carriers—like the Russians spoke to their soldiers when they were ordered to retake control in Red Square—before entry into Palestinian cities turns into a murderous urban warfare.

And I accuse myself of knowing all of this, yet crying little and keeping quiet too often.

I am going because Elie Wiesel won't go.
I am going because I am getting old.
I am going because I've never felt better.
I am going to practice works of mercy.
I am going to receive works of mercy.
I am going to practice reverence for life.
I am going because you once wrote:

Why is it that I meet so many Jewish and Christian leaders who support empire, actively or through silence, and so many "unaffiliated" Jews and Christians who, confused, searching, and without the requisite Hebrew training or Christian "faith," resist empire?

It may be that what is called for is a new discipline, a new crossing of boundaries that joins fidelity to the dead and seeks to build a world that protects and encourages life. This discipline would promote community and fight against empire, not so much in search

of utopia but a life grounded in hospitality in the broadest sense—
personal, cultural, spiritual, and political.

I am going because I want to resist empire with mindfulness.

The Gospel according to Mev
(The Human Form Divine/4)

Mev's Journal, 7 January 1991

This is changing my life! It is—as I read these words of commitment, Sylvia—"It is a time to take our option for the poor to the ultimate consequences, that is what we're trying to do in this community, to go to the ultimate consequences of the option we've made."

And I think that our world, primarily at the instigation of "my" country, is on the brink of war—nuclear potential, no less—and I am in the process of conversion. This is a significant moment. The convergence of hearing daily the words, stories, laughter, challenges of people who have made an option and are paying the cost, are reaping the grace—I am called. I am called forth to say no to injustice, war, the preparation for war. I am called forth to yes to life, yes to diversity, yes to the stepped-on ones standing up and claiming what is theirs.

This is a turning point in my life. I was an activist in college, engaged in various ways. But the Middle East situation has told me that my life as usual can't continue when such massive bloodshed is being planned, discussed, prepared for! It makes me sick. There is not a moral indignation, but a moral revulsion, nearly physical, that impels me to move, to do, to deepen my reflection, to put my body out there on the line. Enough. Stop the bloodshed. Repent. God have mercy. God, empower us to strive and struggle with integrity, love and humility for a better world, to strive and struggle courageously, willing to risk, willing to be inaccommodated, placing our freedom on behalf of others' unfreedom—empower and inspire us to act creatively and justly and lovingly and disruptingly. Life as usual cannot go on, as it grinds the poor into the dust and sand— sick, sick, sick. God, heal this sick world and let us be your hands. Condemning no one and afraid of no one. Putting our bodies before the wheels of the great machine that crushes the bones of the poor, blacks, gays, PWAs, elderly, children, orphans, strangers, Jews, Palestinians, Latin Americans, Iraqis, U.S. soldiers—no more. No more. No more.

Young boy; Chiapas, Mexico; 1983
Mev Puleo

Some things are profound enough to interrupt our lives. And, as I watch the war machine grow more deadly, the world more precarious each day—I listen to the

voices of prophets and saints and "good persons doing good things locally," yet stretching their voices globally through my ears, eyes, and hands—they are calling more forth. The communion of saints. Toinha, Goreth, Sylvia, Dom Pedro, Clodovis, Carlos Mesters—all. You are a mirror, and it sometimes chills me and embarrasses me to look at myself in your light. I feel disgrace, a need for mercy, a need for your strength to pull forth to me. You who have lived through death threats and dictatorships, monstrous bishops and abuse from Mother Church, you who walk daily attending Lazarus's wounds. Help me. Move me. Be with me. We are one. Yes, the struggle is one. The struggle is one.

RESOURCES

Something that you feel will find its own form

Jack Kerouac

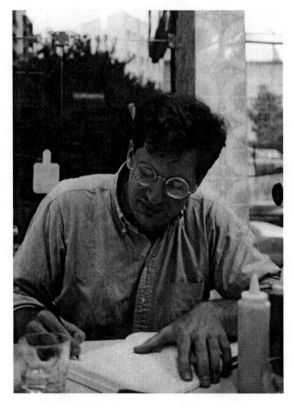

Mark Chmiel; São Paulo, Brazil; 1990
Mev Puleo

Books

Aitken, Robert. *The Dragon Who Never Sleeps: Verses for Zen Buddhist Practice*. Berkeley: Parallax Press, 1992.

Albert, Michael. *Stop The Killing Train: Radical Visions for Radical Change*. Cambridge, MA: South End Press, 1994.

Ambrose, Pamela. *Mev Puleo: Witness to Life*. Saint Louis, MO: Saint Louis University: Samuel Cupples House and McNamee Gallery, 1997.

Arenas, Reinaldo. *The Color of Summer, or, The New Garden of Earthly Delights*. Translated by Andrew Hurley. New York: Penguin Books, 2001.

Arnove, Anthony, ed. *Iraq under Siege: The Deadly Impact of Sanctions and War*. Updated edition. Cambridge, MA: South End Press, 2002.

Ateek, Naim, Marc Ellis, and Rosemary Radford Ruether, ed. *Faith and The Intifada*. Maryknoll, NY: Orbis Books, 1992.

Azar, George Baramki. *Palestine: A Photographic Journey*. Berkeley and Los Angeles: University of California Press, 1991.

Berrigan, Daniel. *Isaiah: Spirit of Courage, Gift of Tears*. Minneapolis: Fortress Press, 1996.

——————. *Steadfastness of the Saints: A Journal of Peace and War in Central and North America*. Maryknoll, NY: Orbis Books, 1985.

Berrigan, Daniel and Thich Nhat Hanh. *The Raft is Not The Shore: Conversations towards a Buddhist / Christian Awareness*. Boston: Beacon Press, 1975.

Bloch, Ariel and Chana. *The Song of Songs: A New Translation With an Introduction and Commentary*. New York: Random House, 1995.

Brainard, Joe. *I Remember*. New York: Granary Books, 2001.

Cao, Ngoc Phuong. *Learning True Love: How I Learned and Practiced Social Change in Vietnam*. Berkeley: Parallax Press, 1993.

Chmiel, Mark. *Elie Wiesel and The Politics of Moral Leadership*. Philadelphia: Temple University Press, 2001.

Chödrön, Pema. *The Places That Scare You: A Guide to Fearlessness in Difficult Times*. Boston: Shambhala, 2001.

Chomsky, Noam. *Fateful Triangle: The United States, Israel, and The Palestinians*. Updated edition. Cambridge, MA: South End Press, 2001.

_____. *World Orders Old and New*. Updated Edition. New York: Columbia University Press, 1996.

Crossan, John Dominic. *The Essential Jesus: Original Sayings and Earliest Images.* San Francisco: HarperSanFrancisco, 1994.

Cummings, E.E. *Complete Poems, 1904-1962.* Edited by George J. Firmage. New York: Liveright, 1991.

Dear, John, S.J., ed. *Apostle of Peace: Essays in Honor of Daniel Berrigan*. Maryknoll, NY: Orbis Books, 1996.

Dostoevsky, Fyodor. *The Brothers Karamazov: A Novel in Four Parts with Epilogue.* Translated and annotated by Richard Pevear and Larissa Volokhonsky. New York: Vintage Books, 1991.

Ellis, Marc H. *Ending Auschwitz: The Future of Jewish and Christian Life*. Louisville, KY: John Knox / Westminister, 1994.

_____. *Practicing Exile: A Religious Odyssey of an American Jew*. Minneapolis: Fortress Press, 2001.

_____. *Unholy Alliance: Religion and Atrocity in Our Time*. Minneapolis: Fortress Press, 1997.

Ellsberg, Robert. *All Saints: Daily Reflections On Saints, Prophets, And Witnesses for Our Time*. New York: Crossroad, 1997.

Finkelstein, Norman G. *The Rise & Fall of Palestine: A Personal Account of The Intifada Years.* Minneapolis: University of Minnesota Press, 1996.

Galeano, Eduardo. *The Book of Embraces.* Translated by Cedric Belfrage with Mark Schafer. New York: Norton, 1991.

Gebara, Ivone. *Longing for Running Water: Ecofeminism and Liberation.* Translated by David Mollineaux. Minneapolis: Fortress Press, 1999.

Ginsberg, Allen. *Spontaneous Mind: Selected Interviews, 1958-1996*. Edited by David Carter. New York: HarperCollinsPublishers, 2001.

Kavanaugh, John F. *Following Christ in a Consumer Society: The Spirituality of Cultural Resistance*. Revised edition. Maryknoll, NY: Orbis Books, 1991.

Kohen, Arnold. *From The Place of The Dead: The Epic Struggles of Bishop Belo of East Timor*. New York: St. Martin's Press, 1999.

Maddow, Ben. *Let Truth Be The Prejudice: W. Eugene Smith, His Life and Photographs.* New York: Aperture, 1985.

Manguel, Alberto. *A History of Reading*. New York: Viking, 1996.

Mann, Thomas. *The Magic Mountain: A Novel*. Translated by John E. Woods. New York: Vintage, 1996.

Metz, Johann-Baptist. *The Emergent Church: The Future of Christianity in a Postbourgeois World*. Translated by Peter Mann. New York: Crossroad, 1986.

Metz, Johann-Baptist and Jürgen Moltmann. *Faith and the Future: Essays on Theology, Solidarity, and Modernity*. Maryknoll, NY: Orbis Books, 1995.

Mulligan, Joseph E., S.J. *The Jesuit Martyrs of El Salvador: Celebrating the Anniversaries*. Baltimore: Fortkamp Publishing, 1994.

Nelson-Pallmeyer, Jack. *School of Assassins: The Case for Closing the School of The Americas and for Fundamentally Changing U.S. Foreign Policy*. Maryknoll, NY: Orbis Books, 1997.

Nhat Hanh, Thich. *Teachings on Love*. Berkeley: Parallax Press, 1997.

_____. *Living Buddha, Living Christ*. New York: Riverhead Books, 1995.

Novick, Peter. *The Holocaust in American Life*. Boston: Houghton Mifflin Company, 1999.

Pinto, Constâncio and Matthew Jardine. *East Timor's Unfinished Struggle: Inside the Timorese Resistance—A Testimony*. Cambridge, MA: South End Press, 1997.

Proust, Marcel. *In Search of Lost Time*. Translated by C. K. Scott Moncrieff and Terence Kilmartin, revised by D. J. Enright. 6 vols. New York: Modern Library, 1999.

Richard, Pablo and Jon Sobrino, ed. *The Idols of Death and The God of Life*. Maryknoll, NY: Orbis Books, 1983.

Rose, Gillian. *Love's Work: A Reckoning with Life*. New York: Schocken Books, 1995.

Ruether, Rosemary Radford. *Disputed Questions: On Being a Christian*. Maryknoll, NY: Orbis Books, 1989.

Ruether, Rosemary Radford and Herman Ruether. *The Wrath of Jonah: The Crisis of Religious Nationalism in The Middle East*. Minneapolis: Fortress Press, 2002.

Said, Edward W. *The Politics of Dispossession: The Struggle for Palestinian Self Determination, 1969-1994*. New York: Pantheon, 1994.

_____. *Representations of the Intellectual: The 1993 Reith Lectures*. New York: Pantheon, 1994.

Salgado, Sebastião. *Migrations: Humanity in Transition*. New York: Aperture, 2000.

_____. *Other Americas*. New York: Pantheon Books, 1986.

_____. *Terra: Struggle of The Landless*. London: Phaidon, 1997.

_____. *Workers: An Archaeology of The Industrial Age*. New York: Aperture, 1993.

Salzberg, Sharon. *Faith: Trusting Your Own Deepest Experience*. New York: Riverhead Books, 2002.

Seitz, Ron. *A Song for Nobody: A Memory Vision of Thomas Merton*. Liguori, MO: Triumph Books, 1993.

Sobrino, Jon, S.J. and Juan Hernández Pico, S.J. *Theology of Christian Solidarity*. Translated by Phillip Berryman. Maryknoll, NY: Orbis Books, 1985.

Soelle, Dorothee. *Against The Wind: Memoirs of a Radical Christian*. Minneapolis: Fortress Press, 1999.

Steiner, George. *Language and Silence: Essays on Language, Literature, and the Inhuman*. New York: Atheneum, 1967.

_____. *No Passion Spent: Essays 1978-1995*. New Haven: Yale University Press. 1996.

_____. *Real Presences*. Chicago: University of Chicago Press, 1989.

Stohlman, Nancy and Laurieann Aladin, ed. *Live from Palestine: International and Palestinian Direct Action Against the Israeli Occupation*. Cambridge, MA: South End Press, 2003.

Szymborska, Wislawa. *Miracle Fair: Selected Poems of Wislawa Szymborska*. Translated by Joanna Trzeciak. New York: Norton, 2001.

Taylor, John G. *Indonesia's Forgotten War: The Hidden History of East Timor*. London: Zed Books, Ltd., 1991.

Tordai, J.C. and Graham Usher. *A People Called Palestine*. Stockport, England: Dewi Lewis Publishing, 2001.

Towell, Larry. *Then Palestine*. New York: Aperture, 1998.

Tracy, David. *On Naming the Present: Reflections on God, Hermeneutics, and Church*. Maryknoll, NY: Orbis Books, 1994.

Turner, Michele. *Telling: East Timor, Personal Testimonies 1942-1992*. Kensington, Australia: New South Wales University Press, Ltd., 1992.

Waldman, Anne. *Vow to Poetry: Essays, Interviews & Manifestos*. Minneapolis: Coffee House Press, 2001.

Yeats, William Butler. *Selected Poems and Three Plays*. Edited by M. L. Rosenthal. New York: Macmillan, 1986.

Zinn, Howard. *A People's History of the United States, 1492-Present*. Revised and updated edition. New York: New Press, 1997.

Music

The Beach Boys, "Wouldn't It Be Nice," *Pet Sounds*, 1990.

Leonard Bernstein, Gustav Mahler's Symphony #6 "Tragic," 1967.

David Bowie and Freddy Mercury, "Under Pressure," David Bowie, *Singles Collection*, 1993.

Sarah Brightman, "Wishing You Were Somehow Here Again," *The Phantom of the Opera* soundtrack, 1987.

Tracy Chapman, "Fast Car," *Tracy Chapman*, 1988.

The Clash, "Washington Bullets," *London Calling*, 1979.

Elvis Costello, "(What's So Funny 'Bout) Peace, Love and Understanding," *The Very Best of Elvis Costello and The Attractions*, 1994.

Mason Daring, "Over The Moor to Maggie / The Bucks of Oranmore," *The Secret of Roan Inish* soundtrack, 1995.

Bob Dylan, "Brownsville Girl," *Bob Dylan's Greatest Hits Volume 3*, 1994.

Bob Dylan, "Not Dark Yet," *Time Out of Mind*, 1997.

Duke Ellington, "Take The 'A' Train," *Duke Ellington's Greatest Hits*, 1997.

Marvin Gaye, "What's Going On," *What's Going On*, 2001.

Glenn Gould, *The Goldberg Variations*, 1955.

Glenn Gould, *The Goldberg Variations*, 1981.

The Indigo Girls, "Closer to Fine," *Indigo Girls*, 1989.

Led Pelvis, *You're Out of the Band*, 1988.

Shane MacGowan and Sinéad O'Connor, "Haunted," *Haunted*, 1995.

Bobby McFerrin, "Don't Worry, Be Happy," *Don't Worry, Be Happy*, 1988.

Sarah McLachlan, "Hold On," *Fumbling Towards Ecstasy*, 1993.

Ennio Morricone, *Cinema Paradiso* soundtrack, 1989.

Anne Sophie Mutter, *Mendelssohn / Brahms: Violin Concertos*, 1995.

Michael Nyman, *The Piano* soundtrack, 1993.

Sinéad O'Connor, "Thank You for Hearing Me," *Universal Mother*, 1994.

The Proclaimers, "I'm Gonna Be (500 Miles), *Benny and Joon* soundtrack, 1993.

Jonathan Richman, *I, Jonathan*, 1983.

Shakira, "Ojos Así," *Donde están los ladrones?*, 1998.

Mercedes Sosa, "Gracias A La Vida," *30 Años*, 1993.

Bruce Springsteen, "The Ghost of Tom Joad," *The Ghost of Tom Joad*, 1995.

Bruce Springsteen, *Lucky Town*, 1992.

Bruce Springsteen, *Tunnel of Love*, 1987.

U2, "All I Want Is You," *Rattle and Hum* soundtrack, 1988.

U2, "Sunday Bloody Sunday," *War*, 1983.

Web Sites

Campaign against Caterpillar Business with Israel: *www.stopcat.org*

Catholic Worker Movement: *www.catholicworker.org*

Center for Theology and Social Analysis: *www.ctsastl.org*

Noam Chomsky Archive: *www.zmag.org*

Christians for Peace in El Salvador: *www.crispaz.org*

City Lights Bookstore: *www.citylights.com*

East Timor Action Network: *www.etan.org*

Marc Ellis: *www3.baylor.edu/American_Jewish/*

Fifty Crows Social Change Photography: *www.fiftycrows.org*

Amy Goodman: *www.democracynow.org*

Graduate Theological Union: *www.gtu.edu*

International Solidarity Movement: *www.palsolidarity.org*

Maryknoll: *http://home.maryknoll.org/index.php*

Nhat Hanh: *www.plumvillage.org*

Plowshares Movement: *www.plowsharesactions.org*

Palestinian Liberation Theology: *www.sabeel.org*

Pax Christi: *www.paxchristiusa.org*

Edward Said: *www.edwardsaid.org*

Saint Louis University: *www.slu.edu*

Sebastião Salgado: *www.terra.com.br/sebastiaosalgado*

School of Americas Watch: *www.soaw.org*

University of Central America: *http://www.uca.edu.sv*

Voices in The Wilderness: *www.vitw.org*

Wellness Community: *www.thewellnesscommunity.org*

Witness for Peace: *http://www.w4peace.org*

References

[1] Natalie Goldberg, *Writing Down The Bones: Freeing The Writer Within* (Boston: Shambhala, 1986), 11.

[2] Thich Nhat Hanh, *Being Peace* (Berkeley: Parallax Press, 1987).

[3] Noam Chomsky, *The Chomsky Reader*, ed. James Peck (New York: Pantheon, 1987).

[4] See Judith M. Noone, *The Same Fate as the Poor* (Maryknoll, NY: Orbis Books, 1995).

[5] Thich Nhat Hanh, "Call Me By My True Names," in idem, *Love in Action:Writings on Nonviolent Social Change* (Berkeley: Parallax Press, 1993), 107-109.

[6] Published as Thich Nhat Hanh, *The Miracle of Mindfulness! A Manual on Meditation* (Boston: Beacon Press, 1976).

[7] John Kavanaugh, *Following Christ in a Consumer Society* (Maryknoll, NY: Orbis Books, 1982).

[8] Gustavo Gutiérrez, *A Theology of Liberation: History, Politics and Salvation*, trans. Sister Caridad Inda and John Eagleson (Maryknoll, NY: Orbis Books, 1988).

[9] See the collected papers in Marc H. Ellis and Otto Maduro, ed., *The Future of Liberation Theology: Essays in Honor of Gustavo Gutiérrez* (Maryknoll, NY: Orbis Books, 1989).

[10] Marc H. Ellis, *A Year at the Catholic Worker: A Spiritual Journey Among the Poor* (Waco, TX: Baylor University Press, 2000).

[11] Adapted from Mev Puleo, "Interview with Gustavo Gutiérrez," *St. Anthony Messenger* (February, 1989).

[12] Thich Nhat Hanh, *Present Moment Wonderful Moment: Mindfulness Verses for Daily Living* (Berkeley: Parallax Press, 1990), 32.

[13] Jean-Bertrand Aristide, *In The Parish of The Poor:Writings from Haiti* (Maryknoll, N.Y.: Orbis Books, 1990), 33-34.

[14] Spinoza, *Ethics*, ed. and trans. G. H. R. Parkinson (Oxford: Oxford University Press, 2000), 316.

[15] Irving Greenberg, "Cloud of Smoke, Pillar of Fire: Judaism, Christianity, and Modernity after the Holocaust" in *Auschwitz: Beginning of a New Era?*, ed. Eva Fleischner (New York: KTAV Publishing House, Inc., 1977), 23.

[16] Elie Wiesel, *A Jew Today* (New York: Vintage, 1979), 13-14.

[17] George Steiner, "Jewish Values in the Post-Holocaust Future: A Symposium," *Judaism* 16 (Spring 1967): 285-286.

[18] Thich Nhat Hanh, *Interbeing: Commentaries on the Tiep Hien Precepts* (Berkeley: Parallax Press, 1987), 34.

[19] Mev Puleo, "Art as Advocacy: Reflections of a Photographer," *Breakthrough* (Winter, 1990).

[20] See, for example, Pablo Richard et al., *The Idols of Death and the God of Life: A Theology*, trans. Barbara E. Campbell and Bonnie Shepard (Maryknoll, NY: Orbis Books, 1983).

[21] Erich Fromm, *You Shall Be As Gods: A Radical Reinterpretation of the Old Testament and Its Tradition* (Greenwich, CT: Fawcett Publications, Inc., 1966), 40.

[22] Javier Giraldo, S.J., *Colombia: The Genocidal Democracy* (Monroe, ME: Common Courage Press, 1996), 34-36.

[23] William Blake, "The Divine Image," in Alfred Kazin, ed., *The Portable Blake* (New York: Viking Press, 1976), 91.

[24] This is an edited version of Mev's original interview. A shorter version was published as Mev Puleo, "The Struggle Continues: Interviewing Ilza Mendes," *Maryknoll Magazine* (January, 1990).

[25] Penny Lernoux, *Cry of The People: The Struggle for Human Rights in Latin America—The Catholic Church in Conflict with U.S. Policy* (New York: Penguin, 1982).

[26] Nhat Hanh, *Present Moment Wonderful Moment*, 34-35.

[27] Thich Nhat Hanh, *Peace Is Every Step: The Path of Mindfulness in Everyday Life* (New York: Bantam, 1991), 37-38.

[28] Quoted in Marc H. Ellis, *Towards a Jewish Theology of Liberation* (Maryknoll, NY: Orbis Books, 1987), 35.

[29] Ibid., 45.

[30] Quoted in Noam Chomsky, *Turning the Tide: U.S. Intervention in Central America and the Struggle for Peace* (Boston: South End Press, 1985), 48.

[31] Ignacio Ellacuría, "Persecution for the Sake of the Reign of God" in Jon Sobrino et alia, *Companions of Jesus: The Jesuit Martyrs of El Salvador* (Maryknoll, NY: Orbis Books, 1990), 66-67.

[32] Ibid., 66.

[33] See Teresa Whitfield, *Paying The Price: Ignacio Ellacuría and the Murdered Jesuits of El Salvador* (Philadelphia: Temple University Press, 1994),

[34] Ignacio Ellacuría, "The University, Human Rights, and The Poor Majority," in *Towards a Society That Serves Its People: The Intellectual Contribution of El Salvador's Murdered*

Jesuits, ed. John Hassett and Hugh Lacey (Washington, D.C.: Georgetown University Press, 1991), 211.

[35] Ignacio Ellacuría, "The Task of a Christian University," *Towards a Society That Serves Its People*, 150.

[36] Quoted by Jon Sobrino, *Jesus The Liberator: A Historical-Theological View*, trans. Paul Burns and Francis McDonagh (Maryknoll, NY: Orbis Books, 1993), 262-263.

[37] John F. Kavanaugh, S.J., and Mev Puleo, *Faces of Poverty, Faces of Christ* (Maryknoll, NY: Orbis Books, 1991).

[38] Naim Ateek, *Justice and Only Justice: A Palestinian Theology of Liberation* (Maryknoll, NY: Orbis Books, 1990).

[39] Elie Wiesel, *Against Silence: The Voice and Vision of Elie Wiesel*, ed. Irving Abrahamson (New York: Holocaust Library, 1985), 1: 149.

[40] Ibid., 1: 216.

[41] Richard L. Rubenstein, *After Auschwitz: Radical Theology and Contemporary Judaism* (Indianapolis: Bobbs-Merrill, 1966).

[42] Richard L. Rubenstein, *The Cunning of History: The Holocaust and the American Future* (San Francisco: Harper and Row, 1975), 91.

[43] See Edward W. Said, *The Question of Palestine* (New York: Vintage Books, 1992).

[44] Quoted in Noam Chomsky, *The Fateful Triangle: The United States, Israel and the Palestinians* (Boston: South End Press, 1983), 257-258.

[45] See Marc H. Ellis, *Beyond Innocence and Redemption: Confronting the Holocaust and Israeli Power* (San Francisco: Harper and Row, 1990).

[46] Said, *The Question of Palestine*, xxi.

[47] Jack Kerouac, "Belief & Technique For Modern Prose: List of Prose Essentials," in *The Portable Beat Reader*, ed. Anne Charters (New York: Penguin, 1992), 58-59.

[48] Mev Puleo, *The Struggle is One: Voices and Visions of Liberation* (Albany, NY: SUNY Press, 1994), 47-48.

[49] Ibid., 48-49.

[50] Ibid., 52.

[51] Ibid., 119.

[52] Ibid., 62.

[53] Ibid., 15.

[54] Ibid., 26.

[55] Ibid., 83-84.

[56] Ibid., 97.

[57] Ibid., 111.

58 Ibid., 127.

59 Ibid., 152.

60 Ibid., 182.

61 Ibid., 188.

62 Ibid., 208.

63 Ibid., 242.

64 This is excerpted from Mev Puleo, "Bare Feet on Holy Ground: Bishop Casaldaliga of Brazil," *St. Anthony Messenger* (February 1992).

65 Allan Nairn, "Witness to the Santa Cruz Massacre," http://www.motherjones.com/east_timor/evidence/nairn.html

66 This is an excerpt from Mev Puleo, "Faith and War in El Salvador," *Catholic HealthWorld* (July 1, 1993).

67 Mev Puleo, "'Walk Humbly with God:' Interview with Jon Sobrino, S.J." *Maryknoll Magazine* (February 1994).

68 See Arnold Kohen, *From The Place of The Dead: The Epic Struggles of Bishop Belo of East Timor* (New York: Saint Martin's Press), 1999.

69 See Mark Achbar, ed., *Manufacturing Consent: Noam Chomsky and the Media* (Montréal: Black Rose Books, 1994).

70 Quoted in Judith Miller, *One, by One, by One: Facing the Holocaust* (New York: Touchstone, 1990), 228.

71 See also Mev Puleo, "The Prophetic Act of Bearing Witness: The Work of Sebastião Salgado," *ARTS: The Arts in Religious and Theological Studies* (7:1): 1994.

72 Subcommandante Marcos, *Our Word is Our Weapon: Selected Writings*, ed. Juana Ponce de Leon (New York: Seven Stories Press), 17.

73 See http://www.plowsharesactions.org/webpages/JUBILEEPLOWSHARES.htm

74 Harold Bloom, *The Western Canon: The Books and School of the Ages* (New York: Harcourt Brace & Company, 1994), 519.

75 Ibid., 518.

76 William Blake, *The Portable Blake*, 255.

77 Herbert G. May and Bruce M. Metzger, ed., "Song of Solomon," *The New Oxford Annotated Bible with The Apocrypha (Revised Standard Version)* (New York: Oxford University Press, 1977), 817-818.

78 Quoted in Eknath Easwaran, *God Makes The Rivers To Flow: Selections from The Sacred Literature of The World / Chosen for Daily Meditation by Eknath Easwran*, 2nd ed.(Tomales, CA: Nilgiri Press, 1991), 114.

79 Puleo, *The Struggle is One*, 208-209.

[80] Brue Springsteen, "The Ghost of Tom Joad," *The Ghost of Tom Joad* (Columbia, 1995).

[81] Dorothy Day, *The Long Loneliness: An Autobiography* (San Francisco: Harper and Row, 1981), 286.

[82] See Dante Alighieri, *La Vita Nuova*, trans. Barbara Reynolds (New York: Penguin, 1969).

[83] Quoted in Allen Ginsberg, *Deliberate Prose: Selected Essays, 1952-1995*, ed. Bill Morgan (New York: HarperCollins, 2000), 265.

[84] Ibid.

[85] Later on, the Puleos wanted to make sure SLU undergraduates were able to have the immersion Mev undertook in her various Latin American projects. Funds were made available to several students each summer to live and work in Nicaragua. It was a joy that several of my students were able to take advantage of this opportunity.

[86] Kathy Kelly, "Banning Child Sacrifice," http://www.iacenter.org/sacrific.htm.

[87] Mark Chmiel, *Elie Wiesel and The Politics of Moral Leadership* (Philadelphia: Temple University Press, 2001), 170-171.

[88] Rachel Corrie, "Rachel's Reports" in *Live from Palestine: International and Palestinian Direct Action Against the Israeli Occupation*, ed. Nancy Stohlman and Laurieann Aladin (Cambridge, MA: South End Press, 2003), 175.

To purchase photographs and videos by Mev Puleo
or to schedule a presentation based on *The Book of Mev*,
contact Mark Chmiel at mark@ctsastl.org